The World of Art Deco

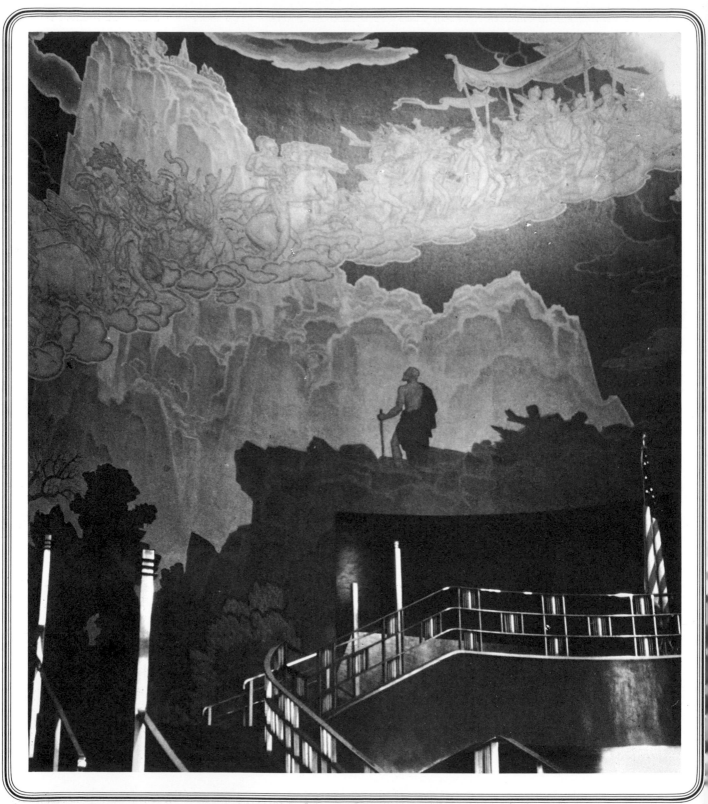

Main Lobby, Radio City Music Hall, Rockefeller Center, New York City

The World of ART DECO

Text by Bevis Hillier

An Exhibition organized by The Minneapolis Institute of Arts
July – September
1971

E. P. Dutton New York

An Exhibition organized by The Minneapolis Institute of Arts
Works of art selected by Bevis Hillier

Exhibition Staff
Anthony M Clark *Director*
David Ryan *Coordinator of the Exhibition*
Bevis Hillier *Guest Curator*
Edgar Peters Bowron *Registrar*
Ann Mason/Peter Georgas *Publicity*
Susan Johnson *Secretary*

First published, 1971, in the United States by E. P. Dutton,
a division of Elsevier-Dutton Publishing Co., Inc.,
2 Park Avenue, New York, N.Y. 10016.
© Text Bevis Hillier 1971
All rights reserved
Produced and designed by Rainbird Reference Books Limited,
Marble Arch House, 44 Edgware Road, London W2,
for The Minneapolis Institute of Arts, Minneapolis, Minnesota,
and E. P. Dutton, New York.
Original edition printed by Westerham Press Ltd., Westerham, Kent, England

Bibliography Robert Brown
House Editor Mark Amory
Designer Trevor Vincent
Jacket Design Bentley, Farrell, Burnett

ISBN: 0-525-93216-X (cloth)
ISBN: 0-525-47680-6 (DP)

Printed and bound by Dai Nippon Printing Co., Ltd., Tokyo, Japan

Contents

Lenders to the Exhibition

Anonymous Loans
John Astrop, London
Yvette Barran, Paris
Bibliothèque Forney, Paris
David Bindman, London
Mrs Gertrude Bloodhart, Minneapolis
Mr and Mrs Peter M. Brant, New York
Mr and Mrs Jonathon Brown, Princeton, N.J.
Robert K. Brown Art & Books, New York
University of California, The Art Galleries, Santa Barbara
Edward Lee Cave, New York
Alain Cical, Houilles, France
Anthony M. Clark, Minneapolis
Cooper-Hewitt Museum of Design,
Smithsonian Institution, New York
Cranbrook Academy of Art, Art Galleries,
Bloomfield Hills, Mich.
Mme Sonia Delaunay, Paris
Miss Jessica Dragonette, New York
Adrian Emmerton, London
Harvey Feinstein, New York
Mr and Mrs Miles Fiterman, Minneapolis
Barry and Audrey Friedman, Antiques, Kew Gardens, N.Y.
Anthony Haden-Guest, London
Charles Handley-Read, London
Miss Mary Hillier, London
Fred Hughes, New York
Stanley Insler, New York
John Jesse, London
Wilma Keyes, Mansfield Center, Conn.
Kiki Kogelnik, New York
Stanley Landsman, New York
Larcada Gallery, New York
Mrs F. Legrand-Kapferer, Paris
Miss Jean Leonard, New York
Alain Lesieutre, Paris
Mr and Mrs Roy Lichtenstein, New York
Locksley/Shea Gallery, Minneapolis
Lords Gallery Ltd, London
Dr and Mrs Leonard Lustgarten, New York
Galerie du Luxembourg, Paris
Paul Magriel, New York

Félix Marcilhac, Paris
Martins-Forrest Antiques, London
Ted McBurnett, New York
Christopher Mendez, London
The Metropolitan Museum of Art, New York
Miss Marie Middleton, London
Minneapolis Public Library
Musée Christofle, St Denis, France
Musée des Arts Décoratifs, Paris
Museum of Costume, Bath, England
The Museum of Modern Art, New York
Lillian Nassau Ltd, New York
Nebraska State Historical Society, Lincoln
Anthony d'Offay, London
Miss Margaret Mary Olson, Minneapolis
Dr Robert Pincus-Witten, New York
Yves Plantin, Paris
Miss Prudence Pratt, London
Mr and Mrs Michael Pruskin, London
Puiforcat-Orfèvre, Paris
Radio City Music Hall, Rockefeller Center, New York
Mr and Mrs Michael Raeburn, London
Leslie Randle, London
Mr Christian Rohlfing, New York
Mr and Mrs Samuel Sachs, II, Minneapolis
Mrs M. Shepley-Watson, London
Gilbert Silberstein, Paris
Dr K. C. P. Smith and Paul Smith, Bristol, England
Sonnabend Gallery, New York
Galerie Ileana Sonnabend, Paris
Matthew and Gillian Stein, Bristol, England
Jon Nicholas Streep, New York
Mrs Janet Street-Porter, London
Miss Barbra Streisand, New York
Robin Symes, London
Thomas Designs, Minneapolis
Mr and Mrs John Varian, New York
John Vassos, Norwalk, Conn.
Victoria and Albert Museum, London
Andy Warhol, New York
Mrs Kem Weber, Santa Barbara, Calif.
Mr and Mrs Lewis V. Winter, New York

List of Photographers

Photographs in the introduction are listed by page numbers shown in medium weight.
Photographs in the catalogue are listed by exhibition numbers shown in light weight.

C. H. Cannings, Sussex, England

P.24 (both), P.25 (left). Cat. No: 8, 158, 159, 161, 162, 201, 202, 231, 294, 330, 336, 385–91, 437, 463, 520, 557, 573, 586–90, 599, 600, 608, 628, 646, 656, 703, 713, 739, 992, 1003, 1010, 1015a, 1018, 1031, 1138, 1138a, 1144, 1146, 1152, 1153, 1155, 1163, 1165, 1197.

Leland Cook, New York

P.14 (left), P.15 (right), P.22 (both), P.25 (right), P.28, P.32. Cat. No: 26, 28, 32, 90, 91, 216, 234, 240, 241, 344, 356, 365, 369, 501, 526, 684, 1192, 1381.

Carol Ted Hartwell, Minneapolis

P.37 (below). Cat. No: 44, 54, 84, 85, 406, 423, 949a, 955, 1288.

Ted McBurnett, New York

P.15 (left), P.17, P.26 (right), P.27, P.40 (right). Cat. No: 152, 427, 890, 893, 934, 1221, 1226, 1254, 1278.

Laurent Sully-Jaulmes, Paris

P.39 (left). Cat. No: 36, 50, 100, 238, 257, 263, 267, 271, 277, 278, 283–9, 314, 339, 523–5, 569, 611, 624, 637, 638, 652, 661, 667, 719, 727, 758, 772 782, 788, 789, 810, 815, 818, 824, 833, 857, 876a, 882, 910, 914, 917, 920, 1200, 1207, 1297–1300.

Julian Nieman, London

P.42, P.43 (above, left and right). Cat. No: 236, 242, 243, 246, 256, 270, 341, 354, 384, 392, 394, 395, 439, 442, 446, 451, 452, 466, 477, 480, 493–7, 513, 553, 581–4, 603, 606, 683, 790, 864, 866, 873, 876, 878, 886, 888, 894, 899, 900, 907, 911, 923, 924, 931, 935, 947, 948, 950, 951, 967, 968, 969, 972, 974, 976–81, 991a, 1020, 1083, 1206, 1234, 1235, 1271, 1286, 1386–97, 1404, 1420, 1438, 1441.

Desmond Tripp Studios, Bath, England

Cat. No: 73, 1036, 1037, 1040, 1048, 1058–72, 1084–95, 1097, 1099, 1100.

Derrick Witty, London

P.16 (right, above and below), P.19, P.39 (above right), P.40 (above left). Cat. No: 118, 411, 1283.

Musée des Art Décoratifs, Paris

Cat. No: 56, 57, 67, 78, 79, 370, 528, 529, 929, 932, 1130, 1131, 1251, 1294, 1296, 1301–3, 1336.

Puiforcat-Orfèvre, Paris

P.41 (below right). Cat. No: 169, 171, 172, 174, 177, 178, 321, 552.

Musée Christofle, St Denis

Cat. No: 130, 134, 136, 139, 140, 142, 146.

John R. Freeman & Co., London

P.14 (right). Cat. No: 940.

Dr David Gebhard, Santa Barbara, California

P.35 (below). Cat. No: 1367a.

Marvin Rand, Los Angeles

Cat. No: 1371.

Salisbury Photo Press, Salisbury, England

P.45, P.46, P.47. Cat. No: 1357.

Tim Street-Porter, London

Cat. No: 1104, 1350, 1355–6, 1360, 1362.

Susan Janssen, Amsterdam

Cat. No: 1353–4

Acknowledgments

On behalf of The Minneapolis Institute of Arts we wish first to express our warmest gratitude to the collectors, dealers, galleries and institutions who have generously made their collections available. We are greatly indebted to them for their kind and enthusiastic support.

We are particularly grateful to the individuals whose personal interest and assistance brought this exhibition into being:

Elayne Varian, Director, Contemporary Wing, Finch College Museum of Art, and her staff, who organized an admirable exhibition of Art Deco which forms part of the present show.

David Gebhard, Director, Art Galleries, University of California, Santa Barbara, for his patient counseling and the use of his architectural photographs.

Judith Applegate, Contributing Editor, *Art International*, who did valuable research in Paris and gave the organizers the benefit of her specialist knowledge of aspects of French decorative art.

Robert Brown, for contributing to the scholarship of Art Deco by compiling its first definitive bibliography. Thanks are due to Peter D. Eisenman, Jonathon Brown and the staff of the Art and Architecture Department of the New York Public Library for their courtesy and assistance to Mr Brown.

John Peterson, Associate Director, Art Galleries, Cranbrook Academy of Art, who coordinated the shipment of many American loans.

We extend our thanks to Bentley, Farrell & Burnett for the catalog cover, end papers, poster and invitation designs; also, to Michael Raeburn, Mark Amory and Trevor Vincent of George Rainbird Ltd, for catalog design, production and distribution.

We appreciate the untiring assistance of the Institute staff, especially those directly responsible for the exhibition: Anthony M. Clark, who encouraged us through each phase of the exhibition from its inception in July 1969; Peter Bowron, who efficiently managed the complex aspects of insurance, packing and shipping; Ann Mason and Peter Georgas, who coordinated publicity, and Susan Johnson, who contributed extensive secretarial assistance.

Bevis Hillier / David Ryan

Foreword

Three years ago The Minneapolis Institute of Arts energized its exhibition program by formally reserving its summer schedule for one large, imaginative exhibit of major importance. This decision has resulted in three exhibitions of considerable merit, each adding significantly to the vitality of this region's summer resources, as well as contributing to the achievements of American museums.

The first exhibition of the series, *The Past Rediscovered: French Painting, 1800–1900*, was acclaimed by critics and public alike. The second exhibit, *Richard Avedon*, was particularly well received by our young audience and was the first comprehensive survey of Avedon's work to date.

Art Deco is the first international, encyclopedic presentation of this forgotten and extraordinary style. Nearly fifteen hundred works, of all sorts, created by hundreds of excellent craftsmen and designers have been borrowed from generous lenders.

Art Deco has been composed from thousands of possibilities. Understandably, any style that has endured several decades of derision will prompt much debate — ours is, after all, a pioneer exhibition, and one that immediately invites connoisseurship. Therefore, I wish formally to record that the Institute is extremely proud of the selections made by Bevis Hillier.

Soon after the exhibition was conceived in the summer of 1969, Mr Hillier was asked to participate in its execution, a decision based largely on the strength of his commendable book, *Art Deco*, which appeared in this country roughly at the same time. His was the first effort published in English defining the style's origins, influences and many stylistic differences and, in fact, served as a guideline for this exhibition. Mr Hillier has given generously of his time, always with a spirit of enthusiasm, devotion and humor.

It is equally pleasing to know that today's museum can draw upon the vast resources of an international scholastic community: Judith Applegate, Bentley/Farrell/Burnett, Robert Brown, David Gebhard, Robert Pincus-Witten, Stuart Silver, Elayne Varian and others far too numerous to list here have contributed their time and expertise to the exhibition.

Finally, I wish to thank David Ryan, the Institute's Curator of Exhibitions. It was Mr Ryan who conceived of this exhibition and whose reason and enthusiasm won the total support of his colleagues and brought Mr Hillier to our aid. Mr Ryan's backbreaking work over numerous obstacles even more difficult than a disruptive British postal strike has made this exhibition possible and good.

I hope the community will share our excitement for *Art Deco* by joining me in welcoming this important exhibit to Minneapolis.

Anthony M. Clark *Director*

Introduction

The year is 1929. We are on the outskirts of Ascot, England, not far from Windsor Castle. The house is set back from the main road, shielded from it by banks of dusty laurel bushes. A jobbing gardener is spraying the greenfly on the roses. A terracotta fountain, shaped like a set of humming tops balanced on each other, is dribbling its waters feebly into its glazed ultramarine basin, for this is a time of drought. The house, which was built two years ago, is large, white and 'modernistic'. It is not wholly symmetrical: the front door, masked from the July sun by a striped canvas curtain, is set to the right; down the lower part of the right-hand wall five porthole windows are vertically spaced. The roof is flat and something like a ship's taffrail runs along its front edge. Up there, the daughter of the house, Fuchsia, is sunbathing. Through her plastic sun-glasses she is reading the latest Aldous Huxley novel, *Point Counter Point*.

It is Saturday morning, and all the family are home. Mr Reynolds is practising golf strokes on the large back lawn. Mrs Reynolds is chatting with cook about the day's menu. You can see their son, Reggie, through the Crittall metal-framed front window. Reggie is down from Oxford for the Long Vacation. He wears huge Oxford bags, which in profile look like Edith Cavell's skirt, and a silk shirt by Sulka, with silver and enamel cufflinks. He is lounging in an armchair by the gramophone listening to Gertrude Lawrence singing about how her doctor, 'less like a doctor than a Turk', is fascinated by her metabolism but doesn't love her.

> *He said my bronchial tubes are entrancing,*
> *My epiglottis filled him with glee;*
> *He simply loved my larynx*
> *And went wild about my pharynx,*
> *But he never said he loved me.* [1]

The mock-Sheraton cabinet of the gramophone, with its marquetry inlay and cabriole legs, is oddly out of harmony with the rest of the *décor*, which is self-consciously modern. (Odd that the most advanced technical object in the room should be disguised as the most archaic.) Reggie's armchair has great sausagey leather arms with

CRITTALL

HOUSE at SILVER END, ESSEX for D.F. CRITTALL ESQ.,
ARCHITECTS: SIR JOHN BURNET AND PARTNERS.

METAL WINDOWS

HEAD OFFICE
210, HIGH HOLBORN, LONDON. W.C.I.

MANOR WORKS BRAINTREE.

1 My more vigilant and knowledgeable readers will probably notice that for the sake of representing something from the 'thirties in this essentially 'twenties *mise en scène* I have allowed two anachronisms to creep in. Gertrude Lawrence was already a great star in the 'twenties; but her 'Physician' song was first heard at the Adelphi Theatre, London, in October, 1933. And the film *My Weakness*, from which Reggie's song 'Gather lip-rouge while you may' was taken, also dates from 1933.

He said my epidermis was darling
And found my blood as blue as can be;
He went through wild ecstatics
When I showed him my lymphatics
But he never said he loved me.

Like all young men, Reggie knows it is perfectly possible to do two things at once. (Two? A dozen!) So, while Lawrence warbles away he is reading Francis Hackett's new book *Henry VIII*. His tutor had prescribed sterner holiday reading, but Reggie was attracted by the book jacket designed by Lee Elliott, a bright pattern made up of several silhouette Henry VIIIs. Across it runs the legend: '*Henry VIII* by Francis Hackett author of *That Nice Young Couple*.' Whether unconscious or not, the irony is lost on Reggie, who is not a very cerebral young man, having been given a place at Oxford because his uncle is the Bishop of Barchester. Even if he finishes the book, he will not know whether Henry had six wives or eight.

Mr Reynolds is a stockbroker by profession and a golfer for pleasure. He does not pretend to any interest in things artistic. His wife, on the other hand, was once a student at the Kingston School of Art. She also took private lessons from Yeend King, RI, a friend of her father's.

pink tassels hanging from the ends. He flicks the ash from his Balkan Sobranie cigarette into a chrome and black plastic smoker's companion, a futurist contraption with a large chrome bowl as the ashtray, the matches perched in a chrome clip held by parallel chrome wires. At intervals, he sips his cocktail ('Satan's skin') from a frosted and black-enamelled conical glass. The silver cocktail-shaker, with its jazzy enamelled triangle motifs, sits on a macassar and ivory sideboard made by Emile-Jacques Ruhlmann, ordered by the Reynoldses at the 1925 Exposition in

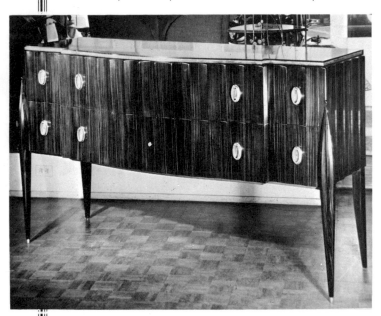

Paris, where they happened to be staying that year en route for the Le Mans races.

The carpet is, to tell the truth, rather too aggressive. In thirty to forty years those acid greens, electric blues and chrome oranges will have mellowed to a nice muted colour orchestration; just now, they are a clashing cacophony, and even Gertrude Lawrence's passionate vibrato can hardly compete:

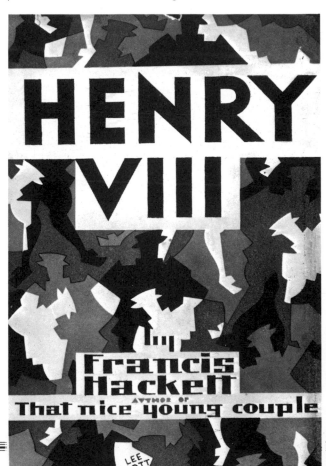

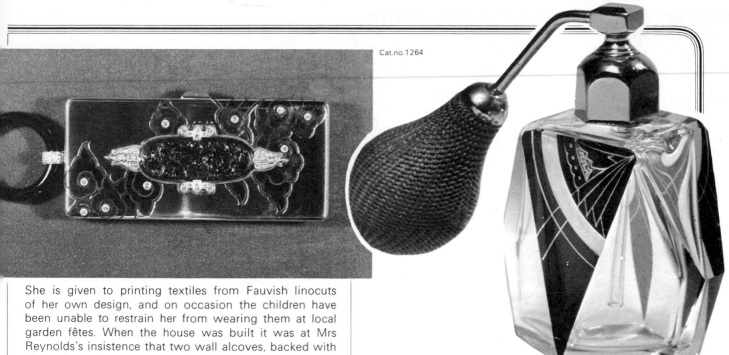

Cat.no.1264

Cat.no.592

She is given to printing textiles from Fauvish linocuts of her own design, and on occasion the children have been unable to restrain her from wearing them at local garden fêtes. When the house was built it was at Mrs Reynolds's insistence that two wall alcoves, backed with pink mirror-glass, were included in the design. On the glass shelves, supported by miniature ziggurats of chrome, are the varied memorials of her taste. Some are, as she would say, not half bad. There is the Simon Gate engraved Orrefors glass bowl (souvenir of a fortnight in Sweden) with its design of leaping women and dogs. There is a vanity case given her by a French vicomte who had business dealings with her husband and stayed with them at Queen's Lacey (for such is the name of their house) for the weekend. The children tease her that she must have had an affair with him to earn such a lavish gift. She wishes it were true. The vicomte's vanity case is too fine to carry in her crocodile handbag, except to very special 'do's'; for daily use she has a silver and enamel job from Mappin and Webb, Regent Street. In one of the alcoves, pride of place is given to a Chiparus figure of a harlequin and columbine with ivory faces and an onyx plinth. There is also a glass scent-spray with what Reggie, in his Oxford drawl, describes as 'a rather *suggestive* rubber bulb, Mama — *too* shaming'.

Between the two alcoves is a large tiled chimney-piece — the Reynoldses still burn logs and coal in this main room, though there are fitted Belling fires in most of the bedrooms — and on the mottled mantelshelf is a bronze and marble *garniture de cheminée*; a marble ten-day clock made by R. Jay of Paris and London, with bronze nude female supporters holding aloft what look like alabaster golf balls (they don't, surprisingly, light up) flanked by marble vases which might have been bought from a funeral parlour, an impression Mrs. Reynolds heightens by filling them with hydrangea blooms.

Mrs Reynolds's taste, in fact, might be politely described

as 'erratic'. Sometimes she picks a real winner. For example, the McKnight Kauffer and Marion Dorn rugs in the entrance hall; the Puiforcat coffee equipage in the morning room; above all, the magnificent suite of furniture by Maurice Dufrène, upholstered in magenta tapestry with panels of stylized flowers, which she had shipped from Paris on the advice of her friend Syrie Maugham (Somerset's wife), the fashionable interior decorator. Against the off-white walls of her boudoir (where she sips *bouillon* when the family get, my dear, *too* much for her, leaving cook to cope downstairs) the rich sofa and exotic armchairs look like a Matthew Smith still life. Subdued lighting comes from rearing bronze cobra lamps by Edgar Brandt, in the modish Egyptian taste.

Less happy are Mrs Reynolds's adventures in tubular steel and bakelite, the concession of a naturally luxurious woman to the ideas of 'purism' and 'architectural nudism' preached by 'Corb', as she is au fait enough to call Le Corbusier. Mr Reynolds, who would really be infinitely more at ease among deep leather club armchairs and antlers, finds frankly repellent the curious steel and leather couch, not unlike a dentist's operating chair, which graces the far end of the dining-room nearest the sun-lounge. When he wants to light his pipe, he often forgets that one lighter is concealed in a plastic replica of a tennis ball, the other in the belly of a bronze fan-dancer. Ash from his Craven A cigarettes falls in volcanic deposits on the zebra rugs as he vainly hunts for the ashtray — a small tin tray proffered by a metal dumb waiter in tin evening dress.

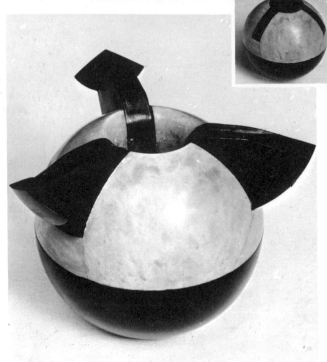

What of the rest of the house, upstairs? As one would expect, the children of so advanced a mother have been given a free hand in the decoration and fitting-out of their bedrooms, or 'dens', as Mrs Reynolds whimsically calls them. The glory of Fuchsia's room is a dressing-table, ninety per cent looking-glass and ten per cent cabinet. The glass is big and round like a harvest moon brought indoors. The cabinet — a chic nest of drawers with tassels as handles — is lacquered in fuchsia to match her name. It is a rather imaginative (also very expensive) piece of furniture. If it were not permanently covered with lip-rouge containers, powder boxes, mascara brushes, scent-sprays, perfume phials, bizarre cakes of soap with oriental names, paper lanterns from Cynthia's twenty-first party at Sunningdale, dog-eared love-letters, pot-pourri packets from the church jumble sale, curling papers, musk-laden shampoos and other preparations for keeping the skin succulent, the eyes lustrous, the lips lurid, it would be worthy of a half-page illustration in *The Studio*: *The New Art of Mirror Glass: a Vanity Table with a Difference*, or the like.

Fuchsia's wardrobe is not extensive, for she is still at her private school and can attend balls only in the holidays. But what she has got is all of fine quality, except for a few arty smocks designed, made and printed by her mother. There is a pale blue cloth suit — jacket and skirt — with dark blue silk facings and sunray tucks, by Paquin. It's a bit old for her, but Fuchsia and her friends all try to look more than their seventeen years. Her favourite evening dress is of black muslin embroidered with blue beads, and is worn over a black slip. Her handbags, shoes and gloves, strewn about the room in profusion, mostly come from London stores, though several were made in Paris.

Reggie's room is not less elegant, for at Oxford he is considered an 'aesthete', not a 'hearty'. He fancies himself as a pianist. The piano is small, upright and cream-painted, with chrome candelabra in the newest taste. The music on the rest is 'Je m'donne', the Maurice Chevalier number from the operette *Dédé*. The music sheet has a charmingly

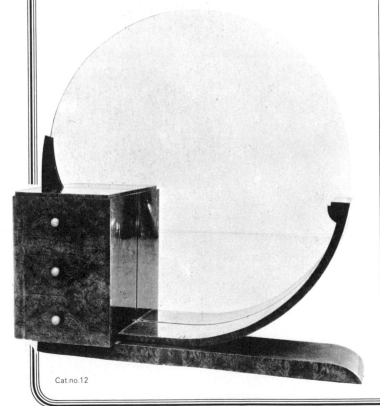

Cat.no.12

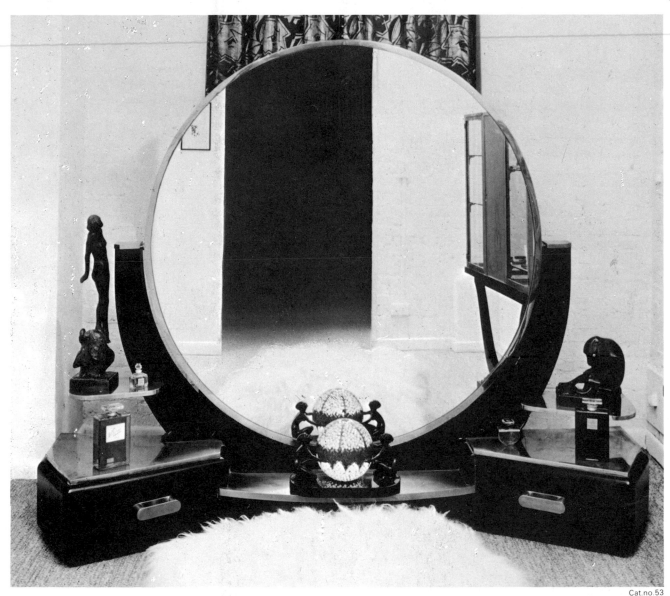

arch cover by de Valerio, showing the slick-haired male assistant in a shoe-shop fitting a court shoe on the foot, and caressing the ankle, of a lady who is coyly peeking from behind her muff. Reggie has also brought back from Italy 'Il Fox-Trot delle Gigolettes', a Franz Lehár song which he picked up in a music-shop in Rome. Another part of his repertoire. equally in demand at Oxford smoking-concerts or 'smokers', is 'Gather lip-rouge while you may', a song from the Fox film *My Weakness*, starring Lilian Harvey and Lew Ayres, which he has been to see at the Windsor Gaumont three times. (That superb movie-palace with its giant Wurlitzer pumping out medleys, and

its surreal interior which changes colour in the intervals from peach melba to banana split to crème de menthe.)

Reggie's wardrobe includes three very dashing dressing-gowns. Noël Coward himself would not scorn them. One, by Sonia Delaunay, is jazz-patterned, another, of red silk, is embroidered with gold dragons; the third, of electric blue silk, has black quilted lapels. He never needs to hire a dinner-jacket or a morning- or evening-suit, for there they all are in the cupboard, hung with smelly sachets which are supposed to be death to moths. His crimson velvet smoking-jacket, tasselled skull cap and ivory cigarette-holder have been laid out on the bed

MANNEQUINS HOMMES

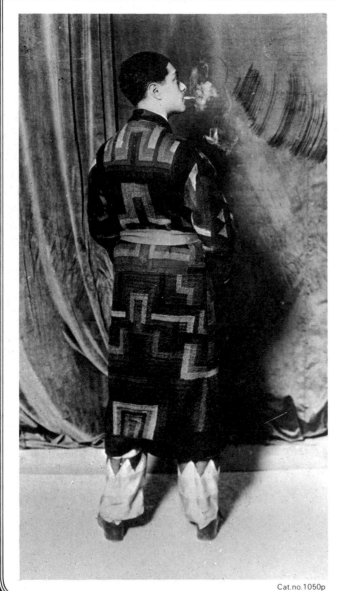

Cat. no. 1050p

ready for the evening by Maisie, the maid, who is a *very* good friend of Reggie's. She worships the monogrammed slippers (from Lobb's of Duke Street, St. James's) he walks on.

From Reggie's window you can see about an acre of immaculate lawn (the Reynoldses believe in keeping the garden in its proper place — the roof). Reggie's black and cream Lagonda is in the drive — with its silver nude radiator-cap mascot which no one has yet stolen or been speared upon in any of his three spectacular crashes. The garage houses his father's statelier limousine. Overhead, a silver bi-plane is writing 'Kensitas Cigarettes' in the blue Windsor sky, in white ragged calligraphy like sea spume. And beyond the swing-chair at the bottom of the garden, with its striped awning; beyond Fuchsia's hammock; beyond private tennis-courts, new roads and numberless flat white roofs, looms the mediaeval hulk of Windsor Castle, apparently untouched by the 'twenties; though inside, past the cannon and arrow-slits, Her Majesty Queen Mary is trying on a dress from Worth.

Let us admit it, the Reynolds family is a little exceptional — almost as exceptional as that rather better-known family beyond the tennis-courts. They are a little too Art Deco to be true. But in 1929 you could have found families not so unlike them in London, Paris and New York — though the Mr Reynoldses of New York were on the brink of harder times, and the Depression of that year would have its effect in London and Paris too. And while I chose the well-to-do Reynolds family to illustrate the social divergence of the 'twenties from today (a difference perfectly illustrated by the Art Deco notice on the lift doors at Park Place West, London: 'Servants may not use this lift') there were millions of families of a lower social status who had their chromium-plated candlesticks, their plaster figures of starlets with borzois, and their plastic pendants and handbag clasps.

Born in 1940, I grew up amid the débris of that period, and it was in an attempt to understand how the motifs and styles of Art Deco developed that I wrote a book on the subject in 1968. In tackling the subject now for the second time in two years, I find myself rather in the position of Dr F. R. Leavis in his recent book on Dickens. In a famous book on the novel, *The Great Tradition* (New York University Press, New York and Chatto and Windus, London, 1948), Leavis had asserted, with challenging dogmatism: 'The great English novelists are Jane Austen, George Eliot, Henry James and Joseph Conrad.' (My American friends will realize how vast is the compliment implied by calling James English.) Of Dickens's novels, Leavis found only one even worthy of mention: *Hard Times*. For the rest, Dickens's genius was dismissed as 'that of a great entertainer', and Leavis added that Dickens 'had for the most part no profounder responsibility as a creative artist than

this description suggests.' In a new book on Dickens[1] (written with his wife) Leavis abandons these reservations. Many more of Dickens's works are received into the Leavis canon. Inevitably certain critics of the new book, while welcoming it, have rebuked Leavis for not admitting his *volte-face*. There were not, they implied, enough sackcloth and ashes in evidence.

Although my conversion to Art Deco is less dramatic, and has taken two years, not twenty, my shift in position is comparable to Leavis's: and I intend to show myself suitably penitent. Like Leavis on Dickens, I had treated my subject too much, perhaps, as one of inspired comedy. Though I singled out some of the Art Deco designers as 'men of genius' — Ruhlmann, Puiforcat, Mallet-Stevens — my main concern was not to show what was most lofty and admirable in the style; rather I wanted to discover how such an extraordinary set of artistic conventions had come into being; how the Reynoldses had come to live in such a setting. Hence my emphasis on the different influences which had contributed to the hybrid of Art Deco. This approach both misled those to whom Art Deco was a new idea (*The Times Educational Supplement*, London, of December 6, 1968, for example, suggested that 'Few of Mr. Hillier's illustrations can be taken more seriously than the jazzy grandfather clock with a cocktail cabinet in its belly') and was fiercely resented by the few Art Deco collectors who already existed. One of these was Janet Street-Porter — now sufficiently reconciled to me to have lent, most generously, to the present exhibition. She wrote in *Architectural Design*, May, 1969:

An opportunity has been lost. . . . The author isn't bowled over by his subject and fails to communicate the essential vitality and liveliness of it. The best examples of the period are already in danger because of a lack of appreciation; this book could have been useful propaganda — it could have knocked out the 'uninformed layman' with examples illustrating the diversity and lasting importance of the principles behind the style, instead of quibbling over influences and sources. . . . It's a real sell-out.

Them's fightin' words, I thought at the time.[2] But now I feel there was something in what she said. Something.

There were two main reasons why I did not do a simple public relations job for Art Deco in 1968: a lack of conviction, and a lack of knowledge. On the one hand I was not sure that there was much to be said for the bulk of

1 F. R. Leavis and Q. D. Leavis, *Dickens the Novelist*, Oxford, 1970.

2 Against Miss Street-Porter's view of my 'deadpan scholarship' it was possible to set the diametrically opposed but hardly more flattering suggestion of the English art critic John Russell that my text had 'a surface-dazzle like that of the Welsh Harp during speedboat trials on a fine Sunday in the 1920s' (*Sunday Times*, December 1, 1968). Another Art Deco collector wrote, with what I grudgingly concede is wit, if not justice or grammar: 'Advertised as the first book in English on the subject, one can only hope that somewhere an angel is not fearing to tread the same ground.' (*Art and Artists*, January, 1969.)

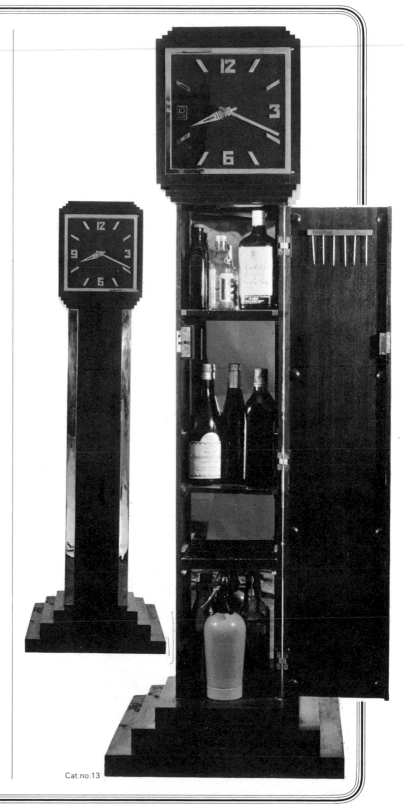

Cat.no.13

Apart I say from such faults of taste, which few as they numerically are yet affect my liking and more repel my sympathy than do all the rude shocks of his purely artistic wantonness — apart from these there were definite faults of style which a reader must have courage to face, and must in some measure condone before he can discover the great beauties. For these blemishes in the poet's style are of such quality and magnitude as to deny him even a hearing from those who love a continuous literary decorum and are grown to be intolerant of its absence.

It was again Dr Leavis who sourly remarked of this passage that 'It is possible to put readers of Hopkins too much at their ease'. Yet it is easy to understand why Bridges chose to introduce his friend's poetry in this way. He was acutely aware, as himself an establishment poet, Poet Laureate indeed, of the aspects of Hopkins which would repel men whose staple poetic diet was Tennyson and Browning, with Housman and Rupert Brooke as their *avant-garde*. He knew that he must not play down those aspects, but must try to explain them and reconcile his readers to them. My approach to Art Deco was comparable; and if anyone doubts that there are people not swooning with admiration for Art Deco, he need only read the swingeing editorial of the English magazine *Art and Antiques Weekly* of 21 November, 1970. The top page of this issue was headed 'They're rushing to buy Art Deco . . . see centre pages'. On the centre pages was a long article by Deborah Stratton, enthusiastically celebrating Art Deco. But the editor, evidently feeling that this approach might alienate readers who thought the magazine was there to teach them about Chelsea and Chippendale, contributed these grave objurgations:

Art Deco; on the other, I had in many respects not seen the best Art Deco — and without seeing the most favourable evidence, one cannot advance the best defence.

On the first count — lack of conviction — I would like to take another literary parallel. I am at present writing a biography of the Jesuit poet Gerard Manley Hopkins. He died in 1889, but his poems were not introduced to a wide public until 1918, when a selection was published with an introduction by Hopkins's friend Robert Bridges. Hopkins's greatest poems, such as *The Wreck of the Deutschland,* were written in the 1870s: so the time-lag between creation and promulgation was similar to that between the creation of Art Deco and my book: forty to fifty years. Bridges has incensed later admirers of Hopkins by his reserved, if not actually condescending, attitude in his Introduction of 1918. With a few obvious adaptations, what he had to say could stand for what I said of Art Deco. He wrote:

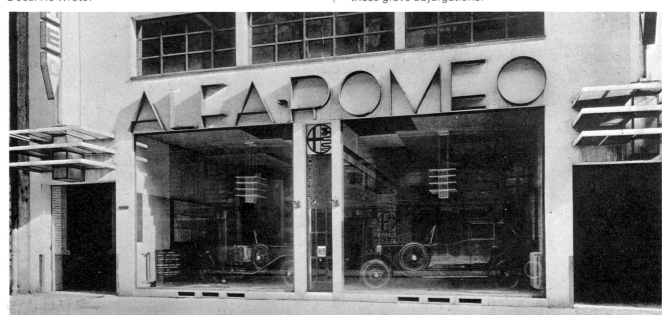

Cat.no.1342

WHAT IS THE PLACE FOR ART DECO?

We anticipate a shudder of protest from a number of more traditional readers when they see this week's centre-page feature on Art Deco.

However, our first duty is to inform, and as there is an increasing amount of Art Deco material passing through the major sale-rooms — and fetching ever increasing prices — we feel there is a justifiable demand for more details about a subject that has been very scantily treated in print.

It is, therefore, a valid subject in our context as a newspaper, but we are not falling upon it with unqualified enthusiasm (*pace* Deborah Stratton).

Art Nouveau was a completely recognizable movement, a genuine expression by artists, designers and craftsmen who produced material that is now, and almost certainly always will be, worth admiring and collecting. The identity of Art Deco, on the other hand, is less sure and its credentials a little suspect. Much of it is flashy tat that has become the subject of a collecting fad that is probably a passing one.

The flapper's powder compact, the 'lounge' clock, and the jazzy cigarette case will undoubtedly find a place in the museum of the future, but is their place in the collector's cabinet any more justified than that of the Pears soap advertisement or the nineteenth century manhole cover?

On the second charge to which I have pleaded guilty, lack of knowledge, I can only claim in mitigation that mine was the first book in English on the subject. Looking back, I ask: how could I possibly have written on Art Deco with not a single mention of Radio City Music Hall (which now seems to me *the* Art Deco shrine); or the Chanin Building and Chrysler Building, New York; the Richfield Building, Los Angeles; French commercial buildings of the 'twenties, such as the superb showrooms of Alfa Romeo; the Tuschinski Cinema and the American Hotel in Amsterdam; or even, nearer at home for me, the Rainbow Room of Derry and Toms' store, Kensington High Street, London? How could I have omitted all mention of such designers as Kem Weber (who in the year after my

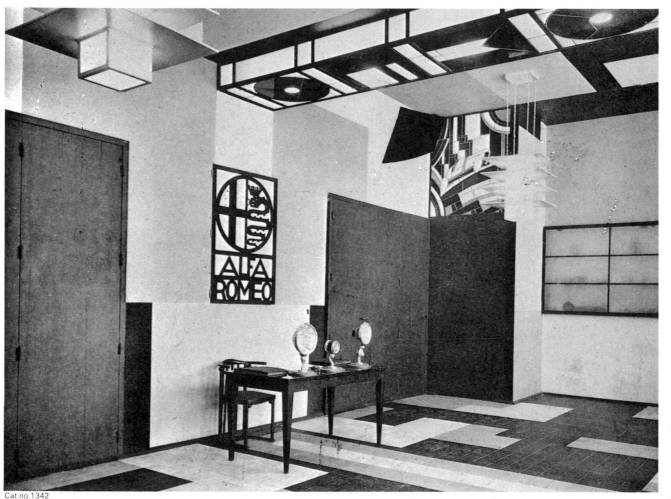

Cat.no.1342

Cat.no.121

Cat.no.29

book was published became the subject of the first monograph on an Art Deco designer); Donald Deskey; the jewellery of Fouquet; the engraved Swedish glass of Simon Gate; or the glass of Marinot, of which one vase can now command a price of £3,000? I did not know the silver of Charles Boyton, of which we have such fine examples in the exhibition; the beaten metal and lacquer work of Jean Dunand, which I have come to recognize as of outstanding importance in the development of Art Deco; the marvellous book illustrations of Schmied, again well-represented in the Minneapolis show; the glass of Decorchemont, the enamels of Fauré, the pottery of Decœur, the sculptures of Miklos.

Lytton Strachey said, in the preface to *Eminent Victorians*, that 'Ignorance is the first requisite for the historian — ignorance, which simplifies and clarifies, which selects and omits, with a placid perfection unattainable by the highest art.' By that criterion, I was admirably prepared to write on Art Deco. But there is probably no more effective (not to say gruelling) form of education in an arts subject than to organize an exhibition of it. I now feel well qualified to attempt an 'Art Deco Revisited' essay. The

finest collections have been made available to me. Important new works on the subject have been published. Many scholars and dealers have given their views. At the same time, I do not regret the approach I adopted in writing *Art Deco*. This was, broadly speaking, an art-historical (almost anthropological) rather than an art-critical approach. I asked *why* particular aspects of the style had developed, and I did not often stop to make value-judgments, to award the blue ribands, rosettes and booby-prizes which are the common largesse of aesthetic pundits.

There is not much I would wish to recant. I am as convinced as ever of the importance of cubism, the Russian ballet, Aztec and ancient Egyptian art as influences on Art Deco. And I still believe that, although there was a great and acknowledged difference in character between the 'twenties and the 'thirties, it is wise to use one name — Art Deco — to cover the art of both decades, to emphasize the continuity and essential unity of the style.

On this last point, of terminology, there has been some disagreement between the different writers on the subject, and perhaps it is necessary to justify the title 'Art Deco' for an exhibition of both 'twenties and 'thirties objects — a title already sanctioned by the excellent exhibition staged at the Finch College Museum, New York, by Mrs Elayne Varian in 1970. One of the more caustic reviewers of *Art Deco* said:

Those of more mature age who imagined that Art Deco petered out around 1925 will be surprised to find that all through the 1930s they were surrounded by it, according to Bevis Hillier.

In his book *The Decorative Twenties* (1969) Martin Battersby used the term 'Art Deco' for decorative art up to 1925 and 'Modernist' for post-1925 art; and in reviewing that book in the *Guardian*, Norbert Lynton said 'There will have to be some agreement about nomenclature before any of us get much further.' The situation was further complicated by the publication, in the same year, of *Kem Weber* by David Gebhard and Harriette von Breton. This book carried the sub-title 'The Moderne in Southern California, 1920–1941'. The Moderne (*art moderne, style moderne*) is the favourite name in America for the later phase of the style; but, in addition, the authors of *Kem Weber* distinguished three other strands in its evolution, the 'International Style', the 'Constructivist Machine style' and the 'Machine Expressionist style'. In another book, on the Richfield Building, Los Angeles, Mr Gebhard further splits up the Moderne into 'Zig-Zag Moderne' and 'Streamlined Moderne'.

All these sub-divisions are perfectly valid, and help to clarify different aspects of a promiscuously eclectic style. But in another sense their proliferation is unfortunate, especially so at a time when art historians concerned with the more distant past are abandoning the old art historians'

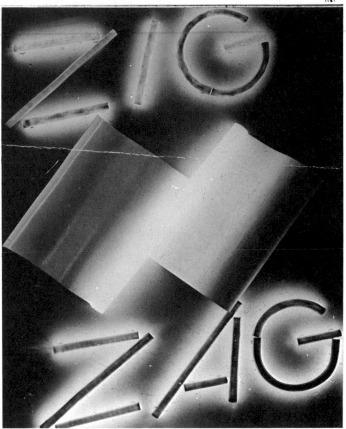

Neon design by Sonia Delaunay, 1923.

game of chopping up art into rigid categories, and are trying instead to show how different manners relate to each other and blend together. One example of this is that rococo is no longer regarded as a discrete style, springing suddenly into life in the early eighteenth century like a miraculous draught of serpents, but is treated as an offshoot of the baroque.[1]

In *Art Deco* I did not try to present a monolithic view of the inter-war years. I made it plain that there was a difference in character between the 'twenties and the 'thirties, mainly because of the Depression. But Art Deco was a developing style. The art of the 'twenties was not suddenly snuffed out in 1930 with a magician's 'Now you see it, now you don't'. Neither did all the artists die of bubonic plague in 1930. There was a strong continuity. In

1 See, for example, Michael Levey, *Rococo to Revolution*, Praeger, New York, and Thames and Hudson, London (1966), p. 15: 'Perhaps it is untrue that there ever was any rococo painting; and certainly it is one of the most puny styles in the brood spawned by art-historians. It could not exist without the baroque and is conceivably no more than the baroque tamed and cut down for a more civilized age, one with a sense of humour too.'

support of this view it is worth listening to what a survivor of both decades, Thomas Yoseloff, has to say in his introduction to Charles Agoff's *The Taste of the Twenties* (1966):

This book is not confined to the decade of the nineteen-twenties. Nor was the decade itself; it died hard, insisting upon intruding into the nineteen-thirties and even the nineteen-forties. Long after the Depression and rise of Hitlerism had rendered obsolete the dominant philosophies of the twenties, they still insisted on remaining alive, appearing incongruous among the sobering philosophies, like a berouged Victorian old lady dancing the Charleston.

The continuity of art is sometimes more striking than that of philosophies. For example, Pierre Brissaud's *baigneuses* of 1945 (Cat. No. 764) could easily be mistaken for works of twenty or more years before. Conversely, the illustrations of Georges Barbier for the magazine *Bon Ton* of 1913 (the Exhibition includes both the published issues, Cat. No. 965, and a Barbier fashion drawing, Cat. No. 746) are already in high Art Deco style, as are his exquisite *culs de lampe* for *La Guirlande des Mois*, 1918, 1919 and 1920. The Exhibition also includes a glass vase of about 1900 by Emile Gallé, decorated with elephants and palm trees (Cat. No. 652); of this the Paris magazine *L'Estampille* (September, 1970) said: *'On peut difficilement s'empêcher toutefois s'être étonné du ton très 1925 de l'œuvre.'* ('One cannot help being astonished, however, at the very 1925 style of the work.') Again, Erté,

Cat.no.150

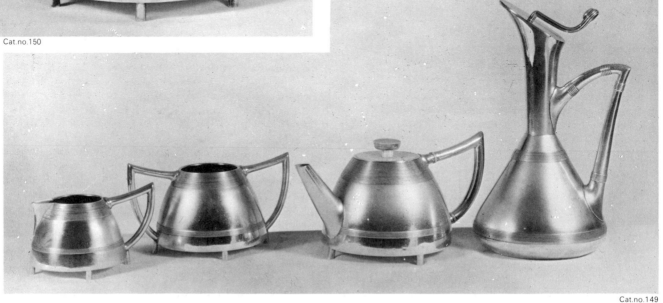

Cat.no.149

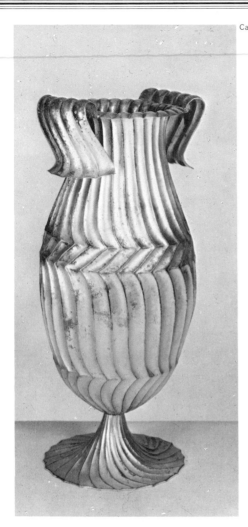

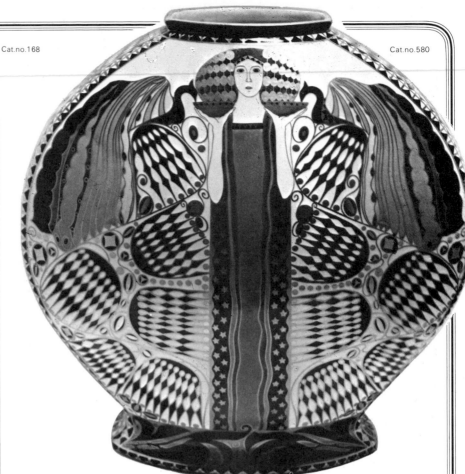

who scored his first theatrical success with costumes for Mata Hari in *Le Minaret* (1913) is still working in a similar vein in the 'seventies; at any rate his illustrations to Lytton Strachey's *Ermyntrude and Esmeralda* (1969) are in unadulterated 'twenties style (Cat. No. 1411).

I am very much of the school that believes it does not much matter whether Shakespeare's plays were written by Bacon, Marlowe, the seventeenth Earl of Oxford, or a glove-maker's son from Stratford on Avon, so long as we have them. Scholars may sub-divide the inter-war arts till they are blue in the face, and call the different morsels of the fricassée 'Inkpot style', 'Dogfish manner', 'Watermelon school' or what they please. For my part, I shall continue to emphasize the unifying, rather than the divisive aspects of — Art Deco.

Nevertheless, the Minneapolis Exhibition, like my book, does seek to distinguish, and in some cases to isolate, the different influences which contributed to Art Deco, and also some of the motifs which became popular in the 'twenties and 'thirties. The contribution of late Art Nouveau, so well illustrated in the recent exhibition of the Vienna Secession at the Royal Academy, London, is impossible to ignore. It is represented in the exhibition by the 1880s silver wares of Dr Christopher Dresser (Cat. Nos. 149–50); the elegantly simple clock-case by Carl Witzmann of the Wiener Werkstätte (Cat. No. 346), the *c.* 1917 vase with a design after Klimt (Cat. No. 580), and the Loetz veined glass vase with a silver inlay in geometric form (Cat. No. 685). The ideals behind the work of designers such as Josef Hoffmann, Joseph Olbrich, Dagobert Peche and Koloman Moser, all of the Vienna movement, were similar to those of the more socialist, moral-conviction type of Art Deco designer, and I have felt justified in including in the exhibition as antecedents such works as the Peche silver vase (Cat. No. 168) — though the very use of silver as a vehicle for machine-influenced or mass-production designs shows the kind of inconsistency in Art Nouveau which was to be solved, in some degree, by the chromes and plastics of Art Deco.

Miklos (Cat. Nos. 314, 544) or the rugs of McKnight Kauffer. The same is true of the Russian ballet influence: it is widely disseminated, diluted and debased, but is seen almost at first hand in the exotic designs of Erté (Cat. No. 779ff) or the ornate 1913 *bandeaux* from the Museum of Costume, Bath (Cat. No. 1073ff). The recent publication of Charles Spencer's book *Erté* (1970) has shown us the full range of Erté's talents, and given a new stature to an artist who had previously been known to many only by his later, less accomplished, work, and not by the miraculously facile, jewelled fantasies of the 'twenties and earlier.

In *Art Deco* I suggested that the art of the American Indians — those of Old and New Mexico, Brazil and the Wild West — had been an important influence on Art Deco. In particular I pointed to the stepped shape of Aztec temples, which had its effect even in things as unsacred as radio sets; to the popularity of the cactus as a motif — see the wallpaper by Martine in the present exhibition, *c.* 1912, (Cat. No. 996). and Keith Henderson's illustrations to W. H. Hudson's *Green Mansions*, 1926 edition, (Cat. No. 899); the Amazon and bat figures on clocks by Preiss (Cat. No. 341); and I quoted from literary sources to

Likewise the table by Carlo Bugatti (Cat. No. 17), which anticipates Art Deco in its combination of machine precision and 'barbaric' design, is made of costly materials. But perhaps the most striking single precursor of Art Deco is the design on the front elevation of Royd House, Hale, Manchester, England (224 Hale Road), designed by Edgar Wood for his own use in 1914 and completed by 1916 (Cat. No. 1364). For its period, this is a visionary building; Wood's later work as an Art Deco designer is seen in the fine mirror (Cat. No. 739) of 1929.[1]

Another Royal Academy exhibition has put on display the products of the Bauhaus, founded by Walter Gropius in 1919. The nature of the very great debt Art Deco owed to the more 'purist' works of the Bauhaus can clearly be deduced from the furniture and the glass of Marianne Brandt and Josef Albers, the light fixtures of Breuer or the textiles of Gunta Sharon-Stolzl, though the most potent influence of the Bauhaus was in architecture.

The influence of Cubism and its allied European art movements is everywhere apparent, though seen in a concentrated form in such works as the sculptures of

1 I am grateful to Mr Charles Handley-Read for drawing Edgar Wood's work to my attention.

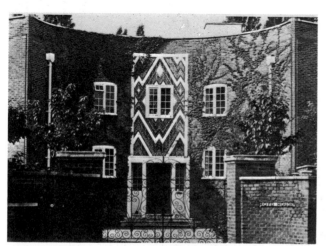

Cat.no.1364

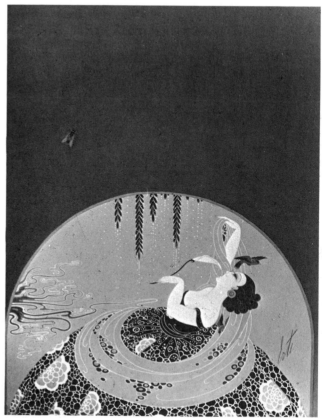

Cat.no.780c

Cat.no.780b

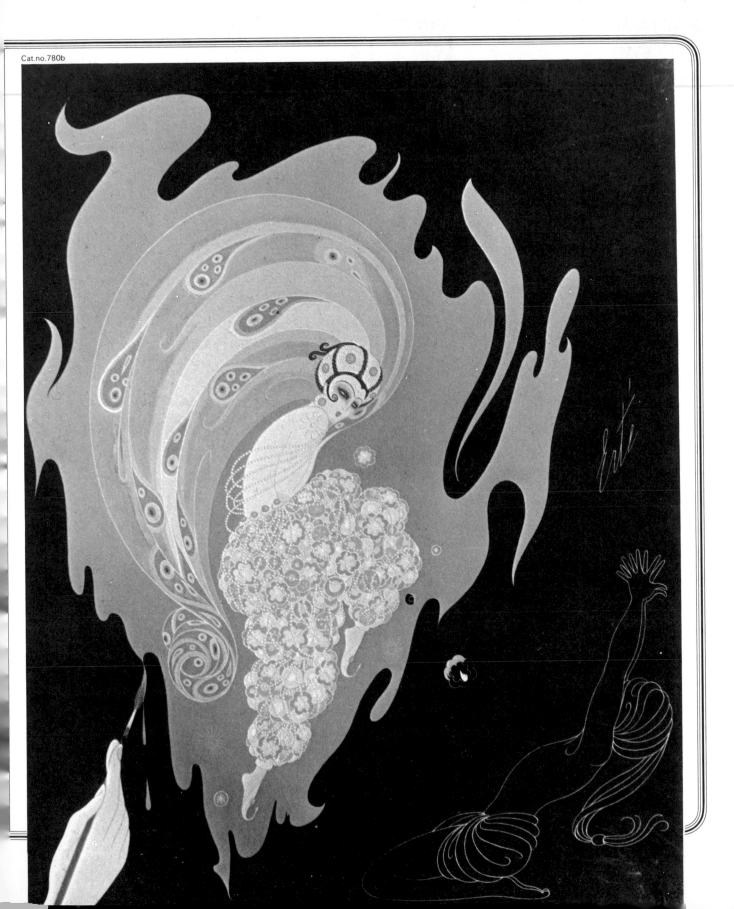

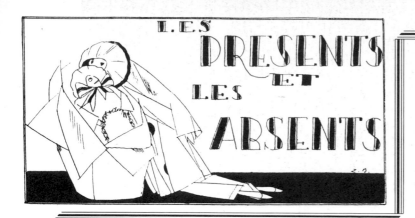

LES PRESENTS ET LES ABSENTS

California, the most thorough and admirable of all researchers into the history of Art Deco architecture.

My first witness is Alfred C. Bossom, a New York architect born and trained in England (where he had also been a Member of Parliament). In 1924, Bossom wrote *An Architectural Pilgrimage in Old Mexico.* Where, he asked, should one seek 'those architectural fabrics most typical of the spirit of all the Americas?' Surely, he said, the soul of America was not to be found in its Colonial architecture, which was modified Georgian, itself founded on Greek and Roman models through the Italian Renaissance. The answer was:

Mexico! Not to visit Mexico is not to know the Western Hemisphere. Not to have viewed the monuments of its romantic past is not to sense the inner meaning of American tradition, nor to fully grasp the development of the American people. . . . To the people of the United States, Mexico is logically a far greater source of influence than has yet been realized or will be until more journeys are made to its ancient fanes. The American architect and the American artist may find much there to kindle their imaginations and inspire their efforts, and the layman also can discover much indeed by making Mexico an inspirational and artistic Mecca. The art of Aztec and Toltec, blended by the free audacious spirit of those old-time cultured world-wanderers with the ideals of Madrid and Seville, made sentient by new requirements, still lives in many a stately pile in the republic below the Rio Grande.

illustrate the general interest in Mexico as a homeland of noble savagery and a site for projected utopias.

My most opprobrious reviewer (*Art and Artists*, January, 1969) wrote: 'His theories about the influence of American Indian art are open to serious doubt.' Just what these doubts were, he did not stop to tell us. I am glad, therefore, to have discovered, later on, some sources of the period itself which illustrate the powerful attraction which Mexico had for certain artists and architects; and also that support is given to my theory (which admittedly was more of a hunch than an edifice of polished argument) in works by Dr David Gebhard of the Art Galleries, University of

Cat.no.268

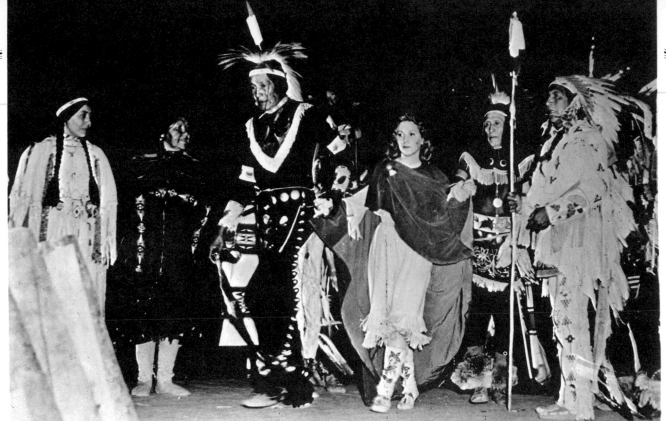

Jessica Dragonette being made an Indian Princess 'Princess Singing Bird'.

Bossom's own interest was admittedly more in the Spanish baroque relics of the Conquistadors than in pre-Columbian monuments (and Dr Gebhard has well indicated the strength of the Spanish Colonial influence in 'The Spanish Colonial Revival in Southern California, 1895–1930', in the *Journal of the Society of Architectural Historians*, vol. 37, May, 1967); but a book of 1938, *The New Architecture in Mexico*, by Esther Born, makes a direct pictorial comparison between the pyramid of Cuicuilco near Tlacopam, D.F. — 'probably the oldest structure on the North American continent' — and a Corbusier building. Bossom himself wrote another book, published in 1934, *Building to the Skies*, in which he illustrated as 'The Original American Skyscraper' the temple of Tikal, Guatemala, 230 feet high. On the page opposite he illustrated 'The Thirty-five Storey Building of Today. The architect for this thirty-five storey building was the Author. Note how the decorations are based on primitive American motives similar to those which inspired the Guatemalians to use such forms nearly 2,000 years ago.'

In these cases, or that of the 'Mayan Theatre', Los Angeles, by Morgan, Walls and Clements,[1] the debt to pre-Columbian art was both direct and explicit. At other times the influence was blatant but unsung. In their book *Kem Weber* David Gebhard and Harriette von Breton discuss the antecedents of pre-Columbianism in North American architecture:

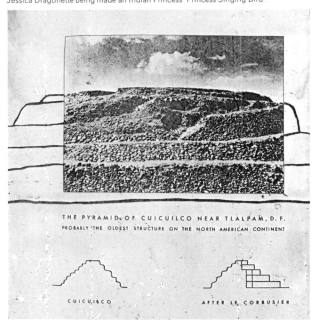

THE PYRAMID OF CUICUILCO NEAR TLALPAM, D.F.
PROBABLY THE OLDEST STRUCTURE ON THE NORTH AMERICAN CONTINENT

CUICUILCO AFTER LE CORBUSIER

Frontispiece from *The New Architecture in Mexico*.

1 See 'Mayan Theatre, Los Angeles', *Architectural Digest*, vol. vi, no. 4, 1929, pp. 8–11.

SOUVENIRS DE LA REVUE

Before the 'twenties had set in, the United States was already drawing upon her own 'Pueblo' Southwestern Indian heritage and that of the pre-Columbian world of Mexico and Peru. Features of Wright's Midway Gardens (Chicago, 1914), of his Imperial Hotel (Tokyo, 1915–22), and above all his Barnsdall House (Los Angeles, 1917–20) freely borrowed from Mayan, Zapotec, and Aztec architecture. R. M. Schindler's unrealized project of 1915 for the Martin house at Taos, New Mexico, shows that Wright was not alone in such borrowings. Both of these architects were to delve even deeper into the Pueblo and pre-Columbian traditions in their work of the 'twenties. Although both the Pueblo Revival and the pre-Columbian Revival really got going in the 'twenties, there were inklings to be found in the preceding decades; in the Los Angeles work of both Sumner P. Hunt and Silas R. Burns; and of Charles F. Whittlesey.

That American Indian art did have a strong influence on Art Deco I take to be now beyond question. But why should it have had such an influence? This is a question I was unable to answer satisfactorily in *Art Deco*. Had new air services to Mexico been opened? Had there been an eye-opening exhibition of pre-Columbian art in New York? A sudden kindling of interest in Brazil could be partially explained by the disappearance of Colonel Fawcett in 1925 and the expedition of Peter Fleming to find him in 1933. But why Mexico? I think the answer, as to most historical questions, is the obvious one. From 1910 to 1920, Mexico was an arena of revolutions. Porfirio Diaz had been overthrown by Francisco Madero, supported by Pancho Villa, a former bandit chieftain; Victoriano Huerta had overthrown Madero and had him shot; Emiliano Zapata had led an Indian peasant rebellion in the mountains of the south, aiming at land reform; Carranza had established control; Obregon had defeated him in an almost bloodless revolt in 1920, the beginning of a new

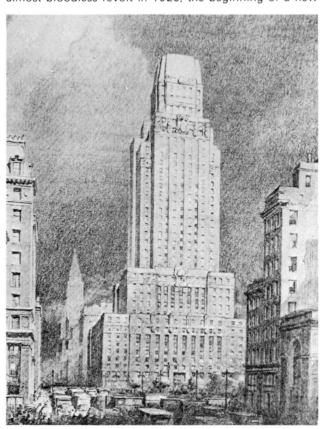

The old and new contrasted in Alfred Bossom's *Building to the Skies*, 1934.

epoch of social reform and growing political stability. These upheavals had focused the attention of the world on Mexico. In particular, they had caught the imagination of young idealists like Aldous Huxley and D. H. Lawrence, and of young socialists who applauded the new social dispensation of Obregon and his successor of 1924, Plutarco Elias Calles. There were some Americans who shared the romantic view of the Mexican Revolution. Carleton Beals, in his *Mexican Maze* (1931, tellingly illustrated by the Mexican revolutionary artist Diego Rivera) stigmatizes the ousted rulers of Mexico as 'the new Huitzilopochtli demanding his due meed of innocent blood' (Diaz); 'he ruled the state by mystic communings with spooks and the planchette' (Madero); 'bloodthirsty drunken troglodyte' (Huerta); 'half-savage bandit Socialist' (Villa); and 'stately obstinate Caesar' (Carranza). But when he turns to the revolutionary heroes, it is a different story — and it is worth quoting the following passage about Felipe Carrillo Puerto for the message it contained (and passed on to America at large) about restoring the old monuments, the Aztec temples:

Near Merida, the capital of Yucatan.

I stand beside the tomb of martyred Felipe Carrillo Puerto, a great race chief of our times, who freed his people from the serfdom of the henequen fincas. Dead now, but I hear his voice talking in that fine tone of his, night after night, as we walk through the soft tropic dark. He tells me of his hopes and plans for the people of his race. I see him standing in the heavy shadow of the great temple of Chichen Itza. Its white columns glisten in the moonlight, rise in white glory out of the black expanse of jungle. 'We must restore the old monuments, that my people may have pride in their race and build again as they builded of old.'

Stuart Chase's *Mexico: a Study of two Americas* (1932, also illustrated by Rivera) gave a similarly jubilant view of the Revolution, and also included a chapter deploring the vulgarity of the American charabanc invasion of Mexico.

But for the most part, the Mexican situation commanded American interest for more practical reasons. The successive dictators of the country had allowed Americans to control vast interests in such industries as concrete and oil: this, indeed, was one of the main grievances of the revolutionaries. In 1916 Villa, enraged by American encroachments, had raided Columbus, N.M., killing seventeen Americans; and General John J. Pershing had led a punitive expedition into Mexico in an unsuccessful attempt to capture him. A new land distribution was one of the main objects, and one of the first results, of the Revolution. The villages were to have their ancestral lands. This meant that the present owners must cede the area, which meant the partitioning of the haciendas, which meant a revision of the going concept of private property, which meant undermining the property claims of all foreign investors in Mexico. As Chase puts it: 'Here was a

pretty kettle of fish. Obviously the Indians could not be satisfied without creating the bitterest dissatisfaction in the $1,500 million or so of alien capital.' In spite of the piteous protests of the American oil companies, Mexico put the land law on the statute books. Battle was joined. The United States, on behalf of its billion dollars, argued that Mexico could not expropriate the property of Americans — plantations, oil lands and mines — citing the sanctity of property in international law. Mexico argued that a nation always had the right to adjust its internal property, otherwise its sovereignty is a myth. There was even talk in the United States of going to war with Mexico to protect American interests.

Revolutions and counter-revolutions, claims and counter-claims kept Mexico continually in the news. But there was also an artistic renaissance after the Revolution, which must have seemed both attractive and challenging to many American artists and architects. The new dispensation for the poorer classes made necessary new schools, hospitals, housing developments and recreation centres — a fuller life for the have-nots, denied them under the Diaz regime. It had been proved that the neo-colonial style was unsuitable for this kind of project. In one year under the leadership of Vasconcelos 52 million pesos had been spent on building seven or eight schools in the neo-colonial style, built around a patio with a general convent plan. Such a cost was prohibitive. Building in a direct, rational way, without the welter of baroque ornament which was the legacy of the Conquistadors, now found its chance, and when the socialist architect Legarreta became head of the Department of Architecture the new approach became dominant. There was still a power struggle over the new architecture, and like so much that happens in Mexico it had an air of soap opera. The opposition claimed that the new architecture was being foisted on Mexico by imperialist interests. What motive the 'imperialist' powers might have for doing this, was not explained. But the campaign continued, and more and more the demand was heard for a 'native Mexican' architecture — which meant, to its champions, a return to the plagiarism of the styles which had *indeed* been imported into Mexico by an imperialist power (Spain) at an earlier date. It is absurdly ironic that, at the same time, both genuinely Mexican motifs (as of Pueblo pottery) and the Spanish colonial style, Hollywood version, were popular in North America.

In Mexico, the Legaretta school won. By 1938 Beau Riley, an American architect, could write admiringly:

Mexico has an architectural movement of probably far sounder and more extensive development than anything we can boast of in the United States.

In the preceding twenty years some magnificent Art Deco buildings had been designed by Mexican architects: the

School of Industrial Technics, Calle Tresguerras, Mexico City, by Juan O'Gorman; the Central School of the Revolution, Mexico City, by Antonio Munoz Garcia; Hogar Infantil, No. 9, Mexico City, by José Villagran Garcia and Enrique de la Mora, architects; the Tuberculosis Sanatorium, Huipulco, Tlalpam, D.F., also by Villagran; the Main Hospital of the National Railroads of Mexico, by Carlos Greenham (architect) and Federico Ramos (engineer); dynamic office buildings like that by José Arnal at Avenida Juarez 60; splendid (though hardly socialist) apartment houses like that at Avenida Insurgentes 411, Mexico City, by Enrique Yanez (architect) and Pedro Bustamente (engineer) or at Calle Estraburgo 20, Mexico City, by Enrico de la Mora and José Creixall (architects), described by Riley as 'unquestionably the most *chic* piece of modern design in the city'.

The Revolution had also inspired three gifted artists: Diego Rivera, José Clemente Orozco, and David Alfaro Siqueiros. All three were best known for their murals — that large-scale didactic form of art so suitable for revolutions in hot countries with illiterate inhabitants and quick-drying walls — and it is arguable that the popularity

of mural decoration in Europe as well as America during the 'twenties and 'thirties may in some part have derived from their example.

Of course the whole question of the sources of and influences on Art Deco is one that has to be approached with caution. There are certain objects, such as the anonymous rug (Cat. No. 1206) in which an American-Indian influence is unmistakable; but there are far more cases in which the eclecticism is either less obvious, or more general. Take, for example, the Hoover building in Western Avenue, near London, with its jagged, jazz-age skyline. In his introduction to the catalogue of an exhibition of Erté's works at the Grosvenor Gallery in London (1967) Charles Spencer suggested that the main influence on the style of the building was 'oriental . . . stemming directly from Bakst's famous sets and costumes for the ballet *Scheherezade*.' In *Art Deco* I countered this suggestion of a Russian ballet influence with the suggestion that an Aztec influence was more likely. And I have since read, in the autobiography of the English art critic and musician George Melly (1965), this passage which suggests that the dominant influence was Egyptian:

Afterwards Mick, Bob and I went for a drive along Western Avenue. We passed the Hoover factory, that great 1930 essay in the mock Egyptian style.
'All that,' I said, 'to suck up shit!'
Mick and Bob enjoyed this remark, and I think it decided Mick to keep me in the band.

Ballet Russe, Aztec or Egyptian? Even if one could speak to the architect, he might not be able to give a definite answer. But as I am able to push my own arguments here, I cannot forbear to quote this extract from Bossom's *Building to the Skies*. Writing of the Chase National Bank, New York City, he says:

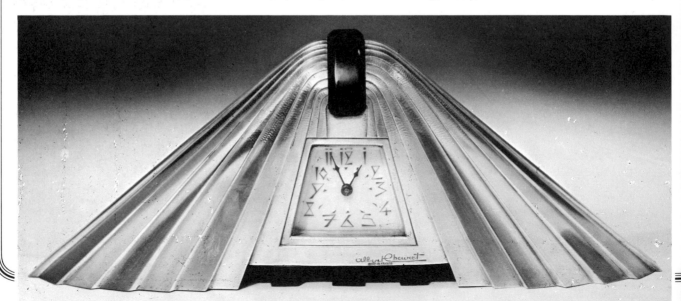

Ancient Egyptians (as envisaged by *La Vie Parisienne*): compare the hairstyles with the Cheuret clock, opposite.

The architect . . . has contrived to erect in this unpromising location a building admirably suited to the purposes of modern commerce, and, at the same time, suggestive of the stepped pyramidal effects of *what is really Mexican, but passes among the uninformed as Egyptian, design*. (My italics.)

This is not to deny the undoubted strength of the Egyptian influence on Art Deco. The Chase Bank itself, as Bossom had to admit, made use of dramatic Egyptian effects: a frieze of sculpted enlargements of coins of all nationalities was incorporated in the main entrance — 'an elaborate Egyptian design in finely-wrought bronze, set in a frame of pink Tennessee marble. The Egyptian motif is continued on the walls and ceiling of the main banking room as well as in the detail of the exterior.'

The 'Egyptian style' came into vogue through the discovery of Tutankhamen's tomb in 1922. The present exhibition includes one very un-Art-Deco shaped teapot by Royal Doulton, decorated with Egyptian motifs and inscribed: 'Tutankhamen's. Treasures. Luxor', (Cat. No. 561) and there is a saucer in the same ware, more brightly decorated (Cat. No. 562). The Egyptian influence is also seen in the scarab pendant with a miniature mummy as clasp (Cat. No. 1234); in the silver and enamel cigarette case (Cat. No. 392); in the fine *lampadères* by Brandt and Daum (Cat. Nos. 361–2); and, in a beautifully assimilated form, in the clock (Cat. No. 338) whose numerals (like those of the Jay clock, Cat. No. 340) are mock-Egyptian, and whose elegant shape suggests a sphinx's head, or the hair-style of Cleopatra (at least, Theda Bara as Cleopatra).

And then there was the influence of the machine itself, to which all the other influences, in the 'thirties, became subordinate. For a classic text on the machine, I turn to Antoine de Saint-Exupéry, high-flying in literature as in life. Born in the year 1900, living and dying by the most exalted and beautiful machine of all, Saint-Exupéry is truly *homme du vingtième siècle*. For a moment, then, I hand over the controls to a master:

Have you looked at a modern aeroplane? Have you followed from year to year the evolution of its lines? Have you ever thought, not only about the aeroplane but about whatever man builds, that all of man's industrial efforts, all his computations and calculations, all the nights spent over working draughts and blueprints, invariably culminate in the production of a thing whose sole and guiding principle is the ultimate principle of simplicity?

It is as if there were a natural law which ordained that to achieve this end, to refine the curve of a piece of furniture, or a ship's keel, or the fuselage of an aeroplane, until gradually it partakes of the elementary purity of the curve of a human breast or shoulder, there must be the experimentation of several generations of craftsmen. In anything at all, perfection is finally attained not when there is no longer anything to add but when there is no longer anything to take away, when a body has been stripped down to its nakedness.

It results from this that perfection of invention touches hands with absence of invention, as if that line which the human eye will follow with effortless delight were a line that had not been invented but simply discovered, had in the beginning been hidden by nature and in the end been found by the engineer.[1]

Those words were written in 1939. The chapter in which they are found is the most eloquent and speciously argued defence ever made of the machine. He suggests that the machine does not isolate men from the great problems of nature, but plunges him the more deeply into them. The central struggle of men has been to understand one another, to join together for the common weal.[2] And the machine helps them to do this — by transport, telephone, films. Was the invention of writing, printing, the sailing-ship a degradation of the human spirit? The kind of back-to-cottage-craft revolution attempted by Gandhi seemed to Saint-Exupéry 'as simple-minded as a child trying to empty the sea on to the sand with the aid of a tea-cup'. Of the 'pseudo-dreamers' he asks, with delicious slyness: 'What is it makes them think that the ploughshare torn from the bowels of the earth by perforating machines, forged, tempered, and sharpened in the roar of modern industry, is nearer to man than any other tool of steel? By what sign do they recognize the inhumanity of the machine?' Saint-Exupéry admits that he, too, misses the village with its crafts and folk-songs. The town fed by Hollywood seems impoverished to him, despite its electric street-lights. But he feels that this decline in values is only a temporary result of the very sudden transition to the machine age. 'It was only yesterday that we began to pitch our camp in this country of laboratories and power stations.' Our psychology, he says, has been shaken to its foundations. To grasp the

1 Translation by Lewis Galantière, Penguin edition, 1966, p. 40.

2 'To me, in France, a friend speaks from America. The energy that brings me his voice is born of damned-up waters a thousand miles from where he sits. The energy I burn up in listening to him is dispensed in the same instant by a lake formed in the River Yser which, four thousand miles from him and five hundred from me, melts like snow in the action of the turbines.' (*Ibid*, p. 42.)

world of today we are still using a language created to express the world of yesterday. 'We are in truth emigrants who have not yet founded our homeland. We Europeans have become again young peoples, without tradition or language of our own.' And he adds: 'Young barbarians still marvelling at our new toys — that is what we are. Why else should we race our planes, give prizes to those who fly highest, or fastest?' Perhaps, he says, we have driven men into the service of the machine, instead of building machinery for the service of man. But could anything be more natural? It has all happened so quickly. Now the time has come to stop being conquerors and to become colonists, to make habitable the house which is still without character. 'Little by little the machine will become part of humanity.' He illustrates this humanizing process by reference to the railway: at first regarded as an 'iron monster', now 'for the villager . . . a humble friend who calls every evening at six.' Every machine will eventually take on this patina.

With all his flair for romantic hyperbole, Saint-Exupéry knew better than to spoil a good case by overstating it. That had already been done in 1930, at the beginning of the machine-design decade, by Sheldon Cheney, the American art-historian and critic. On the first page of his book *The New World Architecture*, Cheney stated confidently:

We may be sure that the future will judge the architecture of the half-thousand years prior to 1900 as bad: weak, unoriginal, vacillating, showy.

Versailles, farewell! Michelangelo, pack your traps! Like Saint-Exupéry, Cheney was conscious of being part of a New Dawn. He chose as the epigraph of his book these lines from Walt Whitman:

All the past we leave behind,
We debouch upon a newer, mightier world, varied
 world,
Fresh and strong the world we seize, world of labor and
 the march,
Pioneers! O Pioneers!

Like bad taste that transcends itself to become classic kitsch, Cheney's arrogance attains the sublime. It is curious, for example, to hear the word civilization used in tones of contempt, yet Cheney can write:

After civilization, what? The question is not an idle one. Granted that civilization is what we have, humanity is about ready to move on to something else. . . . Civilization is not final; nor is its architecture. Like barbarism, it is a stage ultimately to be outgrown.

Cheney finds it significant that the first outcroppings of 'Modernist art', including architecture, should have had more affinity with primitive than with 'civilized' style. There is, he says, a universality about savage, barbaric and even early civilized work that is absent when a national culture has flowered — a hardness, precision, and reliance on basic proportion that civilization has usually lost in favour of 'a softer ornamentalism'.

He deplores the fact that, 'machine-users that we are, ninety-nine one-hundredths of us live in houses of the merely civilized, not the machine-age era.'[1] So far, plumbing, heating and refrigeration were only 'incrustations upon the "civilized" house'. He wonders why our dwelling-places cannot be conceived and built as cleanly, efficiently and beautifully as an automobile: '*that* has just the combination of mechanical efficiency and comfort, of cleanliness and pleasurable brightness, of mechanically perfect shelter and of beauty out of proportioning and structure, that we should relish in a house.'

In terms of strict logic, some of Cheney's arguments can be easily demolished. Streamlining is designed to make fast-moving machines faster. Houses are stationary. Is it not, therefore, just as incongruous to apply streamlining to the house as it would be to apply flying buttresses to a Chrysler? (And actually, the Chrysler building does, most incongruously, have Nôtre-Dame type gargoyles, in the form of the Chrysler's stylized eagle radiator cap.) On the other hand, most present-day architects would be sympathetic to his picturesque attack on the old eclectic architecture:

1 Some of the outstanding antecedents of Cheney's attitudes on the application of the machine to architecture are collected in a recent book, *Programmes and manifestoes on 20th-century architecture*, edited by Ulrich Conrads, translated by Michael Bullock; Lund Humphries, London, 1970: the *credo* of Henry van de Velde (1907); the belief expressed by Adolf Loos that 'The evolution of culture is synonymous with the removal of ornament from utilitarian objects' (1908); the Deutscher Werkbund manifesto of Hermann Muthesius that 'To help form recover its rights must be the fundamental task of our era' (1911); Paul Scheerbart on glass architecture (1914); an essay on the Futurist city, 'dynamic in all its parts', by Antonio Sant'Elia and Filippo Tommaso Marinetto, who believed that 'The decorative must be abolished' (1914); the De Stijl manifesto of 1918; Walter Gropius on the Bauhaus programme (1918); Erich Mendelsohn on the problem of a new architecture (1919); the celebrated statement of Le Corbusier that 'The house is a machine for living in' (1920).

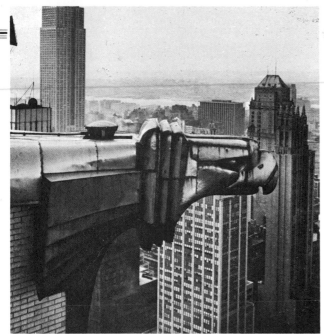

Cat.no.1381

Let us drape no more columned temples over our banks, no more gabled monasteries over our college halls — really educational factories needing more light and air than the small leaded windows will let in — and no more French palaces or Roman imperial baths over our railway stations: instead, a clean expression of mechanization.[1]

Art Deco of the 'thirties pushed the interest in new industrial materials, and in streamlines, far beyond any functional or economic advantages that could be claimed for them. There came a point where streamlining had more to do with aesthetics than with function; where glass bricks, vitaglass, vitriolite and bakelite were used not for their structural superiority but for 'modernistic' chic; the machine's importance had become symbolic, not real.[2] Streamlining was applied to many kinds of object never intended for speed: radios, refrigerators, accordions, fans, irons, vacuum-cleaners, sales registers, alarm clocks, tractors, toasters, Chinese restaurants and underwear. The streamlining of buildings was simply another imposed style, another form of packaging, quite

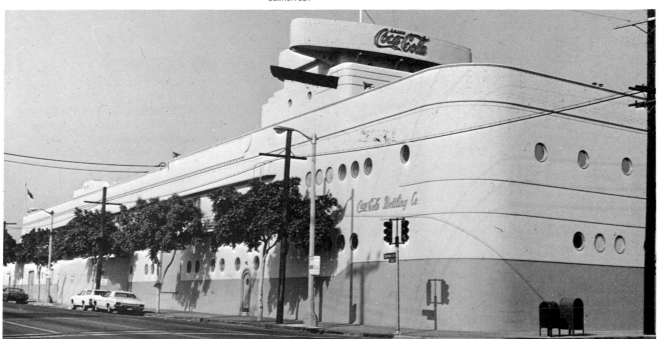

Cat.no.1371a

1 Cf. Bruno Taut, 'Down with seriousism' (1920), quoted in Ulrich Conrads, *ibid*, p. 57:
 'Away with the sourpusses, the wailing Willies, the sobersides, the brow furrowers, the eternally serious, the sweet-sour ones, the forever important!
 '"Important! Important!" This damned habit of acting important! Tombstone and cemetery façades in front of junk shops and old clothes stores! Smash the shell-lime Doric, Ionic and Corinthian columns, demolish the pin-heads! . . .
 'Down with all camels that won't go through the eye of a needle!' Or Corbusier (1925), quoted *ibid*, p. 91:

'Architecture submerged beneath a deluge of disconnected heritages attracted the spirit only via a difficult detour and stirred the emotions only weakly.'

2 Gebhard and von Breton point out (*Kem Weber*, 1969, p. 6) that as early as 1931 Philip Johnson suggested that the architecture of the International Style was significant, not because it was functional but because it symbolically expressed the machine. Reyner Banham also notes (pp. 329–30 *Theory and Design in the First Machine Age*, Praeger, New York, and Architectural Press, London, 1960) that the International Style architects were more concerned with a new packaging than with an actual use of the machine.

as irrelevant, from a functional point of view, as the use of Renaissance *lambrequins* or any other form of historical plagiarism. Erich Mendelsohn, the most gifted of the early architects who took the machine as their model, gave his factories in the shape of transport machines the spurious justification that they were inhabited by machines. (Which reminds one somewhat of Sydney Smith's remark to the boy who was tickling a tortoise's shell to give the tortoise pleasure, that he might as soon expect to please the Dean and Chapter of St Paul's by stroking the dome.) But as Mary Kathleen Church mischievously comments in her unpublished thesis on The Moderne, it is odd that Mendelsohn's sketch of 1914 for an optical goods factory does not resemble any kind of machine for making eyeglasses, 'but

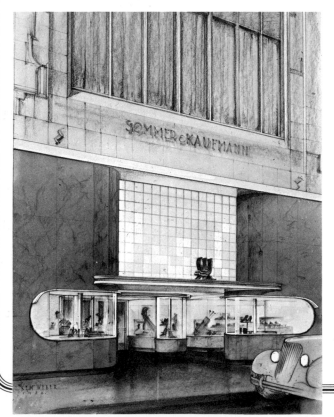

quite resembles the bridge of a ship, topped by two round smokestacks'.[1]

The liner and the aeroplane are the two transport machines to which there is most overt reference in Art Deco architecture and design. Gebhard and von Breton suggest that 'In the 'twenties the symbolic kinship was with the ship and the auto, by the late 'thirties and 'forties, the Moderne was almost exclusively tied to the airplane.'[2] Miss Church points to 'the roofs of convalescent homes designed to resemble upper decks and apartment houses which look like they should be tied up to docks (see Peaslee's The Moorings in Washington D.C. of 1928)' and more subtle variations on the theme such as marine balcony railings, metal tube chairs and bathroom fixtures.[3] She adds that blatant reference to the ship persists in *moderne* architecture as late as 1935 — instancing the smokestack forms atop Hollywood's Pan Pacific Auditorium (Wurdeman and Becket, 1935) which has a striking resemblance to Mendelsohn's eyeglass factory design. Among 'airplane-like forms' she notes particularly the winged shapes of Kem Weber's 1936 Sommer and Kaufmann shoe-store, San Francisco, and the architecture of Norman Bel Geddes in the early 'thirties.[4] By the late 'thirties, streamlining was so universal an aspect of transport machines that it is almost impossible to relate a given design to any particular type of machine. Of Frank Lloyd Wright's Johnson Wax Building, Racine, Wisconsin (1938–9), Reyner Banham writes: '. . . at the cornice (for want of a better word) the walls come to life with a glistening bulge of glass, for all the world like the chromium edge-trim of some primitive piece of Detroit car-styling.'[5]

While some brought the machine to art, others took art to the machine. One thinks of H. and M. Farman's jazzy Parisian seat-covers for a Joubert and Petit aeroplane cabin; Maurice Dufrène's zigzag design for a limousine (*c.* 1925); and the charming conceit by which Sonia Delaunay painted chequers on her car as an exact match to her dress. The romantic appeal of the machine is clearly shown in Winold Reiss's mural (*c.* 1930) of aeroplane, express train and motor-car, against a background of skyscrapers (Cat. No. 835); in the mosaic from a taxicabmen's shelter in Hampstead, London (dated 1935), with its cogs and other industrial symbols (Cat. No. 1362); and in the batik mural lent by Miss Jessica Dragonette, with its radio antennae, microphones, zeppelins, the *Berengaria* at sea, and electrical flashes (Cat. No. 1192).

1 Mary Kathleen Church, *The Moderne* (unpublished thesis, 1968), p. 26.
2 Gebhard and von Breton, *op. cit.,* p. 10.
3 Church, *op. cit.,* p. 28.
4 *Loc. cit.*
5 Banham, *Guide to Modern Architecture*, Van Nostrand-Reinhold Books, New York, and Architectural Press, London, 1962, p. 88.

Cat.no.1373a

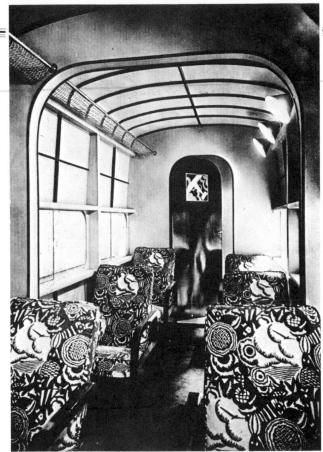

Farman seat-covers for Joubert and Petit aeroplane cabin.

As well as attempting to identify and illustrate some of the main sources of Art Deco, the exhibition also isolates some of its leading motifs. Reviewing Charles Spencer's book on *Erté* in *The Times* (October 5, 1970), Dr Roy Strong, Director of the National Portrait Gallery, London, wrote:

One also needs some effort to decipher what these images are all about. Erté would be a wonderful basis for a study of the iconography of the between-the-wars period, a mythology now getting as distant and in need of unravelling as that of the Pre-Raphaelites: a terrifying woman with nodding, menacing plumes screeching at a caged bird, a butterfly resting on the pupil of a human eye, or a handbag clip of two women kissing. What is it all about?

I will risk an answer to Dr Strong's question. The caged bird of paradise, the butterfly,[1] and the human eye are all symbols of evanescence. In *Art Deco* I suggested that 'The iridescent bubble about to burst is almost the official symbol of the 'twenties' and instanced the book and textile designs of E. O. Hoppé; the same symbol is seen in the Carlton Ware coffee-service of the 'twenties (Cat. No. 465) and in the end-piece to Claude Bragdon's book, *The Frozen Fountain*. It is a little macabre to equate the eye with the bubble, but we have G. M. Hopkins's lines from 'Binsey Poplars', in which he is lamenting the transience of natural beauty:

> . . . *like this sleek and seeing ball*
> *But a prick will make no eye at all.*

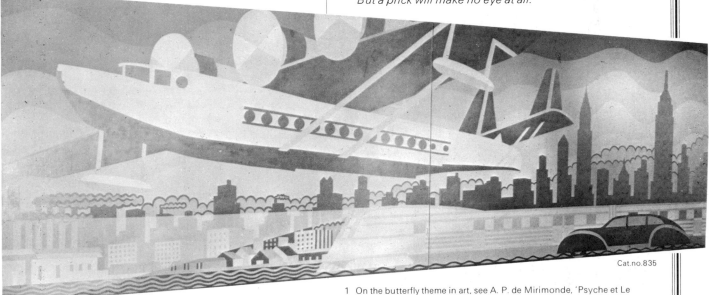

Cat. no. 835

1 On the butterfly theme in art, see A. P. de Mirimonde, 'Psyche et Le Papillon', *L'Oeil*, December, 1968.

As for the women kissing, both female and male homosexuality were unusually prevalent during the 'twenties. This can in part be rationalized as a result of the First World War. The five years of the war had accustomed men to living together, had created conditions of implicit, if not overt, homosexuality, the 'cameraderie of the trenches'. It has been plausibly argued that when they came back from the war, many of them wanted not women, but substitute boys — and that the cropping of women's hair in the 'bobbed' style of the decade,[1] and the flat-chested fashion in dress, were signs of women trying to accommodate themselves to this taste. In addition, the war had reduced the number of eligible males by millions, leaving many women with no chance of getting a husband. It had also given women a new independence. The part they had taken in the war effort could not be disregarded; after 1918

there was no more need of suffragettes, the case for Women's Rights was tacitly ceded.[2] The shortage of men and the new-found independence of women were conditions in which lesbianism could spread.

George Barbier's drawing of lesbians (Cat. No. 747) is dated 1923. Compton Mackenzie's novel about lesbians, *Extraordinary Women*, appeared in 1928, as did Radclyffe Hall's *Well of Loneliness* with its similar theme. In the same year Beresford Egan published his satire on Radclyffe Hall's book (affectionate, and mainly pictorial), *The Sink of Solitude*. It contained these lines:

The way to make a modern novel is
To have a preface done by HAVELOCK ELLIS
The book is published and success seems clear
When sympathetic notices appear.
In praise of RADCLYFFE (Gracious what a nark!)
The TIMES LIT. SUP. is promptly off the mark
In BOOT'S and MUDIE'S the subscribers stand
Supply falls rapidly below demand,
In London streets the groves of Lesbos bloom —
Man-hatted girls, tweed-coated, light the gloom.
Women in love now only love themselves
And men are left (like duller books) on shelves.

Male homosexuality also flourished in the 'twenties: A. J. P. Taylor (who was at Oxford in the 'twenties) has written in his volume of the *Oxford History of England*:

The strange one-sexed system of education at public schools and universities had always run to homosexuality. In Victorian times this, though gross, had been sentimental and ostensibly innocent. At the *fin de siècle* it had been consciously wicked. Now it was neither innocent nor wicked. It was merely, for a brief period, normal. By the end of the decade, even former public school boys were beginning to discover that women were an improvement on painted boys.

1 See 'Bernice Bobs Her Hair', Scott Fitzgerald's short story of 1920.

2 'On 1st May 1919 . . . S.S. *Chindwara* passed "the Wight" . . . came up the Thames at night, and anchored off Tilbury at 2.30 a.m. Next day a tug conveyed the passengers ashore, and as a first sign of all that had happened since 1912, their tickets were examined by a girl.' (Lady Pentland, *Memoir of Lord Pentland*, Methuen, London, 1928, p. 278.)
 See also the Marchioness of Londonderry, *Retrospect*, Muller, London, 1938, p. 127:
 'There were the splendid remount girls employed at the big depots, who learnt to strap and ride a horse astride as well as any man. The late Lord Chaplin went down to stay with the Officer Commanding one of these depots. He never could resist a horse, and when he saw these attractive amazons in their neat Jodhpur breeches doing all the work in the stables, under the management of a stud groom, his admiration knew no bounds. He had always been opposed to Woman Suffrage, but after seeing these girls he said to me that he had completely changed his idea. The combination of their pluck and their good looks, above all their horsemanship, was too much for him. "Bless their little hearts," he said, "they deserve everything!" . . .
 'I also recall Mrs Munro-Ferguson's feat in driving a Mogul tractor-plough in a ploughing competition during the war. In the judges' opinion she drove as straight a furrow as any man accustomed to a horse-driven plough for years.'

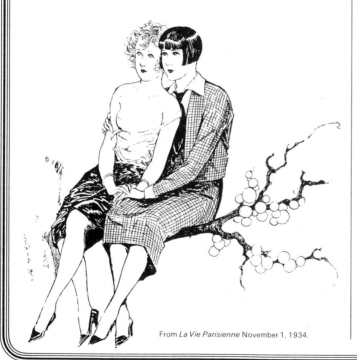

From *La Vie Parisienne* November 1, 1934.

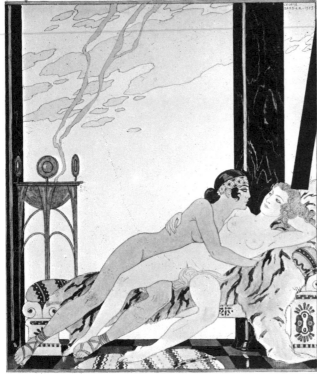

Cat.no.747

Cat.no.665

claimed for even the minor themes and motifs of Art Deco. An iconographical study of Art Deco — Paradise Glossed, as it were — would be as rewarding a task as the *catalogue raisonné* of Art Deco designers which is equally desirable; but it is not possible to attempt it within the scope of a catalog introduction. The recurring themes of *Les Biches* — deer, gazelles, antelopes; of women with dogs; of nude, thrusting female dancers who perhaps derive from the Isadora Duncan cult — are all worth investigating. But here I will concentrate on the two motifs which, I suggested in *Art Deco*, were most dominant in, respectively, the 'twenties and the 'thirties: the fountain motif, and the sun-ray motif.

Cat.no.1130

In the 'thirties the tenor of homosexuality changes from the Firbankian, 'decadent' type, to the 'butch', *mens-sana-in-corpore-sano* type which went with nudism, athletics, sun-bronzed he-men, etc. (Though the novels of Christopher Isherwood in the 'thirties show that the old kind was not extinct.) *En passant*, we may note that a consciousness of the transience of mortal beauty (as symbolized in Erté's caged bird, butterfly and eye) is a characteristic trait of male homosexuals[1]; while Erté's 'terrifying woman with nodding, menacing plumes' suggests the over-dominant mother figure (note the caged bird) of the homosexual's background, and perhaps too something of the *belle dame sans merci* who recurs in homosexual fantasy.[2]

All this may seem an elaborate way of answering Dr Strong's question. But it does indicate how various and complex are the origins that can (I think, reasonably) be

1 See Timothy d'Arch Smith, *Love in Earnest: some notes on the lives and writings of English 'Uranian' poets from 1889–1930*, pp. 163–6, and 172–5, Coward McCann, New York, and Routledge and Kegan Paul, London, 1970.

2 On male homosexuality in the 'twenties, see Terence Greenidge, *Degenerate Oxford?*, Chapman & Hall, London, 1930, pp. 89–114. Greenidge was a contemporary and friend of Evelyn Waugh: see Waugh, *A Little Learning*, pp. 176–9, 183–4, 207, 208, 213; and Plates 10 and 11, Chapman and Hall, London, 1964.
 For an account of male and female homosexuality in the 'thirties, see Taylor Croft, *The Cloven Hoof: a Study of Contemporary London Vices*, Denis Archer, London, 1932, chapters v and vi.

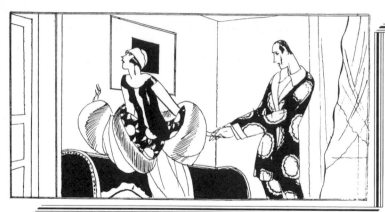

'La Source', diamond and
platinum brooch.

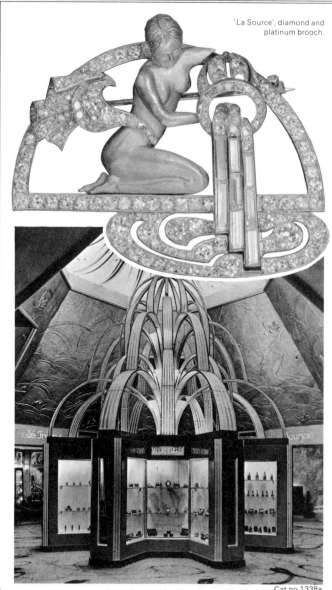

Cat. no. 844

Cat. no. 1338a

It is pleasing to have intuitive observations confirmed by documentary proof; and with the fountain motif — represented in the exhibition by the Bénédictus tapestry, *Les Jets d'Eau* (Cat. No. 1130), in the Sue et Mare design for the *Parfumerie d'Orsay* (Cat. No. 1338a), in the engraved mirror (Cat. No. 603), in Erté's drawing *La Cage Improvisée* 1922 (Cat. No. 780d), — and in the drawings of Alfred Tulk (Cat. Nos. 844–5). I am glad to have had my attention drawn to Claude Bragdon's book of 1932, *The Frozen Fountain*. Bragdon began his artistic life in the 'nineties as a posterist in the Beardsley tradition. He became an architect, and his design for Grand Central Station makes one understand Elizabeth Smart's impulse to sit down there and weep. *The Frozen Fountain* is his artistic manifesto; his Candide-like hero, Sinbad (so named because we all do — get it?) is sent trapesing about the modern world, eyes agog and heart aflame. From the roof of the Megopolis, Sinbad views the City of Frozen Foun-

SINBAD, FROM THE ROOF OF THE MEGOPOLIS, VIEWS THE CITY OF FROZEN FOUNTAINS

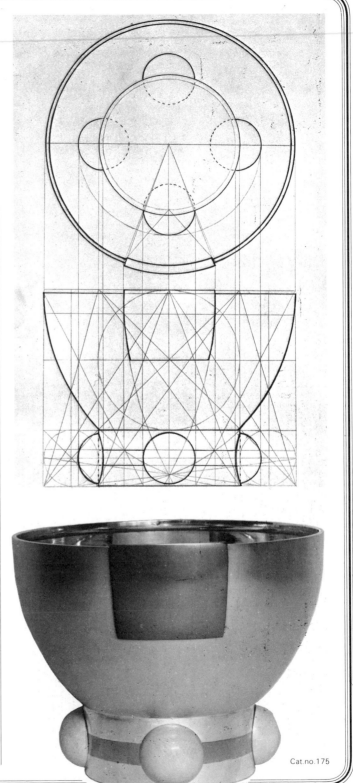

tains. Like Sheldon Cheney, Bragdon is not a man to lose a case by understatement. He writes of this scene:

What is this unit-form of nature, the archetype of all visible images? What formula most perfectly expresses our sense of the life-process? Is it not an ascension and a declension — in brief, a fountain: a welling-up of a force from some mysterious source, a faltering of the initial impulse by reason of some counter-aspect of that force, a subsidence, a *return* all imaged in the upward rush and downward fall of the waters of a fountain, a skyrocket, a stone flung from the hand into the air? . . .
The idea once grasped that *life is a fountain*, we see always and everywhere fountains, fountains! — the sun itself, the up-drawn waters and the descending rain, the elm, the willow, the heart, phallus and the mammary gland.

Fountains to Bragdon were as communists to Senator MacCarthy: he could find them anywhere and everywhere. Again he writes:

A building a fountain: how clarifying a point of view! . . . The needle-pointed *flèche* of the Chrysler Tower catches the sunlight like a fountain's highest expiring jet. The set-backs of the broad and massive lofts and industrials appear now in the semblance of cascades descending in successive stages from the summits to which they have been upthrust. The white vertical masses of the Waldorf-Astoria, topped with silver, seem a plexus of upward rushing, upward gushing, fountains, most powerful and therefore highest at the center, descending by ordered stages to the broad Park Avenue river.

Bragdon's book is indeed a kind of compendium of Art Deco sources. He reproduces Hokusai's print 'The Water-fall' — another example of the Japanese influence to which I drew attention in *Art Deco*. Much of the book is based on those classical ideals of proportion, and geometrical precepts, to which Jean Puiforcat subscribed: in the exhibition we are able to show Puiforcat's golfing cup of 1934 under the design for which Puiforcat wrote: 'Tracé Harmonique. Figure de départ R$\sqrt{2}$.' This is yet another indication of the strength of neo-classicism in the Art Deco period. As we have seen, the tail-piece to Bragdon's work is a drawing of a bubble-blower. And, to cap it all, it was published by Borzoi Books Ltd.

Cat. no. 175

Cat.no.245

Cat.no.474

Then there is the sunray motif. In this exhibition it is perhaps the most dominant of all: the sun-worshipper bookends (Cat. No. 245), the Clarice Cliff sunray bowl (Cat. No. 474), the Simon Gate sunray vase, the sunray compact (Cat. No. 393), the sunray tucks in a Paquin dress of about 1930 (Cat. No. 1054), and the now celebrated sunray shoes (Cat. No. 1057) being only a few examples. Why did it become so popular in this period? This was another of the questions I was unable to answer satisfactorily in *Art Deco*; but it has since been answered, with what may appropriately be called brilliance, by John Weightman, Professor of French at Westfield College in the University of London, England. Professor Weightman devoted a lecture, at the Westfield Festival, 1970, to 'The Solar Revolution: reflections on a theme in French literature.' In this lecture (printed in December, 1970, in *Encounter*), and to a lesser extent in a previous *Encounter* article, 'A View of the Côte d'Azur' (October, 1959), he showed how the cult of sunbathing grew in the 'twenties, and made some convincing suggestions as to its metaphysical significance.

He pointed out that sun-worship as a thorough-going religion is as old as recorded history, and that two outstanding examples of it occurred in Ancient Egypt and Ancient Peru (both of whose cultures, we may note, were influential on Art Deco). But in Europe, he said, 'the sun is by way of being a very recent invention'. He noticed that the Westfield students lay about with as few garments on as possible: before 1914, the girls would have walked about with parasols, shielding themselves from the sun. The solar revolution had taken place in Europe in rather less than a hundred years. When and where did the revolution begin? Professor Weightman thought it was with the sunshine clinic at Leysins in the Swiss Alps, opened by a Swiss doctor, Auguste Rollier, in 1923. When Rollier published an English version of his book *Heliotherapy*, in 1923, he was hailed in England as 'the high priest of modern sun-worshippers' and he was no doubt the person largely responsible for the now almost universal belief that sunshine is good for one, an elixir of youth.

But Professor Weightman does not believe that the new popularity of the sun was due simply to the discovery of its therapeutic qualities. He saw the change as being rather a part of the general return to the idea of nature which began at the Renaissance and has gathered momentum, more especially since the eighteenth century. Strangely, Rousseau was not interested in the sun — with all his passion for woods and singing birds, moonlight and water. Perhaps this had something to do with his hostility to Voltaire, a committed Newtonian. Nor were most of the nineteenth-century writers great sun men. Wordsworth contemplating the daffodils or the lesser celandine, Baudelaire describing Nature as a temple with living pillars, were continuing the Rousseauist attitude.

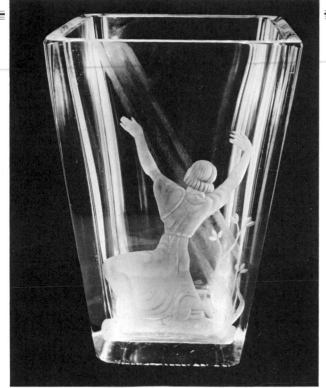

Cat. no. 712

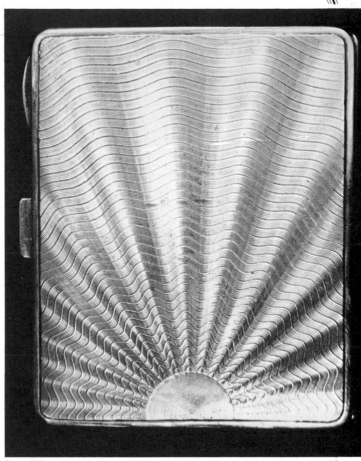

Cat. no. 1057

Cat. no. 393

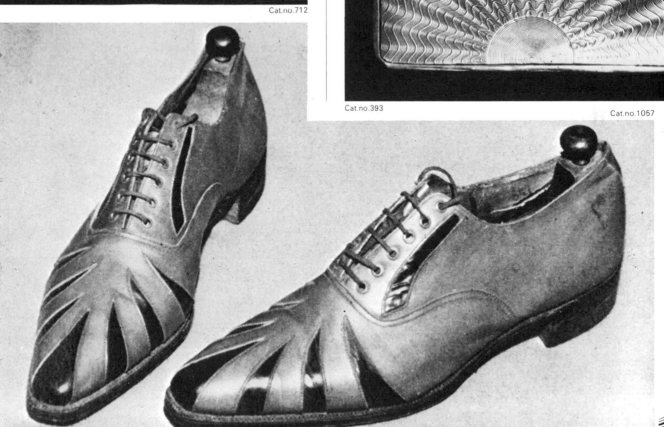

The nineteenth century was the great period of mountain climbing: healthy exercise, an element of danger, an upward movement toward the sublime. 'The Lake District in particular became a sort of national park for the enjoyment of lyrical naturism.' Sea-bathing involved little exposure to sunlight.

Towards the end of the nineteenth century and at the beginning of the twentieth, says Professor Weightman, there was a change in emphasis, with the Impressionists, who turned trees, water-lilies and cathedrals into mere reflectors of sunlight, 'part of the pagan décor of the world'; Gide's *Les Nourritures terrestres*, which was published in 1897 but 'in the 'twenties and 'thirties became the bible of French youth', with its descriptive passages expressing the pleasure of basking in the sun; and, in 1902, Gide's *L'Immoraliste*, in which the hero actually takes off all his clothes and lies down naked in the sunshine. 'So far as I know, this is the very first mention of sun-bathing in French literature.' It preceded the general practice of sun-bathing in France by at least twenty-five years, because as late as 1920, Claude Anet, a minor novelist who had just visited a sun-bathing beach on the Danube, declared in *L'Illustration* that such a delightful practice was only conceivable among the Austrians; it was out of the question in France.

Professor Weightman traces the spectacular development of the Riviera, or, as the French call it, the *Côte d'Azur*. During the whole of the nineteenth century the Mediterranean coast between Menton and Cannes was a preserve first of the English aristocracy and then of the various European royal houses and aristocracies connected with Queen Victoria. But it was a winter resort: no one stayed there in summer because the hot summer sun was thought to be unhealthy. Only a few Frenchmen ventured there in those days, in spite of the efforts of one or two publicists such as Stéphen Liégeard, the man who seems to have invented the term *Côte d'Azur*. The French middle classes, as they gradually discovered sea-bathing and summer walks, went to Normandy, Britanny, and the Atlantic coast. 'These Northern holidays are enshrined for all time in

Proust's *A la recherche du temps perdu*, and there is no sun-bathing in that novel, although it shows an Impressionist feeling for light.' But the First World War swept away most of the royal houses and aristocracies, so that the cosmopolitan winter season on the *Côte d'Azur* was never re-established in its former glory. Professor Weightman continues:

From about 1920 onwards, for the first time people began to stay along the Mediterranean coast in the summer. They were still not French; they were a second cosmopolitan wave, composed not of aristocrats but of artists, writers, bohemians and drop-outs of all kinds, predominantly American, English, German and Scandinavian. This was the period of Isadora Duncan, Scott Fitzgerald, D. H. Lawrence, Aldous Huxley and Somerset Maugham, and it was of course very different from the previous aristocratic dispensation, because it combined the attributes of immoralism, naturism, and non-conformism. . . . The winter sun had been quite decorous and reserved, and consonant with Victorianism, since Queen Victoria herself had visited the Riviera. It may have become slightly more racy with Edward VII, but only marginally so. But in the aftermath of the First World War, the summer sun became synonymous with freedom and revolt, as can be seen from Cyril Connolly's excellent short novel, *The Rock Pool.*

Gradually the French themselves began to discover the Riviera — in particular Gide himself and Colette, who took a house in St Tropez and made the *Côte d'Azur* the setting of many of her stories. And in 1936 the *Front Populaire* introduced annual paid holidays, and a new rush to the south began, only interrupted by the Second World War.

American and English sun-worshippers were outside the scope of Professor Weightman's second paper, which was concerned with French literature; but he had touched on the subject in his first *Encounter* article, of 1959. There he pointed out that the same people as went to Mexico also went to the Riviera — Lawrence, Huxley, Katherine Mansfield, Scott Fitzgerald, Diaghileff and Grace Moore. In the old religious sun of Mexico, or the new secular sun of the *Côte d'Azur*, they sought emancipation, colour, and a comparatively cheap way of life.

Iconoclasts, artists and sexual deviationists (and often the same persons were all three) went south to escape from philistinism and convention and turned the Riviera into the stamping-ground of the detribalized Anglo-Saxon. The *Promenade des Anglais* was given final consecration through being the place where Isadora Duncan was romantically strangled by her own scarf.

Professor Weightman believes that the fundamental purpose of sun-worship was 'serious communion with the source of life'. He quotes Lawrence's expression of the movement in the description of the repressed girl in *The Lovely Lady*: 'Luxuriously she spread herself, so that the sun should touch her limbs fully, fully; if she had no other lover, she should have the sun. . . .' And in his second paper he adds:

When Michel, the hero of *L'Immoraliste*, takes off all his clothes and bathes naked in the sun, he is not simply performing a physical action. The gesture is also, I think, a symbolic recognition of the truth that all life depends ultimately on the sun, and incidentally an assertion that life should, in the first place, be accepted as an undifferentiated explosion of energy, before one tries to categorize that energy as good or bad.

Perhaps there was, too, behind nudism and exposure to the sun's rays, some unformed idea of integrating man more surely in the cosmos, in the same way as Art Deco designers were trying to integrate the separate parts of things into single and total designs. Sheldon Cheney wrote of the modern motor-car: 'Here is a clean athletic transportation machine for the modern clean athletic body — and we should have houses to match.' The human body, too, after all, was a machine for living in.[1]

One of the criticisms levelled against *Art Deco* was that my judgments were more analytic than aesthetic. As even my most sympathetic reviewer, Dr Joseph Mashek, wrote: 'The only reservation might be that you don't get much help in connoisseurship — how to tell good Art Deco from bad.'

The difficulty here, of course, is to define 'good' and 'bad'. Art Deco is the ultimate test of tolerance thresholds. If, as I think we can, we divide it very roughly into the feminine, somewhat conservative style of 1925, chic, elegant, depending on exquisite craftsmanship and harking back to the eighteenth century; and the masculine reaction of the 'thirties, with its machine-age symbolism and use of new materials like chrome and plastics in place of the old beaux-arts materials such as ebony and ivory, we shall find that critics of high discrimination and wide experience usually show a preference for one or the other. Martin Battersby in his written work; Elayne Varian in her choice for the New York exhibition; Lillian Nassau in the provender of her New York shop; or Alain Lesieutre in that of his Paris galleries, all display a distinct predilection for the earlier, beaux-arts school. While Lewis Winter and his wife in their New York collection, John Jesse in his London shop and (if I may include myself in this distinguished company) I in my written work, make clear our alarming partiality for the more popular Art Deco, which borders at times, no, let us be honest, plunges wholeheartedly at times, into the most extravagant kitsch. Personally I feel that whatever our preferences may be, and we

should certainly not fight against them, we should not uphold one mode against another and talk, if we are in the one camp, of the 'mincing lines and effete derivations' of the one, or if our allegiance lies with the opposing party, of the 'vulgarity, crudeness and lack of finish' of the other. We can appreciate both, for different reasons. Caviar and roast beef are not mutually exclusive.

The debate (if debate there must be) is made more complicated by the rapidly changing attitudes of art criticism. Kitsch itself has been accepted and even exalted in Pop Art. Gebhard and von Breton make the point that even styles such as Hollywood Spanish Colonial can now be appreciated:

Fortunately that which became vital in the late 'fifties and early 'sixties — namely 'Pop' and an admiration for the commercial vernacular — has at least partially freed us from the moral restraint of the International Style and its ideology of functional moralism. . . . Thus we are now free to sample other stylistic containers of the 'twenties and 'thirties. We are slowly beginning to sense that the architecture of the period revivals was not really an empty eclecticism devoid of merit. These buildings were as expressive of the period as the International Style itself.

Many critics came to an appreciation of Pop Art before they ever recognized Art Deco as a coherent style. This was a curious situation. It was rather as if one were to admire nineteenth-century neo-Gothic without knowing about Chartres, or to rhapsodize about Picasso's variations on *Las Meniñas* with no inkling that a Velasquez original existed. Of course, Art Deco was all around them. They did

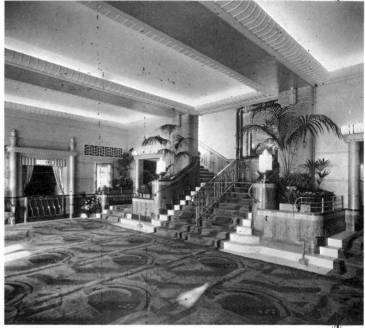

Cat.no.1358a

1 Cheney, *The New World Architecture*, 1930, p. 80. On the topic of man's desire in the 'twenties and 'thirties to integrate himself in the cosmos, Cheney also observes (p. 31) 'One of the most salutary signs of contemporary cultural progress — in spite of those who cry "superficial" and "emotional" — is the prevalence of bird's-eye views, outlines and dramatized "stories" of every subject important to man's happiness and progress. From "The Story of Mankind" and "The Outline of History" to the full-view accounts of religion, the arts, the occupations, and professions of humankind, this is an indication of a great desire for broader understanding, for world outlook.'

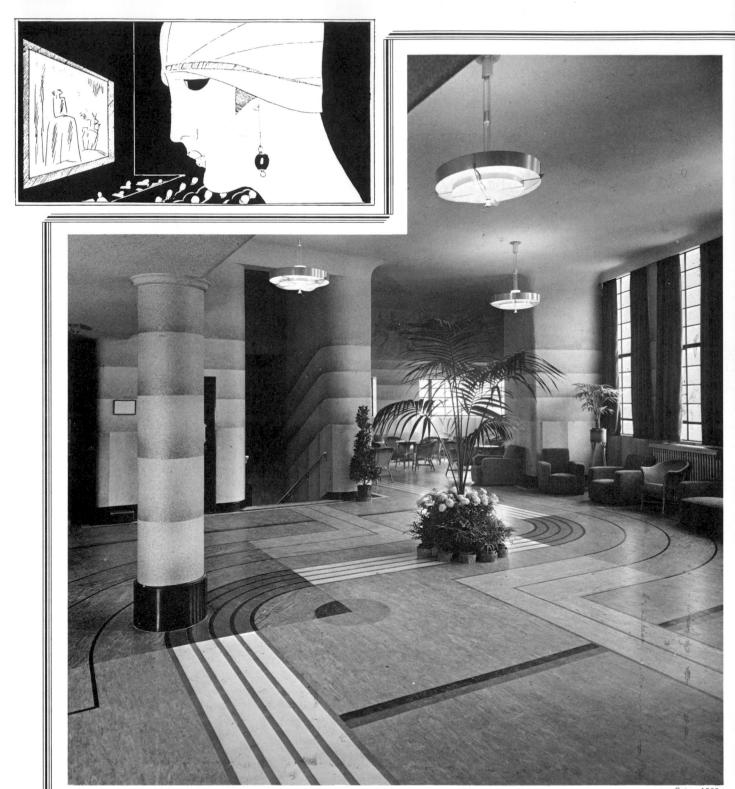

Cat.no.1363a

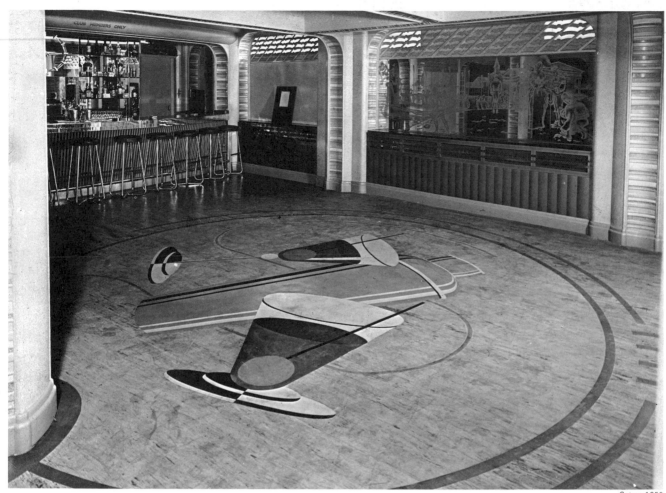

not have to go to Chartres to see bakelite walls and frosted glass, or to the Prado to feast their eyes on chrome-plated railings. Even if certain manifestations of Pop Art were not recognized as pastiche, parody, or glorification of the inter-wars style, the spirit of the style was absorbed by osmosis, impinged on them in rich curves, jagged motifs and colour combinations of black, tractor orange and lime green.

If one had to present to someone the quintessence of Art Deco, what would one show him? My (prejudiced) choice would be one of the cinemas — not the outrageous follies, such as the Granada, Tooting, London, or the Granada, Woolwich, London, or the Old Fox Theatre, San Francisco, with their neo-Gothic and neo-Baroque interiors, but a more humble, run-of-the-mill cinema such as the Odeon in my home town of Redhill, Surrey, or the Rex, Tarascon, France. The importance of the cinema in art was that it gave designers and decorators a chance to let themselves go, untrammelled by the limitations imposed by bourgeois purses and bourgeois domestic tastes. In them we see Art Deco in its fully-realized form, functional to the extent that any cinema has to be, but also giving scope for the farthest indulgence of the designer's taste: a great staircase with chrome rails billowing out into the foyer; a design of cocktail glasses on the linoleum; chandeliers or wall sconces which are wild freaks of the exotic. Entering, past the mirror glass and fluted columns, we can relive the days when the mighty Wurlitzer pumped out its unspeakable medleys and the auditorium, vibrating with emotion, changed colour in the arc-lights from pink to green. As C. Day Lewis wrote in his poem 'Newsreel' (1938):

Enter the dreamhouse, brothers and sisters, leaving
Your debts asleep, your history at the door:
This is the home for heroes, and this loving
Darkness a fur you can afford.

If it be objected that I have chosen, as my quintessence, the more *kitsch* aspect of Art Deco, I can reply: so has the contemporary artist who has most successfully drawn on Art Deco in his works — Roy Lichtenstein, whose 'Sculpture with velvet rope' (1969) is a parody of Art Deco as delicious as Max Beerbohm's literary parodies in *A Christmas Garland*. And it is perhaps significant that Lichtenstein is best known for his paintings derived from comic strips. For the critical response to Art Deco — at least, the type of Art Deco that interests Lichtenstein — has developed in much the same stages as the response to the comic strip. In both cases the primitive attitude is anti: comics and Art Deco are 'trash'. Then comes the slightly more liberal view that these things are necessary as roughage in the literary or artistic diet: familiarity with the clichés of the bad will accustom the reader of comics or the viewer of Art Deco to avoid them himself. Then comes the anthropological approach: George Orwell anatomizes comics for their social import, Art Deco is similarly dissected for its social origins.

Finally, both gain artistic acceptance, both are made the subject of inspired parodies by Lichtenstein. Both become international twentieth-century folk art, influencing our advertising, fashion, cinema and television, giving impetus to Pop Art. Both are the subject of large exhibitions, comics at the Institute of Contemporary Arts, London, and Art Deco at several museums in America, France and England. Jules Feiffer's remarks about comics, in his *Great Comic Book Heroes* (1965) could equally well be applied to, not all Art Deco, but to a large element in it:

Comic books, first of all, are junk. To accuse them of being what they are is to make no accusation at all: there is no such thing as uncorrupt junk or moral junk. . . . Junk, like the drunk at the wedding, can get away with doing or saying anything because, by its very appearance, it is already in disgrace. It has no one's respect to lose; no image to endanger. Its values are the least middle class of all the mass media. That's why it is needed so.

There will be those who relish in this exhibition only the more rarefied glories of Puiforcat silver, Bénédictus textiles, Worth fashions, Ruhlmann and Dufrène furniture, Marinot glass, Dunand lacquer, Dupas paintings, Schmied book illustrations, Kieffer bindings, Fouquet jewelry and the like. Others, in common with Lichtenstein, will feel the strongest response to plaster figures from the fairground, sunray wireless sets, chrome and plastic ashtrays, cinema crowd barriers; will adopt as their high art the lowest art of the 'thirties. Our invitation to all of them should perhaps be a diplomatic echo of those C. Day Lewis lines:

> *Enter the dreamhouse, brothers and sisters, leaving*
> *Your debts asleep, your history at the door.*

Opposite: Cat.no.1360
Overleaf: Cat.no.35 (above); 36 (below).

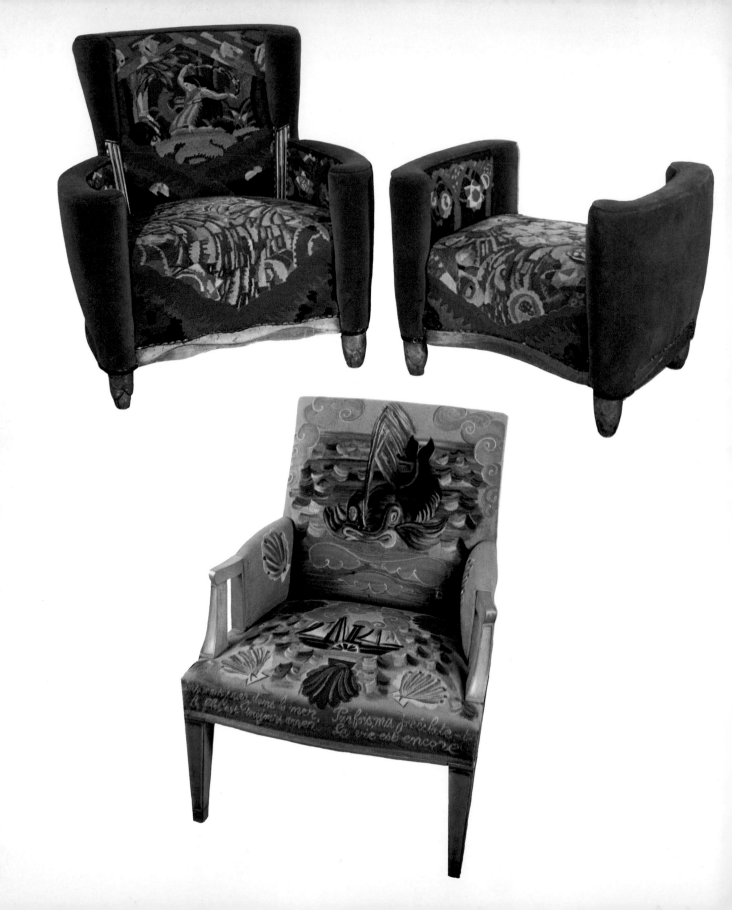

Exhibits

'An Exhibition arranged by
The Minneapolis Institute of Arts'

Paris Exposition, 1925' refers throughout to the
*Exposition International des Arts Décoratifs et
Industriels Modernes*, Paris, 1935.

'Paris Exposition, 1937' refers to the exhibition
Le Décor de la Vie de 1900–1925, Paris,
Musée des Arts Décoratifs, 1937.

Dimensions. All dimensions are in inches;
height precedes width precedes depth.

Furniture

1. ANONYMOUS. Chair.
Wood with step back and arm design.
c.1930. 28 × 25 × 24½.
Coll. Mr Stanley Insler.

2. ANON. Vitrine. French.
Inlaid wood and brass, semicircular.
c.1925. 68 × 40 × 15.
Courtesy of Lillian Nassau, Ltd.

3. ANON. Table from the *S.S. Normandie.*
Chrome and smoked glass.
60 × 24 × 30.
Coll. Mr Paul Magriel.

4. ANON. Round-topped table.
Wood.
28½ × 31½.
Coll. Mr Fred Hughes.

5. ANON. Table.
Wood, glass and chrome.
29⅞ × 54¾ × 25¾.
Coll. Mr and Mrs Samuel Sachs, II.

6. ANON. Firescreen. French.
Wrought-iron with waterfall motif.
c.1925. 38½ × 7½ × 19.
Coll. Miss Barbra Streisand.

7. ANON. Side table. American.
Steel.
c.1927. 18 × 22 × 42.
Coll. Kiki Kogelnik.

8. ANON. Table.
Wood, supported by caryatids. Mask in
center of surround.
c. 1920–30. 32 × 54.
Coll. Mr Adrian Emmerton.

9. ANON. Easy chair. German.
Walnut veneer with loose cushions.
1923. 25 × 27½ × 33¼.
Lent by Victoria and Albert Museum.

10. ANON. Table.
Satinwood veneer on pine, with black
lacquer.
27 × 33.
Coll. Miss Marie Middleton.

11. ANON. Two tables.
Ziggurat-shaped legs.
20 × 21½ × 21½.
Courtesy of Sonnabend Gallery.

12. ANON. Dressing table.
Chest of drawers with large round
looking-glass assymmetrically attached.
55 × 53½ × 14.
Courtesy of Sonnabend Gallery.

13. ANON. Cocktail cabinet with clock.
c.1930.
Coll. Mr Christopher Mendez.

14. ALVAR AALTO. Lounge chair.
Moulded and bent birch plywood.
c.1934. H: 25½.
Lent by The Museum of Modern Art,
Gift of Edgar Kaufmann, Jr.

15. DJO BOURGEOIS. *Meuble d'appui.*
Veneered mahogany, with trapezoid
handles in white alloy.
c.1925–30. 35½ × 79 × 18.
Lent by Musée des Arts Décoratifs.

16. EDGAR BRANDT. Firescreen.
Wrought-iron.
c.1924. 29½ × 35¾.
Lent by Metropolitan Museum of Art,
Gift of Cheney Brothers.

17. CARLO BUGATTI. Table.
Parchment-covered wood, with red and
white copper ornaments.
c.1913. 29 × 36 × 19.
Courtesy of M. Alain Lesieutre.

18. Bugatti. Armchair.
Parchment-covered wood, with red and
white copper ornaments.
c.1913. 43 × 23½ × 21.
Courtesy of M. Alain Lesieutre.

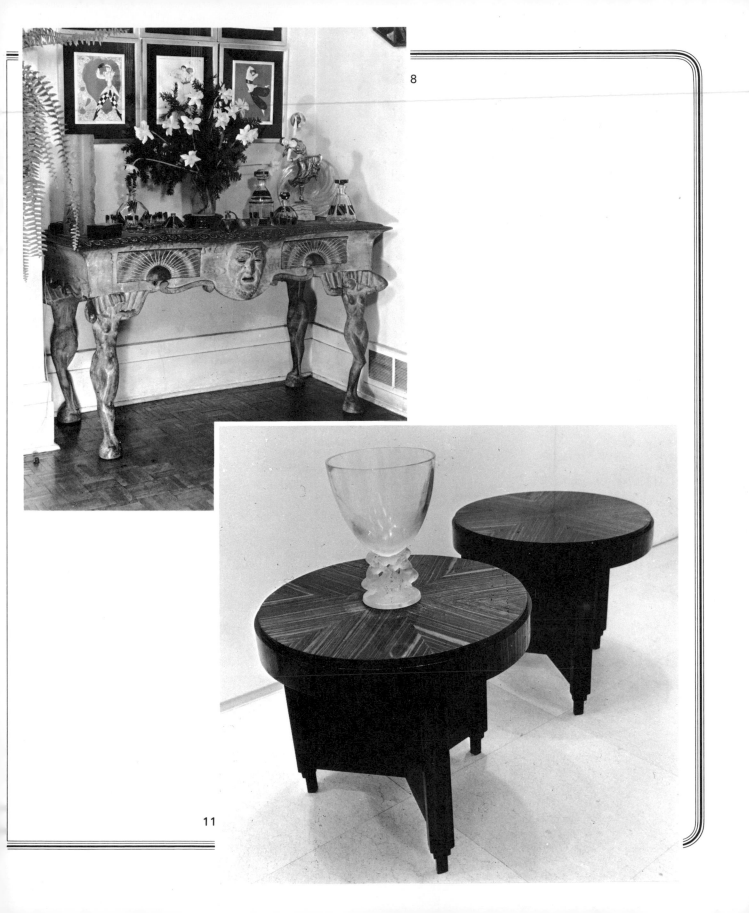

8

11

19. Bugatti. Mirror.
Triangle of mirrored glass in painted wood frame.
c.1913. $16\frac{1}{2} \times 22\frac{1}{2} \times \frac{1}{2}$.
Courtesy of M. Alain Lesieutre.

20. PIERRE CHAREAU (1883–1950).
Bureau.
Rosewood veneer on mahogany and oak.
1925. $55 \times 30\frac{1}{2} \times 30$.
Exh: *Paris Exposition*, 1925; *Les Années '25'*, Paris, 1966, cat.no.577.
Literature: René Herbst, *Pierre Chareau*, Paris, 1954, p.53 and illustration, p.90.
Yvonne Brunhammer, *Lo Stile 1925*, Fabbri, Milan, 1966, p.76, colour reproduction p.78, Pl.35.
Lent by Musée des Arts Décoratifs.

21. Chareau. Bureau armchair.
Lacquered and varnished beech.
1925. $31\frac{1}{2} \times 28\frac{1}{2}$.
Exh: *Paris Exposition*, 1925; *Les Années '25'*, Paris, 1966, cat.no.578.
Literature: René Herbst, *Pierre Chareau*, Paris, 1954, illustration p.90. Yvonne Brunhammer, *Lo Stile 1925*, Fabbri, Milan, 1966, p.76, illustration p.78, Pl.35.
Lent by Musée des Arts Décoratifs.

22. Chareau. Table.
Wood covered with parchment of natural color and veneer of *bois de violette*. (The work-table of Rose Adler.)
c.1925. $26\frac{1}{2} \times 55 \times 19$.
Exh: Musée des Arts Décoratifs, 1960–1; *Les Années '25'*, Paris, 1966, cat.no.579.
Lent by Musée des Arts Décoratifs.

23. Chareau. Armchair.
Courtesy of Sonnabend Gallery.

24. MARCEL COARD (1889–).
Armchair.
Oak and red lacquer, with round cushion in gold and black.
c.1920–5. $34 \times 26 \times 31$.
Exh: *Jacques Doucet – Mobilier 1925*, Musée des Arts Décoratifs, 1961; *Les Années '25'*, Paris, 1966.
Literature: Yvonne Brunhammer, *Lo Stile 1925*, Fabbri, Milan, 1966, p.68, colour reproduction p.69, Pl.30.
Lent by Musée des Arts Décoratifs, Gift of Jean Dubrujeaud in memory of Jacques Doucet.

25. LE CORBUSIER (CHARLES-EDOUARD JEANNERET, 1887–1965).
Chaise longue.
Chromium-plated steel tube frame, self-adjusting on mild steel base; pony skin, leather, steel tension springs. Original design 1928: Gebrüder Thonet, Vienna, Paris. Reproduced from 1965 by Aram Designs Ltd, London, and Cassina, Milan. Used by Corbusier in the furnishing of a villa in Ville d'Avray, 1928–9.
First exhibited at the *Salon d'Automne*, Paris, 1929.
Lent by Thomas Designs Inc.

26. DONALD DESKEY. Side table with attached lamp.
Aluminum and painted wood.
Designed for Radio City Music Hall.
$28 \times 60 \times 21$.
Lent by Radio City Music Hall.

27. Deskey. Two end tables.
Aluminum and painted wood.
Designed for Radio City Music Hall. 27×14.
Lent by Radio City Music Hall.

28. Deskey. Two floor lamps.
Aluminum, painted wood with shade.
Designed for Radio City Music Hall. H: 57.
Lent by Radio City Music Hall.

29. Deskey. Two standing corner lamps (torch form).
Aluminum and painted wood.
Designed for Radio City Music Hall. $7 \times 9\frac{1}{2}$.
Lent by Radio City Music Hall.

30. Deskey. Two settees.
Aluminum, upholstered.
Designed for Radio City Music Hall.
$20 \times 55 \times 19$.
Lent by Radio City Music Hall.

31. Deskey. Sofa.
Aluminum, upholstered.
Designed for Radio City Music Hall.
$28 \times 60 \times 34$.
Lent by Radio City Music Hall.

31a. Deskey. Two stuffed chairs.
Wood, upholstered.
Designed for Radio City Music Hall.
$31 \times 25 \times 33$.
Lent by Radio City Music Hall.

32. Deskey. Cabinet.
Wood, aluminum, with marble top.
Designed for Radio City Music Hall.
$36 \times 77 \times 21$.
Lent by Radio City Music Hall.

33. D.I.M. (Décoration Intérieur Moderne). Writing table.
Walnut, amboyna and ivory.
c.1925.
Exh: *Paris Exposition*, 1925.
Lent by Musée des Arts Décoratifs.

34. DOMINIQUE (Association of André Domin and Marcel Genevrière). Chair.
Polished rosewood, covered with flowered silk. Made by Dominique at the end of 1925 and the beginning of 1926 for the Musée des Arts Décoratifs, Paris, after a model at the 1925 Exposition. Bears a metal plaque: 'Dominique Paris'.
$33\frac{1}{2} \times 17\frac{3}{4} \times 17\frac{3}{4}$.
Exh: *Les Années '25'*, Paris, 1966.
Illus: Léon Moussinac, *Le Meuble Français Moderne*, Paris, 1925, Pl.47, Fig.58; Yvanhoë Rambosson, 'Les Meubles de Dominique', *Art et Décoration*, January–June, 1924, vol.xlx, p.134; *Meubles et Décors*, November, 1966, No.820, p.71; illustration 13.
Lent by Musée des Arts Décoratifs.

35. MAURICE DUFRÈNE (1876–1955).
Armchair and stool.
From a suite of six pieces (sofa, two armchairs, two stools and a square pouffe) executed by Dufrène in sculpted gilt wood and with tapestry in rich colour worked by Jean Beaumont in Beauvais.
1925.
Exh: *Paris Exposition*, 1925.
Coll. Mrs F. Legrand-Kapferer.

36. RAOUL DUFY (1877–1953). Suite, comprising two chairs and a sofa. Covered in tapestry. Wood frames by Jean Lurçat, 1935. (Originally there were five pieces in the suite: canapé, two armchairs, two chairs without arms.)
Side chair $37 \times 18 \times 19\frac{3}{4}$.
Armchair $37 \times 18 \times 27\frac{1}{2}$.
Illus: Raymond Cogniat, *Dufy Décorateur*, Cailler, Geneva, 1957, p.47.
Courtesy of M. Alain Lesieutre and Galerie du Luxembourg.

37. JEAN DUNAND (1877–). Table.
Lacquer and *coquille d'œuf*.
1927. $17 \times 31\frac{1}{4} \times 19$.
Coll. Mr and Mrs Peter M. Brant.

38. Dunand. *Bibliothèque*.
Lacquered wood.
1927. $72 \times 48\frac{1}{2}$.
Coll. Mr and Mrs Peter M. Brant.

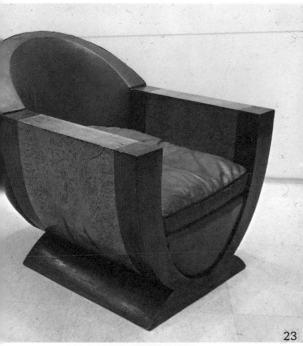

23

32

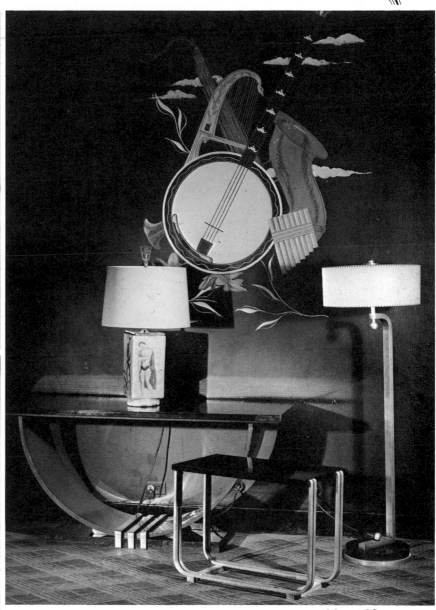

26 and 28

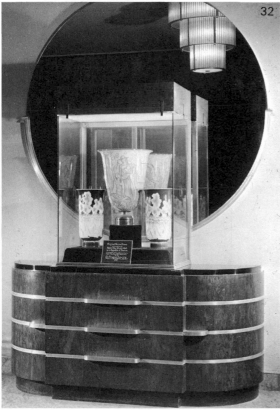

39. Dunand. Sofa.
Lacquered wood.
1927. 60 × 36.
Coll. Mr and Mrs Peter M. Brant.

40. Dunand. Two armchairs.
Wood and lacquer.
c.1925. 31½ × 29 × 24.
Coll. Mr and Mrs Peter M. Brant.

41. Dunand. Desk.
Wood, lacquer and *coquille d'œuf*.
c.1925. 29¾ × 52 × 26.
Coll. Mr and Mrs Peter M. Brant.

42. Dunand. Three chairs.
Lacquer with barrel back.
1927. 31½ × 29 × 24.
Coll. Mr and Mrs Peter M. Brant.

43. Dunand. Table.
Lacquer and *coquille d'œuf.*
c.1927. 17 × 31¼ × 19.
Coll. Mr and Mrs Peter M. Brant.

44. Dunand. Bar.
Lacquer and *coquille d'œuf.*
c.1925. 27¼ × 41½ × 33.
Coll. Mr and Mrs Peter M. Brant.

45. Dunand. Table.
Lacquered.
c.1925. 26¾ × 39½ × 39½.
Exh: *Les Années '25',* Paris, 1966,
cat.no.587.
Lent by Musée des Arts Décoratifs.

46. Dunand. Screen.
Four-leaf. Lacquer, depicting gazelles and
birch trees.
c.1930. Each leaf 63 × 20.
Courtesy of M. Alain Lesieutre.

47. Dunand. Screen.
Lacquer, depicting a woman who is
wearing ten jewels designed by Dunand.
c.1925. 40 × 26.
Courtesy of M. Alain Lesieutre.

49. PAUL FOLLOT (1877–1941). Chair.
Carved sycamore, ebony and amaranth.
The carved back represents a basket of
flowers and fruit.
c.1913. 36 × 23 × 17.
Exh: *Les Années '25',* Paris, 1966.
Illus: Maurice Dufrène, 'A propos de
Meubles, Le Siège', *Art et Décoration*,
July–December, 1913, vol.xl, p.23;
Guillaume Janneau, 'Paul Follot', *Art et
Décoration*, July–December 1921, p. 143;
Léon Riotor, 'Paul Follot', *La Connaissance*,
Paris, 1923, Fig.9; Léon Moussinac,
Le Meuble Français Moderne, Hachette,
Paris, 1925, Fig.17.
Lent by Musée des Arts Décoratifs.

50. FOUJITA. Table.
Fruitwood with ivory, burl and ebony inlay
of a *trompe l'œil* design including playing
cards, a pipe, an envelope, a key and the
artist's spectacles.
Courtesy of M. Alain Lesieutre.

51. JEAN-MICHEL FRANK
(–1944).
Coffee table.
Parchment-covered wood.
c.1935. 19⅝ × 21⅞ × 21⅞.
Lent by the Cooper-Hewitt Museum of
Design, Smithsonian Institution,
Gift of Mr and Mrs Forsythe Sherfesee.

52. PAUL T. FRANKL (1878–1962).
Chair.
Wood, with arms curving from the top of
the chair to the seat in an even gradient.
c.1928. 26½ × 25 × 28.
Coll. Mr Stanley Insler.

53. Frankl. Dressing-table.
Brass and black lacquer.
1930. 70 × 8 × 19.
Coll. Mr Fred Hughes.

54. ANDRÉ GROULT (1884–1967).
Commode.
White galuchat on wood.
c.1925. 35½ × 78½ × 19¼.
Coll. Mr and Mrs Peter M. Brant.

55. Groult. Table.
Wood and galuchat.
1922. 21½ × 30.
Exh: *Paris Exposition*, 1925 ('Chambre de
Madame l'Ambassadrice').
Courtesy of M. Félix Marcilhac.

56. Groult. *Bergère gondole.*
White galuchat on beech. Upholstered in
gaufré velvet with floral decoration, from
the Maison Delaroière et Leclercq.
1925. 39¼ × 26½ × 26.
Exh: *Paris Exposition*, 1925 ('Chambre de
Madame l'Ambassadrice'); *Les Années
'25',* Paris, 1966, cat.no.593.
Illus: Henri Clouzot, 'Le Meuble Français
Moderne', *L'Illustration*, September 19,
1925, p.278.
Lent by Musée des Arts Décoratifs.

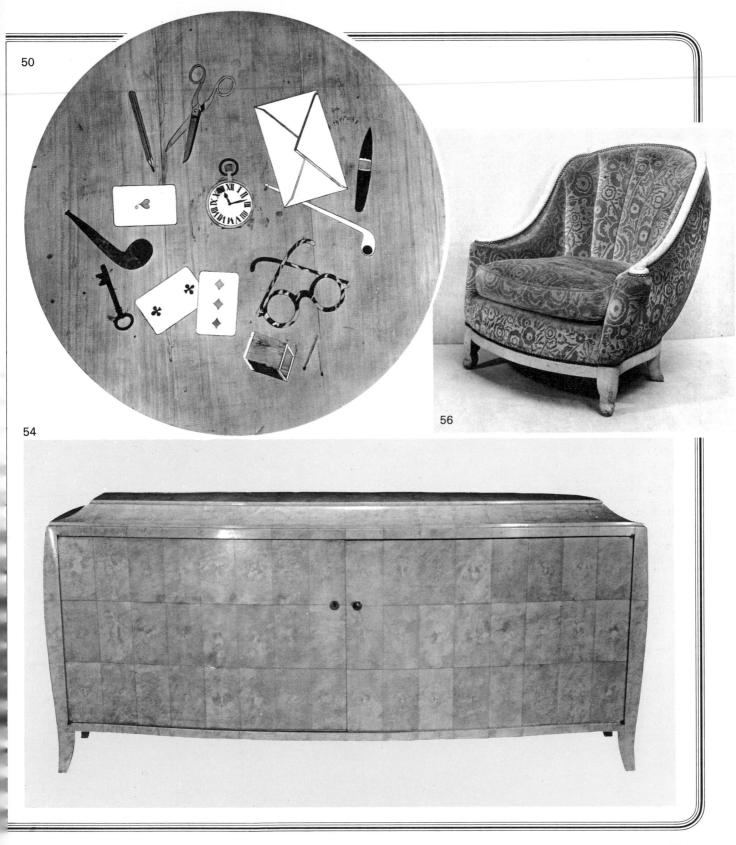

50

54

56

57. CHARLES HAIRON. Radio cabinet, in two parts.
Rosewood and mahogany. The cupboard in the base of the cabinet has a door by Saddier.
c.1925. $53\frac{1}{2} \times 27\frac{1}{2} \times 20$.
Lent by Musée des Arts Décoratifs.

58. WOLFGANG HOFFMAN.
'Century of Progress' chair.
Birch and cherry wood with upholstered seat.
c.1933. $43\frac{3}{4} \times 35\frac{1}{2} \times 23\frac{1}{2}$.
Coll. Wilma Keyes.

59. PAUL IRIBE (1883–1935). *Bergère*.
Mahogany ornamented with ebony.
Signed and dated 1913.
Exh: *Le Décor de la Vie de 1900 à 1925*, Paris, 1937, cat.no.726; *Jacques Doucet – Mobilier 1925*, Paris 1961.
Les Années '25', Paris, 1966, cat.no.596.
Lent by Musée des Arts Décoratifs.

60. LEON JALLOT (1874–).
Occasional table.
Wood and galuchat.
c.1925. $19\frac{3}{4} \times 19\frac{3}{4} \times 11\frac{1}{2}$.
Coll. Mr and Mrs Peter M. Brant.

61. Jallot. Cabinet.
Mahogany and marble.
c.1925. $51\frac{5}{8} \times 44\frac{3}{4} \times 17\frac{7}{8}$.
Lent by the Metropolitan Museum of Art, Purchase, 1925, Edward C. Moore Jr Gift Fund.

62. Jallot. *Secrétaire*.
Bois d'amourette, amboyna and amaranth.
1914. $55 \times 24\frac{1}{2} \times 14\frac{1}{4}$.
Exh: *Salon de la Société Nationale des Beaux-Arts*, Paris, 1914; *Les Années '25'*, Paris, 1966.
Illus: R. Koechlin, 'Les Premiers Efforts de Renovation (1885–1914), 'Exposition des Arts Décoratifs, 1925, Gazette des Beaux-Arts, p.262; Serg Grandjean, 'The Nineteenth Century: France' in *World Furniture*, ed. Helena Hayward, London, 1965, p.246, Fig.943.

63. RENÉ JOUBERT AND PHILIPPE PETIT. Woman's writing desk.
The front with lock opening out to form writing table; two drawers with ivory knobs inlaid with parallel vertical lines.
$46\frac{1}{2} \times 31\frac{1}{2} \times 16$.
Exh: travelling exhibition of *Paris Exposition*, 1925.
Literature: *Studio Year Book*, 1925.
Lent by Art Galleries, Cranbrook Academy of Art.

64. HAMMOND KROLL (1898–).
Chest of drawers.
Striped mahogany veneer with Australian maple burl veneer decoration.
c.1932. $41\frac{3}{4} \times 38 \times 24\frac{1}{4}$.
Lent by Cooper-Hewitt Museum of Design, Smithsonian Institution, Gift of Mrs Helen Segal.

65. Kroll. Pair of night tables.
Figured and striped mahogany veneer, brown-tinted glass and mirror.
c.1932. $24\frac{1}{8} \times 23\frac{3}{4} \times 11\frac{3}{4}$.
Lent by Cooper-Hewitt Museum of Design, Smithsonian Institution, Gift of Mrs Helen Segal.

66. Kroll. Mantle.
Light wood with inset pink mirrored surface. Fireplace opening painted black with pink mirror frame and border of darker wood at each side of base, attached to flat base of pewter.
c.1935. $49\frac{3}{8} \times 25\frac{3}{16} \times 11\frac{1}{4}$.
Lent by Cooper-Hewitt Museum of Design, Smithsonian Institution, Gift of Mrs Helen Segal.

67. PIERRE LEGRAIN. *Chaise longue*.
Beech, lacquered black and inlaid with mother-of-pearl. Covered with velvet imitating zebra skin.
c.1925. $35\frac{3}{4} \times 51\frac{1}{4} \times 23\frac{1}{4}$.
Exh: *Jacques Doucet – Mobilier 1925*, Paris, 1961; *Les Années '25'*, Paris, 1966, cat.no.607.
Lent by Musée des Arts Décoratifs.

68. Legrain. Two chairs.
'Egyptian' style with palmwood veneer and black and green lacquer.
c.1925. $30\frac{3}{4} \times 17\frac{3}{4} \times 17\frac{3}{4}$.
Exh: *Jacques Doucet – Mobilier 1925*, Paris, 1961; *Les Années '25'*, Paris, 1966, cat.no.606.
Literature: Robert Bonfils, *Pierre Legrain, Relieur*, Blaizot, Paris, 1965, p.xxxvi; Yvonne Brunhammer, *Lo Stile 1925*, Fabbri, Milan, 1966, p.1, colour reproduction p.70, Pl.31;
Illus: *L'Arte Moderna*, Fabbri, Milan, 1967, p.304.
Lent by Musée des Arts Décoratifs.

69. Legrain. *Guéridon* (pedestal table).
Rosewood veneer, partially silvered and painted in imitation of *coquille d'œuf*.
c.1923. $23\frac{1}{2} \times 25\frac{3}{4}$.
Exh: *Jacques Doucet – Mobilier*, Paris, 1961; *Les Années '25'*, Paris, 1966, cat.no.603.
Literature: a very similar piece by Legrain is illustrated in Léon Moussinac, *Le Meuble Français Moderne*, Hachette, Paris, 1925, p.57, Fig.63.
Lent by Musée des Arts Décoratifs.

70. JULES LELEU. Commode.
Amboyna wood, marble and ivory.
c.1925. $35 \times 49\frac{1}{4} \times 8\frac{1}{2}$.
Lent by Metropolitan Museum of Art, Gift of Agnes Miles Carpenter, 1946.

71. Leleu. Pair of armchairs.
Silver feet and blue-upholstered seats.
c.1925.
Courtesy of M. Alain Lesieutre.

72. PIERRE LENOIR. Fountain.
Bronze female figures.
c.1926.
Coll. Mr Fred Hughes.

73. MARY LODER. Screen.
Three-leaf, covered with a 1930s collage of *Vogue* covers of the 1920s and 1930s.
Each leaf 72×21.
Lent by Museum of Costume, Bath.

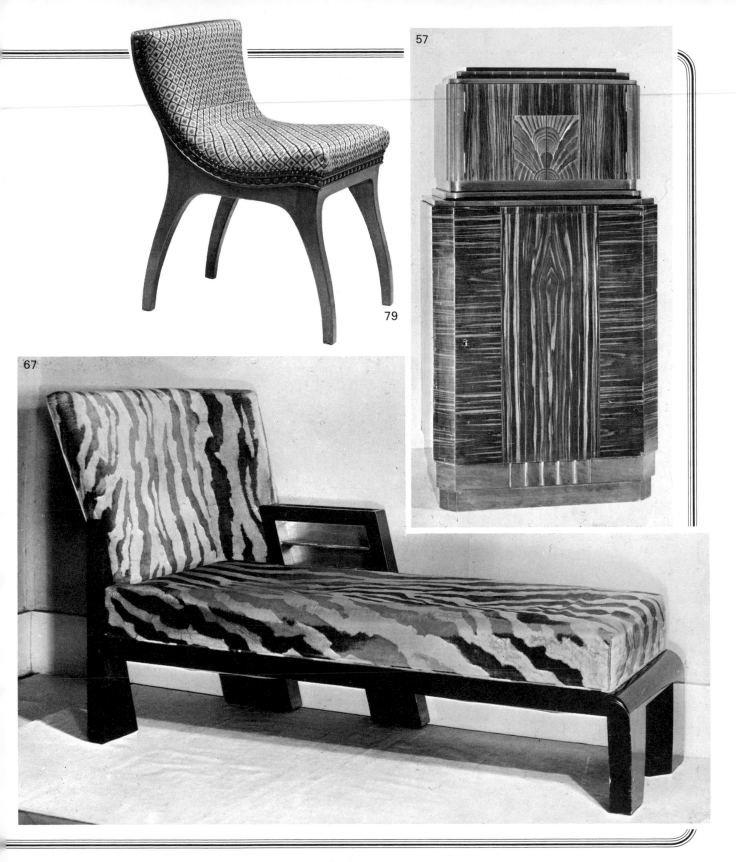

57

79

67

74. ANDRÉ MARE (1887–1932).
Two dining-room chairs.
Polished cherry wood.
c.1911. 31¼ × 18⅜ × 17½.
Exh: *Salon d'Automne* 1911 (where it was acquired by the Musée des Arts Décoratifs); *Les Années '25'*, Paris, 1966, cat.no.617.
Illus: Gaston Quenioux, *Les Arts Décoratifs Modernes (France)*, Larousse, Paris, 1925, p.105.
Lent by Musée des Arts Décoratifs.

75. PAUL-LOUIS MERGIER
(1891–). *Meuble d'appui.*
Wood covered with green morocco, decorated with ivory, parchment, lacquer, mother-of-pearl, *coquille d'œuf*, and tassel handle.
c.1928–9. 40⅝ × 51¼ × 15⅝.
Exh: *Jacques Doucet – Mobilier, 1925*, Paris, 1961; *Les Années '25'*, Paris, 1966, cat.no.621; *André Suares*, Musée Anton Bourdelle, 1968, cat.no.136, reproduced p.36.
Literature: André Joubin, 'Le Studio de Jacques Doucet' *L'Illustration*, May 3, 1930, No.4548, p.20 and No.4557, .p.387; André Joubin, 'Jacques Doucet, 1853–1929', *Gazette des Beaux-Arts*, 1930, p.79, Fig. 5; J. F. Revel, 'Jacques Doucet, Couturier et Collectionneur', *L'Oeil*, No.84, December, 1961, p.45.
Lent by Musée des Arts Décoratifs.

76. H. NELSON (1871–).
Pair of chairs.
Mahogany with brass feet and insets, upholstered in original petit-point.
c.1926. 34¾ × 23.
Courtesy of Lillian Nassau, Ltd.

77. NESSEN STUDIO. Mirrored glass and chrome side table.
1930. 30½ × 38.
Coll. Mr Edward Lee Cave.

78. ARMAND RATEAU (1882–1938).
Armchair.
Bronze patinated in *vert antique*, with ocelot fur cushion; the back and seat are formed of small chains of fishplates joined at head and tail.
c.1920–5. 37½ × 24½.
Model created for the swimming bath of Mme Georges Blumenthal, New York.
Exh: *Paris Exposition*, 1937, cat.no.762; *Les Années '25'*, Paris, 1966, cat.no.626.
Illus: Yvonne Brunhammer, *Cent chefs d'œuvre du Musée des Arts Décoratifs*, Paris, 1964, p.112.
Lent by Musée des Arts Décoratifs.

79. Rateau. Chair.
Cherry-wood, back and seat in one piece, carved with a frieze of ovals. Tapestry in *point quadrillé*. Made for the installation of Jeanne Lanvin, 16 rue Barbet-de-Jouy, 1920–2. 26¼ × 16½ × 20.
Exh: *Les Années '25'*, Paris, 1966, cat.no.630.
Lent by Musée des Arts Décoratifs.

80. Rateau. *Travailleuse.*
Bronze patinated *vert antique* and marble, in the form of an antique urn, pierced with marguerite and butterfly designs. Made for the installation of Jeanne Lanvin, 16 rue Barbet-de-Jouy, 1920–2.
Exh: *Les Années '25'*, Paris, 1966, cat.no.637. 32 × 15½.
Illus: Eveline Schlumberger; 'Au 16 rue Barbet-de-Jouy avec Jeanne Lanvin', *Connaissance des Arts*, August 1963, p.66, No.8.
Lent by Musée des Arts Décoratifs.

81. ROWLEY GALLERY, LONDON.
Screen.
Three-fold in ebonized wood with surround of gilt gesso. Each leaf contains an oval panel of marquetry in coloured woods with figures in landscapes of trees and columns. Probably designed by William Arthur Chase (b.1878) for the Rowley Gallery, c.1920.
Exh: *The Jazz Age*, Brighton Museum and Art Gallery, 1969, cat.no.6.
Lent by Victoria and Albert Museum.

82. EMILE-JACQUES RUHLMANN
(1879–1933). *Secrétaire.*
Veneer of amboyna and rosewood, with ivory handles, the interior lined with green morocco.
1924. 55 × 38½ × 16.
Exh: *Exposition Retrospective E.-J. Ruhlmann*, Musée des Arts Décoratifs, 1934, cat.no.60; *Les Années '25'*, Paris, 1966, cat.no.656.
Illus: *L'Arte Moderna*, Fabbri, Milan, 1967, vol.x, no.89, p.289.
Lent by Musée des Arts Décoratifs.

83. Ruhlmann. *Cla-cla.*
Table for the display of prints.
Rosewood.
1926. 26½ × 31½ × 23½.
Given by the artist to the Musée des Arts Décoratifs in 1933.
Exh: *Exposition Retrospective E.-J. Ruhlmann*, Musée des Arts Décoratifs, 1934; *Les Années '25'*, Paris, 1966, cat.no.660.
Literature: Pierre Devinoy and Guillaume Janneau, *Le Meuble Léger en France*, Paul Hartmann, Paris, 1952, pp.51–2 and Pl.324.
Lent by Musée des Arts Décoratifs.

84. Ruhlmann. *Coiffeuse.*
Amboyna, ivory, galuchat.
1927. 54 × 49½ × 28.
Coll. Mr and Mrs Peter M. Brant.

85. Ruhlmann. Chair.
Beechwood.
c.1925. 34½ × 27 × 22.
Coll. Mr and Mrs Peter M. Brant.

86. Ruhlmann. Commode.
Amboyna, with ivory inset.
1927. 37½ × 55½ × 23¼.
Illus: *L'Illustration*, 1927.
Coll. Mr and Mrs Peter M. Brant.

87. Ruhlmann. *Chaise longue.*
Metal and rosewood.
1928. 27¾ × 58 × 22½.
Illus: *Intérieurs au Salon des Artistes Décorateurs*, ed. Charles Moreau, Paris, 1928.
Coll. Mr and Mrs Peter M. Brant.

88. Ruhlmann. Two armchairs.
Wood covered in red leather.
c.1925. 31¼ × 26½ × 27¼.
Coll. Mr and Mrs Peter M. Brant.

89. Ruhlmann. Chair.
Amboyna.
c.1925. 26½ × 17 × 20.
Coll. Mr and Mrs Peter M. Brant.

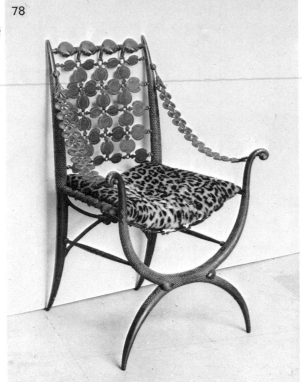

78

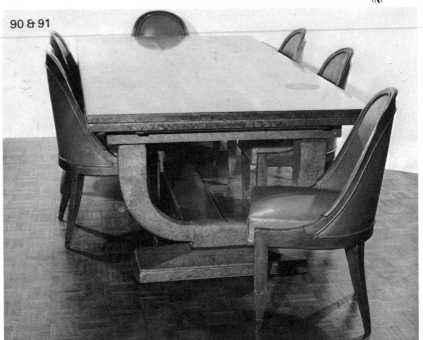

90 & 91

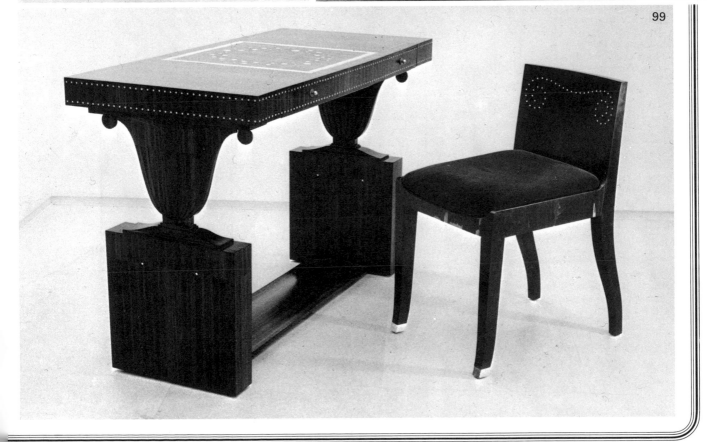

99

90. Ruhlmann. Dining-room extension table.
Burled walnut, matching chairs listed below.
1925. 25 × 98 × 47.
Exh: *Paris Exposition*, 1925.
Courtesy of Lillian Nassau, Ltd.

91. Ruhlmann. Eight chairs.
Burled walnut, *forme gondole*.
1925. 36 × 21 × 19½.
Courtesy of Lillian Nassau, Ltd.

92. Ruhlmann. Coffee table.
Mahogany with ivory inlay.
1925. 17 × 31¼.
Exh: Ruhlmann Pavilion, *Paris Exposition*, 1925.
Courtesy of Lillian Nassau, Ltd.

93. Ruhlmann. Sideboard.
Burled walnut with black marble top, bronze medallion.
1925. 41½ × 80 × 24½.
Exh: *Paris Exposition*, 1925.
Courtesy of Lillian Nassau, Ltd.

94. Ruhlmann. Sideboard.
Ebony macassar with silvered bronze.
1925. 42¾ × 73 × 23¼.
Courtesy of Lillian Nassau, Ltd.

95. Ruhlmann. Mirror.
Silvered bronze and glass.
1925. 18¼ × 16 × 9¼.
Courtesy of Lillian Nassau, Ltd.

96. Ruhlmann. Sideboard.
Ebony macassar with tassel.
1925. 35½ × 41 × 16.
Courtesy of Lillian Nassau, Ltd.

97. Ruhlmann. Round-topped table.
Burled walnut.
25½ × 19½.
Coll. Mr and Mrs Peter M. Brant.

98. Ruhlmann. Chair.
Acacia wood, upholstered in mushroom pink corduroy velvet.
c.1925.
Chairs of this kind were used in Yardley's London showrooms.
Exh: *Paris Exposition*, 1925.
Illus: *Art et Décoration*, vol.xlviii, 1925, p.19; and Léon Moussinac, *Le Meuble Français Moderne*, Paris, 1925, Pl.37.
Lent by Victoria and Albert Museum.

99. Ruhlmann. Table and chair.
Courtesy of Sonnabend Gallery.

100. Ruhlmann. Bed.
Loup d'orme wood.
c.1930.
Courtesy of M. Alain Lesieutre.

101. Ruhlmann. Low round table.
Macassar wood with ivory fittings.
c.1925. 20 × 31.
Courtesy of M. Alain Lesieutre.

102. Ruhlmann. Two chairs.
Forme gondole. Upholstered in brown leather.
c.1925. 35 × 20 × 17.
Courtesy of M. Alain Lesieutre.

103. Ruhlmann. Linen chest.
Amboyna with circular keyhole surrounds in ivory, ivory feet, and scroll trim running up the front corners.
c.1925.
Courtesy of M. Alain Lesieutre.

104. ELIEL SAARINEN (1873–1950).
Dining-room extension table.
Round with wood inlay.
c.1928. 30½ × 53.
Lent by Art Galleries, Cranbrook Academy of Art.

105. Saarinen. Armless chairs.
Backs flaring upward, with vertical strips of black wood.
c.1928. 37¾ × 17 × 17.
Lent by Art Galleries, Cranbrook Academy of Art.

106. Saarinen. Coffee table.
Square with geometric design in wood inlay.
c.1927. 21 × 28 × 28.
Lent by Art Galleries, Cranbrook Academy of Art.

107. Saarinen. Two-door vertical cabinet.
Geometric design in wood inlay.
c.1928. 60 × 37 × 17½.
Lent by Art Galleries, Cranbrook Academy of Art.

108. Saarinen. Two-door horizontal cabinet on legs.
Geometric design in wood inlay.
c.1928. 39½ × 59 × 14⅝.
Lent by Art Galleries, Cranbrook Academy of Art.

109. Saarinen. Two sofa ends.
Geometric design in wood inlay.
c.1928. 22 × 30 × 8.
Lent by Art Galleries, Cranbrook Academy of Art.

110. Saarinen. Chair.
Three-sided with geometric design in wood inlay, upholstered with arms and back slightly flared.
c.1928. 31 × 21½ × 24¾.
Lent by Art Galleries, Cranbrook Academy of Art.

110a. SOUBRIEZ. Cabinet.
65 × 37¼ × 15.
Courtesy of Sonnabend Gallery.

111. SUË ET MARE. (LOUIS SUE, 1875– , and **ANDRÉ MARE,** 1887–1932). Commode.
Veneer of amboyna on oak, carved rosewood; the four handles, in bronze *ciselé* and *doré*, consist of medallions by Pierre Poisson after Paul Vera, symbolizing the Four Seasons. c.1921. 35 × 49½ × 57½.
Exh: *Les Années '25'*, Paris, 1966, cat.no.662.
Illus: R. Koechlin, 'Les Premiers Efforts de Rénovation (1885–1914)', Exposition des Arts Décoratifs, 1925, *Gazette des Beaux-Arts*, p.263; and *Meubles et Décors*, No.820, November 1966, p.68.
Lent by Musée des Arts Décoratifs.

112. Suë et Mare. Desk and chair.
Ebony, ormolu and pigskin.
c.1925.
Desk; 30¼ × 61⅞ × 32½.
Chair; 34½ × 24 × 19.
Lent by Metropolitan Museum of Art, Purchase, 1925, Edward C. Moore Jr Gift Fund.

113. KEM WEBER. Airline chair.
1934–5.
Designed for Airline Chair Co., Los Angeles.
Coll. Mrs Kem Weber.

114. Weber. Design for plywood furniture for Berkey and Gay, Grand Rapids, Mich. Mixed media. 1936.
Lent by Art Galleries, University of California, Santa Barbara.

115. Weber. Project for dressing-table.
Drawing.
1930.
Lent by the Art Galleries, University of California, Santa Barbara.

116. FRANK LLOYD WRIGHT (1867–1959). Chair.
Octagonal seat and hexagonal back.
Designed for the Imperial Hotel, Tokyo.
Oak with yellow leather octagonal seat and hexagonal back.
c.1922. 37½ × 15¼ × 19.
Coll. Wilma Keyes.

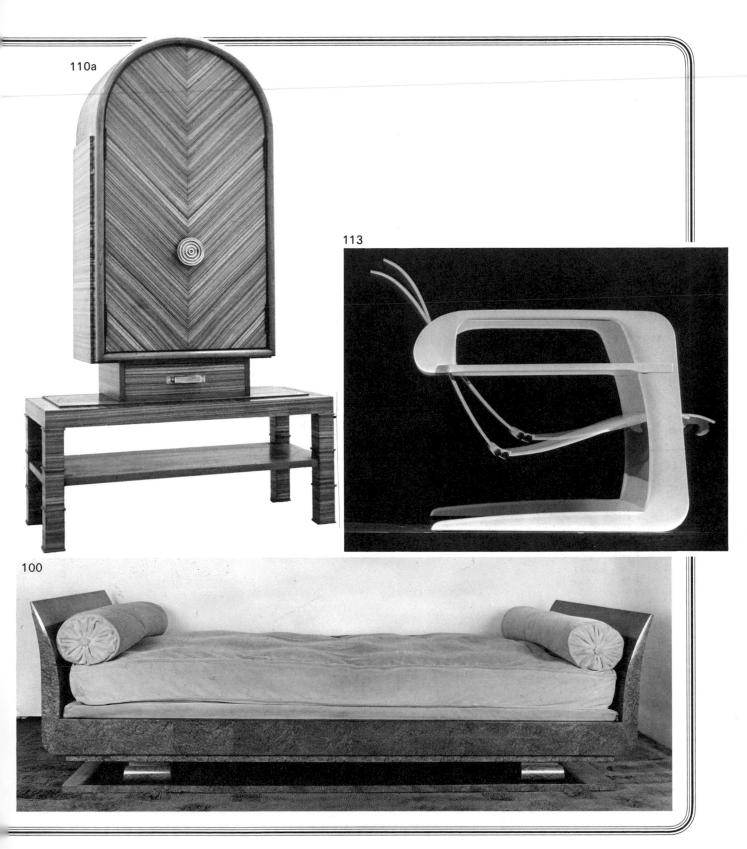

110a

113

100

Silver

117. ANONYMOUS. Tazza.
Imported into England, 1927. Probably
made in France. Green-stained ivory stem.
$2\frac{5}{8} \times 6\frac{3}{16}$.
Anonymous loan.

118. ANON. Fluted casket.
Green plastic handles.
Made in Austria before April 22, 1922.
$5\frac{1}{8} \times 8 \times 4\frac{1}{2}$.
Anonymous loan.

**119. ADIE BROS., Birmingham,
England.** Tea-set.
Designed by Harold Stabler, R.D.I. for
Adie Bros. Though this set is silver, the same
model was also made in electro-plate, with a
brown plastic tray.
Teapot: $3\frac{3}{4} \times 7\frac{7}{8}$.
Jug: $2\frac{3}{4} \times 4\frac{1}{2} \times 2\frac{1}{8}$.
Sugar bowl: $2 \times 2\frac{3}{4} \times 2\frac{1}{8}$.
1936.
Anonymous loan.

120. BOIN-TABURET. Covered dish.
Circular with raised bands at edge, cover
surmounted by a knob of floral motif.
$3\frac{1}{4} \times 4\frac{3}{4}$.
Exh: *Paris Exposition*, 1925.
Lent by Art Galleries, Cranbrook Academy
of Art.

120a. Boin-Taburet. Bowl.
$4\frac{5}{8} \times 15\frac{1}{4}$.
Lent by Art Galleries, Cranbrook Academy
of Art.

121. CHARLES BOYTON. Four-piece
tea-service.
Square form, bearing monogram 'H.W.'.
Coll. Mr and Mrs Lewis V. Winter.

122. Boyton. Tea *equipage*: Tray, teapot,
cream-jug and sugar-bowl.
With ivory handles.
Tray: 10. London, 1939.
Teapot: $5 \times 4\frac{1}{4}$. London, 1937.
Jug: $3\frac{1}{8} \times 2\frac{1}{2}$. London, 1937.
Sugar-bowl: 3×3. London, 1937.
Anonymous loan.

123. Boyton. Cup on stem.
London, 1932. $7\frac{7}{8} \times 3\frac{1}{4}$.
Anonymous loan.

124. L'ORFÈVRERIE CHRISTOFLE
(founded 1839). Vase.
Ovoid with two rows moulded at the top,
decorated with green color on a roughened
surface, leaving the silver in patterns, two
rows of vertical rectangles around the top.
10×6.
Exh: *Third International Exhibition of
Contemporary Industrial Arts*, 1930.
Lent by Art Galleries, Cranbrook Academy
of Art.

125. L'Orfèvrerie Christofle. Flatware.
Double rectangle design on handle.
c.1930. L: $6\frac{3}{4}$.
Courtesy of Sonnabend Gallery.

126. L'Orfèvrerie Christofle.
Water pitcher.
Chevron decoration, modelled by Sue.
c.1910–20. $7\frac{1}{8} \times 7\frac{7}{8} \times 4$.
Lent by Musée Christofle.

127. L'Orfèvrerie Christofle. Goblet.
Chevron decoration, modelled by Sue.
c.1910–20. $3\frac{1}{8} \times 3$.
Lent by Musée Christofle.

128. L'Orfèvrerie Christofle. Teapot.
Fluted sides, modelled by Cazès.
1925. $7\frac{1}{8} \times 9\frac{1}{4} \times 5\frac{1}{8}$.
Lent by Musée Christofle.

129. L'Orfèvrerie Christofle. Milk-jug.
Fluted sides, modelled by Cazès.
1925. $4\frac{3}{4} \times 5\frac{1}{8} \times 3$.
Lent by Musée Christofle.

130. L'Orfèvrerie Christofle. *Drageoir*.
In the form of a cubist-style squirrel,
modelled by Sue.
c.1910–20. $7\frac{1}{4} \times 7\frac{1}{8} \times 4\frac{1}{2}$.
Lent by Musée Christofle.

131. L'Orfèvrerie Christofle.
Automobile ash-tray, modelled by Sue.
1910. $\frac{3}{8} \times 3\frac{7}{8} \times 2$.
Lent by Musée Christofle.

132. L'Orfèvrerie Christofle.
Round vegetable dish with cover.
Handle in the forms of a green hardstone
ring, modelled by Fjerdingstad.
1925. $5\frac{1}{2} \times 11\frac{3}{8}$.
Lent by Musée Christofle.

133. L'Orfèvrerie Christofle.
Octagonal fruit-cup.
Modelled by Fjerdingstad.
c.1920–5. $3\frac{3}{8} \times 8\frac{1}{8}$.
Lent by Musée Christofle.

134. L'Orfèvrerie Christofle. Sauce-boat
in form of a swan with spoon, modelled by
Fjerdingstad.
c.1920–5. $2\frac{3}{8} \times 7\frac{7}{8}$.
Lent by Musée Christofle.

135. L'Orfèvrerie Christofle.
Surtout de table for vegetables.
Modelled by Fjerdingstad.
c.1920–5. $5\frac{7}{8} \times 1\frac{3}{8} \times 7\frac{1}{8}$.
Lent by Musée Christofle.

130

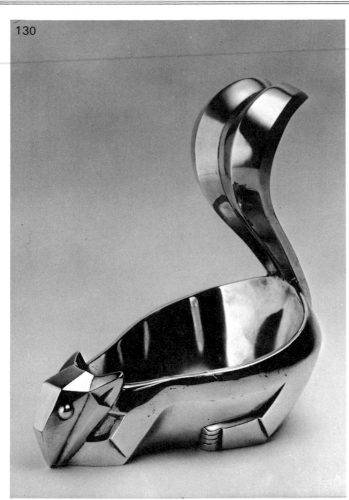

118

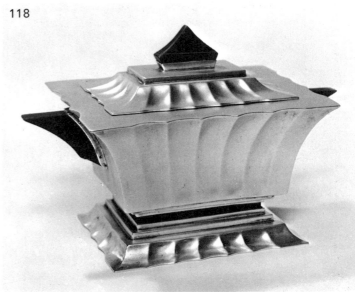

134

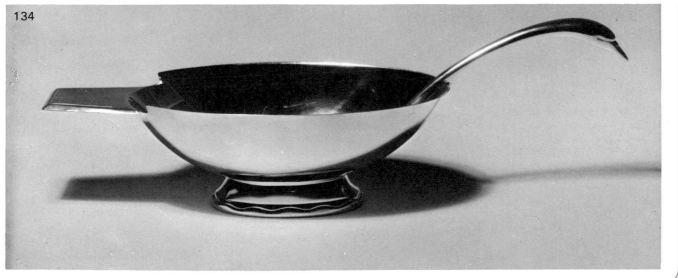

136. L'Orfèvrerie Christofle.
Decagonal box.
Oxydized. Executed for the Paris
Exposition, 1925.
$7\frac{1}{2} \times 4\frac{3}{4}$.
Lent by Musée Christofle.

137. L'Orfèvrerie Christofle.
Fork and spoon.
Modelled by Fjerdingstad.
c.1920–5. Fork L: $9\frac{1}{4}$. Spoon L: $9\frac{1}{4}$.
Lent by Musée Christofle.

138. L'Orfèvrerie Christofle.
Oxydized vase.
Geometric motifs, modelled by Lanel.
1925. $10\frac{5}{8} \times 6\frac{3}{4}$.
Lent by Musée Christofle.

139. L'Orfèvrerie Christofle.
Champagne-bucket.
Modelled by Lanel for the *Normandie*.
1935. $8\frac{1}{4} \times 9\frac{1}{4}$.
Lent by Musée Christofle.

140. L'Orfèvrerie Christofle. Ice-bucket.
Modelled by Luc Lanel for the *Normandie*.
1935. $5\frac{3}{8} \times 4\frac{7}{8}$.
Lent by Musée Christofle.

141. L'Orfèvrerie Christofle.
Vegetable-dish.
Modelled by Luc Lanel for the *Normandie*.
1935. $3\frac{3}{4} \times 8\frac{1}{2} \times 11\frac{3}{8}$.
Lent by Musée Christofle.

142. L'Orfèvrerie Christofle.
Spherical salt-cellar.
Modelled by Luc Lanel for the *Normandie*.
1935. D.$2\frac{3}{4}$.
Lent by Musée Christofle.

143. L'Orfèvrerie Christofle.
Couvert Boréal.
Three pieces.
1925. Table-knife, L.$9\frac{5}{8}$. Table-spoon, L.$8\frac{1}{8}$.
Table-fork, L.$8\frac{1}{8}$.
Lent by Musée Christofle.

144. L'Orfèvrerie Christofle.
Couvert Commodore.
Three pieces.
Table-knife, L.$9\frac{1}{2}$. Table-spoon, L.$8\frac{1}{8}$.
Table-fork, L.$8\frac{1}{8}$.
Lent by Musée Christofle.

145. L'Orfèvrerie Christofle.
Two *Commodore* dishes.
1925–30. $10\frac{1}{4} \times 1$.
Lent by Musée Christofle.

Opposite:Cat.nos.84 and 85.
Overleaf: Cat.no.44.

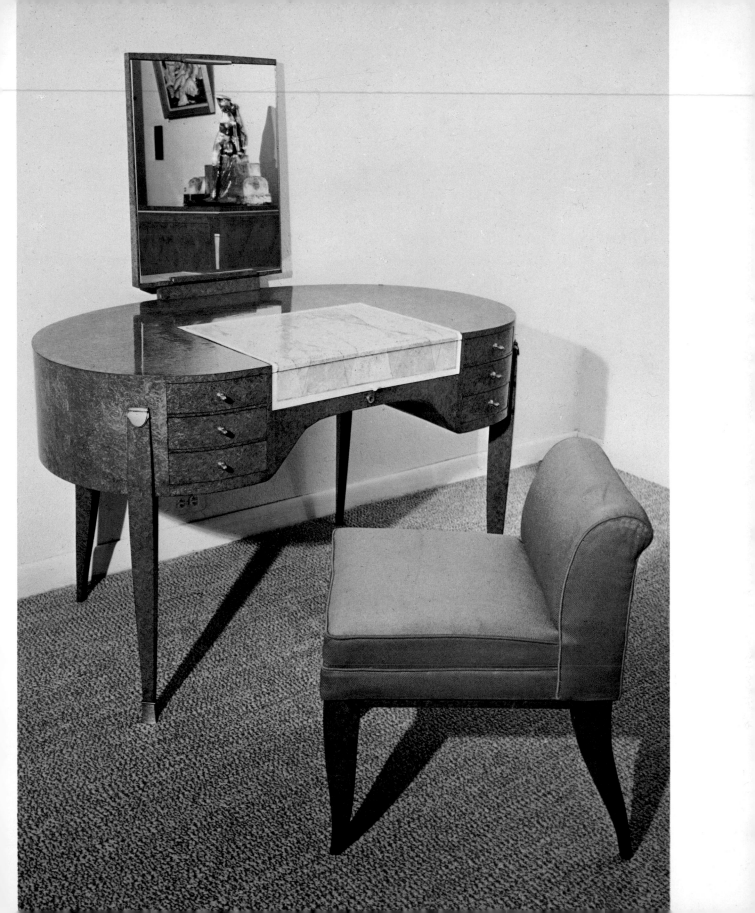

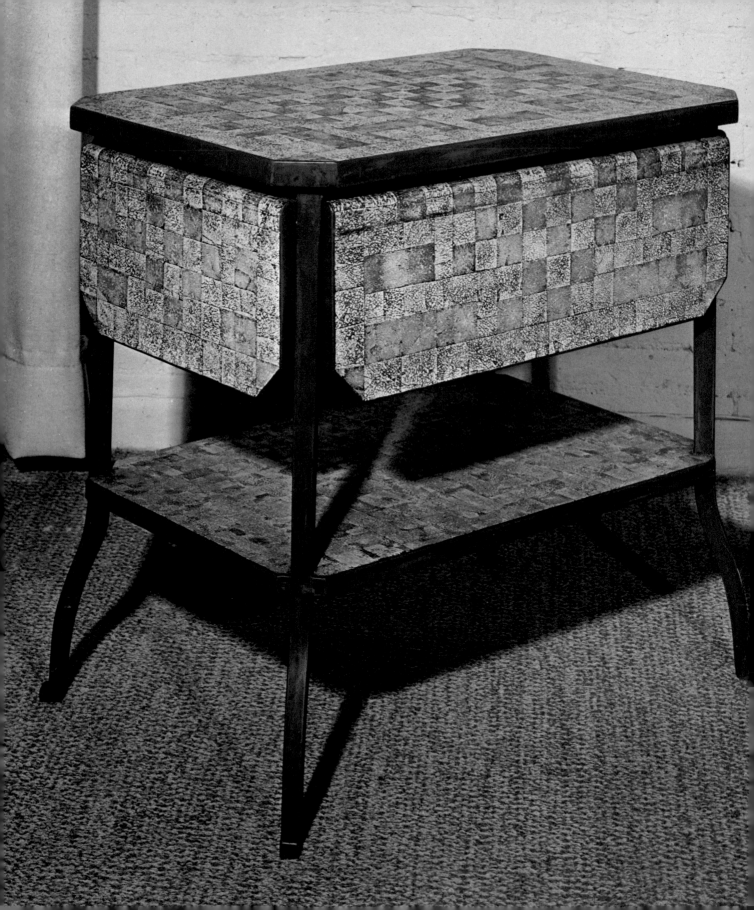

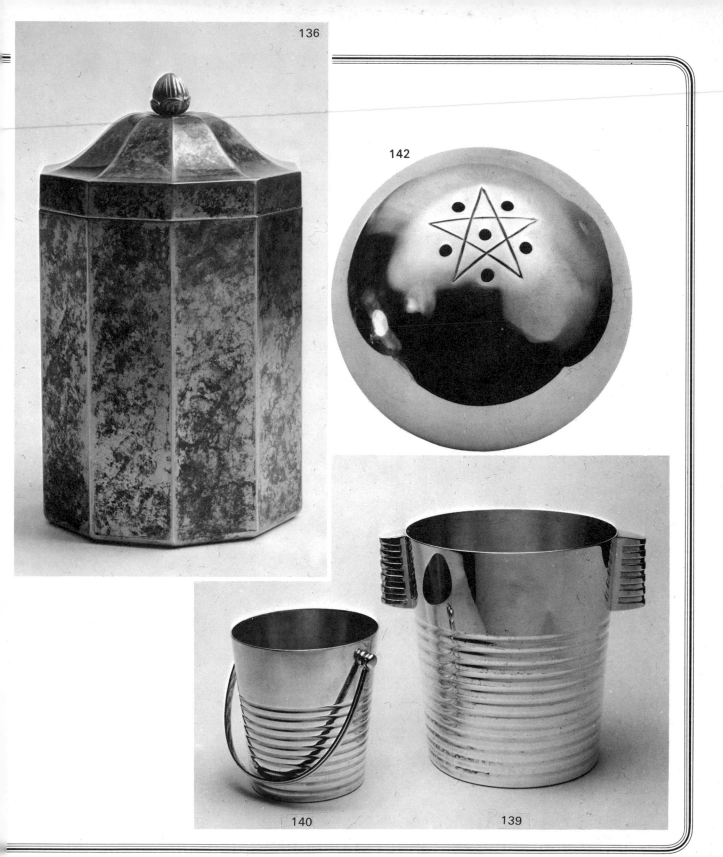

136

142

140

139

146. L'Orfèvrerie Christofle.
Chalice and paten.
Gilded.
c.1920–5. $6\frac{3}{4} \times 6\frac{3}{4}$.
Lent by Musée Christofle.

147. L'Orfèvrerie Christofle. Vase.
Executed by Christofle for the Paris
Exposition, 1925.
$11\frac{3}{4} \times 3\frac{3}{4}$.
Lent by Musée Christofle.

148. L'Orfèvrerie Christofle.
Three-light candelabra.
1920. $15\frac{3}{4} \times 9\frac{5}{8} \times 6\frac{1}{4}$.
Lent by Musée Christofle.

148a. JEAN DESPRÈS. Flatware.
Double rectangle design on handle.
c.1930. L: $6\frac{3}{4}$.
Courtesy of Sonnabend Gallery.

149. CHRISTOPHER DRESSER.
Art nouveau tea-set.
Made by Elkington and Co., Birmingham,
England. The original designs for this set are
in the Print Room of the Victoria and Albert
Museum, London.
Teapot: Regd. design no.22864. Model
no. 16676. F. Elkington hallmark 1884.
Ivory handle.
$4\frac{1}{2} \times 8\frac{1}{4} \times 5$.
Sugar-bowl: Regd. design no.22864.
Model no.16676. Elkington hallmark 1884.
$3\frac{3}{8} \times 6\frac{1}{4} \times 4\frac{1}{4}$.
Cream-jug: Regd. design no.22864.
Model no.16676. Elkington hallmark 1884.
$2\frac{3}{4} \times 4\frac{5}{8} \times 3\frac{1}{2}$.
Ewer: Regd. design no.22872. Model
no.17558. Birmingham hallmark 1885.
$9\frac{3}{4} \times 5$.
Anonymous loan.

150. Dresser. Teapot.
Designed 1879 for J. D. Dickson & Son.
$5\frac{1}{4} \times 8\frac{1}{2}$.
Anonymous loan.

151. KAY FISHER (1893–).
Tobacco-box.
Octagonal, composed of eight rows of
raised moulding and ten depressions
running horizontally. Flat top, surmounted
by a tall cylindrical knob of ebony.
1928. $5\frac{7}{8} \times 4$.
Exh: *Third International Exhibition of
Contemporary Industrial Arts*, 1930.
Lent by Art Galleries, Cranbrook Academy
of Art.

152. JEAN FOUQUET (1899–).
Tea-service.
Teapot: $4\frac{1}{4} \times 7$. Creamer: $2\frac{3}{4} \times 3\frac{3}{4}$.
Sugar-bowl: $3\frac{1}{4} \times 5$.
Coll. Mr Fred Hughes.

153. HANS HANSEN. Coffee-set.
Ivory decoration. 1934. Engraved 'S.1937'
when presented.
Coffee-pot: $6\frac{1}{2} \times 5\frac{1}{2} \times 4$.
Creamer: $1\frac{1}{2} \times 5\frac{1}{8} \times 3$.
Sugar-bowl: $1\frac{1}{2} \times 5\frac{1}{2} \times 3$.
Anonymous loan.

154. FRANTZ HINGELBERG.
Oval tea-set.
Each part hammered out of a single piece of
silver, with no edges inside except where the
spout is soldered. Designed by Svend
Weirauch for Hingelberg.
Made 1934; imported into England 1935.
Teapot: $4\frac{1}{4} \times 9\frac{1}{4} \times 4\frac{1}{2}$. Creamer: $2\frac{3}{8} \times 5 \times 2\frac{3}{8}$.
Sugar-bowl: $2\frac{1}{8} \times 6\frac{1}{2} \times 3$.
Anonymous loan.

155. BERNARD INSTONE. Spoons.
Enamel decoration. Birmingham hallmark
for 1928.
L: $5\frac{3}{4}$.
Coll. Mr John Cox.

156. GEORG JENSEN (1866–1935).
Candlestick.
Cylindrical on twelve-sided base, the lower
half divided into twelve panels with a
beaded band near the upper rim.
1931. $6 \times 3\frac{3}{4}$.
Lent by Art Galleries, Cranbrook Academy
of Art.

157. Jensen. Vase.
Model mark 521.
$6\frac{1}{4} \times 4\frac{1}{4}$.
Anonymous loan.

158. Jensen. Menu-holder.
Coll. Miss Marie Middleton.

159. Jensen. Caddy-spoon.
Coll. Miss Marie Middleton.

160. Jensen. Bangle.
Pierced foliate motifs.
Coll. Miss Marie Middleton.

161. Jensen. Six brooches.
Coll. Miss Marie Middleton.

162. Jensen. Pair of earrings.
Coll. Miss Marie Middleton.

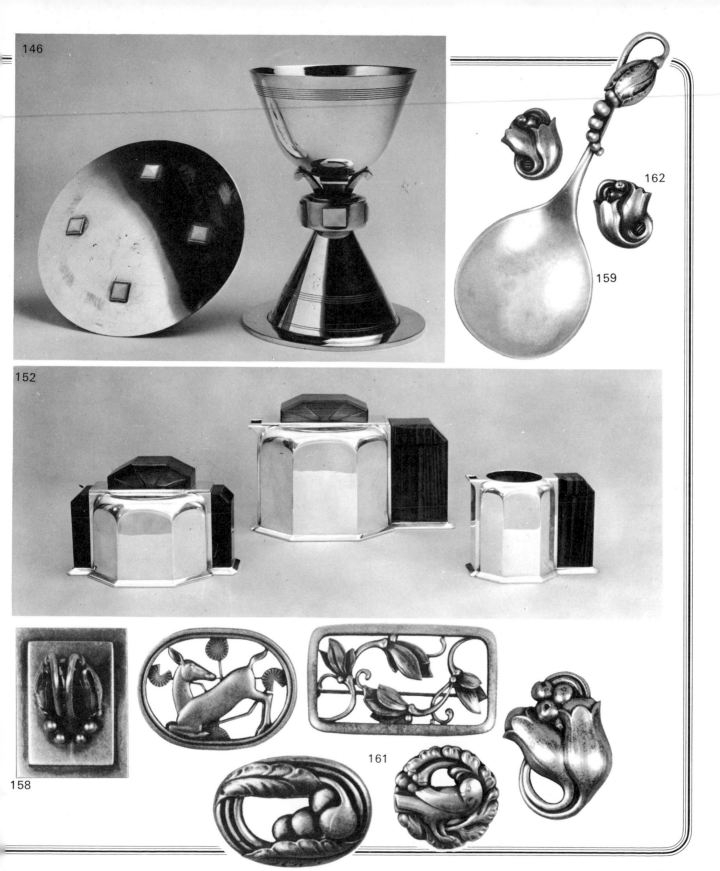

146

152

158 161

163. ARTHUR NEVILL KIRK. Tea-service.
Polygon with ebony knobs and handles.
1933. Teapot: $5\frac{3}{4} \times 5$. Creamer: $3\frac{3}{4} \times 3\frac{1}{8}$.
Sugar-bowl: $2\frac{7}{8} \times 3\frac{7}{8}$.
Lent by Art Galleries, Cranbrook Academy
of Art.

164. LAPARRA. Sugar-bowl.
Spherical body on low rim; curved top with
square ebony knob set in silver pieces
ornamented with parallel grooves; two
rectangular hanging pieces of ebony on each
handle; body decoration of enamel in tiers,
blue and black.
$4\frac{1}{16} \times 4\frac{1}{16}$.
Exh: *Third International Exhibition of
Contemporary Industrial Arts*, 1930.
Lent by Art Galleries, Cranbrook Academy
of Art.

165. LAURENT LLAURENSOU. Tray.
Octagonal shape with overlapping
concentric circles radiating from outer edges.
1929. Purchased from Edgar Brandt, 1934.
D: $13\frac{3}{4}$.
Lent by Art Galleries, Cranbrook Academy
of Art.

166. H. G. MURPHY (1884–1939).
Cigarette-box.
Decorated with circular ridges, grouped and
spaced evenly around the box.
Acorn-shaped knob on lid.
1930. $4 \times 2\frac{3}{4}$.
Lent by Art Galleries, Cranbrook Academy
of Art.

167. Murphy. Cylindrical box.
Lid set with amethysts and mother of pearl.
London, 1931. $4 \times 2\frac{5}{8}$.
Anonymous loan.

167a. ELFORD NEILSEN.
Fork and Spoon. Silver.
Cake fork: $5\frac{3}{4}$. Teaspoon: $5\frac{1}{4}$.
1929.
Coll. Mr and Mrs Lewis V. Winter.

168. DAGOBERT PECHE. Vase.
Fluted.
c.1920. $10\frac{1}{2} \times 4\frac{1}{2}$.
Anonymous loan.

169. JEAN PUIFORCAT (1897–1945).
Heavy silver platter.
Rectangular, with thick ivory handles.
$3\frac{1}{4} \times 20\frac{1}{2} \times 11$.
Courtesy of Puiforcat-Orfèvre.

170. Puiforcat. Coffee/tea-service.
Four pieces. Rosewood handles.
Coffee-pot: $7 \times 6\frac{1}{2} \times 3\frac{1}{2}$. Teapot: $4\frac{1}{4} \times 7\frac{1}{2} \times 4$.
Creamer: $3\frac{1}{2} \times 3\frac{3}{4} \times 2$.
Sugar-bowl: $3\frac{1}{4} \times 5 \times 3\frac{1}{4}$.
Courtesy of Puiforcat-Orfèvre.

171. Puiforcat. Circular vegetable-dish,
with cover.
Pale green-white jade handle in the form of a
ring. Incised lines on lid form a sunray
pattern. Incised bands in horizontal rings on
the base.
$5\frac{1}{2} \times 9\frac{1}{2}$.
Courtesy of Puiforcat-Orfèvre.

172. Puiforcat. *Bonbonnière.*
Round with truncated rectangular at side;
sphere of pale jade as top handle, and trim of
small silver balls.
$4\frac{1}{2} \times 5\frac{1}{4}$.
Courtesy of Puiforcat-Orfèvre.

173. Puiforcat. Soup-tureen.
Green aventurine handles and tray *en suite*.
Courtesy of Puiforcat-Orfèvre.

174. Puiforcat. Rectangular platter.
Large vermeil loop handles.
$5 \times 19\frac{3}{4} \times 10$.
Courtesy of Puiforcat-Orfèvre.

175. Puiforcat. Golfing cup.
Four ivory hemispheres at base.
c.1934. $6\frac{1}{8} \times 7\frac{3}{8}$.
Courtesy of Puiforcat-Orfèvre. Puiforcat's
original 1934 design is illustrated page 41.

176. Puiforcat. Fork and spoon.
Handles formed from a flattened oval
intersecting a flat bar.
L: 8.
Courtesy of Puiforcat-Orfèvre.

177. Puiforcat. Fish-slice.
Two half-oval slits and small beading at
base of handle.
L: $8\frac{3}{4}$. 'Bowl' of slice, W: $2\frac{1}{8}$.
Courtesy of Puiforcat-Orfèvre.

178. Puiforcat. Salad-spoon.
Part of a salad-service. Shallow teeth at end.
On the back of the handle, within a
flattened scroll, is a monogram designed by
Puiforcat, 'G.L.' in stylized characters.
$10\frac{1}{4}$. Bowl, W: $2\frac{3}{8}$.
Courtesy of Puiforcat-Orfèvre.

179. Puiforcat. Champagne-cooler.
Silver body and tray, one-piece with
removable ice-container.
c.1925. $9\frac{1}{4} \times 12\frac{1}{4}$.
Lent by The Metropolitan Museum of Art,
Purchase, 1925, Edward C. Moore Jr Gift
Fund.

180. Puiforcat. Bowl.
Silver and glass.
c.1930. $5\frac{3}{4} \times 8\frac{5}{8}$.
Lent by The Metropolitan Museum of Art,
Purchase, 1934, Edward C. Moore Jr Gift
Fund.

181. Puiforcat. Tureen.
Silver and gilt.
1937. $10 \times 11 \times 11$.
Literature: *Jean Puiforcat Orfèvrerie*,
Flammarion, 1951.
Coll. Mr and Mrs Peter M. Brant.

169

174

172

171

182. Puiforcat. Tea- and coffee-set.
1925. Coffee-maker: $13 \times 8\frac{1}{2}$.
Teapot: $4\frac{1}{4} \times 9$. Chocolate pot: $9 \times 8\frac{1}{2}$.
Coffee-pot: $6 \times 8\frac{1}{2}$. Sugar-bowl: $3\frac{1}{2} \times 6\frac{3}{4}$.
Slop-bowl: $2\frac{3}{4} \times 4\frac{1}{4}$.
Coll. Mr and Mrs Peter M. Brant.

183. Puiforcat. Tea- and coffee-set.
Silver and gilt.
1930. Teapot: $4\frac{3}{4} \times 7 \times 5$.
Coffee-pot: $5\frac{3}{4} \times 6\frac{1}{4} \times 4\frac{1}{2}$.
Creamer: $3\frac{3}{4} \times 4 \times 2\frac{5}{8}$.
Sugar-bowl: $3\frac{1}{2} \times 4\frac{1}{4} \times 4\frac{1}{4}$.
Coll. Mr and Mrs Peter M. Brant.

184. Puiforcat. Tea- and coffee-set.
Silver and ebony.
1937. Teapot: $4\frac{1}{2} \times 8\frac{3}{4} \times 5$.
Coffee-pot: $5\frac{1}{2} \times 8\frac{1}{2} \times 4\frac{3}{4}$.
Creamer: $3\frac{1}{2} \times 5 \times 2\frac{3}{4}$.
Sugar-bowl: $3\frac{1}{4} \times 5\frac{1}{2} \times 4$.
Literature: *Jean Puiforcat-Orfèvrerie*,
Flammarion, 1951; *Golden Gate
International Exhibition,* 1939.
Coll. Mr and Mrs Peter M. Brant.

185. Puiforcat. Mustard-pot.
Silver and lapis lazuli.
1925. $3 \times 3 \times 2\frac{1}{4}$.
Coll. Mr and Mrs Peter M. Brant.

186. Puiforcat. Sugar-shaker.
1925. $4 \times 3\frac{1}{3} \times 3\frac{1}{2}$.
Coll. Mr and Mrs Peter M. Brant.

187. Puiforcat. Candy-dish.
Silver and crystal.
1925. $4 \times 8 \times 8$.
Coll. Mr and Mrs Peter M. Brant.

188. Puiforcat. Candy-dish.
Silver and ivory.
1925. $4 \times 8\frac{1}{2} \times 8$.
Coll. Mr and Mrs Peter M. Brant.

189. Puiforcat. Candy-dish.
Silver and ebony.
1930. $4 \times 8 \times 8$.
Coll. Mr and Mrs Peter M. Brant.

190. Puiforcat. *Petite Bonbonnière.*
Silver and ivory.
1925. $3 \times 5\frac{1}{4} \times 5$.
Coll. Mr and Mrs Peter M. Brant.

191. Puiforcat. Vase.
Silver with liner.
1937. $13\frac{1}{4} \times 9 \times 9$.
Literature: *Jean Puiforcat-Orfèvrerie*,
Flammarion, 1951.
Coll. Mr and Mrs Peter M. Brant.

192. Puiforcat. Vase.
Silver and crystal.
1925. $5\frac{1}{4} \times 8\frac{3}{4} \times 8\frac{3}{4}$.
Coll. Mr and Mrs Peter M. Brant.

193. Puiforcat. Pin-box.
Silver, vermeil, crystal and ivory.
1937. $3 \times 3 \times 3$.
Coll. Mr and Mrs Peter M. Brant.

194. Puiforcat. Samovar.
Mahogany fittings.
c.1930. $8\frac{1}{2} \times 8\frac{1}{4}$.
Coll. Mr Fred Hughes.

195. Puiforcat. Brush and mirror set.
Circular pattern on reverse.
c.1930. Mirror: $8\frac{1}{2} \times 4\frac{3}{4}$. Brush: $7 \times 2\frac{1}{4}$.
Brush: $7\frac{1}{4} \times 4$. Brush: $6\frac{1}{2} \times 1\frac{3}{4}$.
Coll. Mr Fred Hughes.

196. Puiforcat. Coffee pot.
Silver with ivory fittings.
c.1930. 7×8.
Golden Gate International Exhibition, 1939.
Coll. Mr Fred Hughes.

197. Puiforcat. Baby brush-set, in box.
c. 1930. $5\frac{1}{2} \times 2\frac{1}{4}$.
Coll. Mr Fred Hughes.

198. Puiforcat. Flatware.
Created for the Maharajah of Indore.
1930. Salad-fork L: $8\frac{1}{2}$. Butter-knife L: $6\frac{1}{3}$.
Demitasse spoon L: 5. Seafood-fork L: 5.
Salad-server L: $11\frac{3}{4}$. Cake-server L: 9.
Coll. Mr and Mrs Lewis V. Winter.

199. Puiforcat. Flatware.
Created for the Maharajah of Indore.
1930. Dinner-knife L: $9\frac{1}{4}$. Fork L: $8\frac{1}{4}$.
Fish-knife L: 8. Soup-spoon L: 7.
Demitasse spoon L: $4\frac{1}{4}$. Oyster-fork L: 5.
Coll. Mr Fred Hughes.

200. Puiforcat. Fork and table-spoon with
six-sided flat handles; knife with ivory
handle.
1925. Fork L: 8. Table-spoon L: 8.
Knife L: $8\frac{3}{4}$.
Exh: *Paris Exposition,* 1925.
Les Années '25', Paris, 1966.
Lent by Musée des Arts Décoratifs.

177

178

202

201. Puiforcat. Tea- and coffee-service
with ivory fittings.
c.1930. Tray D: 22. Teapot: $3\frac{1}{2} \times 9 \times 5\frac{1}{2}$.
Coffee-pot: $5\frac{3}{4} \times 8\frac{1}{4} \times 5$.
Creamer: $2\frac{3}{4} \times 3\frac{3}{8} \times 2\frac{5}{8}$.
Covered sugar-basin: $3\frac{1}{4} \times 6\frac{3}{8} \times 4\frac{1}{4}$.
Samovar: $10\frac{1}{2} \times 8\frac{3}{4} \times 6\frac{1}{4}$.
Anonymous loan.

202. Puiforcat. Tea-service.
With rosewood handles.
c.1930. Teapot: $5\frac{1}{4} \times 8\frac{3}{4} \times 3\frac{7}{8}$.
Creamer: $3 \times 5 \times 2$.
Sugar-bowl, with cover: $3\frac{5}{8} \times 4\frac{3}{4} \times 3\frac{1}{4}$.
Slop-bowl: $2\frac{3}{4} \times 4\frac{3}{4} \times 3\frac{1}{4}$.
Illus: Hillier, *Art Deco*, 1968, p.117.
Anonymous loan.

203. Puiforcat. Flatware.
Silver with rosewood handles.
1925. Spoon: $5\frac{1}{2}$. Pusher: $5\frac{1}{2}$.
Spoon-cum-fork: $5\frac{1}{2}$. Knife: $6\frac{3}{4}$.
Anonymous loan.

204. WALDEMAR RAEMISCH
(1888-1955). Candelabrum.
$20\frac{1}{2} \times 21$.
Lent by Art Galleries, Cranbrook Academy
of Art, Gift of Mrs Ruth Raemisch.

205. OMAR RAMSDEN (1873-1939).
Vase.
Eight sides ornamented with diamond-
shaped facets; spreading foot slightly flared
at top.
$9 \times 3\frac{7}{8}$.
Lent by Art Galleries, Cranbrook Academy
of Art.

206. ELIEL SAARINEN (1873-1950).
Bowl.
Six sections, the center forming a swirl.
1935. $3\frac{1}{4} \times 13$.
Lent by Art Galleries, Cranbrook Academy
of Art.

207. Saarinen. Compote.
Flaring bowl mounted on short, vertically
ridged column.
1935. $4\frac{3}{4} \times 9\frac{7}{8}$.
Lent by Art Galleries, Cranbrook Academy
of Art.

208. Saarinen. Compote.
Flat bowl mounted on tall, vertically
fluted column, with flat foot.
1935. $9\frac{3}{4} \times 7\frac{7}{8}$.
Lent by Art Galleries, Cranbrook Academy
of Art.

209. Saarinen. Vase.
Small sphere mounted on a hollow,
vertically ridged column.
1935. $8\frac{1}{2} \times 3\frac{3}{4}$.
Lent by Art Galleries, Cranbrook Academy
of Art.

210. Saarinen. Urn and tray.
1935. 22×18.
Lent by Art Galleries, Cranbrook Academy
of Art.

211. Saarinen. Compote.
With hammered silver bowl.
Executed by Charles R. Price, 1933.
$8\frac{5}{16} \times 6\frac{3}{4}$.
Lent by Art Galleries, Cranbrook Academy
of Art.

212. Saarinen. Cigarette-box.
Rectangular hammered design with figure
blowing bubbles.
Executed by Arthur Nevill Kirk, 1933.
$5\frac{1}{2} \times 3\frac{5}{8} \times 4\frac{1}{2}$.
Lent by Art Galleries, Cranbrook Academy
of Art.

213. Saarinen. Candy-box.
Twelve-sided in hammered silver,
surmounted by a tall stem with a bird.
Executed by Arthur Nevill Kirk, 1933.
$7 \times 3\frac{3}{4}$.
Lent by Art Galleries, Cranbrook Academy
of Art.

214. SIDNEY JAMES SPARROW.
Ewer.
Green-dyed wood handle.
London, 1936. 7×3.
Anonymous loan.

215. ARTHUR J. STONE (1847–1938).
Bowl.
Small low-rim base, flaring toward the top;
decoration of shaped panels formed by
indentations on the outside.
1930. $4\frac{1}{16} \times 6\frac{5}{8}$.
Lent by Art Galleries, Cranbrook Academy
of Art.

216. TETARD FRÈRES. Hairbrush, mirror
and comb. Silver plated.
Coll. Mr and Mrs Lewis V. Winter.

217. KEM WEBER. Bowl.
Silver.
1928.
Coll. Mrs Kem Weber.

218. Weber. Cocktail-shaker.
Silver. Designed for Friedman Silver Co.,
New York,
1928.
Coll. Mrs Kem Weber.

219. Weber. Vase.
Silver.
Coll. Mrs Kem Weber.

216

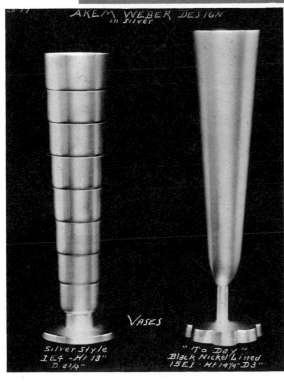

A KEM WEBER DESIGN
in silver

VASES

Silver Style
1 E 4 - Ht 13"
D 2 3/4"

"To Day"
Black Nickel Lined
15 E 1 - Ht 14 1/2" D 3"

219

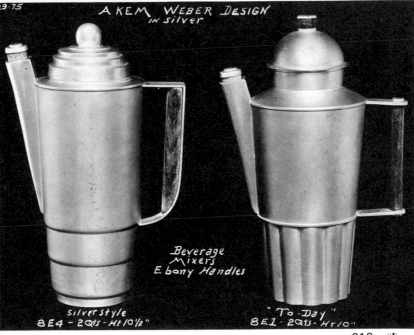

A KEM WEBER DESIGN
in silver

Beverage
Mixers
Ebony Handles

Silver Style
8 E 4 - 2 Qts - Ht 10 1/2"

"To Day"
8 E 1 - 2 Qts - Ht 10"

218

Stone/Wood Metal/Enamels

220. Pair of candlesticks. French.
Green malachite.
1930. $8 \times 3\frac{1}{4}$.
Courtesy of Lillian Nassau, Ltd.

221. Candelabra. Austrian.
Bronze.
c.1920. $19\frac{1}{2} \times 10$.
Coll. Mr Stanley Insler.

223. Pair of andirons.
Brass.
c.1939. $19 \times 6\frac{1}{2} \times 20\frac{1}{2}$.
Lent by the Cooper-Hewitt Museum of
Design, Smithsonian Institution.

224. Tray. Austrian.
Brass with geometrical design.
c.1920. $21\frac{1}{4} \times 14\frac{1}{2}$.
Coll. Mr Stanley Insler.

225. Tray.
Brass.
c.1930. $10\frac{1}{2} \times 10\frac{1}{2}$.
Coll. Mr Stanley Insler.

226. Three intertwined mermaids.
Chrome-plated bronze.
c.1930. $12\frac{1}{4} \times 26$.
Courtesy of Barry and Audrey Friedman,
Antiques.

227. *Leda and the Swan.*
$24 \times 5\frac{1}{2} \times 5$.
Coll. Mr Stanley Insler.

228. Panel. French.
Carved wood with two nude female figures.
Lent by Art Galleries, Cranbrook Academy
of Art.

229. *Printemps et Hiver.*
Door-plate. Gilded bronze.
1925. $17\frac{1}{2} \times 2\frac{3}{4}$.
Coll. Mr Stanley Insler.

230. Plaque.
Cast aluminum representing science.
c.1930. $20 \times 17\frac{1}{2}$.
Coll. Mr Stanley Insler.

231. Two chrome aeroplanes.
On wood plinths, with moveable perspex
propellers.
9×5.
Coll. Mr Adrian Emmerton.

232. Purse.
Cream and black enamel on chrome, in the
form of an elephant.
4×4.
Miss Marie Middleton.

233. Pair of salts.
Silver and black and yellow enamel, in the
form of fish.
Coll. Miss Marie Middleton.

234. Table-lighter.
Chrome and black plastic, in the form of a
miniature bar.
Coll. Mr and Mrs Lewis V. Winter.

235. Radio set.
Cased in green glass.
Coll. Mr and Mrs Lewis V. Winter.

235a. Radio set.
Blue mirror glass and chrome.
c.1935.
Lent by The Museum of Modern Art.

236. Smoker's companion.
Chrome and black plastic.
c. 1935. $29 \times 16 \times 8\frac{1}{2}$.
Anonymous loan.

237. Smoker's companion-cum-dumb-
waiter in the form of a metal figure of a
waiter.
Enamelled in black and white.
c.1930. $35 \times 11\frac{1}{2} \times 9\frac{1}{2}$.
Anonymous loan.

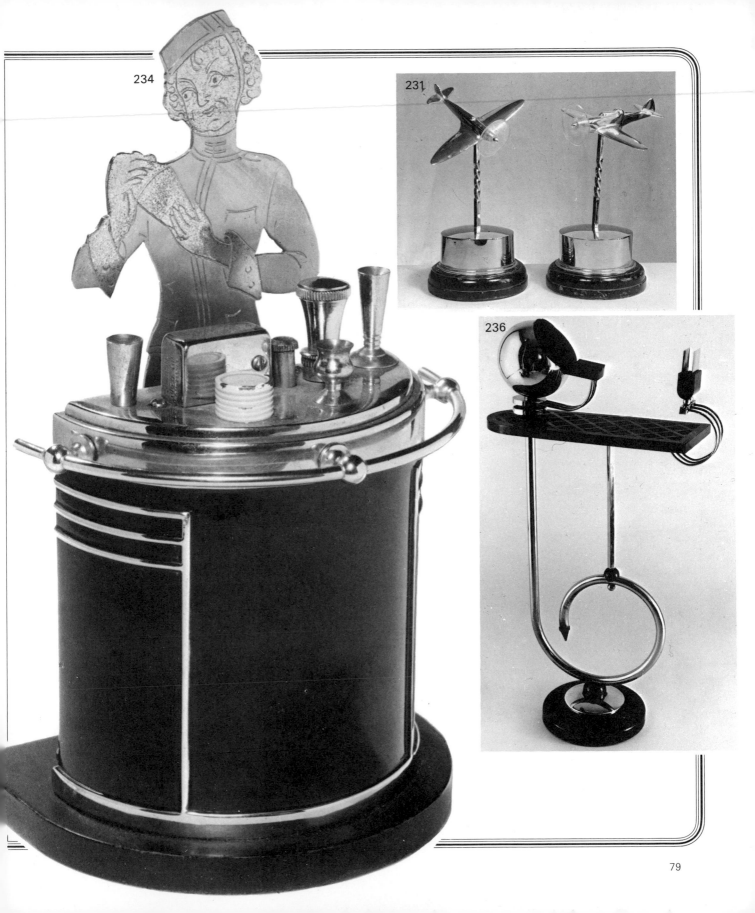

234

231

236

238. Two dark wood panels, with light
wood figures decorated with chrome.
c.1930. 81 × 35.
Coll. M. Félix Marcilhac.

239. Rectangular spirit-flask. English.
Chrome-plated, with swivelling corner as lid.
c.1930. $3 \times 2\frac{1}{4} \times \frac{3}{4}$.
Anonymous loan.

240. Circular wall boss.
Bronze with ornament in high relief.
Coll. Mr and Mrs Lewis V. Winter.

241. Oval wall-boss.
Bronze, figure of nude woman.
Coll. Mr and Mrs Lewis V. Winter.

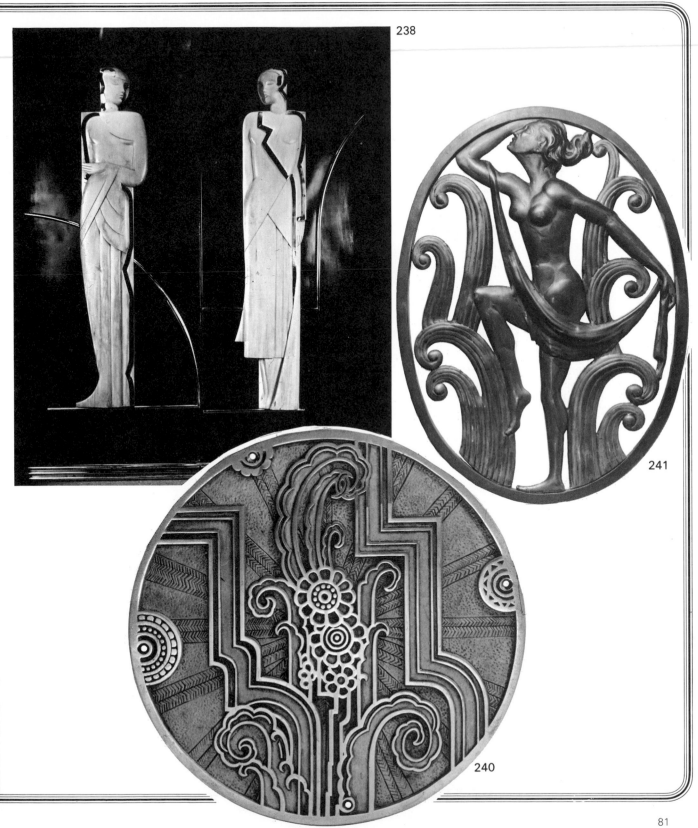

238

241

240

242. Tin racing-car.
Painted yellow with transfer prints of
rabbits.
$4 \times 12\frac{1}{2} \times 4\frac{1}{2}$.
Coll. Mr and Mrs Matthew Stein.

243. Tin aeroplane.
Painted blue and cream.
$7 \times 17 \times 21$.
Coll. Mr and Mrs Matthew Stein.

244. Two figures.
Painted bronze. Ivory faces and hands.
Coloured marble base (Chiparus/Preiss
type).
$21 \times 12 \times 6\frac{1}{2}$.
Coll. Dr K. C. P. Smith and Mr Paul Smith.

245. Two metal book-ends.
In the form of male sun-worshippers, metal
on alabaster bases.
$6 \times 4 \times 2\frac{1}{2}$.
Coll. Dr K. C. P. Smith and Mr Paul Smith.

246. Radio set.
In the form of a sailing-ship, with wooden
hull containing the valves and chrome sails
with wire rigging.
$17 \times 19 \times 4\frac{1}{2}$.
Anonymous loan.

247. L. ALLIOT. Nude woman with hoop.
Bronze figure on marble base.
H: $18\frac{1}{4}$.
Coll. Mr Adrian Emmerton.

247a. ASTANA. Pocket watch.
Case decorated with geometric pattern in
red and black enamel, with tassel.
1930. $1\frac{1}{2} \times 1\frac{3}{8}$.
Courtesy of Sonnabend Gallery.

248. LUCIEN BAZOR. Letter-opener.
Bronze.
1922. $10 \times 1\frac{3}{4}$.
Coll. Mr Stanley Insler.

249. A. BAZZONI. Woman in flight. Paris.
Bronze.
1937. 17×31.
Coll. Mr Stanley Landsman.

250. BECQUEREL. Radiator-cap.
Silvered bronze rabbit.
c.1925. $7\frac{1}{2} \times 1\frac{1}{2}$.
Courtesy of Lillian Nassau, Ltd.

251. F. BEHN. Figure of a monkey.
Bronze.
1925. $10 \times 5 \times 9$.
Coll. Mr Christian Rohlfing.

252. JOSEF BERNARD (1866–1931).
Sphinx Moderne.
Head in patinated bronze.
H: $12\frac{1}{2}$.
Courtesy of Galerie du Luxembourg.
Another version, in marble, is illustrated in
R. Cantinelli, *Josef Bernard*, Van Oest,
Brussels and Paris, 1928, Pl.18.

253. Bernard. *La Femme à la Toilette.*
Bronze with a connected base.
c.1925. $25\frac{1}{4} \times 8\frac{1}{2} \times 7$.
Lent by Art Galleries, Cranbrook Academy
of Art.

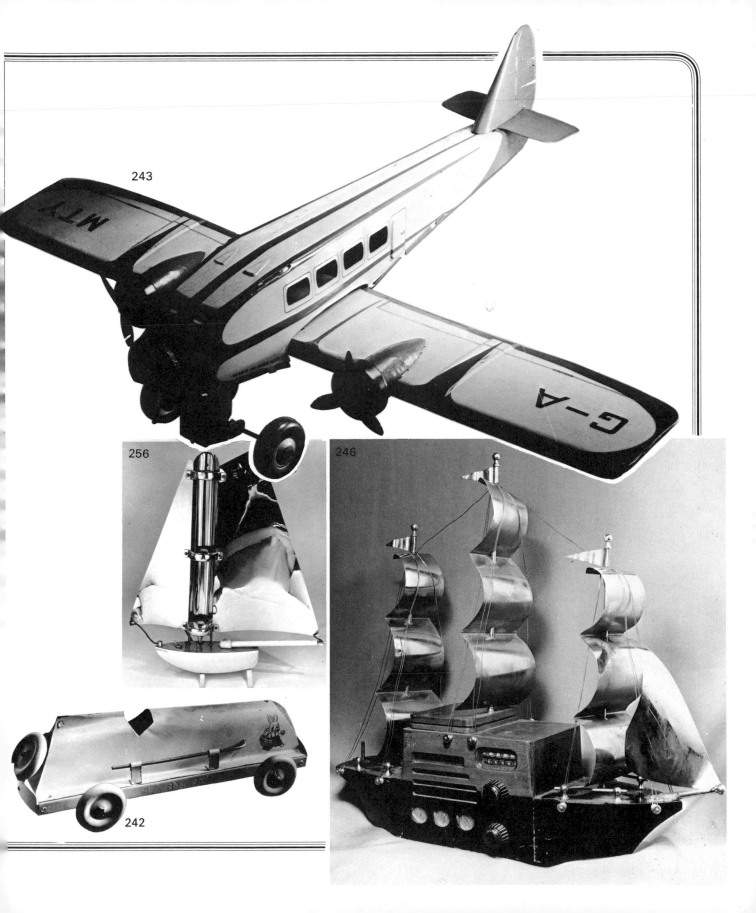

243

256

246

242

254. BOURAINE. *Penthesilea.*
Silvered bronze.
1931. 9 × 17 × 4.
Coll. Mr Stanley Insler.

255. EDGAR BRANDT (1880–1960).
Pair of large steel and plastic doors.
Courtesy of Sonnabend Gallery.

256. BUNTING ELECTRIC COMPANY.
Electric fire in the form of a sailing-ship.
Chrome sails and deck, cream enamelled
hull and mast. The sails are adjustable to
direct heat and reflect the filament.
Regd. design no.842176.
$30\frac{1}{2} \times 26 \times 4\frac{1}{2}$.
Anonymous loan.

257. CHAUVIN. *Un Prophète.*
Bois-de-cuba.
1927. $31 \times 6\frac{1}{2} \times 8$.
Coll. M. Félix Marcilhac.

258. D. H. CHIPARUS. Dancing figures.
Ivory and bronze on marble base.
c.1930. 24 × 22.
Courtesy of Barry and Audrey Friedman,
Antiques.

259. Chiparus. Bronze and ivory figure.
H: $21\frac{3}{4}$.
Coll. Mr Stanley Landsman.

260. Chiparus. Female dancer in *Ballet
Russe* costume.
Bronze and ivory figure on rouge marble
base.
20 × 24 × 6.
Courtesy of Martins-Forrest Antiques.

261. Chiparus. *Cat-woman.*
Bronze and ivory figure on rouge marble
base inset with black marble and onyx.
$29\frac{1}{2} \times 9 \times 4\frac{1}{2}$.
Courtesy of Martins-Forrest Antiques.

262. CREVEL. Vase.
Sarlandie enamel on copper, cylindrically
shaped with silver base and silver trim, clear
enamel with vertical lines in white and small
rectangles in black edged with cobalt blue.
$3\frac{3}{4} \times 4\frac{1}{8}$.
Exh: *Third International Exhibition of
Contemporary Industrial Arts,* 1930.
Lent by Art Galleries, Cranbrook Academy
of Art.

Opposite: Cat.nos. 201 (above); 694 and 695 (below).
Overleaf: Cat.nos. 284–9.

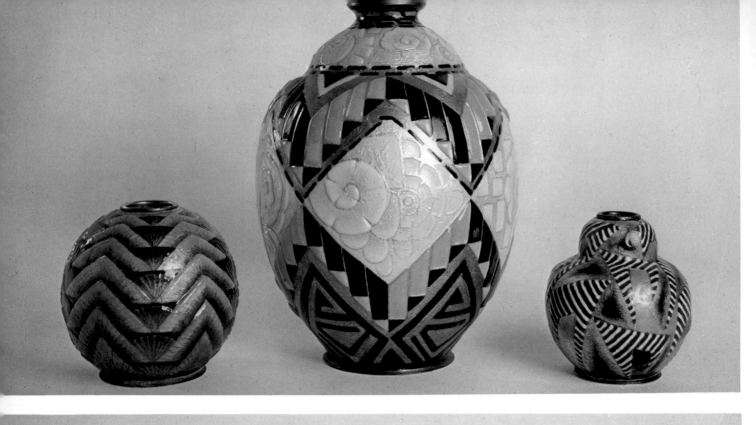

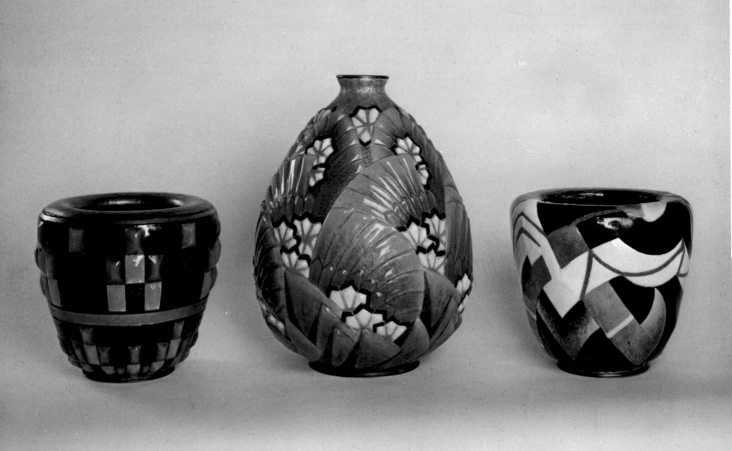

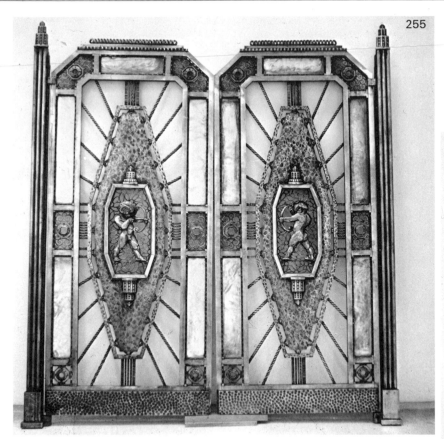

255

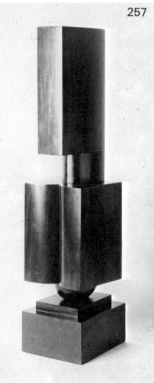

257

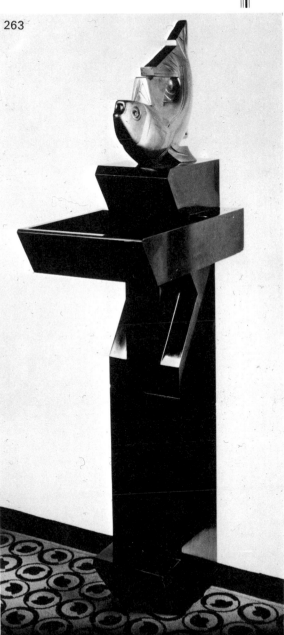

263

263. JOSEF CSAKY (1888–).
Fish on plinth.
Fountain in bronze.
1927. 65 × 15 × 23.
Coll. M. Félix Marcilhac.

264. Csaky. Negro.
Bronze.
$8\frac{1}{2} \times 2 \times 3\frac{1}{2}$.
Coll. M. Félix Marcilhac.

265. Csaky. Eagle.
Bronze on white marble plinth.
1924. $7\frac{1}{2} \times 8 \times 2\frac{1}{2}$.
Coll. M. Félix Marcilhac.

266. Csaky. Cubist head.
Stone.
1913. $22 \times 12\frac{1}{2} \times 5\frac{1}{2}$.
Coll. M. Félix Marcilhac. Bronze versions
of this head exist in the Musée d'Art
Moderne, Paris, the Musée d'Art et
d'Industrie, Saint-Etienne, France, and the
Kunsthalle, Hamburg.

267. Csaky. Couple.
Marble.
$22 \times 12\frac{1}{2} \times 5\frac{1}{2}$.
Coll. M. Félix Marcilhac.

268. ZUMEL D'ARTE. Indian on
horseback.
Bronze with onyx base.
1926. $8\frac{1}{2} \times 15\frac{1}{2} \times 2\frac{7}{8}$.
Courtesy of Lillian Nassau, Ltd.

269. DECOUX. Antelope.
Bronze with *vert antique* patina, on black
marble base. Figure and base both signed
by Decoux.
$6\frac{1}{4} \times 11\frac{1}{2}$.
Anonymous loan.

270. DESNY. Two cocktail-goblets.
Silver-plated.
$4\frac{3}{4} \times 3$.
Coll. Mr John Jesse.

271. PHILIPPE DEVRIEZ. *Dancer.*
Bronze with green patina. Signed on base.
$28 \times 9 \times 6$.
Courtesy of M. Alain Lesieutre.

272. MAURICE DUFRÈNE (1876–1955).
Wood panel of ornamental locksmith work.
Designed by Dufrène for Fontaine and Co.
Three door-handles, a lock, keyhole and key.
Panel: $5\frac{1}{4} \times 4\frac{3}{4}$.
Exh: *Les Années '25'*, Paris, 1966,
cat.no.586.
Lent by the Musée des Arts Décoratifs.

273. JEAN DUNAND (1877–). Vase.
Ovoid shape covered with *coquille d'œuf*
with a ring of orange enamel around the
opening.
c.1925. $9\frac{3}{4} \times 6\frac{1}{2} \times 6\frac{1}{2}$.
Coll. Mr and Mrs Peter M. Brant.

274. Dunand. Vase.
1929. $8\frac{1}{2} \times 5$.
Purchased from Edgar Brandt, 1929.
Lent by Art Galleries, Cranbrook Academy
of Art.

275. Dunand. *Fawn in the Forest.* Plaque.
Lacquer.
1930. $5\frac{1}{4} \times 3\frac{1}{2}$.
Courtesy of M. Alain Lesieutre.

276. Dunand. Tray.
Black lacquer with red and gold decoration.
c.1920. $11\frac{1}{2} \times 7$.
Courtesy of M. Alain Lesieutre.

277. Dunand. Vase.
Metal, lacquered red and black.
c.1925. $11\frac{1}{2} \times 10$.
Courtesy of M. Alain Lesieutre.

278. Dunand. Vase.
Black steel, fluted with 31 'flowers' in gold.
Dated 1913. $7\frac{1}{2} \times 5$.
Courtesy of M. Alain Lesieutre.

279. Dunand. Vase.
Beaten metal with blue lacquer inlay.
Dated 1913. $13\frac{1}{2} \times 8\frac{1}{2}$.
Courtesy of M. Alain Lesieutre.

280. Dunand. Vase.
Bronze in the shape of a gourd.
c.1913–14. $10\frac{1}{2} \times 5\frac{1}{2}$.
Courtesy of M. Alain Lesieutre.
Formerly in the Mazure collection, Tangiers.

281. Dunand. Vase.
Red and black lacquer decoration.
c.1913–14. $7\frac{1}{2} \times 5$.
Courtesy of M. Alain Lesieutre.

282. Dunand. Cup.
Beaten metal on *piédouche* with running
animals in silver inlay.
c.1913–14. $4\frac{1}{2} \times 7$.
Courtesy of M. Alain Lesieutre.

283. Dunand. Gong.
Lacquer and *dinandier,* silver inlay.
Mahogany support.
$18 \times 13\frac{3}{4}$.
Illus: Gabriel Mourey, *L'Art Français de la
Révolution à nos Jours,* p.225.
Courtesy of Galerie du Luxembourg.

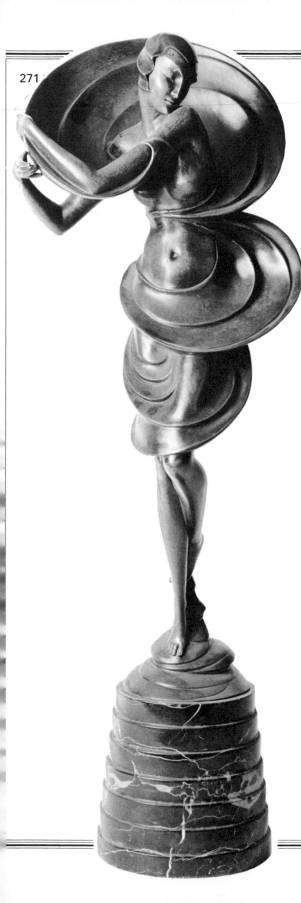

271

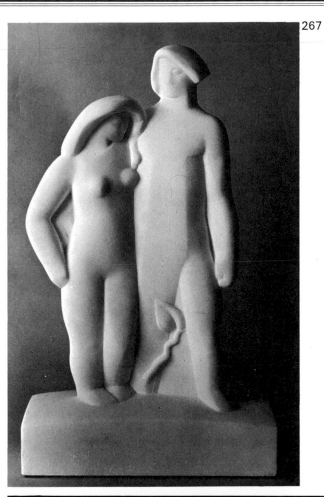

267

270

283a. FADA RADIO SET & ELECTRIC CO. INC., NEW YORK. Radio set.
Model 1000. Universal Superheterodyne.
Plastic case.
c.1935. 6 × 10 × 5½.
Anonymous loan.

284. C. FAURÉ. Vase.
Black, blue and white enamel with panels of floral motifs.
14 × 8.
Courtesy of M. Alain Lesieutre.

285. Fauré. Vase.
Blue, maroon and scarlet enamel, chevron design.
5½ × 5½.
Courtesy of M. Alain Lesieutre.

286. Fauré. Vase.
Gourd-shaped with triangle and stripe design in turquoise and cobalt-blue enamel.
5½ × 4½.
Courtesy of M. Alain Lesieutre.

287. Fauré. Vase.
Kettledrum shape, blue with raised lozenges of pink, red and yellow enamel.
7 × 7.
Courtesy of M. Alain Lesieutre.

288. Fauré. Vase.
Egg-shaped, with fan and floral motifs in blue, green, yellow and white enamel.
14½ × 6½.
Courtesy of M. Alain Lesieutre.

289. Fauré. Vase.
Kettledrum shape, diagonal decoration in blue, black and white enamel.
7 × 7½.
Courtesy of M. Alain Lesieutre.

290. Fauré. Vase.
Pendant shape, floral decoration in white and green enamel.
11 × 3½.
Courtesy of M. Alain Lesieutre.

291. Fauré. Vase.
Grenade shape, geometric decoration in black, red and purple enamel.
7½ × 5.
Courtesy of M. Alain Lesieutre.

292. FRANKARD. Figure of huntress.
Plaque.
c.1930. 8 × 8.
Coll. Mr Stanley Insler.

293. NOACK FRIEDENAU. Figure.
Bronze.
1927. 11½ × 5 × 4.
Coll. Mr Stanley Insler.

294. GERDAGO. Enamelled statuette.
Silvered bronze with ivory hands and face, mounted on onyx. Signed by Gerdago with additional monogram A.R. within square.
13 × 13.
Coll. Miss Marie Middleton.

295. GEVA. Box.
Silver, red and black enamel.
3½ × 2¾.
Anonymous loan.

296. ALBERTO GIACOMETTI.
Two buttons.
Coll. Mr Jon Nicholas Streep.

297. Giacometti. Two door-knobs.
Coll. Mr Jon Nicholas Streep.

298. G. GILLOT. Figure of a woman.
Bronze.
Coll. Mr Stanley Landsman.

299. Gillot. Ceres with dog.
Bronze.
11½ × 11¾ × 2¾.
Coll. M. Gilbert Silberstein.

300. GUYOT. Panther.
Bronze.
c.1935.
Courtesy of M. Alain Lesieutre.

301. ATELIER HAGENAUER.
Dancing-girl. Austrian.
Silvered bronze and ebony.
c.1930. 12½ × 9¼.
Coll. Mr Fred Hughes.

302. C. P. JENNEWEIN.
Gazelle with Cupid.
Bronze.
c.1926. 27 × 5¾ × 17¾.
Lent by Art Galleries, Cranbrook Academy of Art.

303. ANDRÉ LAVRILLIER.
Leda and the Swan.
Bronze plaque.
c.1930. 4 × 2⅜.
Coll. Mr Edward Lee Cave.

304. LIMOGES. Vase.
Silver lip and foot with stylized figures, Sarlandie enamel.
1930. 10¼ × 6.
Courtesy of Lillian Nassau, Ltd.

305. Limoges. Vase.
Silver lip and foot, conically-shaped geometric design, Sarlandie enamel.
1930. 10½ × 10.
Courtesy of Lillian Nassau, Ltd.

306. Limoges. Vase.
White with dancing nude figure in black, gold ring around opening.
c.1930. 7 × 2.
Courtesy of Barry and Audrey Friedman, Antiques.

307. Limoges. Vase.
Bronze tone and ivory enamel in geometric pattern, Sarlandie enamel.
1926. 11¼ × 5½.
Courtesy of Lillian Nassau, Ltd.

307a. Limoges. Vase.
12 × 10.
Coll. Mr Roy Lichtenstein.

308. CLAUDIUS LINOSSIER
(1893–1955). Vase.
Hammered copper.
1926. 7¾ × 7.
Courtesy of Lillian Nassau, Ltd.

309. Linossier. Circular tray.
D: 15½.
Exh: *Exhibition of Modern Decorative Art,*
Seligmann, 1926.
Lent by Art Galleries, Cranbrook Academy of Art.

310. Linossier. Vase.
Copper inlaid with silver, patinated.
1925. 4¾ × 4½.
Anonymous loan.

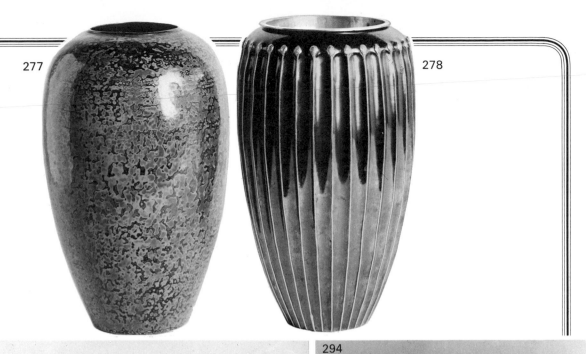

277

278

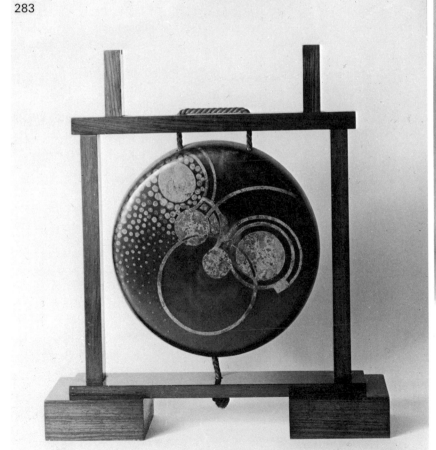

283

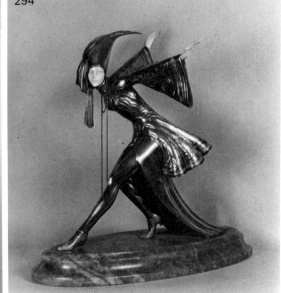

294

311. MADY. Candelabra.
Bronze in shape of a torch bearer.
c.1932. $5\frac{1}{4} \times 1\frac{1}{2}$.
Coll. Mr Stanley Insler.

312. PAUL MANSHIP (1885–1966).
Europa and the Bull.
Bronze.
1926. $11 \times 8\frac{1}{2} \times 14\frac{1}{2}$.
Lent by Art Galleries, Cranbrook Academy of Art.

313. JOEL AND JAN MARTEL.
Radiator-caps.
Chromed bronze. Four exist; originally there were five, but one was stolen after the 1966 exhibition at the Musée des Arts Décoratifs (cat.no.419).
Courtesy of Galerie du Luxembourg.

314. GUSTAVE MIKLOS (1888–).
Bronze of a woman.
1927. $30\frac{1}{2} \times 5 \times 5$.
Exh: Galerie de la Renaissance.
Coll. M. Félix Marcilhac.

315. CARL MILLES (1875–1955).
Swedenborg Praying.
Sketch in wood for a monument made at the request of the Swedenborg Church in London showing Swedenborg kneeling; words of the Lord's Prayer are carved on the base.
1930. $24 \times 6\frac{1}{2} \times 12\frac{1}{2}$.
Lent by Art Galleries, Cranbrook Academy of Art.

315a. MOVADO. Pocket watch.
Case decorated with geometrical pattern in black enamel.
c.1930. $\frac{3}{8} \times 2$.
Courtesy of Sonnabend Gallery.

316. CHANA ORLOFF. Sculpture.
Wood.
$11 \times 12 \times 7\frac{1}{2}$.
Exh: *Chana Orloff*, Musée Rodin, Paris, 1971.
The original drawing for this sculpture is also included in the exhibition, cat.no.829.
Coll. M. Félix Marcilhac.

317. PETERSON. *The Calf.*
Bronze.
$10 \times 7\frac{3}{4} \times 3\frac{1}{2}$.
Illus: Armand Dayot, *Les Animaux*, ii, Pl.48.
Courtesy of M. Alain Lesieutre.

318. F. PREISS. Pierette.
Painted bronze with ivory hands and face on marbleized plinth.
$17 \times 4 \times 4$.
Coll. Dr K. C. P. Smith and Mr Paul Smith.

319. Preiss. *Flame woman.*
Bronze and ivory.
H: 13.
Courtesy of Link and Cresswell.

320. PROHAR. Pair of andirons.
Bronze with monkey motif.
c.1928. $21 \times 3\frac{1}{4} \times 3\frac{1}{4}$.
Coll. Mr Stanley Insler.

321. JEAN PUIFORCAT (1897–1945).
Eagle.
Bronze.
$8\frac{1}{4} \times 13\frac{3}{8} \times 11\frac{1}{2}$.
Courtesy of Puiforcat-Orfèvre.

322. REVERE, NEW YORK. Book-holder.
Spring steel.
c.1930. $5 \times 4\frac{1}{2} \times 6$.
Coll. Kiki Kogelnik.

323. Revere. Cylindrical Martini shaker.
Chrome.
H: $11\frac{1}{8}$.
Coll. Mr Edward Lee Cave.

324. EDOUARD MARCEL SANDOZ.
Sitting condor.
Black Belgian marble.
1929. $17 \times 8\frac{1}{2} \times 24$.
Lent by Art Galleries, Cranbrook Academy of Art.

325. Sandoz. *Sitting cat.*
Black Belgian marble.
1929. $16\frac{3}{4} \times 8\frac{1}{2} \times 9$.
Lent by Art Galleries, Cranbrook Academy of Art.

326. Sandoz. The Fenec.
Silvered bronze of a sand-fox.
Illus: Armand Dayot, *Les Animaux*, iv, Pl.21.
Courtesy of M. Alain Lesieutre.

327. E. P. SCIACI. Candelabra.
Bronze torch-bearers.
c.1925. $18\frac{1}{2} \times 18\frac{1}{2}$.
Coll. Mr Stanley Insler.

328. R. SERTORIO. Sphinx radiator-cap.
Silvered bronze with ivory face.
H: 6.
Courtesy of M. Alain Lesieutre.

329. SIMARD. Girl with cheetah.
Silvered bronze.
$19 \times 4 \times 4$.
Coll. Mr John Jesse.

330. TEMPORAL. Bust of Beethoven.
Bronze.
$21 \times 11\frac{1}{2}$.
Coll. Miss Marie Middleton.

331. M. L. VERDIER. Aztec warrior.
Bronze on stone pedestal. Stylized warrior preparing to throw spear.
1931. $11 \times 22 \times 8$.
Coll. Mr Stanley Insler.

332. WALKER AND HALL, SHEFFIELD, ENGLAND. Dish with handles-cum-feet in the form of rings.
Silver-plated. Mark: 52339 A1; also 'L' in a bullet-shaped shield.
$2 \times 9\frac{5}{8}$.
Anonymous loan.

333. THEODORE WENDE (1883–).
Desk pad, with silver seal.
c.1925. $4 \times 1\frac{3}{4}$.
Courtesy of Lillian Nassau, Ltd.

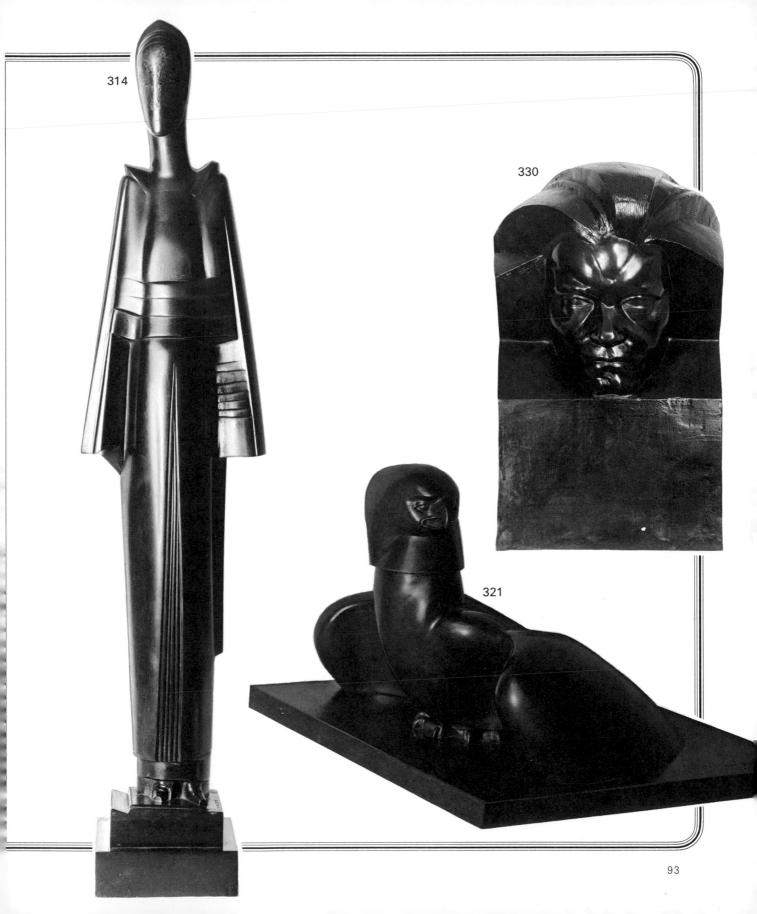

314

330

321

Clocks

334. ANONYMOUS. Desk-clock. Swiss.
Onyx, enamel, jade.
c.1930. 6 × 8¼.
Courtesy of Lillian Nassau, Ltd.

335. ANON. Cup-shaped clock.
Chrome on concentric semi-circular rests
and ball feet. 5½ × 7 × 1¾.
Courtesy of Sonnabend Gallery.

336. ANON. Clock.
Metal, with hollowed numerals in die form.
Coll. Miss Prudence Pratt.

337. J. E. CALDWELL AND CO.
Desk-clock.
Enamelled, die-shape with blue dots.
1934. 2 × 2 × 2.
Courtesy of Lillian Nassau, Ltd.

338. ALBERT CHEURET. Clock.
Silvered bronze.
1930. 6½ × 16¾ × 4.
Courtesy of Lillian Nassau, Ltd.

339. G. GILLOT. Clock.
Bronze *doré, bombé* profile; surmounted by
a nude child holding a garland of stylized
flowers. The center of the dial is designed as
a daisy, with cloud-pattern scallops around
the face.
11½ × 6 × 4½.
Courtesy of M. Alain Lesieutre.

340. R. JAY, PARIS AND LONDON.
Garniture de cheminée.
Marble clock and two marble side-vases.
The clock is decorated with bronze figures of
nude women supporting alabaster globes.
The gold clock-face has numerals in
Egyptian style.
c.1928. Clock: 14½ × 20¾ × 4½.
Vases: 9½ × 5 × 2⅛.
Anonymous loan.

341. F. PREISS. Marble clock.
Surmounted by figure of an Amazon.
9 × 20 × 4½.
Illus: A similar clock, Hillier, *Art Deco*, 1968,
p.49.
Coll. Dr K. C. P. Smith and Mr Paul Smith.

342. EMILE-JACQUES RUHLMANN.
Electric clock. French.
Wood and gold gilt.
c.1923.
Lent by Mr Harvey Feinstein.

343. SABINO. Clock. French.
Glass and chrome, illuminated by a fitting in
the chrome base. The glass intaglio-cut
with two female figures holding fronds and
flowers. Glass and base both marked.
c.1925. 8½ × 19 × 2½.
Courtesy of Martins-Forrest Antiques.

344. TELECRON. '$50' clock.
Electric.
1920s.
Coll. Mr and Mrs Lewis V. Winter.

345. KEM WEBER. Two clock designs.
Produced by Lawson Clocks Ltd,
Los Angeles. Watercolor.
1934.
Lent by Art Galleries, University of
California, Santa Barbara.

346. CARL WITZMANN. Clock-case.
Light wood inlaid with ebony.
c.1912. 16½ × 14½ × 2¼.
A similar clock by Witzmann, cased in black
and white mother of pearl, illus: *The Studio*,
London, December, 1912.
Courtesy of Mr John Jesse.

335

339

344

336

Lamps

347. ANONYMOUS. Lamp. American. Low metal base with scroll-end feet, half-oval isinglas shade patterned in light and dark brown.
c.1925. $25\frac{3}{4} \times 13 \times 5\frac{1}{8}$.
Lent by Cooper-Hewitt Museum of Design, Smithsonian Institution, Bequest of Georgiana L. McClellan.

348. ANON. Lamp. American. Chrome-plated bronze and glass, double-decker base with tri-tubular stem, bell-shaped top with glass ring; flaring glass side panels.
c.1930. H: 69.
Coll. Miss Barbra Streisand.

349. ANON. Lamp. French. Painted glass and lacquered wood with brass finial.
c.1930. H: 15.
Coll. Miss Barbra Streisand.

350. ANON. Lamp. American. Etched green glass, for cinema.
c.1930. 13×3.
Coll. Mr Stanley Insler.

351. ANON. Pair of lamps. French. Polished steel with parchment shade.
c.1930. $25 \times 5\frac{1}{4} \times 5\frac{1}{4}$.
Coll. Mr and Mrs Peter M. Brant.

352. ANON. Table-lamp. Block of glass with carved fish on wood base.
c.1930. $7 \times 10\frac{1}{2} \times 3\frac{3}{4}$.
Courtesy of Lillian Nassau, Ltd.

353. ANON. Floor lamp. Copper with green patina, polished brass rings at base and top of flared tube.
c.1930. $65 \times 17\frac{1}{2}$.
Coll. Mr Fred Hughes.

354. ANON. Lamp. In the form of a parachutist, the parachute as shade. Bronze and parchment.
33×21.
Coll. Mr John Jesse.

355. ANON. Wall-light. Moulded, frosted and polished glass in the form of a square pyramid.
$10 \times 11\frac{1}{2} \times 4$.
Coll. Mr Adrian Emmerton.

356. ANON. Lamp. Chrome with four-square chequered square shade.
Coll. Mr and Mrs Lewis V. Winter.

357. ANON. Two lamps. Chrome.
H: 25.
Coll. Mr and Mrs Peter M. Brant.

358. EDGAR BRANDT (1880–1960). Floor-lamp. Wrought-iron with ormolu decorations and moulded-glass panel.
c.1927. H: $65\frac{1}{2}$.
Coll. Mr Stanley Insler.

359. Brandt. Two pairs of wall-sconces. Iron with orange glass shades.
21×17.
Courtesy of Lillian Nassau, Ltd.

360. Brandt. Table-lamp. Bronze *doré* and marble.
c.1928. 39×16.
Courtesy of Lillian Nassau, Ltd.

361. BRANDT AND DAUM. Floor-lamp. Iron standard by Brandt, in form of cobra, glass shade by Daum.
Courtesy of M. Félix Marcilhac.

362. Brandt and Daum. Floor-lamp. Iron standard by Brandt, in form of a cobra, glass shade by Daum. (A smaller version of the preceding item.)
Courtesy of M. Félix Marcilhac.

363. CHASE. Sconce. Chrome and bakelite.
1930. $13\frac{1}{2} \times 9\frac{1}{2}$.
Courtesy of Lillian Nassau, Ltd.

364. ANTOINE DAUM (1864–1930). Chandelier. White and orange cameo cut-glass set in carved walnut frame.
c.1920. D: 30.
Courtesy of Lillian Nassau, Ltd.

365. DONALD DESKEY. Table-lamp. Chrome. Bell-shaped. Hung from semi-circular strut.
Coll. Mr and Mrs Lewis V. Winter.

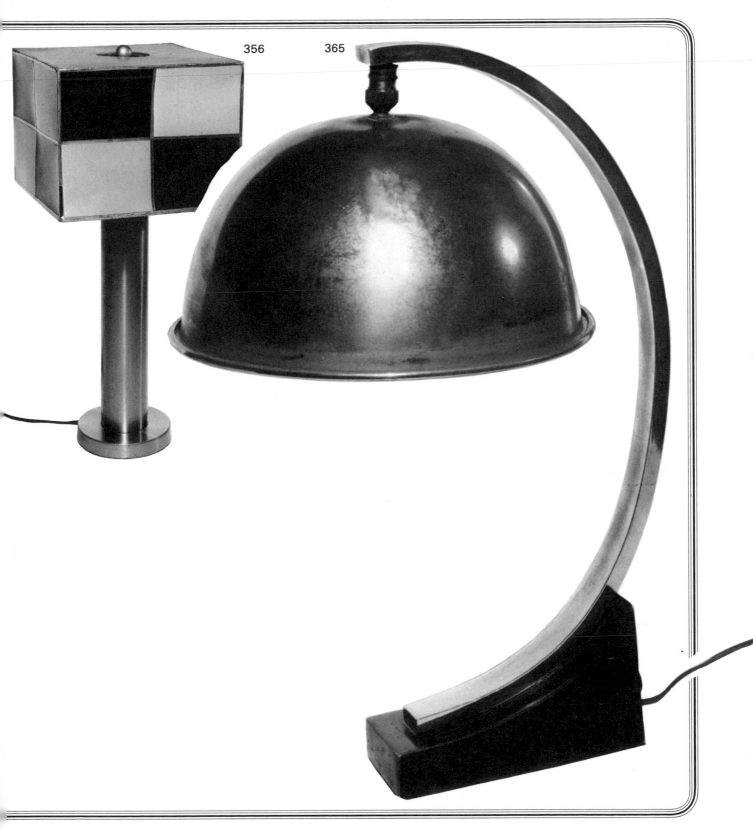

356 365

366. PHILIPPE DEVRIEZ. Table-lamp.
Bronze figure mounted on onyx base,
illuminated from within.
1926. $16\frac{1}{2} \times 13\frac{3}{8} \times 5\frac{3}{4}$.
Courtesy of Lillian Nassau, Ltd.

366a. FAGUAYS. Lamp.
Two women on alabaster base.
Courtesy of Sonnabend Gallery.

367. JEAN-MICHEL FRANK
(—1944). Lamp.
Rock crystal base, shell shade.
c.1935. Base: $7\frac{3}{8} \times 5\frac{1}{4} \times 5\frac{7}{8}$.
Shade: $7\frac{3}{4} \times 10\frac{3}{8} \times 10\frac{3}{4}$.
Lent by Cooper-Hewitt Museum of Design,
Smithsonian Institution.

368. Frank. Lamp.
Turquoise matrix base with paper
parchment shade.
c.1935. Base: $10\frac{3}{8} \times 8\frac{3}{8} \times 4$.
Shade: $9\frac{3}{4} \times 10\frac{1}{2} \times 10\frac{3}{4}$.
Lent by Cooper-Hewitt Museum of Design,
Smithsonian Institution.

369. PAUL T. FRANKL (1878–1962).
Skyscraper lamp.
Wood with white glass light fixture,
geometric-designed base with egg-shaped
fixture.
$57\frac{1}{2} \times 15\frac{1}{2}$.
Coll. Mr and Mrs Lewis V. Winter.

370. ARMAND RATEAU (1882–1938).
Two standard lamps.
Bronze patinated *vert antique*. The
reflectors cupped by bronze pheasants with
spread wings, hooks in the form of snakes in
the pheasants' beaks; the base formed of
four bronze pheasants pecking large pellets
of 'grain' from the ground. Model created
for Jeanne Lanvin, 1920–2, and later used
for the Duchess of Alba and Mme Georges
Blumenthal.
$72\frac{3}{4} \times 21\frac{1}{4}$
Exh: *Les Années '25'*, Paris, 1966,
cat.no.640.
Literature: 'Au 16 rue Barbet-de-Jouy avec
Jeanne Lanvin', *Connaissance des Arts*,
August, 1963, p.68.
Lent by Musée des Arts Décoratifs.

371. FANNY ROZET (1904—).
Table lamp.
Silver bronze figure with *pâte de verre* on
sides.
c.1925. 21×23.
Courtesy of Lillian Nassau, Ltd.

372. EMILE-JACQUES RUHLMANN
(1879–1933). Table-lamp.
Buillotte type.
1925. $23\frac{1}{2} \times 14\frac{1}{2} \times 6$.
Courtesy of Lillian Nassau, Ltd.

373. ELIEL SAARINEN (1873–1950).
Floor-lamp.
Three cones flaring upward, with single pole
and round base.
c.1928. $67\frac{3}{4} \times 13\frac{3}{4}$.
Lent by Art Galleries, Cranbrook Academy
of Art.

374. KEM WEBER. Lamp design for
Ultra Violet Products, Inc.
Lent by Art Galleries, University of
California, Santa Barbara.

375. WIENER WERKSTÄTTE.
Figure lamp.
White metal.
c.1926. $10\frac{3}{4} \times 3\frac{1}{2} \times 3\frac{1}{2}$.
Coll. Mr and Mrs Peter M. Brant.

376. Wiener Werkstätte. Figure lamp.
White metal.
c.1926. $10\frac{1}{2} \times 4 \times 4$.
Coll. Mr and Mrs Peter M. Brant.

377. Wiener Werkstätte. Lamp.
White metal.
c.1926.
Coll. Mr and Mrs Peter M. Brant.

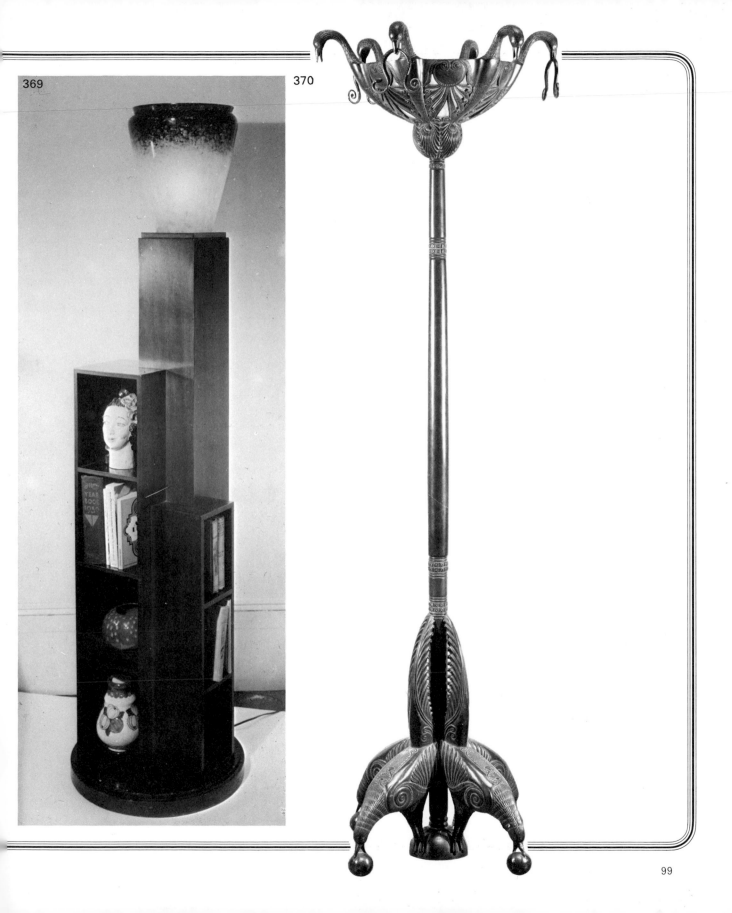

369

370

Cigarette Cases/Compacts/Boxes

377a. ANONYMOUS. Powder-box.
Decorated with geometric shapes in
black enamel.
c.1930. L: 2.
Courtesy of Sonnabend Gallery.

377b. ANON. Powder-box.
Decorated with geometric shapes in black
and red enamel.
c.1930. L: 2.
Courtesy of Sonnabend Gallery.

377c. ANON. Compact.
Decorated in black and red enamel.
c.1930. L: 4.
Courtesy of Sonnabend Gallery.

377d. ANON. Compact.
Polygon, decorated with red enamel and
overlaid with a red enamel triangle.
c.1930. 4×4.
Courtesy of Sonnabend Gallery.

377e. ANON. Compact.
Round, decorated with black enamel on
gold and blue enamel background.
c.1930. D: $2\frac{1}{4}$.
Courtesy of Sonnabend Gallery.

377f. ANON. Compact.
Round, decorated with flash motif in gold
and yellow enamel on a violet background.
c.1930. D: $2\frac{1}{4}$.
Courtesy of Sonnabend Gallery.

377g. ANON. Compact.
Oval, decorated with five circles in red
enamel on chrome and black enamel
background.
c.1930. $3 \times 3\frac{1}{2}$.
Courtesy of Sonnabend Gallery.

377h. ANON. Cigarette and compact box.
Decorated with geometric shapes in red
enamel.
c.1930. $3\frac{1}{2} \times 5$.
Courtesy of Sonnabend Gallery.

377i. ANON. Cigarette-case.
Mauve galuchat.
c.1930. $3\frac{1}{2} \times 4\frac{1}{2}$.
Courtesy of Sonnabend Gallery.

377j. ANON. Cigarette-case.
Decorated with geometric pattern in red and
black enamel.
c.1930. $3\frac{1}{2} \times 2\frac{3}{8}$.
Courtesy of Sonnabend Gallery.

377k. ANON. Note-pad case.
Geometric ornaments in black and blue
enamel.
c.1930. $6\frac{1}{4} \times 3\frac{1}{2}$.
Courtesy of Sonnabend Gallery.

377l. ANON. Note-pad case.
Geometric ornaments in black and green
enamel.
c.1930. $5\frac{1}{2} \times 3$.
Courtesy of Sonnabend Gallery.

378. ANON. Compact.
Rectangular with black and red enamel
cloud motif.
c.1930. $3\frac{1}{2} \times 1\frac{3}{4}$.
Courtesy of Barry and Audrey Friedman,
Antiques.

379. ANON. Cigarette-paper box.
Silver and copper.
c.1930. $2\frac{1}{2} \times 2$.
Coll. Mr and Mrs Peter M. Brant.

380. ANON. Compact.
Grey and white lacquer enamel with
geometric design.
c.1930. 4×2.
Coll. Miss Barbra Streisand.

381. ANON. Cigarette-holder.
Enamelled steel.
c.1930. $4\frac{1}{2} \times 2\frac{1}{4} \times 2\frac{1}{4}$.
Coll. Kiki Kogelnik.

382. ANON. Cigarette-case. American.
Silver with dog handle on lid.
c.1930. $7 \times 6\frac{1}{4} \times 6\frac{1}{4}$.
Coll. Mr Stanley Insler.

383. ANON. Powder compact.
Enamelled with Chinese lantern motif.
D: 2.
Coll. Miss Marie Middleton.

384. ANON. Cigarette-case.
Black enamel on silver, with two figures in
blue, orange, black, brown, grey and yellow
enamel; the reverse with a cherub in pink
enamel on a blue ground. English: maker's
mark 'R. and R.' London hallmark for
1931–2.
$2\frac{1}{8} \times 3\frac{1}{4}$.
Courtesy of Martins-Forrest Antiques.

385. ANON. Cigarette-case.
Silver with black enamel decoration.
$3\frac{1}{4} \times 3$.
Anonymous loan.

385a. ANON. Cigarette-case.
Black and red enamel decoration.
$3\frac{3}{4} \times 3$.
Anonymous loan.

386. ANON. Cigarette-case.
Black enamel decoration.
$4\frac{1}{8} \times 3\frac{1}{4}$.
Anonymous loan.

387. ANON. Cigarette-case.
Silver-plated with *coquille d'œuf*
decoration.
$3\frac{3}{8} \times 3$.
Anonymous loan.

388. ANON. Cigarette-case.
Silver-plated, black enamel decoration.
$4\frac{1}{2} \times 3\frac{1}{4}$.
Anonymous loan.

389. ANON. Cigarette-case.
Silver-plated.
$4\frac{3}{4} \times 3\frac{1}{4}$.
Anonymous loan.

390. ANON. Cigarette-case.
Silver-plated.
$4\frac{1}{2} \times 3\frac{3}{8}$.
Anonymous loan.

391. ANON. Cigarette-case.
Silver, with enamel decoration.
$4\frac{5}{8} \times 3\frac{1}{4}$.
Anonymous loan.

392. ANON. Cigarette-case.
Silver, black, red and pale blue enamels on
silver, with design of Egyptian figures and
scarabs.
$3\frac{1}{4} \times 2 \times \frac{1}{2}$.
Anonymous loan.

393. ANON. Powder-compact.
Silver with blue enamel over sunray pattern.
$3\frac{1}{4} \times 2\frac{1}{4}$.
Anonymous loan.

394. ANON. Compact.
Octagonal, silver and purple enamel with
dancing figures in relief.
$2 \times \frac{1}{2}$.
Anonymous loan.

395. ANON. Powder-compact.
Metal and enamel, stamped 'Chicago
Exhibition 1933'.
$2 \times 1\frac{3}{4} \times \frac{1}{2}$.
Coll. Mr and Mrs Matthew Stein.

384

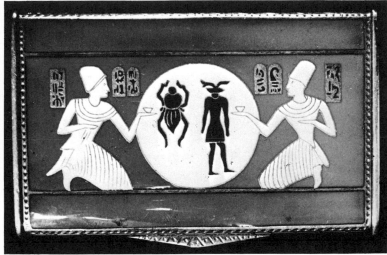

392

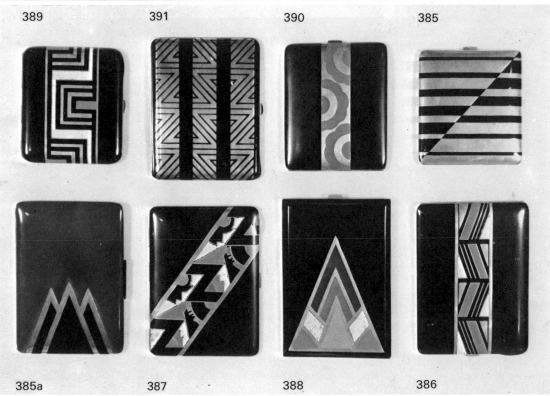

389

391

390

385

385a

387

388

386

396. ANON. Cigarette-case.
Rectangular, with mock snakeskin finish
photographically applied.
$6\frac{1}{4} \times 2$.
Courtesy of Mr Robin Symes.

397. ANON. Cigarette-case and compact.
Mock snakeskin finish photographically
applied.
$5\frac{3}{4} \times 2\frac{1}{2}$.
Courtesy of Mr Robin Symes.

398. ANON. Powder-compact.
Round, with decoration in silver and
sprayed gold lacquer on black enamel.
D: 4.
Courtesy of Mr Robin Symes.

398a. ANON. Powder-box.
Onyx, malachite and silver.
c. 1927. 3×4.
Courtesy Lillian Nassau, Ltd.

399. ANON. Powder-compact.
Oval, with relief decoration in ivory and dark
brown plastic on silver plating.
$4\frac{1}{4} \times 3\frac{1}{2}$.
Courtesy of Mr Robin Symes.

400. ANON. Cigarette-case.
Rectangular with sliding movement.
Decorated in red enamel and sprayed black
lacquer on silver-plating.
$3\frac{3}{4} \times 3\frac{1}{4}$.
Courtesy of Mr Robin Symes.

401. ANON. Cigarette-case.
By the same manufacturer as that preceding.
Red and pink sprayed enamel on silver-
.plating.
$3\frac{3}{4} \times 3\frac{1}{4}$.
Courtesy of Mr Robin Symes.

402. ANON. Powder-compact.
Square with sliding movement, decorated in
pale green, dark green and white enamel.
$3\frac{1}{4} \times 3\frac{1}{4}$.
Courtesy of Mr Robin Symes.

403. ANON. Cigarette-case.
Black enamel and gold speckled lacquer on
silver-plating.
$3\frac{1}{4} \times 2\frac{3}{4}$.
Courtesy of Mr Robin Symes.

404. ANON. Cigarette-case.
Silver with pale blue and red enamel.
$3\frac{1}{4} \times 2\frac{3}{4}$.
Courtesy of Mr Robin Symes.

405. ANON. Powder-compact.
Round, with black enamel, silver-plating
and marbled finish.
D: $3\frac{3}{4}$.
Courtesy of Mr Robin Symes.

406. ANON. Compact and lip-stick case.
Cubist-style designs of women's profiles.
Anonymous loan.

406a. ALPACCA. Cigarette-box.
Silver with geometric shapes in black
and blue.
c.1930. 3×4.
Courtesy of Sonnabend Gallery.

406b. Alpacca. Cigarette-box.
Silver with geometric shapes in black and
red.
c.1930. $3\frac{1}{2} \times 2\frac{1}{2}$.
Courtesy of Sonnabend Gallery.

406c. Alpacca. Cigarette-box.
Silver with geometric shapes in black and
blue.
c.1930. 3×4.
Courtesy of Sonnabend Gallery.

407. Alpacca. Cigarette-case.
Silver with black and pale blue enamel.
4×3.
Courtesy of Mr Robin Symes.

408. Alpacca. Cigarette-case.
Silver with black and pale blue enamel.
4×3.
Courtesy of Mr Robin Symes.

408a. Alpacca. Cigarette-box.
Silver with geometric shapes in black and
blue.
c. 1930. 3×4.
Courtesy of Sonnabend Gallery.

408b. Alpacca. Cigarette-box.
Silver with geometric shapes in black and
red.
c. 1930. $3\frac{1}{2} \times 2\frac{1}{2}$.
Courtesy of Sonnabend Gallery.

408c. Alpacca. Cigarette-box.
Silver with geometric shapes in black and
blue.
c. 1930. 3×4.
Courtesy of Sonnabend Gallery.

409. JEAN DUNAND (1877–).
Cigarette-case.
Black lacquer, *coquille d'œuf*.
1926. $3\frac{3}{8} \times 2\frac{1}{8} \times \frac{3}{8}$.
Courtesy of Lillian Nassau, Ltd.

410. PAUL FLATO. Cigarette-case.
Silver and gold.
c.1925. $3 \times 5\frac{1}{4}$.
Coll. Mr Jon Nicholas Streep.

411. JEAN FOUQUET (1899–)
Cigarette-case.
Silver, enamelled in dark and light blue and
red.
$5\frac{7}{8} \times 5\frac{3}{4}$.
Illus: Hillier, *Art Deco*, 1968, p. 164.
Anonymous loan.

412. GORHAM SILVERSMITHS.
Compact.
Silver, enamel and marcasites.
c.1929. $3\frac{1}{8} \times 2$.
Coll. Mr Stanley Insler.

412a. Marlene. Powder-box.
Round, with clock and decorated with
geometric shapes in white and blue enamel.
D: 2.
Courtesy of Sonnabend Gallery.

413. MURAT. Compact.
Mirrored silver.
c.1925. $4\frac{1}{2} \times 3$.
Coll. Mr Jon Nicholas Streep.

414. Murat. Cigarette-case.
Mirrored silver.
c.1925. 6×3.
Coll. Mr Jon Nicholas Streep.

415. Murat. Pill-box.
Mirrored silver.
c.1925. D: 1.
Coll. Mr Jon Nicholas Streep.

415a. Pomone. Cigarette-case.
Silver decorated with floral patterns in red,
black and blue enamel.
c. 1930. $5\frac{1}{4} \times 3\frac{1}{2}$.
Courtesy of Sonnabend Gallery.

416. EMMY ROTH. Cigarette-box.
Silver.
c.1927. $3 \times 8 \times 5\frac{1}{4}$.
Coll. Mr and Mrs Peter M. Brant.

417. SUE ET MARE (LOUIS SUE,
1875– , and ANDRÉ MARE,
1885–1932). Lip-stick-case with
powder-compact.
Model no.12985. Inscribed to 'Rosanella
1925'.
Lip-stick: L: $2\frac{1}{8}$. Compact: $2\frac{3}{4} \times 2\frac{1}{8}$.
Anonymous loan.

Opposite: Cat.no.341.
Overleaf: Cat.no.354.

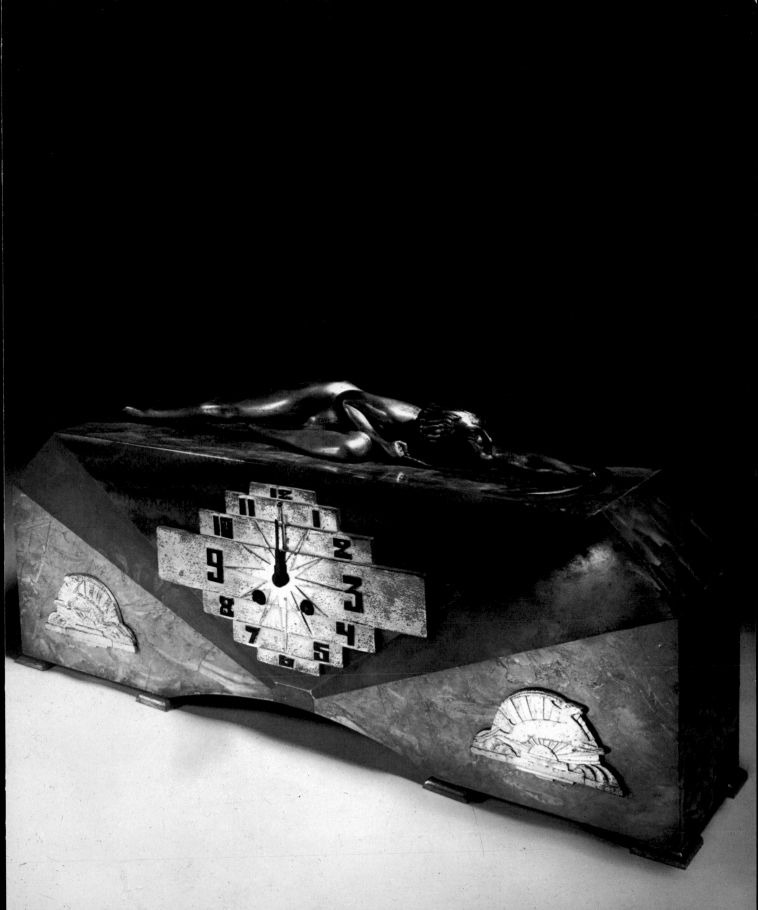

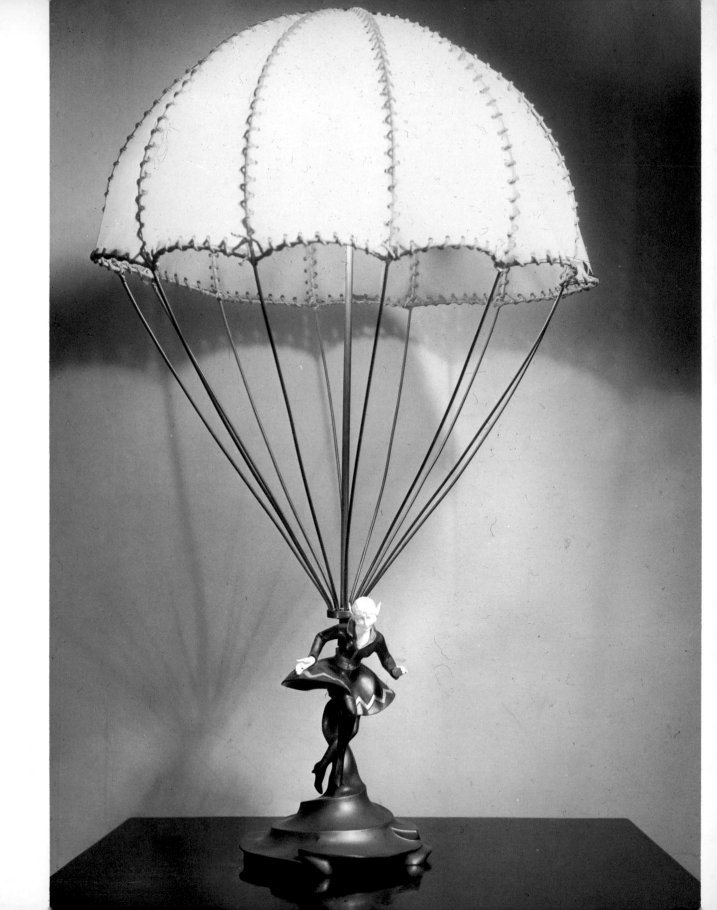

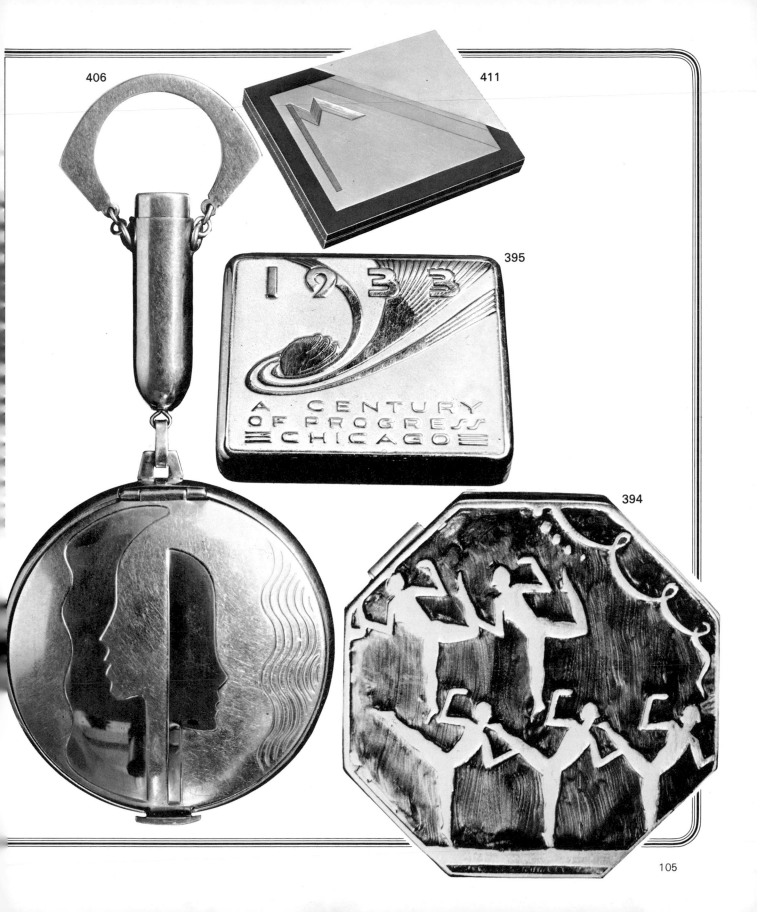

406

411

395

1933
A CENTURY
OF PROGRESS
CHICAGO

394

Medallions

418. ANONYMOUS. *N.B.C.*
1926–36.
Bronze, with worn silver wash.
Coll. Dr Robert Pincus-Witten.

419. P. M. DAMMANN.
*Paris Exposition Internationale Arts et
Techniques.*
1937.
Bronze with gold wash.
Coll. Dr Robert Pincus-Witten.

419a. Damann.
Bronze.
1935.
Courtesy of Sonnabend Gallery.

420. RAYMOND DELAMARRE.
Défense du Canal de Suez.
1930.
Bronze.
Coll. Dr Robert Pincus-Witten.

421. LAURA GARDIN FRASER.
*Lindbergh Medal of the Congress,
United States of America.*
1928.
Bronze.
Coll. Dr Robert Pincus-Witten.

422. PAUL MANSHIP (1885–1966).
*Hail to Dionysus Who First Discovered the
Magic of the Grape.*
1930.
Bronze.
Coll. Dr Robert Pincus-Witten.

423. Manship. Commemorating the
Centennial of the Southern Railway.
1930.
Bronze.
Illus: *The Minneapolis Institute of Arts
Bulletin,* April 4, 1931, p.69.
Coll. The Minneapolis Institute of Arts,
gift of the Southern Railway by Fairfax
Harrison.

424. C. L. MASCAUX. Piano competition.
Depicting girl with bobbed hair at a grand
piano, with classical frieze above; on
reverse, a panel for engraving with the
winner's name, within a cartouche of
stylized roses.
c.1925.
Anonymous loan.

425. MARCEL RENARD. *Music.*
Pan(?) playing reed pipes.
1925.
Coll. Dr Robert Pincus-Witten.

426. RUOTOLO.
Recto: The Italians of New York, New Jersey
and Connecticut to Italo Balbo.
Verso: Tenth Anniversary Air Crossing,
November, 1933. Rome/Chicago/
New York/Rome. 1933.
Coll. Mr Anthony M. Clark.

427. PIERRE TURIN. *Exposition
Internationale des Arts Décoratifs et
Industriels Modernes,* Paris.
1925.
Bronze.
Coll. Dr Robert Pincus-Witten.

428. Turin. *Abundance.*
Female figure supporting mass of flowers.
1925.
Coll. Dr Robert Pincus-Witten.

429. JEAN VERNON. *Le Secret du
Bonheur.*
Bronze.
Coll. Dr Robert Pincus-Witten.

430. Vernon. Maiden voyage of the
Normandie.
1935.
Bronze.
Coll. Dr Robert Pincus-Witten.

423

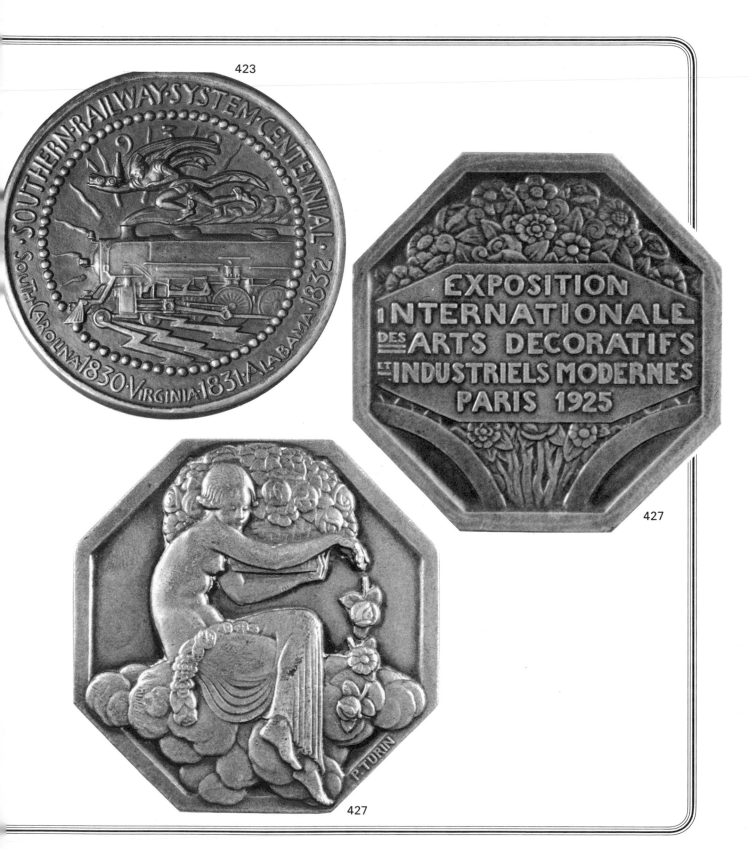

427

P·TURIN

427

Ceramics

431. ANONYMOUS. Plate.
French porcelain. Round, orange-red, with
two wide 'L' shaped gilt patterns and one
wide silvered pattern.
$1 \times 8\frac{3}{8}$.
Exh: *Paris Exposition*, 1937.
Lent by the Cooper-Hewitt Museum of
Design, Smithsonian Institution,
Gift of Mr James M. Osborn.

432. ANON. Vase.
German porcelain. Design of maid and
butler holding a cocktail tray.
H: 4.
Coll. Mr Edward Lee Cave.

433. ANON. Teapot.
Japanese export-type porcelain.
Conventional shape but with Art Deco
style decoration.
c.1930. H: $7\frac{1}{2}$.
Coll. Mr Edward Lee Cave.

434. ANON. Ink-well.
Porcelain, in the form of a woman in a
picture hat.
c.1925. H: 4.
Courtesy of M. Alain Lesieutre.

435. ANON. Powder-puff.
French porcelain. Woman seated in
lustre-ware pottery chair, the puff is
her tu-tu.
Courtesy of Sonnabend Gallery.

436. ANON. Pot.
Probably Czechoslovakian, marked
10403 IV. Raised overglaze motifs in blue,
yellow, orange and purple on green.
$10\frac{1}{2} \times 5$.
Coll. Miss Marie Middleton.

437. ANON. Plaster model head.
From a hairdresser's shop. English.
26×9.
Coll. Miss Marie Middleton.

438. ANON. Book-ends.
Tortoiseshell-glazed pottery, in the form of
Chinamen. Mounted on felt.
Coll. Miss Marie Middleton.

439. ANON. Pottery decorated with yellow
glaze and silver lustre, in the form of a
racing-car. The car's registration number is
'OKT 42' (O.K. Tea for Two).
Mark: Made in England.
$4\frac{1}{2} \times 9$.
Coll. Mr and Mrs Matthew Stein.

440. ANON. Porcelain figure.
Woman in red coat and hat, with borzoi.
5×4.
Coll. Mr and Mrs Matthew Stein.

441. ANON. Two figures.
German porcelain. Women with dogs.
Both by the same manufacturer.
$13 \times 6\frac{1}{2} \times 3\frac{1}{2}$.
Coll. Dr K. C. P. Smith and Mr Paul Smith.

442. ANON. Four figures.
Women in day attire. English.
c.1935. $9 \times 3\frac{1}{2} \times 3\frac{1}{2}$.
Coll. Dr K. C. P. Smith and Mr Paul Smith.

443. ANON. Russian wolfhound.
Plaster figure. English.
c.1935. $36 \times 48 \times 7$.
Coll. Mr John Jesse.

444. ANON. Figure of a woman.
She wears a long blue gown and has two
borzois on a leash. Plaster. English.
c.1935. $18\frac{1}{2} \times 19\frac{1}{2} \times 4\frac{1}{2}$.
Anonymous loan.

445. ANON. Woman bathing.
Green-painted plaster figure. English.
c.1935. $10\frac{1}{4} \times 3\frac{1}{2} \times 4\frac{1}{2}$.
Anonymous loan.

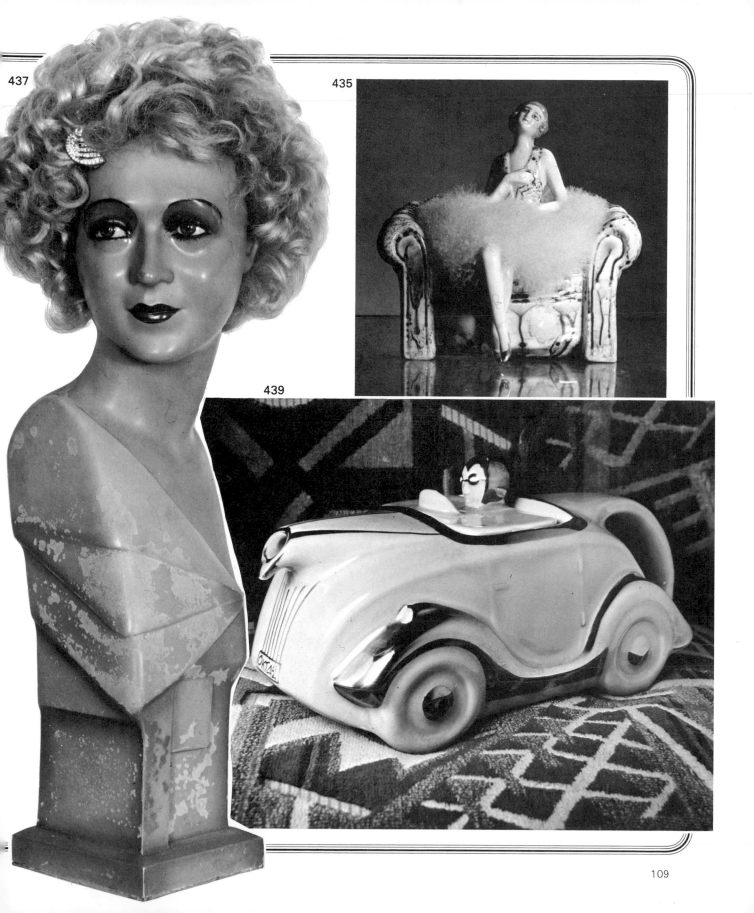

437

435

439

446. ANON. Five dancing women.
Plaster figures. English.
c. 1935. 15 × 10½ × 5.
Coll. Dr K. C. P. Smith and Mr Paul Smith.

447. ANON. Nude seated on globe.
Plaster figure. English.
c.1935. 11 × 8½ × 4½.
Anonymous loan.

448. ANON. Set of three figures of women.
Two with dogs, one with gazelles. Plaster.
Respective dimensions: 7½ × 9 × 2½;
6¾ × 7 × 2¼; 6½ × 5 × 2½.
Anonymous loan.

449. ADRIAN ALLINSON. Diana with
leaping deer.
Earthenware figure with cream glaze.
Designed and made by Allinson, London.
1926. H: 14½.
Exh: *The Jazz Age*, Brighton Museum and
Art Gallery, 1969, cat.no.168.
Lent by Victoria and Albert Museum.

**450. AMERICAN ART CLAY
COMPANY, AMAGO.** Woman with fawn.
Green-glazed pottery figure.
18 × 6 × 4.
Coll. Dr K. C. P. Smith and Mr Paul Smith.

451. ARGILOR, PARIS. Satyr hauling a
victim by ropes.
Porcelain figure.
9½ × 9½ × 3½.
Anonymous loan.

452. ASHTEAD POTTERS, ENGLAND.
Cylindrical pot and cover.
Made and marked by Ashtead potters.
Inscribed 'British Empire Exhibition 1924'
and painted with the design of a lion, the
exhibition symbol.
4 × 5.
Coll. Mr and Mrs Matthew Stein.

453. BLUEJOHN POTTERY, ENGLAND.
Two tall pottery jugs.
Decorated with sunray motifs and with
rainbow designs. Mark 'Bluejohn Pottery
England'.
10 × 4½ × 4½.
Coll. Dr K. C. P. Smith and Mr Paul Smith.

**454. BRETBY ART POTTERY (TOOTH
& CO. LTD), WOODVILLE,
STAFFORDSHIRE.** Pair of pottery vases.
Mark 'Bretby' with sun mark; also
impressed 2406.
D: 6⅝ × 3¼.
Anonymous loan.

455. Bretby Art Pottery.
Flower-holder.
Earthenware with matt orange glaze.
Marks: 'Bretby. Made in England.
3603' impressed.
c. 1935. L: 7.
Lent by Victoria and Albert Museum.

456. Bretby Art Pottery. Burleigh ware.
Mushroom-glazed pottery.
Design of four birds against sun.
D: 10.
Coll. Miss Marie Middleton.

457. RENÉ BUTHAUD (1886–).
Vase.
Pottery.
c.1925. 12½ × 9.
Lent by Art Galleries, Cranbrook Academy
of Art.

458. Buthaud. Ceramic vase.
Oval, with brown figure design.
1925. 8½ × 9.
Courtesy of Lillian Nassau, Ltd.

459. Buthaud. Vase.
Pottery, with foliate decoration in black
and red.
c.1930. 9 × 6.
Courtesy of M. Alain Lesieutre.

460. Buthaud. Vase.
Pottery, decorated with three nude women.
c.1930. 9½ × 4.
Courtesy of M. Alain Lesieutre.

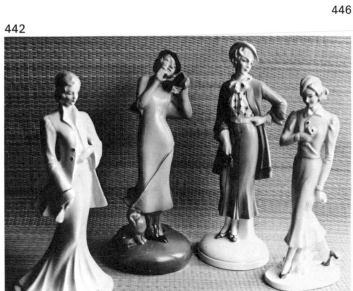

442

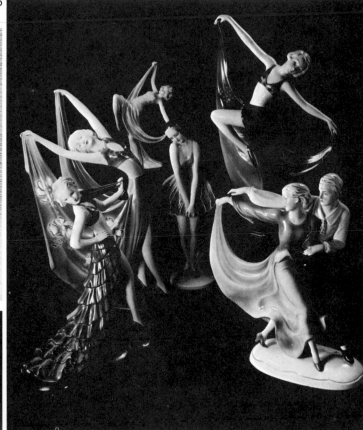

446

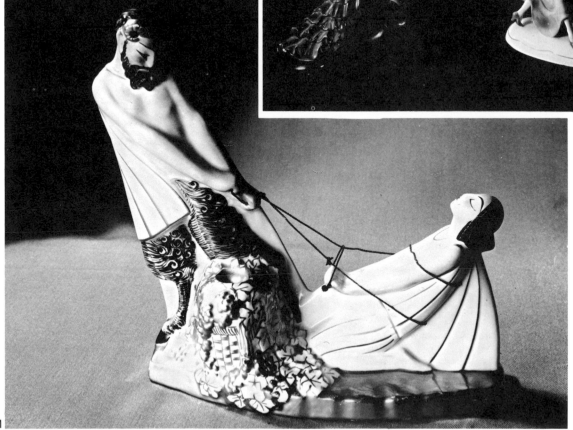

451

461. CARLTON WARE. Vase.
Porcelain in maroon and black with
multi-colored enamelled fans and
hollyhocks.
10 × 5.
Courtesy of Martins-Forrest, Antiques.

462. Carlton Ware. Ginger jar and cover.
Porcelain in orange, with blue and black and
green and black lightning flashes and
enamelled suns, flowers and bubbles in
yellow, black and gold.
10½ × 9.
Courtesy of Martins-Forrest, Antiques.

463. Carlton Ware. Plate.
Porcelain with enamelled fan design.
Anonymous loan.

464. Carlton Ware. Pair of vases.
Porcelain, red, black and white.
10 × 5.
Coll. Mr. Adrian Emmerton.

465. Carlton Ware. Coffee-service.
Porcelain, decorated with roundels of
bubble-blowing sprites, in orange and
gold against a black background;
orange lining; gold rim.
Coffee-pot: 6 × 4. Creamer: 3 × 2.
Sugar-bowl: 2 × 3. Six cups: 2 × 2.
Six saucers: D: 4.
Anonymous loan.

**466. GEORGE CLEWS AND COMPANY
LTD, TUNSTALL, STAFFORDSHIRE,
ENGLAND.** Square tea-set.
Cream-glazed pottery, made for the
Cunard Steamship Company, Ltd.
Marked, and with patent numbers
71594–6, 717702.
Teapot: 3½ × 3½ × 3½. Jug: 4½ × 3½ × 3½.
Creamer: 3 × 2 × 2. Sugar-basin: 1½ × 2 × 2.
Anonymous loan.

467. Clews. *The Cube*. Tea- and coffee-set
from the Cunard Line.
Brown pottery glaze.
Teapot: 3¼ × 3½ × 3½.
Coffee-pot: 4½ × 2½ × 2½.
Creamer: 3 × 2 × 2.
Sugar-bowls: 2 × 2½ × 2; 1¾ × 2 × 2.
Coll. Mr Harvey Feinstein.

468. CLARICE CLIFF. Teapot and
cream-jug.
Floral decoration in green, black, yellow
and beige. Mark: 'Bizarre by Clarice Cliff.
Newport Pottery, England'.
Teapot: 5 × 6. Jug: 2½ × 4.
Coll. Mr and Mrs Matthew Stein.

469. Cliff. Teapot and cream-jug.
Decorated with concentric circles in
green, yellow and brown.
Mark: 'Clarice Cliff. Wilkinson Pottery,
England'.
Teapot: 5 × 6. Jug: 2½ × 4.
Coll. Mr and Mrs Matthew Stein.

470. Cliff. Cigaratte-and-match-holder.
Design of leaves and stripes.
Mark: 'Bizarre. Clarice Cliff.
Wilkinson Pottery, England'.
2½ × 2½.
Coll. Mr and Mrs Matthew Stein.

471. Cliff. Teapot.
Decorated with landscape scene of a house
on a hill with smoking chimneys.
Mark: 'Fantasque. Hand-painted.
Bizarre. Clarice Cliff. Newport Pottery,
England'.
6 × 10.
Coll. Mr and Mrs Matthew Stein.

472. Cliff. Conical bowl.
Decorated with castles. Mark: 'Bizarre.
Clarice Cliff. Newport Pottery, England'.
4½ × 8.
Coll. Mr and Mrs Matthew Stein.

473. Cliff. Cakestand.
Geometric design in orange, blue, purple
and green. Mark: 'Bizarre. Clarice Cliff.
Newport Pottery, England'.
4 × 9.
Coll. Mr and Mrs Matthew Stein.

474. Cliff. Bowl.
Sunray motif. Mark: 'Fantasque. Clarice
Cliff. Wilkinson Pottery, England'.
3 × 6½.
Coll. Mr and Mrs Matthew Stein.

475. Cliff. Jug.
Decorated with stylized flowers in blue,
green and pink. Mark: 'Fantasque.
Clarice Cliff. Wilkinson Pottery, England'.
8½ × 6.
Coll. Mr and Mrs Matthew Stein.

476. Cliff. Vase.
Geometric design in orange, yellow, blue,
green, red, black and purple.
Mark: 'Fantasque. Clarice Cliff.
Wilkinson Pottery, England'.
8½ × 6.
Coll. Mr and Mrs Matthew Stein.

477. Cliff. Tea-service.
Decorated with concentric circles in black,
red, pink and yellow. Mark: 'Fantasque.
Bizarre. Clarice Cliff. Wilkinson
Pottery, England'. Comprising:
Six egg-cups: 2½ × 1½.
Four cups: 3 × 5. Four saucers: ¾ × 6½.
Two dinner-plates: D: 9.
Two side-plates: D: 8.
One large conical bowl: 3½ × 6.
One small conical bowl: 2 × 4½.
One butter-dish and cover: 3 × 5½.
One teapot: 5 × 5.
Coll. Mr and Mrs Matthew Stein.

478. Cliff. Advertising plaque.
For Clarice Cliff Pottery, inscribed: 'Royal
Staffordshire Ceramics by Clarice Cliff.
A. J. Wilkinson Ltd. Burslem England', on
back and front.
4½ × 8½.
Coll. Mr and Mrs Matthew Stein.

479. Cliff. Fruit-bowl.
Decorated with 'flower trees' in green, blue,
and yellow ochre.
4 × 8½.
Coll. Mr and Mrs Matthew Stein.

480. Cliff. Five-piece table-set.
Decorated by Graham Sutherland with
trellis design in green and black. Signed and
dated 1924. Mark: 'Bizarre. Clarice Cliff.
Wilkinson Pottery, England'. Comprising:
Two semi-circular troughs: 2¼ × 10.
Two square candlesticks: 2½ × 2½ × 2½.
One dish: 2½ × 5.
Coll. Mr and Mrs Matthew Stein.

452

452

481. Cliff. Jam-pot with lid.
Geometric design in green and brown.
Mark: 'Bizarre. Clarice Cliff. Wilkinson
Pottery, England'.
3×3.
Coll. Mr and Mrs Matthew Stein.

482. Cliff. Rectangular dinner-plate.
Decorated with red trees in a panel.
Mark: 'The Biarritz. Royal Staffordshire,
Great Britain. Bizarre. Clarice Cliff.
Newport Pottery, England'.
$9 \times 7\frac{1}{2}$.
Coll. Mr and Mrs Matthew Stein.

483. Cliff. Pyramidal candlestick.
Decorated with stylized fruits. Mark:
'Fantasque. Bizarre. Clarice Cliff. Newport
Pottery, England'.
$3\frac{1}{2} \times 3\frac{1}{2} \times 3\frac{1}{2}$.
Coll. Mr and Mrs Matthew Stein.

484. Cliff. Flat bowl.
The underside painted with concentric
circles, the upper side with a landscape
containing stylized trees and large
blooms. Mark: 'Bizarre. Clarice Cliff.
Newport Pottery, England'.
D: 8.
Coll. Mr and Mrs Matthew Stein.

485. Cliff. Plate.
Decorated with fluid, subaqueous design in
green, blue, yellow and orange. Mark:
'Inspiration. Bizarre. Clarice Cliff,
Wilkinson Pottery, England'.
D: 8.
Coll. Mr and Mrs Matthew Stein.

486. Cliff. Rectangular plate.
Decorated with formalized black, orange,
and yellow flowers. Mark: 'Biarritz. Royal
Staffordshire, Great Britain. Bizarre.
Clarice Cliff. Wilkinson Pottery, England'.
$10\frac{1}{4} \times 8\frac{1}{4}$.
Coll. Mr and Mrs Matthew Stein.

487. Cliff. Matching cheese-dish and
cover.
$4\frac{1}{2} \times 7\frac{1}{2} \times 5$.
Coll. Mr and Mrs Matthew Stein.

488. Cliff. Matching tureen and cover.
$6 \times 8 \times 5\frac{1}{4}$.
Coll. Mr and Mrs Matthew Stein.

489. Cliff. Rectangular plate.
Decorated with black and orange gradated
lines. Mark: 'Biarritz. Royal Staffordshire,
Great Britain. Bizarre. Clarice Cliff.
Wilkinson Pottery, England'.
$10\frac{1}{4} \times 8\frac{1}{4}$.
Coll. Mr and Mrs Matthew Stein.

490. Cliff. Matching cheese-dish and
cover.
$4\frac{1}{2} \times 7\frac{1}{2} \times 5$.
Coll. Mr and Mrs Matthew Stein.

491. Cliff. Matching tureen and cover.
$6 \times 8 \times 5\frac{1}{4}$.
Coll. Mr and Mrs Matthew Stein.

492. Cliff. Sugar-bowl.
Crocus pattern. Mark: 'Bizarre. Clarice Cliff.
Newport Pottery, England'. No teapot. The
pieces shown comprise:
Four side-plates: D: 7.
Four cups: $2\frac{1}{2} \times 4\frac{1}{2}$. Four saucers: D: $5\frac{1}{2}$.
One large dish: 11×10.
One cream-jug: $4\frac{1}{2} \times 4$.
One conical bowl: $2\frac{1}{2} \times 4\frac{1}{2}$.
Coll. Mr and Mrs Matthew Stein.

493. Cliff. Octagonal plate.
Decorated with 'balloon tree' in yellow, red,
black and green. Mark: 'Fantasque. Bizarre.
Clarice Cliff. Newport Pottery, England'.
D: $5\frac{1}{2}$.
Coll. Mr and Mrs Matthew Stein.

494. Cliff. Teapot.
Decorated with black blobby trees, houses
and clouds. Mark: 'Fantasque. Clarice Cliff.
Wilkinson Pottery, England'.
$4\frac{1}{2} \times 5\frac{1}{2} \times 3$.
Coll. Mr and Mrs Matthew Stein.

495. Cliff. Matching jam-pot.
4×3.
Coll. Mr and Mrs Matthew Stein.

496. Cliff. Teapot.
Of traditional shape, also decorated with
black blobby trees (slight variation on
design of no. 494).
$6 \times 9\frac{1}{2}$.
Coll. Mr and Mrs Matthew Stein.

497. Cliff. Matching conical sugar-sifter.
$5\frac{1}{2} \times 3$.
Coll. Mr and Mrs Matthew Stein.

498. Cliff. Conical pottery bowl.
Decorated in black and red.
$4\frac{3}{4} \times 9$.
Coll. Mr and Mrs Matthew Stein.

499. Cliff. Tea-service.
'Biarritz' pattern. Executed by Royal
Staffordshire.
Teapot: $6 \times 6\frac{1}{2} \times 3\frac{1}{4}$. Creamer: $6 \times 3\frac{1}{2} \times 2$.
Sugar-bowl: $5\frac{1}{4} \times 4 \times 2\frac{3}{4}$. Plate: $9 \times 7\frac{1}{2}$.
Coll. Mr Stanley Insler.

500. STELLA R. CROFTS (1898–).
Figure of antelope and kids. Earthenware
with cream and mauve glaze. Mark: 'Stella
R. Crofts' incised London, 1928.
H: 5.
Lent by Victoria and Albert Museum.

466

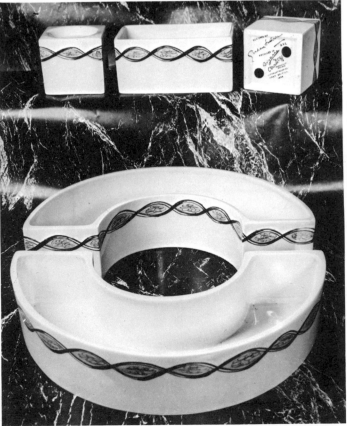

480

493

501. CROWN DEVON. Coffee-service.
Green-glazed porcelain decorated in gold
and black.
c.1930. Coffee-pot: $8 \times 6\frac{1}{2}$. Cup: $2\frac{1}{2} \times 2\frac{7}{8}$.
Coll. Miss Barbra Streisand.

502. ÉMILE DECOEUR (1876–1953).
Stoneware vase.
c.1925. 10×9.
Lent by Art Galleries, Cranbrook Academy
of Art.

503. Decoeur. Vase.
Stoneware, glazed in pink.
c.1930. $8 \times 6\frac{1}{2} \times 5$.
Courtesy of M. Alain Lesieutre.

504. Decoeur. Bowl.
Stoneware, glazed in dark blue.
c.1930. 5×5.
Courtesy of M. Alain Lesieutre.

505. Decoeur. Vase.
Stoneware, decorated with dark blue
stylized lotus flowers.
c.1930. 9×8.
Courtesy of M. Alain Lesieutre.

506. Decoeur. Plate.
Stoneware, decorated with white flower.
c.1930. 4×14.
Courtesy of M. Alain Lesieutre.

**507. LOUIS DEJEAN AND GEORGES
SERRE.** Stoneware figure.
Courtesy of M. Alain Lesieutre.

508. JEAN DUFY. *Légumier* and plate
from the same service.
Porcelain by Theodore Haviland, Limoges.
c. 1925. *Legumier*: $20 \times 42\frac{1}{2} \times 37\frac{3}{4}$.
Plate: D: 38.
Exh: *Paris Exposition*, 1925; *Les Années
'25'*, Paris, 1966, cat.no.729.
Lent by Musée des Arts Décoratifs.

509. FOLEY CHINA. Two porcelain plates.
Of traditional form but with Art Deco
designs in colored enamels. Mark: 'Foley
China. E.B. and Co. Made in England'.
$7\frac{1}{2} \times 7\frac{1}{2}$.
Anonymous loan.

510. FRAUENREUTH. *Cleopatra.*
Porcelain figure.
c.1927. $6\frac{1}{4} \times 4 \times 1$.
Coll. Mr Stanley Insler.

511. GILBERT. *Europa and the Bull.*
Pottery figure.
$12\frac{1}{2} \times 17 \times 6$.
Coll. Mr Adrian Emmerton.

512. GOLDSCHNEIDER. *Pierette.*
Austrian porcelain figure modelled and
signed by Podany. Made and marked by
Goldschneider.
$12 \times 4\frac{1}{2} \times 3\frac{1}{2}$.
Coll. Dr K. C. P. Smith and Mr Paul Smith.

513. Goldschneider. Three figures in
beach costume.
Porcelain, made and marked Goldschneider.
$7\frac{1}{2} \times 4 \times 3$.
Coll. Dr K. C. P. Smith and Mr Paul Smith.

**514. GREEN AND COMPANY, LTD,
ENGLAND.** Biscuits barrel.
Pottery with geometric polychrome design
in enamels. Mark: 'Green and Co. Ltd.
Pharos Oblique Shape'.
$9 \times 4\frac{1}{2} \times 4\frac{1}{2}$.
Coll. Mr and Mrs Matthew Stein.

515. MARCEL GUILLARD. Tobacco-jar.
Ceramic with two shades of green glaze.
c.1931. $7\frac{1}{4} \times 4$.
Courtesy of Lillian Nassau, Ltd.

516. Guillard. Vase.
Editions Etling, Paris.
c.1930. $8\frac{1}{2} \times 8$.
Coll. Mr Stanley Insler.

517. LA BOCH POTTERY. Vase.
Pottery.
c.1928. $8 \times 5\frac{1}{4}$.
Coll. Mr Stanley Insler.

518. RAOUL LACHENAL. Vase.
Pottery with black and white geometric
design.
H: 8.
Courtesy of M. Alain Lesieutre.

519. SUZANNE LALIQUE. Two porcelain
plates.
Dodecagonal with decoration of vines in
green, black and platinum. Designed by
S. Lalique for Theodore Haviland, Limoges.
D: $38\frac{1}{4} \times 38\frac{3}{4}$.
Exh: *Paris Exposition*, 1925; *Les Années
'25'*, Paris, 1966, cat.no.753.
Literature: Yvonne Brunhammer, *Lo Stile
1925*, Fabbri, Milan, 1966, p.98; color
reproduction of one of the plates at p.97,
Pl.44.

520. LEMANCEAU. Elephant and child.
Cream-glazed pottery.
$11\frac{3}{4} \times 17\frac{1}{2} \times 4\frac{1}{2}$.
Coll. Mr Adrian Emmerton.

521. Lemanceau. Greyhounds.
Pottery.
$12 \times 17 \times 6\frac{1}{2}$.
Coll. Mr Adrian Emmerton.

522. Lemanceau. Deer.
Pottery.
$12 \times 17 \times 4\frac{1}{2}$.
Coll. Mr Adrian Emmerton.

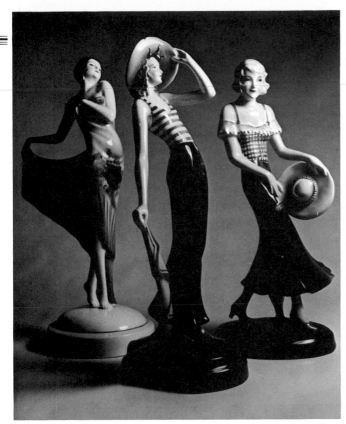

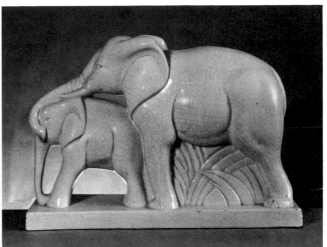

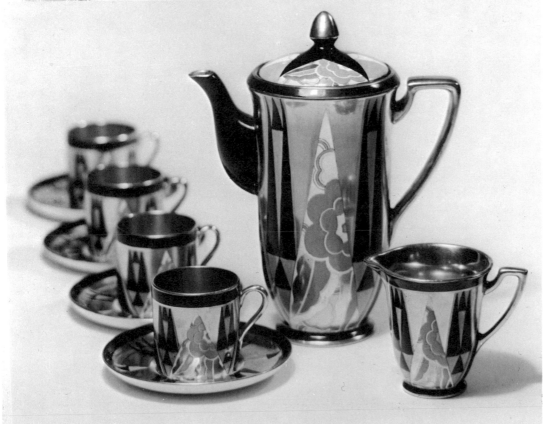

523. EMILE LENOBLE (1876–1940).
Vase.
Stoneware.
c.1925. 12 × 7¼.
Lent by Art Galleries, Cranbrook Academy
of Art.

524. Lenoble. Vase.
Pottery, with decoration in black and brown.
c.1930. H: 4¾.
Courtesy of M. Alain Lesieutre.

525. Lenoble. Vases.
Pottery with decorations.
Courtesy of M. Alain Lesieutre.

526. LONGWY. Two plates.
Faience, decorated with running deer and
female figure in glade.
D: 15½.
Courtesy of Lillian Nassau, Ltd.

527. Longwy. Circular vase.
Decorated, on a light green ground, figure in
a green scarf, the figure surrounded by a ring
of blue. Flaring spout with blue ring.
11 × 9 × 3.
Coll. Mr Harvey Feinstein.

528. JEAN LUCE. White plate porcelain.
Decorated with sunray-and-cloud motifs.
Mark: two interlaced Ls in a red rectangle.
D: 36½.
Exh: *Paris Exposition*, 1925; *Les Années
'25'*, Paris, 1966, cat.no.766.
Coll. Musée des Arts Décoratifs.

529. Luce. Plate. White porcelain.
Decorated with geometric designs in gold,
green and blue. Mark: two interlaced Ls in
a red rectangle.
D: 9¾.
Exh: *Paris Exposition*, 1925; *Les Années
'25'*, Paris, 1966, cat.no.767.
Coll. Musée des Arts Décoratifs.

530. Luce. Cup and saucer.
Silver-gilt rim.
c.1935. Cup: 3⅝. Saucer: 5 × 6.
Coll. Mr Stanley Insler.

531. Luce. Soup dish.
Decorated in black and silver.
c.1930.
Coll. Mr and Mrs Lewis V. Winter.

532. Luce (att.). Plate.
Decorated with silver design.
c.1930.
Coll. Mr and Mrs Lewis V. Winter.

533. JEAN MAYODON (1893–).
Vase.
Pottery.
1926. 9½ × 5¼.
Lent by Art Galleries, Cranbrook Academy
of Art.

534. Mayodon. Vase.
Pottery.
c.1925. 7¼ × 6½.
Lent by Art Galleries, Cranbrook Academy
of Art.

535. Mayodon. Plate.
c.1925. D: 9¼.
Lent by Art Galleries, Cranbrook Academy
of Art.

536. Mayodon. Stemmed dish.
Shallow bowl resting on a slender stem that
expands gradually to base. Red crackle glaze
with gold lustre, design of nude figures.
5⅛ × 6¾.
Exh: *Paris Exposition*, 1925.
Lent by Art Galleries, Cranbrook Academy
of Art.

537. Mayodon. Bowl.
Pottery.
1926. 4¼ × 5¾.
Lent by Art Galleries, Cranbrook Academy
of Art.

538. Mayodon. Bowl.
Pottery.
1926. 3½ × 5.
Lent by Art Galleries, Cranbrook Academy
of Art.

539. Mayodon. Vase.
Pottery, decorated with running gazelles in
green and blue.
H: 17¼.
Courtesy of M. Alain Lesieutre.

540. ANDRÉ METTHEY (1871–1921).
Plate.
Pottery.
D: 8⅞.
Lent by Art Galleries, Cranbrook Academy
of Art.

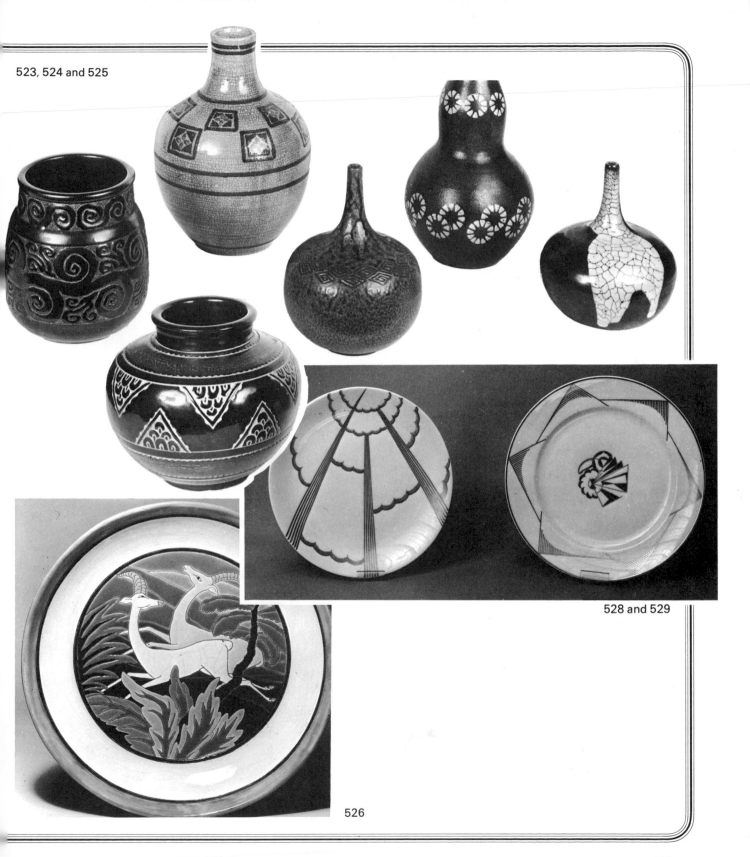

523, 524 and 525

528 and 529

526

541. Metthey. Plate.
Pottery.
c.1919. D: $8\frac{3}{4}$.
Lent by Art Galleries, Cranbrook Academy
of Art.

542. Metthey. Bowl.
Pottery, decorated with white and orange
leaves.
1917. $5 \times 11\frac{1}{2}$.
Courtesy of M. Alain Lesieutre.

543. Metthey. Bottle.
Pottery with geometric decoration in red,
celadon, blue and gold.
$11 \times 4\frac{1}{2}$.
Courtesy of M. Alain Lesieutre.

544. GUSTAVE MIKLOS (1888–).
Plaster patinated black.
1931. 17×10.
Coll. M. Félix Marcilhac.

545. MOORCROFT. Vase.
Pottery. Glazed in red and black.
H: $18\frac{1}{2}$.
Courtesy of M. Alain Lesieutre.

546. KEITH MURRAY. Vase.
White earthenware with matt green glaze,
horizontally grooved. Designed by Murray
for Josiah Wedgwood and Sons, 1939.
Marks: 'Keith Murray' (signature in
facsimile) and 'WEDGWOOD. MADE IN
ENGLAND' printed in blue.
H: 7.
Lent by Victoria and Albert Museum.

547. Murray. Bowl.
Earthenware. Designed by Murray for
Josiah Wedgwood and Sons, 1937.
Marks: 'Keith Murray' (signature in
facsimile) and 'WEDGWOOD MADE IN
ENGLAND' printed in grey, and
'WEDGWOOD MADE IN ENGLAND'
impressed.
$6\frac{1}{2} \times 9\frac{1}{2}$.
Lent by Victoria and Albert Museum.

546. Murray. *Moonstone.* Cigarette-box
and cover.
Earthenware with cream glaze. Designed by
Murray and manufactured by Josiah
Wedgwood and Sons, 1939. Marks: 'Keith
Murray' (signature in facsimile) and
'WEDGWOOD MADE IN ENGLAND'
printed in blue.
$2\frac{3}{4} \times 7\frac{3}{8} \times 3\frac{3}{4}$.
Lent by Victoria and Albert Museum. ·

549. Murray. *Moonstone.* Ashtray.
Earthenware with cream glaze. Designed by
Murray and made by Josiah Wedgwood and
Sons, 1939. Marks: 'KM WEDGWOOD
MADE IN ENGLAND' printed in blue, and
'50639' and 'E' impressed.
$1\frac{1}{8} \times 3\frac{5}{8} \times 2\frac{1}{2}$.
Lent by Victoria and Albert Museum.

550. MYOTT. Two 'cluster' vases.
One marked 'Myott, Son & Co., England'.
Marked vase: $8\frac{1}{2} \times 6 \times 3$.
Other vase: $9 \times 4\frac{1}{2} \times 4$.
Coll. Dr K. C. P. Smith and Mr Paul Smith.

**551. PARAGON CHINA CO. LTD,
ATLAS WORKS, LONGTON,
STAFFORDSHIRE, ENGLAND.**
Tea-service.
Marks: 'Paragon England Regd. No. 766514
Tulip' printed in green. Registered July 7,
1931.
c.1931.
Lent by Victoria and Albert Museum.

552. JEAN PUIFORCAT (1897–1945).
Saint Eloi.
Figure of gilded plaster.
Illus: Frontispiece of Tony Bouilhet,
L'Orfèvrerie française au 20ème siecle, 1941
Courtesy of Puiforcat-Orfèvre.

553. RENARD. Seated figure of a nude
woman.
Pottery. Mark: 'Made in France'.
$10\frac{1}{2} \times 15 \times 4\frac{1}{2}$.
Literature: compare with an almost
identical figure illustrated in Hillier,
Art Deco, 1968, p.131.
Coll. Dr K. C. P. Smith and Mr Paul Smith.

554. RICHARD-GINORI (1896–).
Dish with cover.
Porcelain, decorated with gold.
c.1924. $11 \times 9\frac{1}{2}$.
Literature: *Arts and Decoration,* 1925.
Courtesy of Lillian Nassau, Ltd.

555. ROBJ (PARIS). Teapot.
Porcelain, in the form of a bearded old man
in a fez. $8\frac{1}{2} \times 5$.
Courtesy of Sonnabend Gallery.

556. ROSENTHAL. Figure of a scarf
dancer.
Porcelain.
$2\frac{1}{2} \times 2\frac{1}{2}$.
Coll. Mr Stanley Insler.

557. Rosenthal. Porcelain figure.
Modelled by F. Winkler.
$17 \times 15\frac{1}{2} \times 4\frac{1}{2}$.
Coll. Mr Adrian Emmerton.

558. Rosenthal. Porcelain plate.
Circular, honey gilded and with over-glaze
colors. Mark: 'Rosenthal. Rhododendron
Handgemalt'.
D: 11.
Coll. Miss Marie Middleton.

Opposite: Cat.no.463.
Overleaf: Cat.nos.477 and 493–7.

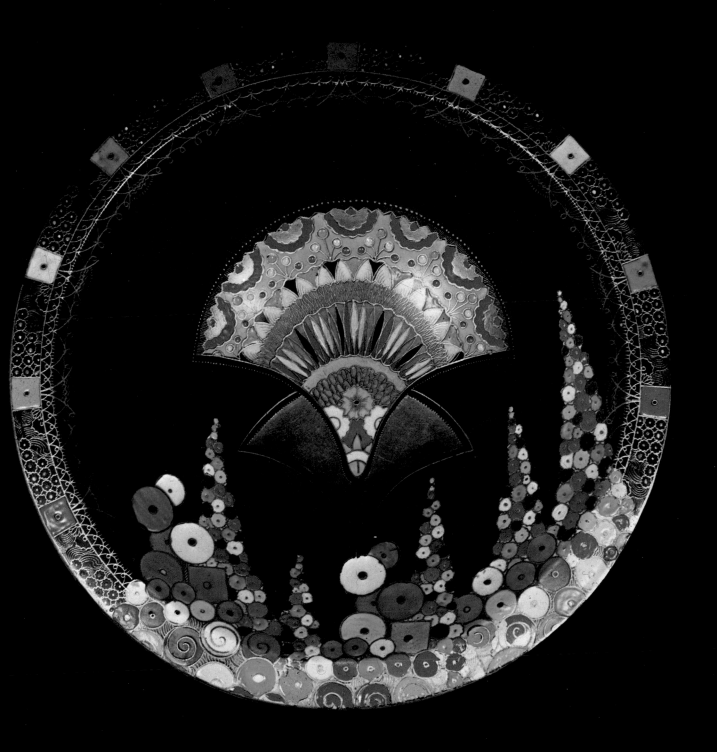

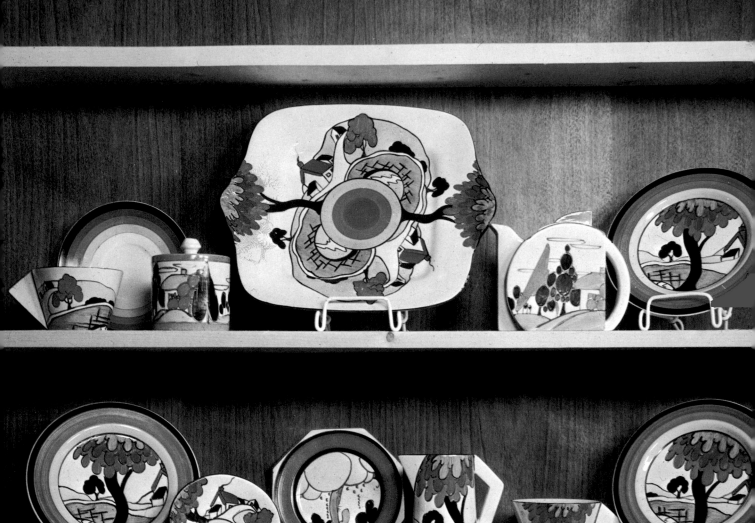
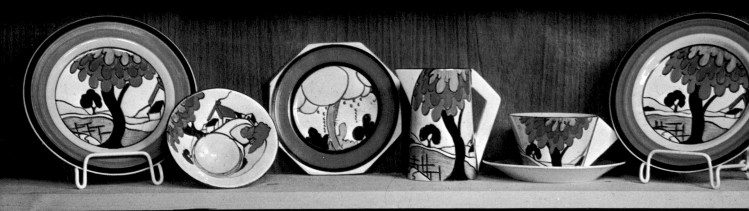
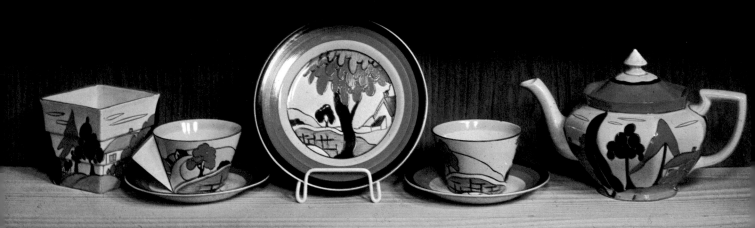

552

553

557

555

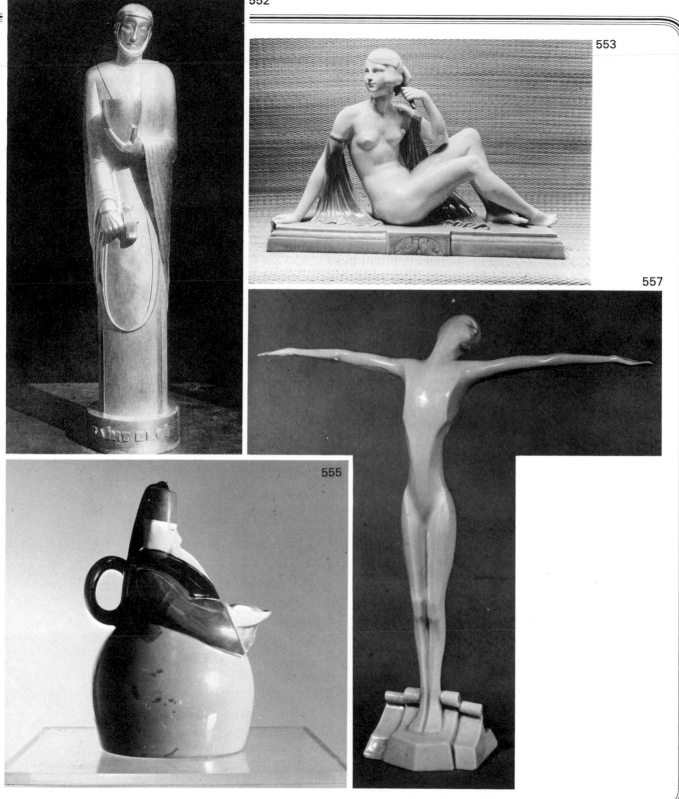

559. ROYAL DOULTON. Vase.
Pottery. 'Brangwyn ware'. Marked '18050'.
Fired in rich palette, purple, dark green, blue,
orange, red and brown.
$7\frac{3}{8} \times 4\frac{1}{2}$.
Anonymous loan.

600. Royal Doulton. 'Barry' service:
coffee-pot, creamer, six cups and saucers.
Decorated in green, black, white and gold.
Teapot: $7\frac{1}{2} \times 6\frac{1}{2}$. Creamer: $3\frac{3}{4} \times 3\frac{3}{4}$.
Cups: $2\frac{1}{2} \times 2\frac{1}{2}$. Saucers: D: $4\frac{1}{2}$.
Coll. Mr Adrian Emmerton.

561. Royal Doulton. Teapot and stand.
Pottery, marked 'Royal Doulton, England.
Titanium'. Decorated with Egyptian figures
and inscribed on body 'Tutankhamen's.
Treasures. Luxor'.
c.1922. $6 \times 7\frac{1}{2} \times 6\frac{1}{2}$.
Anonymous loan.

562. Royal Doulton. Saucer.
Of ware similar to that of preceding item.
Decorated with Egyptian figures on lighter
ground. Mark: 'Royal Doulton. England'.
D: $5\frac{1}{2}$.
Anonymous loan.

563. Royal Doulton. Teapot and creamer.
Pottery with Art Deco shape but
traditional dendriform design, in colored
enamels. Mark: 'Royal Doulton, England.
Syren'.
Teapot: $5 \times 4 \times 2\frac{1}{2}$. Creamer: $3 \times 2 \times 1\frac{1}{2}$.
Anonymous loan.

564. RUMEBE. Vase.
Stoneware with brown and blue flecked
decoration.
c.1930. $11\frac{1}{2} \times 6\frac{1}{2}$.
Courtesy of M. Alain Lesieutre.

565. EDOUARD MARCEL SANDOZ.
Coffee-service.
Porcelain, designed by Sandoz for
Haviland, Limoges.
Courtesy of M. Alain Lesieutre.

566. Sandoz. Teapot and sugar bowl.
Designed by Sandoz for Haviland,
Limoges, in the form of ducks. $7 \times 10\frac{3}{4} \times 5$.
Courtesy of Sonnabend Gallery.

567. SÈVRES. Tea-caddy with cover.
Porcelain.
1924. H: 4.
Courtesy of M. Alain Lesieutre.

568. Sèvres. Vase.
Porcelain, decorated in blue and brown.
c.1925. 10×5.
Courtesy of Lillian Nassau, Ltd.

569. Sèvres. Bowl.
Porcelain. Decoration of birds and flowers
by Emile-Jacques Ruhlmann.
1925. $8\frac{1}{2} \times 10$.
Courtesy of M. Alain Lesieutre.

570. Sèvres. Small vase.
Glazed in white and mushroom.
c.1925. H: $3\frac{1}{2}$.
Courtesy of M. Alain Lesieutre.

571. Sèvres. Vase.
Porcelain. Decorated in blue and brown.
c.1925. 10×5.
Courtesy of Lillian Nassau, Ltd.

**572. SHELLEY POTTERIES, LTD, THE
FOLEY, LONGTON, STAFFORDSHIRE,
ENGLAND.** China tea-service.
Mark: 'Shelley China England Rd. 756533',
printed in black. The shape was registered on
July 18, 1930.
c.1930.
Lent by Victoria and Albert Museum.

573. Shelley Potteries. Tea-service.
Decorated in yellow, black and silver.
c.1935.
Coll. Miss Marie Middleton.

574. Shelley Potteries. Advertisement
figure for Shelley china.
Porcelain figure of woman in patterned
dress and cloche hat.
$12 \times 5\frac{1}{2}$.
Coll. Dr K. C. P. Smith and Mr Paul Smith.

575. JOHN SKEAPING (1901–).
Figure of group of Axis deer.
Earthenware, cream-glazed. Designed by
Skeaping for Josiah Wedgwood and Sons,
1927. Mark: 'Wedgwood' impressed.
H: 8.
Exh: *The Jazz Age*, Brighton Museum and
Art Gallery, 1969, cat.no.169.
Lent by Victoria and Albert Museum.

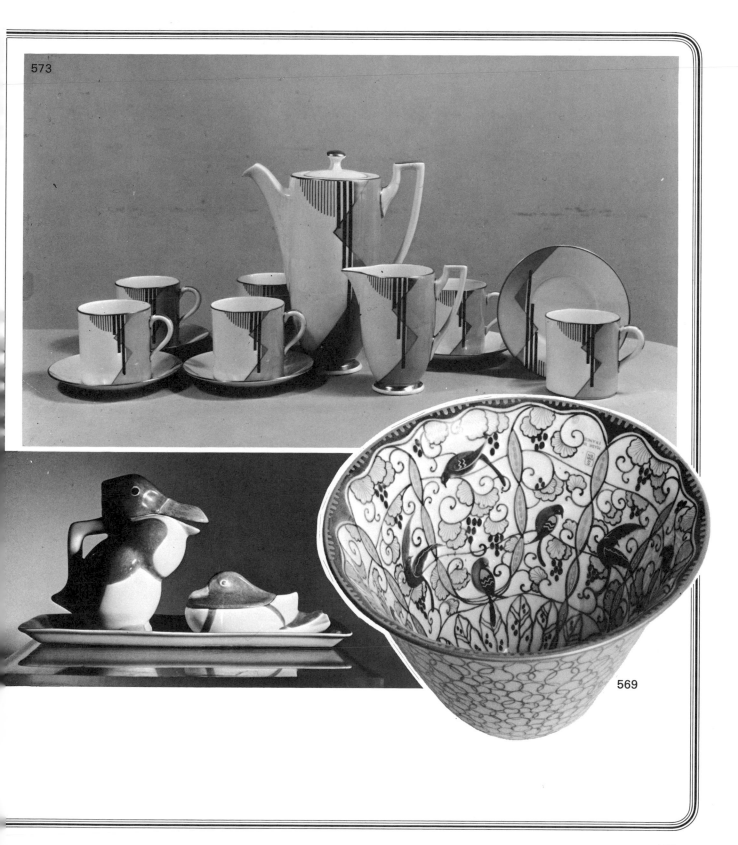

573

569

576. MADELEINE SOUGES (ATELIER PRIMAVERA). Vase.
Stoneware executed by Primavera, Paris.
c.1925. $12\frac{1}{2} \times 5$.
Lent by Art Galleries, Cranbrook Academy of Art.

577. TRAVERSE. *Leda and the Pelican.*
Porcelain figure.
c. 1925. $10 \times 8\frac{1}{2} \times 4\frac{1}{4}$.
Courtesy of Sonnabend Gallery.

578. TUTANJEAN. Pottery statue of woman and dog.
$31 \times 10 \times 10$.
Coll. Mr John Jesse.

578a. VLAMINCK. Vase.
Bold colors.
1920. $11 \times 5\frac{1}{2}$.
Courtesy of M. Alain Lesieutre.

579. WADE, ENGLAND. *Greta.*
Figure of dancer.
$8 \times 5\frac{1}{2} \times 3\frac{1}{2}$.
Coll. Dr K. C. P. Smith and Mr Paul Smith.

580. ERNST WAHLISS. Vase.
Decorated with tall standing figures holding bowls at which two cocks are feeding, on front and reverse. Design after Klimt.
c.1917.
Coll. Mr Harvey Feinstein.

581. LOUIS WAIN. Cat.
Pottery figure in cubist style painted green and orange.
1913. $11 \times 6 \times 4\frac{1}{2}$.
Coll. Mr John Jesse.

582. Wain. Cat.
Pottery figure painted black.
1913. $5\frac{1}{4} \times 3\frac{1}{2} \times 2$.
Coll. Mr John Jesse.

583. Wain. Dog.
Pottery figure.
1913. $5\frac{1}{4} \times 3 \times 2$.
Coll. Mr John Jesse.

584. Wain. Pig.
Pottery figure.
1913. $4\frac{3}{4} \times 3 \times 3\frac{1}{2}$.
Coll. Mr John Jesse.

585. WIENER WERKSTÄTTE. Bowl
with ceramic openwork.
1930. $4\frac{1}{2} \times 8\frac{1}{4}$.
Courtesy of Lillian Nassau, Ltd.

585a. Werkstätte. Water pitcher.
Blue-grey ceramic, circular with one-quarter indentation for handle.
c. 1930. 8×8.
Coll. Mr Harvey Feinstein.

585b. Anne Zinkeisen. *Eve.*
Plaque. Executed in Wedgwood.
1921.
Awarded silver medal in *Paris Exposition, 1925.*
Lent by Art Galleries, Cranbrook Academy of Art.

586. EXAMPLES FROM A COLLECTION OF PLASTER HEADS. Plaster, full face.
Flesh-colored with glossy carmine lips, gold hair and blue eye shadow. Blue blouse trim; blue ear-rings. Unmarked.
$11 \times 8 \times 5$.
Coll. Miss Marie Middleton.

587. Plaster, three-quarters profile.
Yellow face, carmine hat, glossy carmine lips. Gold hair, pink neck bow. Unmarked.
$13 \times 8 \times 5$.
Coll. Miss Marie Middleton.

588. Plaster, 'orange-peel' textured, flesh-coloured three-quarters profile.
Wide hat, dark green and orange. Orange lips, glossy brown stylized hair. Mark: 'Marguerite by Jon Douglas copyright Rd. No. 3377, Made in England'.
$15 \times 12 \times 8\frac{1}{2}$.
Coll. Miss Marie Middleton.

589. Plaster, three-quarters profile.
Yellow face, orange lips and finger-nails. Hand holding green spatter-painted fan. Stylized crimson hair, crimson eyebrows. Unmarked.
$13\frac{1}{2} \times 7 \times 3$.
Coll. Miss Marie Middleton.

590. White pottery, cream-colored full-face.
Blue and orange hat, orange lips, grey eyes, green collar, blue ear-rings. Mark: 'Czechoslovakia 15177'.
$8\frac{1}{2} \times 6\frac{1}{2} \times 1\frac{1}{2}$.
Coll. Miss Marie Middleton.

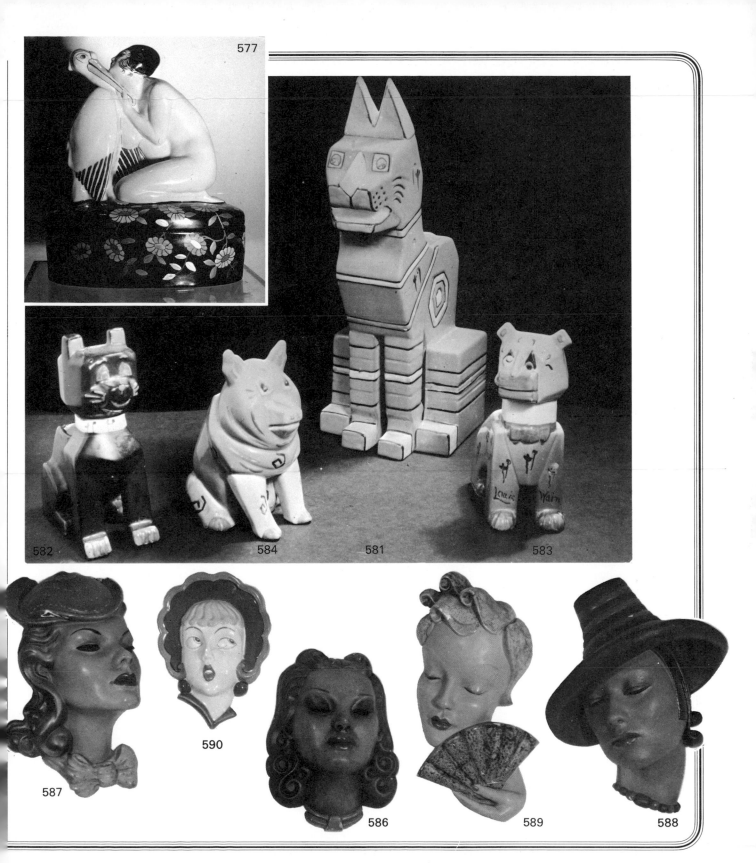

577

582 584 581 583

587 590 586 589 588

Glass

591. ANONYMOUS. Glasses.
Crystal engraved and opaque black.
c.1930. $6\frac{1}{2} \times 4\frac{1}{2}$.
Courtesy of Lillian Nassau, Ltd.

592. ANON. Atomizer.
With etched ruby panels. Czechoslovakian.
c.1935. 4×3.
Coll. Miss Barbra Streisand.

593. ANON. Two perfume bottles.
Cut and enamelled in black geometric
design.
c.1928. $7 \times 4\frac{1}{2} \times 4\frac{1}{2}$.
Coll. Mr Stanley Insler.

594. ANON. Vase set.
Graduated glass bricks. American.
c.1930. H: 7, 6, $3\frac{1}{2}$.
Coll. Mr Edward Lee Cave.

595. ANON. Atomizer and matching
perfume bottle.
Black glass container with multi-colored top
in rectangular design.
c.1930. H: 5, $4\frac{3}{4}$.
Coll. Mr Fred Hughes.

596. ANON. Perfume-bottle.
Glass, metal, soft enamel, marcasites.
Austrian.
c.1930. $4 \times 2\frac{1}{2}$.
Coll. Miss Jean Leonard.

597. ANON. Dresser-set.
Glass, black with gold trim. Two perfume
bottles with stopper and powder vase.
c.1930. H: $4\frac{1}{2}$, 3.
Coll. Miss Jean Leonard.

598. ANON. Liqueur-set.
Geometric red design.
c.1935. Decanter: $9\frac{1}{2} \times 5\frac{1}{2}$.
Glasses: $2\frac{3}{4} \times 2\frac{1}{4}$. Vase: 5×5.
Coll. Mr and Mrs Peter M. Brant.

599. ANON. Decanter.
Black and white glass. Probably French.
c.1930. $8\frac{3}{4} \times 7\frac{1}{8}$.
Illus: Hillier, *Art Deco*, 1968, p.134.
Anonymous loan.

600. ANON. Perfume-bottle.
Enamelled.
Anonymous loan.

601. ANON. Bottle.
Lapis-blue body with design of dancing
nude woman; plain glass stopper with
engraved flourishes.
$8\frac{1}{2} \times 4 \times 1$.
Anonymous loan.

602. ANON. Engraved glass box with two
bottles.
Blue enamelled lids and covers.
Probably French.
c.1925. Bottles: $3\frac{5}{8} \times 3\frac{1}{2} \times 2\frac{1}{4}$.
Box: $3\frac{1}{2} \times 2\frac{1}{4} \times 1\frac{1}{4}$.
Anonymous loan.

603. ANON. Looking-glass.
Cut decoration of fountain motif.
c.1930. $25\frac{1}{2} \times 17\frac{1}{2} \times \frac{3}{4}$.
Anonymous loan.

604. ANON. Basket of fruit.
Crystal, frosted with removable cover.
$7\frac{1}{2} \times 12\frac{1}{2} \times 8$.
Courtesy of M. Alain Lesieutre.

605. ANON. Scent-bottle.
Cut glass with moulded decoration.
Possibly French.
c.1930.
Lent by Victoria and Albert Museum,
Bequest of the Hon. Dame Ada
MacNaughton.

606. ANON. Glass vase.
Acid etched and tinted in pink.
12×6.
Coll. Mr and Mrs Matthew Stein.

607. ANON. Scent bottle.
Imitation malachite nude woman as bottle
and plain glass stopper.
Coll. Dr K. C. P. Smith and Mr Paul Smith.

608. ANON. Two scent-flagons.
Coll. Mr Adrian Emmerton.

609. G. ARGY-ROUSSEAU (1885–).
Lamp.
Pâte de verre with colored flowers.
6×3.
Coll. Miss Barbra Streisand.

610. Argy-Rousseau. Two female figures.
Misty white and purple.
c.1925. $13 \times 9\frac{1}{2}$.
Literature: Ray and Lee Grover, *European
Art Glass*, 1970, p.92, no.120.
Courtesy of M. Alain Lesieutre.

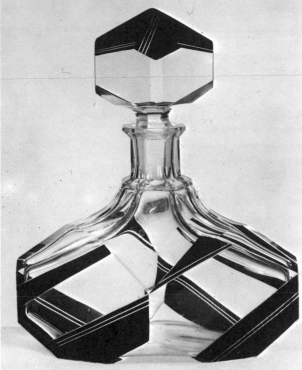

599

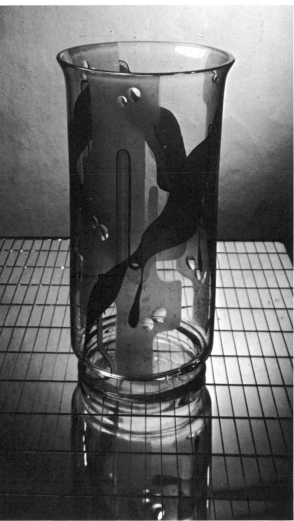

606

603

611. Argy-Rousseau. Stylized turkey.
c.1925. 5 × 8½ × 5.
Courtesy of M. Alain Lesieutre.

612. Argy-Rousseau. Vase.
Green, in artichoke form.
1930. 8½ × 4½.
Courtesy of M. Alain Lesieutre.

613. Argy-Rousseau. Bowl.
Decorated with seagulls with border of
purple shields.
4½ × 5½.
Courtesy of M. Alain Lesieutre.

614. Argy-Rousseau. Vase.
Decorated with masks, satyr, lamb and
girls; brown and red.
c.1925. 9 × 4.
Courtesy of M. Alain Lesieutre.

615. Argy-Rousseau. Vase.
Pale sage green and tortoiseshell with
chevron motifs; two handles.
c.1930. 9½ × 8 × 4.
Courtesy of M. Alain Lesieutre.

616. Argy-Rousseau. Bowl.
Violet with design of lion and parrot.
5½ × 5.
Courtesy of M. Alain Lesieutre.

617. Argy-Rousseau. Vase.
Tortoiseshell.
c.1930. 6 × 6½.
Illus: Ray and Lee Grover, *European Art
Glass,* 1970, p.92, no. 102.

618. Argy-Rousseau. Covered box.
Green and tortoiseshell, cylindrical with
floral decoration.
c.1930. 3 × 4½.
Illus: Ray and Lee Grover, *European Art
Glass,* 1970, p.87, Pl.109.
Courtesy of M. Alain Lesieutre.

619. Argy-Rousseau. Covered box.
Cylindrical with red masks.
c.1930. 2½ × 5½.
Courtesy of M. Alain Lesieutre.

620. Argy-Rousseau. Parrot.
Cream with yellow crest and tail; base
tinted with blue and purple.
c.1925. 5½ × 2½ × 2½.
Courtesy of M. Alain Lesieutre.

621. Argy-Rousseau. Cup.
Geometrical decoration and silvered base.
c.1930. 5 × 7¾.
Courtesy of M. Alain Lesieutre.

622. Argy-Rousseau. Plate.
With bell motifs.
D: 6.
Courtesy of M. Alain Lesieutre.

623. Argy-Rousseau. Bowl.
Amber and black.
6 × 7.
Courtesy of M. Alain Lesieutre.

624. Argy-Rousseau. Two vases.
Decorated in relief with nude women in
panels.
c.1925. 6 × 5 × 4.
Courtesy of M. Alain Lesieutre.

625. Argy-Rousseau. *Pâte de verre* vase.
Design of large stylized female heads.
7½ × 4.
Anonymous loan.

626. Argy-Rousseau. *Pâte de verre* vase.
Design of gazelles and flowers.
3$\frac{3}{16}$ × 4¾.
Anonymous loan.

627. CHARDER. Vase.
Blue and purple with cut geometric design.
c.1930. 6 × 5.
Courtesy of Barry and Audrey Friedman,
Antiques.

628. G. CHEVALIER. Bottle with plain
stopper.
Stylized vegetation in orange, cream and
purple enamel.
8¾ × 3.
Anonymous loan.

629. ARISTIDE COLOTTE. Vase.
Oval crystal with carved heads of horses.
c.1930. 7 × 7½.
Courtesy of Lillian Nassau, Ltd.

630. CORNING GLASS WORKS. Vase.
Wisteria colored crystal, flaring slightly from
bottom to top in eight vertical sections, four
cut with panels of vertical parallel grooves,
four with leaf pattern.
c.1931. 7 × 7.
Lent by Art Galleries, Cranbrook Academy
of Art.

631. Corning Glass Works. Bottle with
stopper.
Crystal.
c.1928. 9 × 4¾.
Lent by Art Galleries, Cranbrook Academy
of Art.

632. COSTA. Fish.
1925. 5½ × 8 × 3.
Courtesy of M. Alain Lesieutre.

633. ANTOINE DAUM (1864–1930).
Vase.
c.1929. 10 × 5¾.
Lent by Art Galleries, Cranbrook Academy
of Art.

634. DAUM AND WALTER. Fish.
Yellow on green waves.
4½ × 7 × 6½.
Illus: Ray and Lee Grover, *European Art
Glass,* 1970, p.161, Pl.110.
Courtesy of M. Alain Lesieutre.

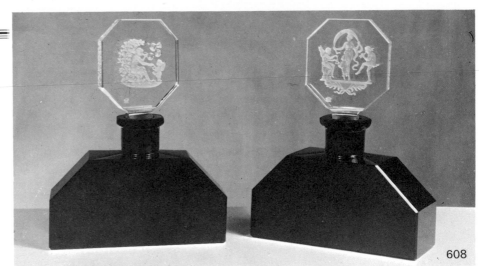

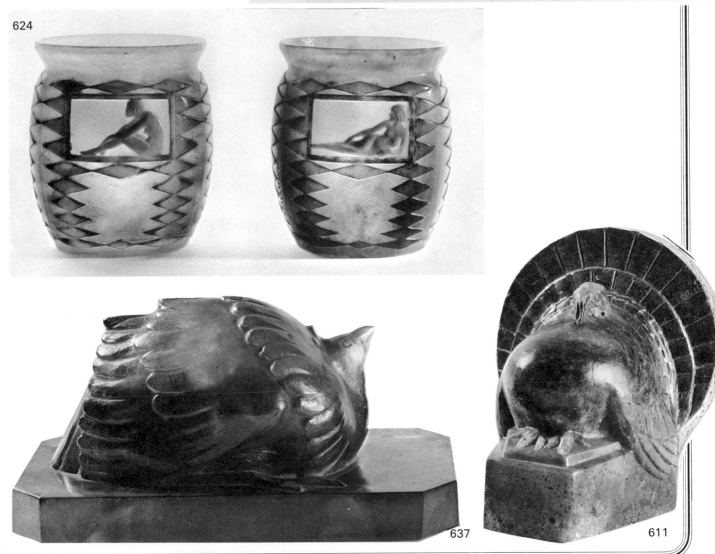

608

624

637

611

635. Daum and Walter. Owl.
Pale violet on green base.
7 × 4 × 5.
Courtesy of M. Alain Lesieutre.

636. Daum and Walter. Ermine.
Cream and green on green base.
c.1930. $4\frac{1}{2}$ × 11 × $3\frac{1}{2}$.
Courtesy of M. Alain Lesieutre.

**637. FRANCOIS-EMILE
DECORCHEMONT** (1880–).
Turkey. Green.
1930. 7 × 5 × $5\frac{1}{2}$.
Courtesy of M. Alain Lesieutre.

638. Decorchemont. Fish.
Blue glass.
c.1930. $9\frac{1}{2}$ × $11\frac{1}{2}$ × 5.
Courtesy of M. Alain Lesieutre.

639. Decorchemont. *Veilleuse.*
Tortoiseshell effect.
c.1935. $4\frac{1}{2}$ × $9\frac{1}{2}$ × $5\frac{1}{2}$.
Courtesy of M. Alain Lesieutre.

640. Decorchemont. Vase.
Brown crystal with handles.
c. 1935. $4\frac{1}{2}$ × $4\frac{1}{2}$ × 5.
Courtesy of M. Alain Lesieutre.

641. Decorchemont. Bowl.
Glass.
c.1926. $6\frac{1}{8}$ × $9\frac{3}{4}$.
Lent by Art Galleries, Cranbrook Academy
of Art.

641a. Decorchemont. Bowl.
Glass.
c. 1927. $6\frac{1}{2}$ × $10\frac{1}{2}$.
Lent by Art Galleries, Cranbrook Academy
of Art.

642. Decorchemont. Vase.
Purple crystal with handles.
c.1935. 4 × 4 × 5.
Courtesy of M. Alain Lesieutre.

643. Decorchemont. Bowl.
Decorated with coiled snake.
c.1925. $3\frac{1}{2}$ × 9.
Courtesy of M. Alain Lesieutre.

644. Decorchemont. Vase.
Decorated with bearded masks.
c.1935. $5\frac{1}{2}$ × $3\frac{1}{2}$.
Courtesy of M. Alain Lesieutre.

645. Decorchemont. Frog.
Yellow ochre, green and blue on black glass
base.
c.1935. 3 × $5\frac{1}{2}$ × $5\frac{1}{2}$.
Courtesy of M. Alain Lesieutre.

646. DELRAUX. Bulbous glass bottle with
stopper.
Enamelled tulips on body. Signed:
Delraux 18 rue Royale Paris.
$6\frac{3}{8}$ × $4\frac{3}{4}$.
Anonymous loan.

647. VICTOR DURAND (1870–1931).
Vase.
Blue iridescent glass, slightly flared at top.
c.1928. 7 × 5.
Courtesy of Barry and Audrey Friedman,
Antiques.

648. ETLING. Book-end.
Frosted-glass figure mounted on wood.
1930. $5\frac{3}{4}$ × $7\frac{1}{2}$.
Courtesy of Lillian Nassau, Ltd.

649. CLYNE FARQUHARSON. Vase.
Clear glass with engraved decoration.
Designed by Farquharson and produced by
John Walsh, Birmingham, England.
c.1935. $8\frac{1}{2}$ × $8\frac{1}{8}$.
Lent by Victoria and Albert Museum.

650. LOTTE FINK. Vase.
Designed by Fink and executed by J. and L.
Lobmeyr, Vienna.
c.1924. 7 × $5\frac{3}{4}$.
Lent by Art Galleries, Cranbrook Academy
of Art.

651. JEAN-MICHEL FRANK
(–1944). Ornaments.
Glass on gessoed and painted stands.
$12\frac{3}{8}$ × $11\frac{1}{4}$ × $4\frac{5}{8}$.
Lent by the Cooper-Hewitt Museum of Art
and Design, Smithsonian Institution, Gift
of Mr and Mrs Forsythe Sherfesee.

652. EMILE GALLÉ. Vase.
Engraved glass with design of elephants and
palm trees against pale green ground.
c.1900. 9 × 4.
Illus: *L'Estampille,* September, 1970,
no.13, p.37.
Courtesy of M. Alain Lesieutre.

653. SIMON GATE (1883–1945). Bottle.
$10\frac{3}{4}$ × $4\frac{1}{4}$.
Exh: Swedish Association of Arts and
Crafts Exhibition, 1927.
Lent by Art Galleries, Cranbrook Academy
of Art.

654. GENSOLI. Vase.
White glass.
1925.
Courtesy of M. Alain Lesieutre.

655. MARCEL GOUPY. Vase.
Orange-enamelled glass.
c.1930.
Illus: Ray and Lee Grover, *European Art
Glass,* 1970, p.194, Pl.334.
Courtesy of M. Alain Lesieutre.

656. Goupy. Faceted bottle.
Orange and black enamel with floral design.
$8\frac{7}{8}$ × $4\frac{1}{8}$.
Anonymous loan.

657. EDWARD HALD. Bowl.
Decagonal, flaring straight from base to rim,
heavy crystal with engraved ornament of
Europa and the Bull on the base.
$3\frac{1}{8}$ × $5\frac{7}{8}$.
Exh: International Exhibition of Glass and
Rugs, 1929.
Lent by Art Galleries, Cranbrook Academy
of Art.

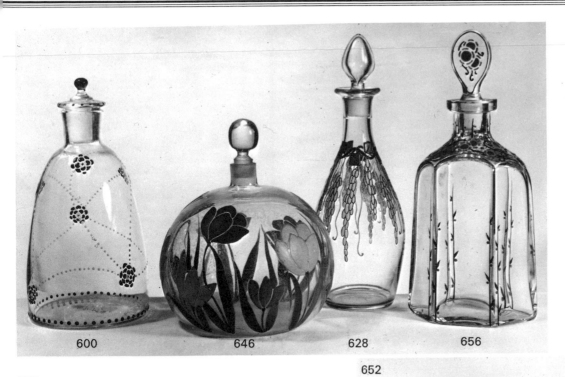

600 646 628 656

652

638

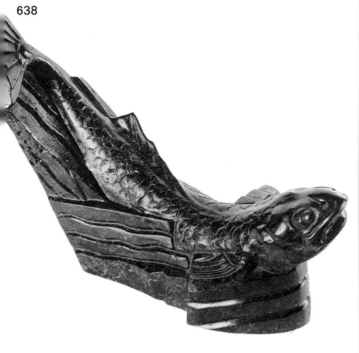

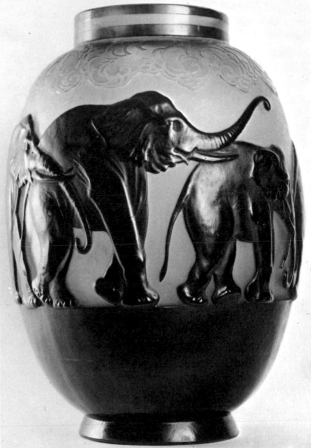

658. V. HENDRYX. Vase.
Glass with transparent crackle.
c.1931. 12 × 4.
Courtesy of Lillian Nassau, Ltd.

659. A. HUNNEBELLE. Vase.
Crystal and blue-green grooves.
6½ × 6.
Coll. Miss Margaret Mary Olson.

660. RENÉ LALIQUE (1860–1945).
Carthage.
Vase of clear glass with matt-finished
exterior. Carved bird motif on each of eight
glass buttresses.
7⅜ × 8⅝.
Literature: *Oeuvres de Lalique*, Paris, 1932.
Lent by Cooper-Hewitt Museum of Design,
Smithsonian Institution, gift of Mrs Sidney
Friedman.

661. Lalique. *Petrarque.* Vase.
Thick-walled, cylindrical with matt-finish
exterior. Two large vertical semicircular
handles moulded in bird and flower design.
8⅝ × 13⅜ × 5⅞.
Literature: *Catalogue de Verreries de René
Lalique*, Paris, 1932.
Lent by Cooper-Hewitt Museum of Design,
Smithsonian Institution, gift of Jacques
Jugeat.

662. Lalique. *Sirène.* Dish.
Circular and satin-finished exterior,
moulded with central figure of nude woman.
2⅝ × 14½.
Literature: *Catalogue de Verreries de René
Lalique*, Paris, 1932.
Lent by Cooper-Hewitt Museum of Design,
Smithsonian Institution, gift of Jacques
Jugeat.

663. Lalique. Vase.
Four vertical clear-glass panels, each
moulded on both sides with two-leafed
branch borders.
c.1940. 9½ × 8.
Lent by Cooper-Hewitt Museum of Design,
Smithsonian Institution, gift of Jacques
Jugeat.

664. Lalique. *Pavot.* Scent-bottle with
stopper.
Red and black on clear glass body with
relief-moulded leaf pattern.
2¼ × 2⅜.
Literature: *The Queen*, 1929.
Lent by Cooper-Hewitt Museum of Design,
Smithsonian Institution, bequest of Joseph
L. Morris.

665. Lalique. Bowl.
Antelope motif handles.
c.1925. 5½ × 18¾ × 5¼.
Illus: Hillier, *Art Deco*, 1968, p.70.
Anonymous loan.

666. Lalique. Box.
Decorated with cat's eyes in the lid.
1 13/16 × 3 13/16.
Anonymous loan.

667. Lalique. Bowl.
With stylized flowers in relief.
c.1930. 10½ × 10½.
Courtesy of M. Alain Lesieutre.

668. Lalique. Bowl.
Decorated with nude nymphs.
c.1930. 3 × 14½.
Coll. Mr and Mrs Lewis V. Winter

669. Lalique. Female figure.
c.1930. 8 × 4½ × 3.
Courtesy of M. Alain Lesieutre.

670. Lalique. Female figure with draped
arms.
c.1930. 9 × 7 × 1½.
Courtesy of M. Alain Lesieutre.

671. Lalique. Three glass seal-stamps.
In the form of an owl, an eagle and fish.
c.1930. Owl: 3½. Eagle: 3½. Fish: 2.
Courtesy of M. Alain Lesieutre.

672. Lalique: Knife-rests.
Engraved crystal, clear and frosted, in the
form of dragonflies.
c.1925. 4½ × 2½.
Courtesy of M. Alain Lesieutre.

673. Lalique. Three figures of birds.
Frosted crystal.
H: 3½.
Courtesy of M. Alain Lesieutre.

674. Lalique. Vase, with large handles.
c.1925. 8½ × 13½ × 6.
Courtesy of M. Alain Lesieutre.

675. Lalique. Vase with design of
budgerigars.
c.1925. 10½ × 9.
Courtesy of M. Alain Lesieutre.

676. Lalique. Perfume-bottle.
Clear and frosted crystal with eight
rectangular reliefs containing semi-nude
women with veils, after the Pompeiian
frescoes. Tinted topaz brown.
5½ × 3 × 3.
Courtesy of M. Alain Lesieutre.

677. Lalique. Vase.
Design of thorns. Pale-brown tint on frosted
glass; pattern of criss-crossed briars in high
relief.
c.1930. 8½ × 3¾.
Courtesy of M. Alain Lesieutre.

678. Lalique. Clock.
Frosted glass, moulded in rose tint. Motif of
four kissing doves surrounding clock-face.
c.1930. 6½ × 8½ × 3½.
Courtesy of M. Alain Lesieutre.

679. Lalique. Clock.
Parabola shape with two kissing doves at
the top. Outside surface covered in stylized
apple blossoms and boughs.
c.1930. 8½ × 6½ × 3½.
Courtesy of M. Alain Lesieutre.

667

661

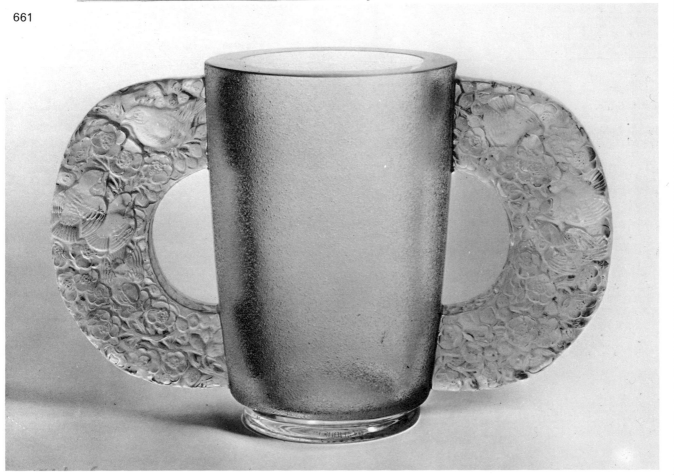

680. Lalique. Ten wine glasses and two decanters.

Two *vin rouge*	$4\frac{1}{4} \times 3\frac{1}{4}$
Two champagne	$4 \times 3\frac{3}{4}$
Two *vin blanc*	$3\frac{1}{2} \times 2\frac{1}{2}$
Two port	$3\frac{1}{2} \times 2$
Two water	$4\frac{1}{2} \times 4$
Two decanters	$9\frac{1}{2} \times 4\frac{1}{2}$

Courtesy of M. Alain Lesieutre.

683. Lalique. Eagle-head radiator mascot. Of the kind Hitler presented to his marshals for their Mercedes limousines.
$5\frac{1}{2} \times 6 \times 4$.
Courtesy of Mr John Jesse.

684. LEE LAWRIE. Plaque.
Black and gold carved glass.
Executed by the Hariton Carved Glass Works.
c.1930. 28 × 32.
Coll. Mr and Mrs Lewis Winter.

685. LOETZ. Art Nouveau vase.
Iridescent veined vase with silver inlay in geometric design.
$10\frac{1}{2} \times 5$.
Coll. Dr K. C. P. Smith and Mr Paul Smith.

686. JEAN LUCE. Inkwell.
Etched glass.
1925. $5\frac{1}{2} \times 5$.
Courtesy of Lillian Nassau, Ltd.

687. Luce. Vase.
c.1929. $8\frac{1}{2} \times 6$.
Purchased from Edgar Brandt, 1929.
Lent by Art Galleries, Cranbrook Academy of Art.

688. Luce. Vase.
Blue glass with band of etched ornamental lines.
$7\frac{3}{8} \times 5$.
Exh: International Exhibition of Glass and Rugs, 1929.
Lent by Art Galleries, Cranbrook Academy of Art.

689. MAURICE MARINOT (1882–1960).
Circular bowl.
For caviar, flares outward from base.
$3\frac{3}{4} \times 5$.
Exh: Modern Decorative Art at Seligmann, 1926.
Lent by Art Galleries, Cranbrook Academy of Art.

690. Marinot. Bottle.
$7\frac{3}{4} \times 3\frac{5}{8}$.
Exh: Modern Decorative Art at Seligmann, 1926.
Lent by Art Galleries, Cranbrook Academy of Art.

691. Marinot. Bottle with stopper.
$6\frac{3}{4} \times 2\frac{3}{4}$.
Exh: Modern Decorative Art at Seligmann, 1926.
Lent by Art Galleries, Cranbrook Academy of Art.

692. Marinot. Bottle with stopper.
$4\frac{3}{4} \times 2\frac{1}{2}$.
Exh: Modern Decorative Art at Seligmann, 1926.
Lent by Art Galleries, Cranbrook Academy of Art.

693. Marinot. Box with cover.
c.1931. $3\frac{7}{8} \times 4$.
Courtesy of Lillian Nassau, Ltd.

694. Marinot. Vase.
Heavy cut crystal, pale-green with bubbles.
c.1930. H: 6.
Literature: Sotheby's Art Nouveau Catalogue, June 23, 1970, p.28, no.145.
Courtesy of M. Alain Lesieutre.

695. Marinot. Vase.
Heavy cut crystal, yellow-green with large bubbles.
c.1930. H: 7.
Courtesy of M. Alain Lesieutre.

696. Marinot. Vase.
Heavy cut crystal with stopper, brownish-green with bubbles.
c.1930. H: $5\frac{1}{2}$.
Courtesy M. Alain Lesieutre.

697. Marinot. Bottle with stopper.
Heavy cut and tinted crystal, green, violet and brown with bubbles.
c.1930. H: 8.
Courtesy of M. Alain Lesieutre.

698. Marinot. Bottle with stopper.
Heavy cut crystal. grey with bubbles.
Dated 1925. H: $6\frac{1}{4}$.
Exh: Coll. Berthou, Paris.
Courtesy of M. Alain Lesieutre.

699. Marinot. Bottle.
Heavy cut and tinted crystal, 'black caviar' effect.
c.1925. $5\frac{1}{2} \times 5$.
Courtesy of M. Alain Lesieutre.

700. Marinot. Bottle.
Heavy cut and tinted crystal.
c.1925. $5\frac{1}{2} \times 5$.
Courtesy of M. Alain Lesieutre.

683

684

703

701. Marinot. Bottle.
Heavy cut and tinted crystal.
c.1925. 4 × 3½ × 2.
Courtesy of M. Alain Lesieutre.

702. Marinot. Bottle.
Green with encrusted decoration.
c.1925. 9½ × 6 × 4.
Courtesy of M. Alain Lesieutre.

703. MAXONADE, PARIS. Lampshade.
Enamelled purple and yellow.
Coll. Miss Marie Middleton.

704. FRÈRES MULLER. Vase.
Luneville crystal with design of running
foxes.
c.1925. 12 × 8½.
Courtesy of Lillian Nassau, Ltd.

705. Muller. Vase.
Blue decorated with silver horses.
c.1925. H: 9½.
Courtesy of M. Alain Lesieutre.

706. Muller. Vase.
Decorated with green leaves, silver leaf inlay.
H: 9½.
Courtesy of M. Alain Lesieutre.

707. HENRI NAVARRE (1885–).
Vase.
Oval-shaped on small rim base, red and
smoke-colored.
3½ × 2¾ × 3.
Exh: International Exhibition of Glass and
Rugs, 1929.
Lent by Art Galleries, Cranbrook Academy
of Art.

708. Navarre. Vase.
Clear crystal with abstract leaf forms in
black.
c.1926. 6½ × 5¾.
Courtesy of Lillian Nassau, Ltd.

709. Navarre. Vase.
Blue.
4½ × 3½ × 3.
Courtesy of M. Alain Lesieutre.

710. Navarre. Vase.
Heavy crystal.
c.1935. 7½ × 5.
Courtesy of M. Alain Lesieutre.

711. NICOLAS. Vase.
Blue on red base.
c.1930. 9 × 7½.
Courtesy of M. Alain Lesieutre.

712. ORREFORS. Vase.
Engraved by Simon Gate with woman
greeting the sun's rays.
6½ × 4½ × 4½.
Coll. Dr K. C. P. Smith and Mr Paul Smith.

713. Orrefors. Bottle.
Inscribed, 'Denna Plunta Och Tillh'o'r'.
Engraved by Hald with picnic scene.
Silver-plated cork stopper. No.295.25.2.5.
5½ × 4¼.
Anonymous loan.

714. ST. LOUIS. Bowl.
Crystal with etched overlay.
1930. 5¾ × 9¾.
Courtesy of Lillian Nassau, Ltd.

715. JEAN SALA. Vase.
Yellow with white handles.
9½ × 6½.
Courtesy of M. Alain Lesieutre.

716. Sala. Fish.
Green.
c.1930. 6 × 11 × 3½.
Courtesy of M. Alain Lesieutre.

717. Sala. Fish.
Rose-colored.
c.1930. 7½ × 10½ × 4.
Courtesy of M. Alain Lesieutre.

718. SCHNEIDER. Vase.
Orange on black base.
c.1930. 6 × 15¾.
Courtesy of M. Alain Lesieutre.

**718a. MADELAINE SOUGEZ
(ATELIER PRIMAVERA).** Untitled.
Pâte de verre.
1925. 8½ × 6.
Coll. Miss Barbra Streisand.

719. SUE ET MARE. Fruit-bowl with cover.
Crystal.
7 × 13.
Courtesy of Galerie du Luxembourg.

720. WALTER DORWIN TEAGUE
(1883–). Table-setting.
Saint Tropez pattern, Steuben crystal,
frosted band near rim and lines crossed to
form diamond patterns around the sides,
with small frosted circles at the free points.
Hand cut, mouth blown, and hand
engraved.
c.1933.

Plate	8½
Cocktail glass	3¾ × 3⅛
Champagne glass	3¼ × 4
Wine glass	3⅞ × 2 5/16
Goblet	6¾ × 2⅞
Goblet	5½ × 3⅜
Finger-bowl	3 × 3⅞
Finger-bowl plate	6⅞
Sherbert glass	3½ × 3⅛

Literature: *Studio Year Book*, 1938.
Lent by Art Galleries, Cranbrook Academy
of Art.

721. Teague. Plate.
Steuben crystal engraved with kneeling
female figure in centre holding a bird in each
hand, surrounded by a circle of stars.
c.1933. 8½.
Lent by Art Galleries, Cranbrook Academy
of Art.

722. Teague. Vase.
Cylindrical, Steuben crystal with slight
outward slope, engraved with groups of
parallel lines which intersect.
c.1933. 10⅜ × 5⅞.
Lent by Art Galleries, Cranbrook Academy
of Art.

722a. THARAUD. Vase.
Circular with silver, blue, gold and white
geometric design.
c. 1925. 7½ × 7½.
Courtesy of Barry and Audrey Friedman
Antiques.

723. THURET. Perfume bottle.
Red and clear crystal.
6 × 3¼.
Coll. M. Félix Marcilhac.

724. Thuret. Vase.
Heavy crystal overlay, green with bubbles
and inlay of silver leaves.
4½ × 4½ × 2½.
Courtesy of M. Alain Lesieutre.

Opposite: Cat.no.917.
Overleaf: Cat.nos.907 (above); 1104 (below).

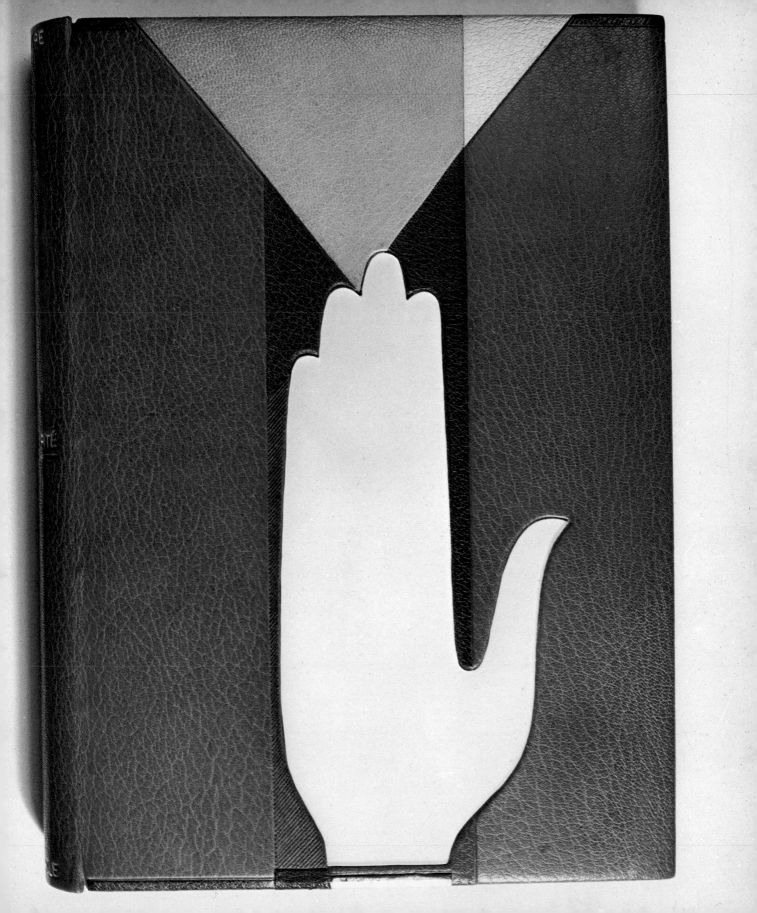

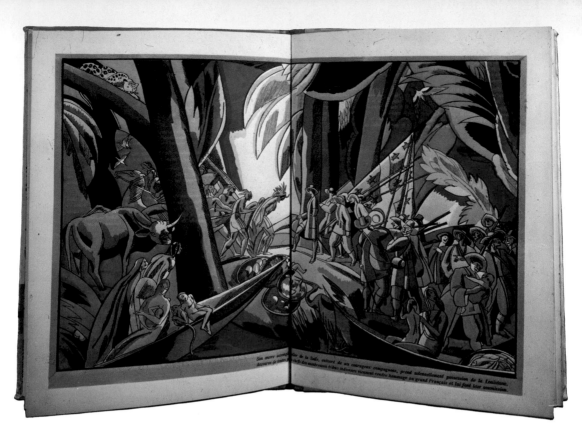

Son œuvre accomplie, Cavelier de la Salle, entouré de ses courageux compagnons, prend solennellement possession de la Louisiane. Accourus de toutes parts, les nombreux tribus indiennes viennent rendre hommage au grand Français et lui font leur soumission.

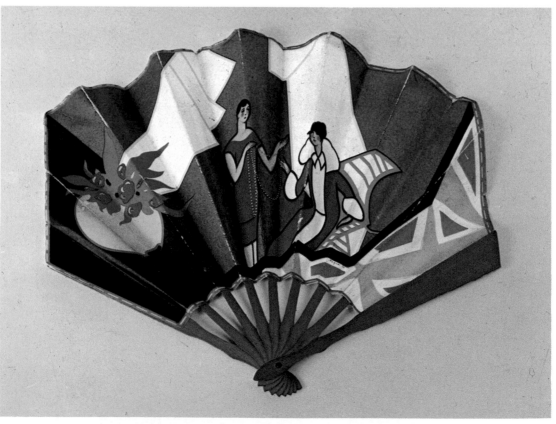

713

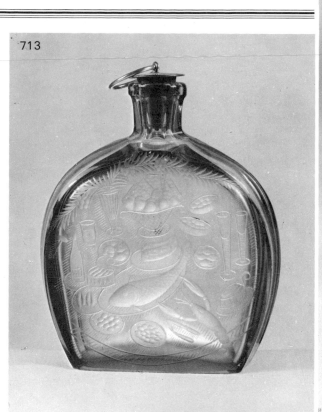

727

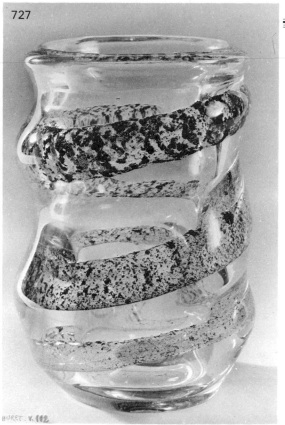

HURET. V. 112.

719

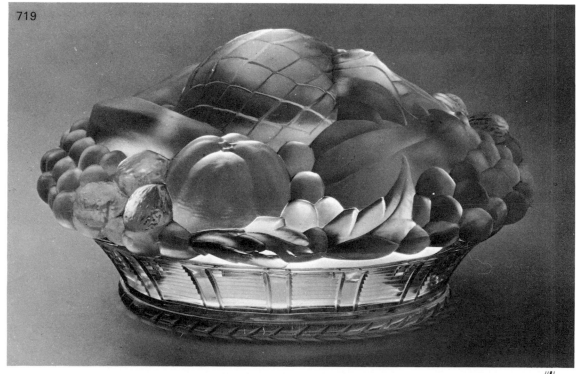

725. Thuret. Vase.
Heavy crystal overlay, blue with air bubbles.
c.1930. $5 \times 5\frac{1}{2} \times 3\frac{1}{2}$.
Illus: Ray and Lee Grover, *European Art Glass*, 1970, p.226, no.404.
Courtesy of M. Alain Lesieutre.

726. Thuret. Vase.
Heavy crystal overlay, purple with air bubbles.
c.1930. $6 \times 4\frac{1}{2}$.
Courtesy of M. Alain Lesieutre.

727. Thuret. Vase.
Heavy crystal with metallic oxidation and green snake design.
c.1930. $10\frac{1}{2} \times 7$.
Illus: Ray and Lee Grover, *European Art Glass*, 1970, p.226. no.406.
Courtesy of M. Alain Lesieutre.

727a. VENINI. Picture-frame.
Murano. Venetian twisted glass.
c. 1930.
Courtesy of Mr Edward Lee Cave.

728. WILHELM VON EIFF. Vase.
Crystal, rounded at the base, slightly concave before flaring at the rim, cut and attached in a pattern of arches within rectangles in a stepped design.
$8\frac{3}{4} \times 7\frac{1}{2}$.
Exh: International Exhibition of Glass and Rugs, 1929.
Lent by Art Galleries, Cranbrook Academy of Art.

729. GASTON LOUIS VUITTON. Bottle.
Square-sided with ebony top, frosted with squares of clear glass cut in parallel lines.
$5\frac{1}{8} \times 2$.
Exh: International Exhibition of Glass and Rugs, 1929.
Lent by Art Galleries, Cranbrook Academy of Art.

730. Vuitton. Seven bottles.
Engraved crystal with gilt silver.
c.1935. H: 2—8.
Coll. Miss Barbra Streisand.

731. ALMERIC WALTER. Vase.
Pâte de Verre.
1925. $5\frac{1}{4} \times 4\frac{3}{4}$.
Coll. Miss Barbra Streisand.

732. Walter. Pair of book-ends.
Faun and Nymph.
$6 \times 4 \times 5\frac{1}{2}$.
Illus: Ray and Lee Grover, *European Art Glass*, p.229, no.412.
Courtesy of M. Alain Lesieutre.

733. Walter. Figure of a pierrot.
Pâte de verre.
c.1935. $10 \times 2\frac{1}{2} \times 4\frac{1}{2}$.
Literature: Ray and Lee Grover, *European Art Glass*, 1970, No. 413.
Courtesy of M. Alain Lesieutre.

734. Walter. Figure of an owl, perched on heart-shaped tray.
Yellow and Green.
$6\frac{1}{2} \times 6 \times 5\frac{1}{2}$.
Courtesy of M. Alain Lesieutre.

735. Walter. Fish on hexagonal green glass plate.
c.1930. D: 7.
Courtesy of M. Alain Lesieutre.

736. Walter. Small blue-bird.
c.1925. $5 \times 2\frac{1}{2} \times 4$.
Courtesy of M. Alain Lesieutre.

737. Walter. Bowl.
Butterfly handles.
c.1930.
Illus: Ray and Lee Grover, *European Art Glass*, p.232, no.423.
Courtesy of M. Alain Lesieutre.

738. Walter. Bowl.
Cat and dog handles.
c.1930. $4\frac{3}{4} \times 7$.
Courtesy of M. Alain Lesieutre.

739. EDGAR WOOD. Looking-glass.
Wooden frame decorated in color.
1928. H: $21\frac{1}{2}$. W at top: $12\frac{3}{4}$.
Coll. Mr Charles Handley-Read.
The cataloguer acknowledges the information from Mr Handley-Read which linked this mirror and the proto-jazz style on the façade of Wood's Royd House (cat.no. 1364).

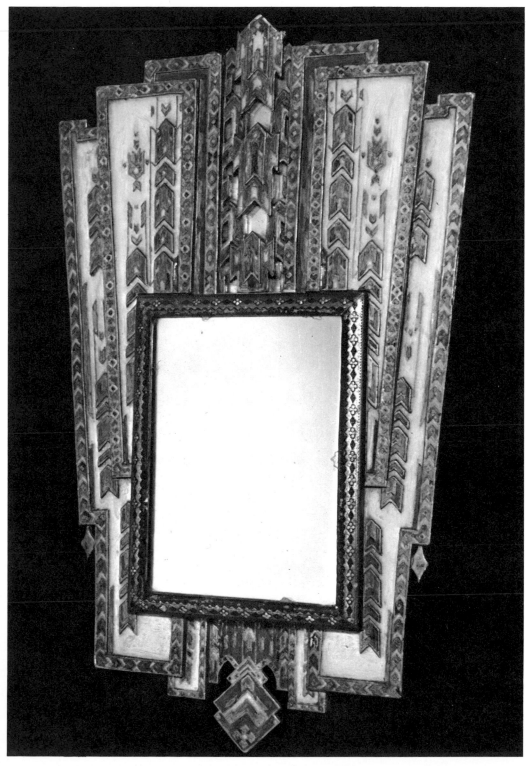

Paintings Drawings

741. ANONYMOUS. Two drawings of nudes: Leda and woman with animal.
1917. 16¼ × 10¼.
Coll. M. Gilbert Silberstein.

742. ANON. *Musidora.*
14¼ × 10¼.
Coll. M. Gilbert Silberstein.

743. ANON. Fashion drawing.
c.1930. 28¼ × 23¼.
Courtesy of Lillian Nassau, Ltd.

744. ALASTAIR. *La Vierge à Sept Douleurs.*
Gouache, pale green, grey, gold and black.
17¾ × 13¾.
Courtesy of Galerie du Luxembourg.

745. LEON BAKST (1866–1924).
Costume design for *Le Dieu Bleu.*
Gouache.
1911. 10¾ × 8¼.
Courtesy of Galerie du Luxembourg.

746. GEORGE BARBIER. Fashion illustration.
6¾ × 5¼.
Courtesy of Robert K. Brown Art & Books.

747. Barbier. *Lesbians.*
Ink, gouache, watercolor and gold on paper. Two women, reclining on a Greek divan covered in tiger skin, background of classical architecture and brazier.
1923. 8½ × 6½.
Courtesy of M. Alain Lesieutre.

748. Barbier. *L'Après-Midi d'un Faune* (Nijinsky).
Ink, with black, red and gold gouache on paper.
1917. 14¼ × 16½.
Courtesy of Galerie du Luxembourg.

749. Barbier. *Le Moure* (Nijinsky in Schéhérézade).
4¾ × 6¼.
Exh: *Les Ballets Russes de Serge Diaghilev,* Strasbourg, 1969.
Courtesy of Galerie du Luxembourg.

750. Barbier. *Nijinsky Dansant.*
1910.
Signed: 'William Larry' (Barbier's pseudonym).
Coll. of M. Alain Cical.

751. Barbier. *Ida Rubinstein.*
1909. 12¼ × 9.
Signed: 'E. William Larry'.
Coll. M. Gilbert Silberstein.

752. Barbier. *Nijinsky.*
1910. 8¾ × 13¾.
Signed: 'Edward William Larry'.
Coll. M. Félix Marcilhac.

753. Barbier. *Le Mandarin.*
Gouache.
1923. 12 × 14.
Courtesy of M. Alain Lesieutre.

754. Barbier. *Femme à la rose.*
Gouache.
1913. 11½ × 7½.
Courtesy of M. Alain Lesieutre.

755. BENITO (reproduced in *Gazette du Bon Ton,* 1922).
11¾ × 9.
Coll. M. Gilbert Silberstein.

756. GUS BOFA. Head of a young girl.
10¼ × 13¼.
Coll. M. Gilbert Silberstein.

757. BOLGUES. Two social scenes.
13¾ × 12¼.
Coll. M. Gilbert Silberstein.

758. BONANOMI. Girl in bathing-costume.
Gouache.
Coll. M. Alain Cical.

759. LOUIS BONAT. *L'Ami de Katty.*
7 × 13.
Coll. M. Alain Cical.

760. ROBERT BONFILS. Drawings, 1914. (Reproduced in *Modes et Manières d'Aujourd'hui.*)
Coll. M. Alain Cical.

761. JULES BOUY. Four drawings. Plans for the dining-room apartment of Miss Agnes Miles Carpenter at 950 Fifth Avenue, New York, 1926. Pencil and crayon on tracing paper.
14 × 20.
Lent by Cooper-Hewitt Museum of Design, Smithsonian Institution, bequest of Agnes Miles Carpenter.

762. PIERRE BRISSAUD (1885–1964).
Le Gallant Vieillard.
c.1927.
Anonymous loan.

763. Brissaud. *Respirons un peu.*
10¼ × 7¼.
Courtesy of Robert K. Brown Art & Books.

764. Brissaud. Two drawings of *baigneuses.*
Watercolor on paper; nude females against Greek architectural background and heavily stylized foliage; one holds a Japanese red parasol.
1945. 8 × 10¼.
Courtesy of M. Alain Lesieutre.

765. UMBERTO BRUNELLESCHI (1886–). Design from *Chansons Arabes.*
Gouache.
c.1927. 5½ × 8.
Anonymous loan.

766. Brunelleschi. Design from *Chansons Arabes.*
Gouache.
c.1927. 5 × 7¾.
Anonymous loan.

767. Brunelleschi. Design from *Chansons Arabes.*
Gouache.
c.1927. 6 × 9.
Anonymous loan.

768. RENÉ BUTHAUD (1886–).
Painting.
Woman and zebra.
18½ × 24.
Courtesy of M. Félix Marcilhac.

769. JOSEF CSAKY (1888–).
Woman with Book.
9 × 4.
Coll. M. Félix Marcilhac.

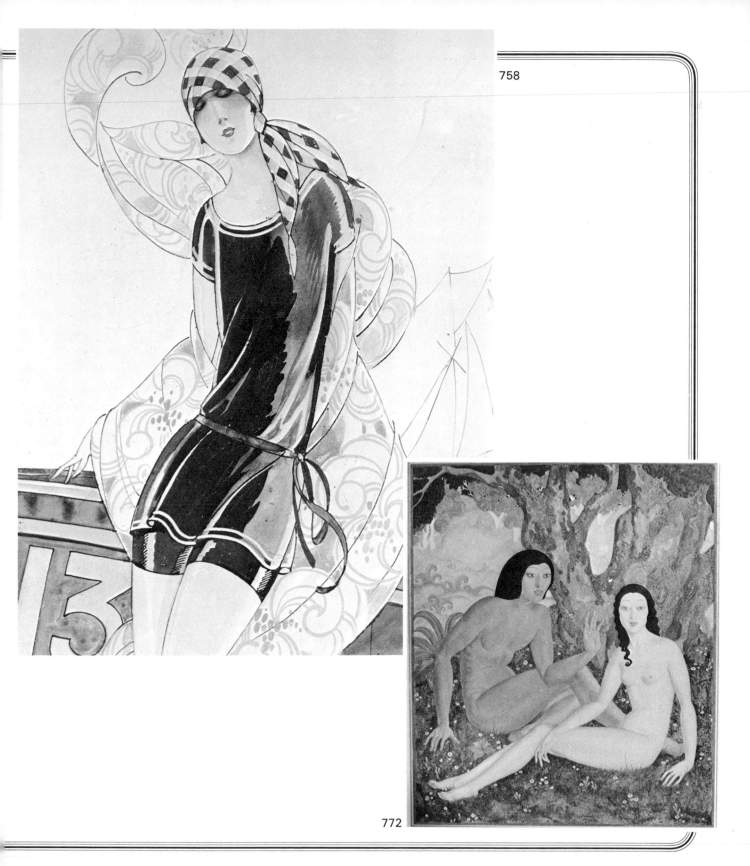

758

772

145

770. Csaky. *Forme humaine.*
1920. 13 × 4.
Courtesy of M. Alain Lesieutre.

771. ROBERT DAMMY. Painting.
11 × 14½.
Courtesy of M. Alain Cical.

772. EDMOND DULAC (1882–1953).
Adam et Eve.
Gouache.
c.1928. 13⅓ × 11½.
Anonymous loan.

773. JEAN DUNAND (1877–).
Untitled.
Silk, painted panels (eight).
1927. 72½ × 12½.
Coll. Mr and Mrs Peter Brant.

774. JEAN DUPAS (1882–).
Two figures.
Oil on paper.
1923. 21¾ × 7½.
Courtesy of Lillian Nassau Ltd.

775. Dupas. Study for poster,
Spring Fashions are Here.
20 × 16.
Coll. Mr Fred Hughes.

776. Dupas. *Woman with fruit and dove.*
Oil on canvas.
1923. 25¾ × 25½.
Courtesy of Lillian Nassau Ltd.

777. Dupas. *Les Perruches*
(The Lovebirds).
Oil on canvas.
1925. 8 × 9.
Coll. Dr and Mrs Leonard Lustgarten.

778. Dupas. *Woman with a parrot
and pigeons.*
Oil on panel.
10 × 10.
Coll. M. Félix Marcilhac.

779. ERTÉ (ROMAIN DE TIRTOFF,
1893–). *Rideau de théâtre.*
Gouache.
c.1927. 7 × 9½.
Anonymous loan.

780. Erté. *Nocturne.*
Gouache.
c.1927. 15¾ × 11¼.
Anonymous loan.

780a. Erté. *L'Eté.*
Gouache.
c.1928. 15½ × 11½.
Anonymous loan.

780b. Erté. *Conte oriental.*
Gouache.
1920. 15 × 10¾.
Anonymous loan.

780c. Erté. *Après l'Orage.*
Gouache.
c.1926. 15½ × 11.
Anonymous loan.

780d. Erté. *La Cage Improvisée.*
Gouache.
1922. 13½ × 10.
Anonymous loan.

780e. Erté. Design of bracelet and bag.
Gouache.
1935. 14½ × 10½.
Anonymous loan.

780f. Erté. Design of globe bottle.
Gouache.
c.1927. 12¾ × 10.
Anonymous loan.

780g. Erté. Slipper.
Gold and tan gouache.
c.1927. 9¾ × 12½.
Anonymous loan.

780h. Erté. Slipper.
Maroon gouache.
c.1927. 9¾ × 12½.
Anonymous loan.

780i. Erté. *Boucles d'oreilles.*
Gouache.
c.1927. 5½ × 4.
Anonymous loan.

780j. Erté. *Peigne en Ambre.*
Gouache.
c.1927. 8½ × 5¾.
Anonymous loan.

780k. Erté. *L'Amore Deitaer.*
14½ × 10⅛.
Courtesy of Robert K. Brown Art & Books.

781. GEORGES DE FEURE.
Nude with Drapes.
9 × 6.
Coll. M. Gilbert Silberstein.

782. De Feure. *Clown.*
Gouache.
1925. 12 × 5½.
Courtesy of M. Alain Lesieutre.

783. De Feure. *Woman in Purple Dress.*
Gouache.
9 × 5½.
Courtesy of M. Alain Lesieutre.

784. De Feure. *Woman in Flowered Hat.*
Gouache.
1925. 10 × 5½.
Courtesy of M. Alain Lesieutre.

784a. PIERRE FIX-MASSEAU
(1809–1937). *Exactitude/Etát.*
Photo-lithograph.
1932. 39⅜ × 24¼.
Coll. The Museum of Modern Art.

785. CHARLES GESMAR (1900–1928).
Mistinguett.
Oil.
c.1927. 17½ × 23.
Courtesy of Sonnabend Gallery.

786. Gesmar. Drawing for poster of
Mistinguett and her dance troupe.
Ink and gouache on paper.
c.1923. 24½ × 13½.
Courtesy of Galerie du Luxembourg.

787. Gesmar. Sketch for Mistinguett
poster.
Pencil, gouache and silver spangles.
28½ × 20.
Courtesy of Galerie du Luxembourg.

788. Gesmar. *Le Diamant Noir.*
Ink and gouache on paper.
c.1923. 18½ × 12.
Courtesy of M. Alain Lesieutre.

788a. EUGENE GISE. *Nazimova in Oscar
Wilde's Salome.*
Lithograph.
1922. 22 × 28.
The Museum of Modern Art, Gift of United
Artists.

789. HARRY. Black man dancing with
white girl.
9½ × 6¼.
Coll. M. Gilbert Silberstein.

le diamant noir

788

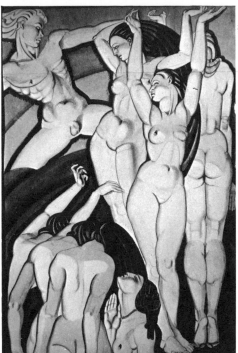

790

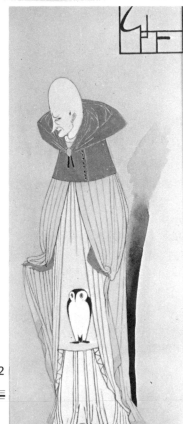

782

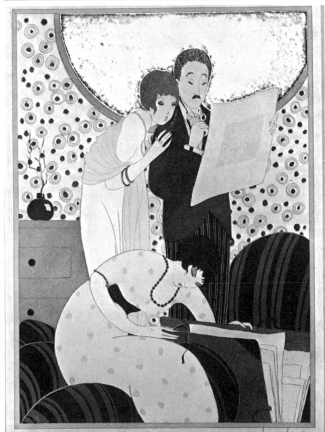

810

790. FRANK HODSON. Watercolor of seven nude female figures and a nude male figure against a sun-ray background of pink and green.
Mounted in black and framed in silver.
Signed and dated, 1930.
The frame bears a plaque: 'Frank Hodson.'
Courtesy of Martins-Forrest Antiques.

791. PAUL IRIBE. Flower with black leaves.
Gouache.
1920. $8 \times 6\frac{1}{2}$.
Courtesy of M. Alain Lesieutre.

792. ROCKWELL KENT (1882–1971).
Illustration.
Ink. 1933. $10\frac{1}{2} \times 11$.
Courtesy of Larcada Gallery.

793. Kent. *Life, Liberty and the Pursuit of Happiness.*
Study for a medallion. Two sketches and final drawing in ink. 1927.
Courtesy of Larcada Gallery.

794. Kent. Book-plate.
Ink.
1930. $6 \times 8\frac{1}{4}$.
Courtesy of Larcada Gallery.

795. Kent. Book-plate.
Ink.
c.1930. $4\frac{3}{4} \times 3\frac{1}{2}$.
Courtesy of Larcada Gallery.

796. Kent. Book-plate.
Ink.
c.1930. $3\frac{3}{4} \times 2\frac{3}{4}$.
Courtesy of Larcada Gallery.

797. Kent. Illustration for automobile advertisement.
Ink.
1932. $3 \times 5\frac{1}{2}$.
Courtesy of Larcada Gallery.

798. Kent. *Two seated figures.*
Pencil tondo.
1930. $3\frac{1}{2}$.
Courtesy of Larcada Gallery.

799. Kent. *Figure by stream.*
Pencil tondo.
1930. $3\frac{1}{2}$.
Courtesy of Larcada Gallery.

800. Kent. *Figure with bird and flower.*
Pencil tondo.
1930. $3\frac{1}{2}$.
Courtesy of Larcada Gallery.

801. Kent. Illustration for *N.Y. Tribune.*
Ink.
c.1920. $7 \times 4\frac{1}{4}$.
Courtesy of Larcada Gallery.

802. Kent. Figure study.
Ink, gouache, dry brush.
1935. $10 \times 7\frac{3}{4}$.
Courtesy of Larcada Gallery.

803. Kent. Figure study.
Pencil.
1932. $11 \times 8\frac{1}{2}$.
Courtesy of Larcada Gallery.

804. Kent. Illustration, *Moby Dick* by Herman Melville. Ink.
1930. $7 \times 7\frac{3}{4}$.
Courtesy of Larcada Gallery.

805. Kent. *Froelicht.*
Ink.
1930. $7\frac{1}{2} \times 7\frac{1}{2}$.
Courtesy of Larcada Gallery.

806. Kent. Figure study.
$13\frac{1}{2} \times 8\frac{3}{4}$.
Courtesy of Larcada Gallery.

807. JEAN-EMILE LABOUREUR (1877–1943). *Printemps au Trocadero.*
Ink on paper.
1928. $4 \times 5\frac{1}{4}$.
Anonymous loan.

808. DE LEMPICKA. *Reclining Figure.*
Oil on canvas.
c.1930. $31\frac{3}{4} \times 48$.
Coll. Mr Howard Molyneux.

809. GEORGES LEPAPE.
La Loge de Théâtre.
1912.
Coll. M. Alain Cical.

810. Lepape. *Les Amateurs d'Estampes.*
Gouache.
1925. $10\frac{1}{2} \times 8$.
Courtesy of M. Alain Lesieutre.

811. LEROY. Drawing.
Signed: 1925. $11 \times 14\frac{3}{4}$.
Coll. M. Alain Cical.

812. JANE LÉVY. *Medusa.*
$8\frac{1}{4} \times 9$.
(Jane Lévy was well known as a Sèvres porcelain decorator.)
Coll. M. Gilbert Silberstein.

813. LEON LEYRITZ. *At the Opera.*
$24\frac{3}{4} \times 19$.
Coll. M. Gilbert Silberstein.

814. FABIUS LORENZI. *Girl with Parasol.*
c.1918. $14\frac{1}{2} \times 9\frac{1}{2}$.
Coll. M. Gilbert Silberstein.

815. Lorenzi. *Girl in armchair with long cigarette-holder.*
$11\frac{3}{4} \times 9$.
Coll. M. Gilbert Silberstein.

816. Lorenzi. *Girl Putting on Stockings.*
$9\frac{3}{4} \times 8\frac{3}{4}$.
Coll. M. Gilbert Silberstein.

817. MARY MACKINNON. *Portrait.*
Illustration for *Vogue* magazine.
Watercolor.
1930. $38 \times 32\frac{1}{2}$.
Coll. Mr Howard Molyneux.

818. MADRAZO. *The Street.*
Gouache.
1926. 27×22.
Courtesy of M. Alain Lesieutre.

819. A. E. MARTY. Drawing.
Three girls at window.
$6\frac{1}{4} \times 5$.
Coll. M. Gilbert Silberstein.

820. Marty. *1813 and 1913.*
Drawing.
1913. $11\frac{1}{2} \times 9$.
Coll. M. Gilbert Silberstein.

821. JACQUELINE MARVAL
Les Cerises.
Oil on wood panel.
1930. $20\frac{3}{4} \times 24\frac{3}{4}$.
Courtesy of M. Alain Lesieutre.

822. GUSTAVE MIKLOS (1888–).
Figures and Dog.
Painting.
1921. $78\frac{1}{2} \times 48$.
Coll. M. Félix Marcilhac.

823. Miklos. Study for the preceding work.
Gouache.
1921. 11×5.
Coll. of M. Félix Marcilhac.

824. Miklos. Study in gold and silver gouache for enamel plaque.
1922.
(The plaque is in the possession of M. Barlach Heuer, Paris.)
Coll. M. Félix Marcilhac.

815

818

825. JACQUES NAM. *The Cats.*
Oil.
c.1930. 18 × 21.
Courtesy of M. Alain Lesieutre.

826. Nam. *The Cobra.*
Black lacquer.
Illus: Armand Dayot, *Les Animaux*, ii, Pl.49.
20 × 21½.
Courtesy of M. Alain Lesieutre.

827. Nam. *The Frog.*
Black lacquer.
15 × 21½.
Courtesy of M. Alain Lesieutre.

828. D'OLIVIER. Oval painting of
woman in eighteenth-century costume
with garden scene.
Gilt frame.
51 × 35.
Coll. Mr Adrian Emmerton.

829. CHANA ORLOFF. Drawing
(study for the wood sculpture, Cat.no.316.)
Dedicated to Liba Chana Orloff.
1925. 15 × 12.
Coll. M. Félix Marcilhac.

830. JEAN PATOU. *Nuance Propre.*
11 × 8½.
Courtesy of Robert K. Brown Art & Books.

831. G. PAVIS. *Coup de vent.*
Coll. M. Alain Cical.

831a. LEO PUTZ. *Des Imagistes.*
Watercolor.
c. 1920. 21½ × 17.
Coll. Mr Paul Magriel.

832. POL RAB. *A Modern Eve.*
Ink and watercolor.
15¾ × 10¼.
Coll. M. Gilbert Silberstein.

833. RANSON. Woman's head.
Black hat with diamond clip.
13¾ × 10¾.
Coll. M. Gilbert Silberstein.

834. MARCIAL ROVIRA Y RECIO.
Dancing Nudes.
1924. 19¼ × 15.
Coll. M. Gilbert Silberstein.

835. WINOLD REISS.
Race between an aeroplane, express train
and a motor-car.
Oil on canvas.
c.1930. 58 × 184 (two panels).
Coll. Kiki Kogelnik.

836. ROMME. Drawing.
11¾ × 2¼.
Coll. M. Alain Cical.

837. KURT HERMAN ROSENBERG
(1884–). Untitled portrait.
Enamel on copper.
1931. 22 × 20⅛.
Courtesy of Lillian Nassau, Ltd.

838. EERO SAARINEN (1911–61).
Five sketches for furniture at Kingswood
School.
Pencil on paper.
1925–34. 11 × 9.
Lent by Art Galleries, Cranbrook
Academy of Arts.

839. ELIEL SAARINEN (1873–1950).
Seventeen designs for furniture.
Pencil on paper.
1924–30. 11 × 9.
Lent by Art Galleries, Cranbrook
Academy of Art.

840. Saarinen. Design for dining-room
chair at Saarinen residence.
Pencil on paper.
1928. 11 × 9.
Lent by Art Galleries, Cranbrook
Academy of Art.

841. Saarinen. Interior designs of
residence, north-east Studio corner,
Cranbrook.
15½ × 29½.
Lent by Art Galleries, Cranbrook
Academy of Art.

842. Saarinen. Photostat of drawing of
Chicago Lake Front Development.
1923. 21 × 15¾.
Lent by Art Galleries, Cranbrook
Academy of Art.

843. BASIL SCHOUKAEF.
Girl in Ballet Costume.
Watercolor.
1927. 16½ × 10¼.
Coll. M. Gilbert Silberstein.

844. ALFRED TULK (1899–).
Watercolor on paper.
Stylized figures, fountains, birds
and flowers.
1931. 19¼ × 12½.
Coll. Mr Stanley Insler.

845. Tulk. Watercolor on paper
Stylized figures, birds and flowers.
19¼ × 12½.
Coll. Mr Stanley Insler.

846. VALLEE. Drawing.
Reproduced in *La Vie Parisienne*.
June 8, 1918. 11¾ × 9.
Coll. M. Gilbert Silberstein.

847. JOHN VASSOS (1898–).
Gouache for *Salomé* by Oscar Wilde.
1925. 16¼ × 16¼.
Lent by the artist.

848. Vassos. *Traffic Ballet.*
Gouache for *Dance Magazine*.
1927. 24 × 17.
Coll. Mr Ted McBurnett.

849. Vassos. *And Leaves the World to
Darkness and to Me.*
Gouache for Gray's *Elegy*.
1931. 20½ × 16.
Coll. Miss Barbra Streisand.

850. Vassos. *Venez Avec Moi.*
Gouache advertisement for Bonwit Teller.
c.1930. 21 × 14½.
Courtesy of Robert K. Brown Art & Books.

851. GERDA WEGENER. Tinted drawing
of women in a café. 1928. 34½ × 26.
Coll. Mme Yvette Barran.

852. Wegener. *Pierrots and devil at a
Masquerade ball.*
Watercolor on paper, circular. 18½ × 16½.
Courtesy M. Alain Lesieutre.

853. MARCO WILFART. *Skvaldina.*
Nude with violin. 15 × 12½.
Coll. M. Gilbert Silberstein.

854. FRANK WILL.
Les Ballets Diaghileff.
Watercolor of two dancers.
1930. 11½ × 8½.
Courtesy of M. Alain Lesieutre.

856. FABIAN ZACCONE. *Men's Journey.*
Engraving. 1938. 12 × 16.
Courtesy of Barry and Audrey Friedman,
Antiques.

857. JOSÉ DE ZAMORA.
Les Clientes Milliardaires.
12½ × 9½.
Coll. M. Gilbert Silberstein.

858. ZINOVIEV. *Oursin.*
Drawing. 11¾ × 9¾.
Coll. M. Gilbert Silberstein.

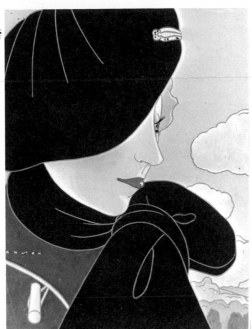

833

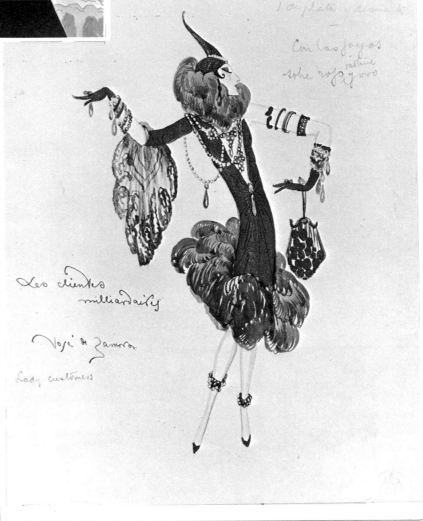

857

Las Jugadoras
1 de plata y diamantes
—
Con las joyas
sobre rosa raline y oro

Les clientes
milliardaires

José de Zamora.

Lady customers

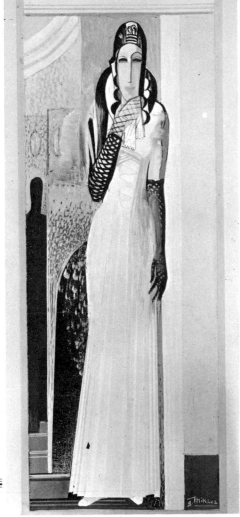

824

Books Bindings

859. MAURICE S. R. ADAMS.
Modern Decorative Art, A Series of 200 Examples of Interior Decoration.
J. P. Lippincott Co., Philadelphia, 1930.
Anonymous loan.

860. MICHAEL ARLEN.
A Young Man Comes to London.
Coll. Mr Anthony Haden-Guest.

861. JOHN AUSTEN. *Rogues in Porcelain.*
Illustrated by John Austen.
Chapman and Hall, London, 1924.
Courtesy of Martins-Forrest Antiques.

862. GEORGE BARBIER.
Personnages de Comédie.
Coll. M. Alain Cical.

863. Barbier. *Nijinsky.*
Coll. M. Alain Cical.

864. CHARLES BAUDELAIRE.
Flowers of Evil.
Translated by Lewis Piaget Shanks.
Illustrated by Major Felten.
Ives Washburn, New York, 1931.
Coll. Mr John Jesse.

865. GEORGE BEATON. *Jack Robinson.*
Chatto and Windus, London, 1933.
Anonymous loan.
Sir Compton Mackenzie wrote of this book in the *Daily Mail*, London, November 9, 1933: '*Jack Robinson* offers incontrovertible evidence that Mr Beaton is a genuine writer, by which I mean to say that *Jack Robinson* does not seem to have been written merely because the author had nothing to do one morning and thought he might try his hand at writing a novel like so many of his friends, or because he wanted to talk about himself and could not afford to pay a psycho-analyst for a consultation; or indeed for any of the innumerable reasons which lead young men to suppose that their acquaintance with the manual exercise of writing is the same thing as the possession of creative imagination.'
In the *New York Times Book Review*, January 14, 1934, Peter Monro Jack wrote: 'We believe that the longest memory will not recall a first novel so capable of exciting the reader with the sense of experience rediscovered.'

866. JACINTO BENAVENTE.
La Melodia del Jazz-Band.
Illustrated by Antonio Merlo.
La Farza, Madrid, 1931.
Anonymous loan.

867. HUGO ADOLF BERNATZIK.
Gari Gari.
Seidel, Vienna, 1930.
Anonymous loan.

868. HANS BETHGE. *Omar Khayyam.*
(German translation of the *Rubaiyat*.)
Berlin, 1921.
Anonymous loan.

869. OSWELL BLAKESTON and
FRANCIS BRUGUIERE. *Few Are Chosen.*
Photographic illustrations by F. Bruguière.
Eric Partridge, London, 1931.
Anonymous loan.

870. EDGAR BOND.
Showcard Lay-out and Design.
Cover design and illustrations by the author.
Blandford Press, London.
Anonymous loan.

871. WALDEMAR BONSELS.
Die Biene Maja und Ihre Abenteuer.
Schuster and Loeffler, Berlin, 1921.
Anonymous loan.

872. JEAN DE BOSSCHÈRE.
The House of Forsaken Hope.
Translated by Donald MacAndrew.
Jacket and illustrations by the author.
Fortune Press, London.
No. 314 of a limited edition of 500 copies on hand-made paper.
Anonymous loan.

873. BRUNO BÜRGEL.
Oola-Boola's Wonder Book.
Translated from the German edition by Ivy E. Clegg.
Illustrated by Anna Zinkeisen.
Bell, London, 1932.
Anonymous loan.

874. SAMUEL BUTLER.
The Way of All Flesh.
Illustrated with wood-engravings by John Farleigh.
Collins, London, 1934.
Anonymous loan.

875. FRANCIS CARCO. *L'Homme Traqué.*
Illustrated by Charles Laborde.
Bound by Paul Bonet, Paris, 1929.
Anonymous loan.

873

866

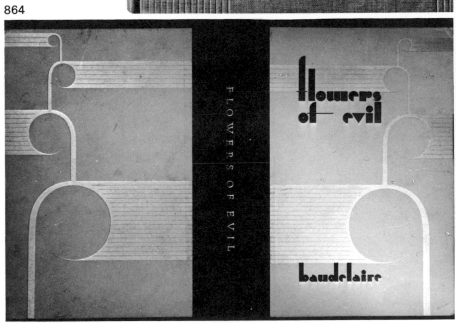

864

876. CASANOVA.
My Life and Adventures.
Translated by Arthur Machen.
Jacket design by Henry Hoyland.
Joiner and Steele, London, 1932.
Anonymous loan.

876a. CHATEAUBRIAND. *Les aventures*
du dernier Abencérage.
Executed by Kieffer from a design by
Pierre Legrain. Coll. M. Félix Marcilhac.

877. S. T. COLERIDGE. *Kubla Khan.*
Illustrated by John Vassos.
E. P. Dutton and Co., Inc., New York, 1933.
Coll. Mr John Vassos.

878. HARRY CRADDOCK.
The Savoy Cocktail Book.
Cover and illustrations by Gilbert Rumbold.
Constable, London, 1930.
Anonymous loan.

879. JACQUES DOREY.
Three and the Moon.
Jacket and illustrations by
Boris Artzybasheff.
Alfred A. Knopf, New York, 1929.
Anonymous loan.

880. ROLAND DORGELES.
Les Croix de Bois.
Illustrated by Dunoyer de Segonzac.
Bound by Pierre Legrain.
Paris, 1921.
Anonymous loan.

881. FYODOR DOSTOIEVSKI.
Une femme douce.
Illustrated by Gierlowski.
Paris, 1927.
Coll. M. Alain Cical.

882. J. DOUCET. *XX Dessins.*
Illustrated by Amadeo de Sousa-Cardoso.
Paris, 1912.
Coll. M. Alain Cical.

883. BERESFORD EGAN.
The Sink of Solitude.
Illustrated by the author.
Hermes Press, London, 1928.
Anonymous loan.

884. NOAH ELSTEIN. *Plight of Peretz.*
Jacket design by Emmanuel Levy.
Allen and Unwin, London, 1930.
Anonymous loan.

885. HUGH FERRIS.
The Metropolis of Tomorrow.
Illustrated by the author.
Ives Washburn, New York, 1929.
Coll. The Minneapolis Institute of Arts.

886. BRADDA FIELD. *The Earthen Lot.*
Harcourt, Brace and Co., New York, 1928.
A presentation copy signed by the author.
Anonymous loan.

887. EDWARD FITZGERALD.
The Rubaiyat of Omar Khayyam.
Illustrations by 'Fish'.
John Lane, London, 1922.
Anonymous loan.

888. HALLIE FLANAGAN. *Shifting*
Scenes of the Modern European Theatre.
Harrap, London, 1929.
Anonymous loan.

889. GUSTAVE FLAUBERT. *Hérodias.*
Illustrations by William Walcot Brown.
Morocco binding by René Kieffer.
Editions d'Art Devambez, Paris, 1928.
Coll. Mme Francine Legrand-Kapferer.

890. PAUL FORT. *Les Ballades*
Françaises: Montagne, Forêt, Plaine, Mer.
Illustrated by F. L. Schmied, Paris, 1927.
Metal work by P. Bout; gilding by A. Jeane,
binding by Paul Bonet, completed, 1933.
Anonymous loan.

891. PAUL T. FRANKL. *New Dimensions:*
The Decorative Arts of Today in Words
and Pictures.
Payson and Clarke Ltd, New York, 1928.
Anonymous loan.

892. REMY DE GOURMONT.
Les Lithanies de la Rose.
Illustrated by A. Domin, Paris, 1919.
Coll. M. Alain Cical.

893. De Gourmont. *Couleurs.*
Illustrated by Laboureur, binding by
Paul Bonet, Paris, 1929.
Anonymous loan.

894. HARRY GRAHAM.
The World We Laugh In.
Illustrated by 'Fish'.
Methuen, London, 1924.
Anonymous loan.

876

876a

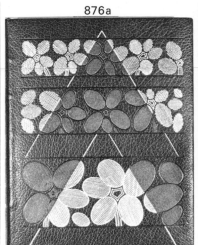

878

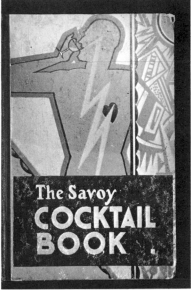

882
and right 886

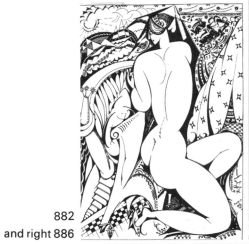

889

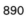

890

888

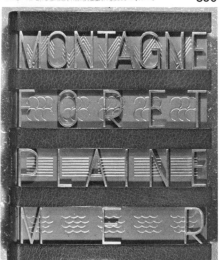

895. THOMAS GRAY.
Elegy in a Country Churchyard.'
Illustrated by John Vassos.
E. P. Dutton and Co. Inc., New York, 1931.
Coll. Mr John Vassos.

896. GREY OWL. *The Adventures of Sajo and Her Beaver People.*
Lovat Dickson and Thompson Ltd, London, 1935.
Anonymous loan.

897. JOHN HASSALL.
Our Darling's First Book.
Cover design by John Hassall.
Blackie, London, 1907.
Anonymous loan.

898. A. HERMANT. *Phili.*
Illustrated by Brunelleschi. Paris, 1921.
Coll. M. Alain Cical.

899. W. H. HUDSON. *Green Mansions.*
Illustrated by Keith Henderson.
Duckworth, London, 1926.
Anonymous loan.

900. GINA KAUS. *Luxury Liner.*
Jacket design by Eric Fraser.
Cassell, London, 1932.
Anonymous loan.

901. ROCKWELL KENT. *Salamina.*
Harcourt, Brace and Co., New York, 1935.
Courtesy of Larcada Gallery.

902. Kent. *N. by E.*
Brewer and Warren, New York, 1930.
Courtesy of Larcada Gallery.

903. RUDYARD KIPLING.
Le Livre de la Jungle.
Illustrated by P. Jouve and engraved by
F. L. Schmied, Paris, 1918. Binding in
brown Morocco by Noulhac, 1929.
Decorated by Mme Noulhac.
This copy was printed for Jouve himself, his
name being printed on the first page instead
of the usual number. (This was one of a
limited edition of 125 copies.) Bound into
the book are a number of Schmied
engravings — trials, different states, and
rejects bearing remarks such as *'bon à tirer'*.
Coll. Mme Francine Legrand-Kapferer.

904. LAFORGE. *ABC.*
Coll. M. Alain Cical.

905. VERNON LEE. *Ballet of the Nation.*
Illustrated by Maxwell Armfield.
Chatto and Windus, London, 1915.
Courtesy of Martins-Forrest Antiques Ltd.

906. EDY LEGRAND. *Macao et Cosmage: ou L'Expérience du Bonheur.*
Illustrated by the author.
Editions de la Nouvelle Revue Française,
Paris.
Anonymous loan.

907. Legrand. *Voyages et Glorieuses Découvertes des Grands Navigateurs et Exploreurs Français.*
Illustrated by the author.
Tolmer, Paris, 1921.
Anonymous loan.

Opposite: Cat.nos.73, 1036 and 1037.
Overleaf: Cat.no.789.

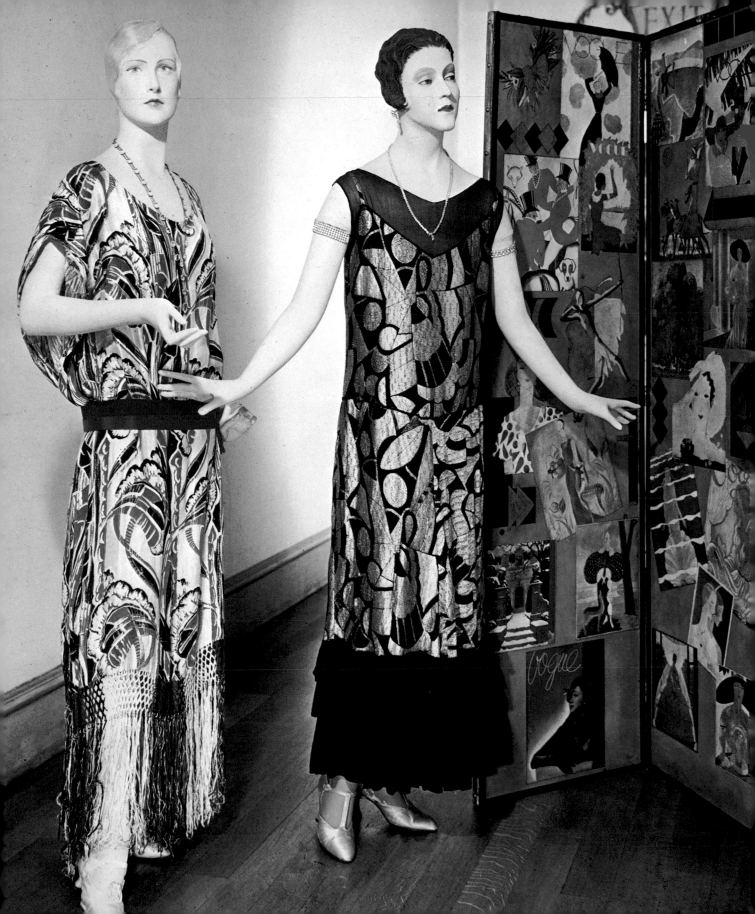

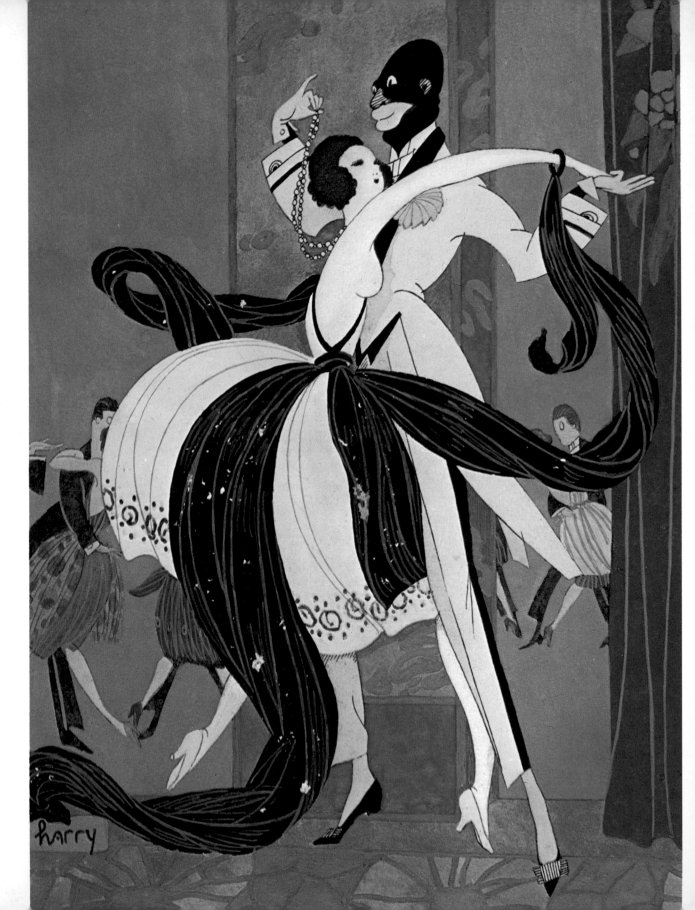

893

900

899

894 and above 911

908. ANDRÉ LEVINSON.
Bakst, the Story of the Artist's Life.
The Baynard Press, London, 1923.
Coll. Mr Adrian Emmerton.

909. SINCLAIR LEWIS. *Die Hauptstrasse.*
Translated into German by Balder Olden
Volksverband der Bücherfreunde, Berlin,
1922.
Anonymous loan.

910. PIERRE LOUYS.
Les Chansons de Bilitis.
Illustrated by George Barbier.
Binding by R. D. Canape.
Coll. M. Félix Marcilhac.

911. BOHUN LYNCH.
A History of Caricature.
Cover design by the author.
Faber and Gwyer, London, 1926.
Anonymous loan.

912. P. MACORLAN. *La Danse Macabre.*
Illustrated by Yan Bernard Dyl.
Paris, 1927.
Coll. M. Alain Cical.

913. DR MARDRUS. *La Création.*
Illustrated by F. L. Schmied.
Paris, 1928..
Coll. M. Alain Cical.

914. Mardrus. *La Création.*
Illustrated by F. L. Schmied.
Binding by René Kieffer.
Coll. M. Félix Marcilhac.

915. Mardrus. *Histoire Charmante de
l'Adolescente Sucre d'Amour.*
Illustrated by F. L. Schmied.
Paris, 1927.
Coll. M. Alain Cical.

916. Mardrus.
Le Livre de la Vérité de Parole.
Illustrated by F. L. Schmied.
Paris, 1929.
Coll. M. Alain Cical.

917. Mardrus.
Le Livre de la Vérité de Parole.
Illustrated by F. L. Schmied.
Binding, incorporating a plastic hand, by
Greusevault.
Paris, 1929.
Coll. M. Félix Marcilhac.

918. Mardrus. *Le Paradis Musulman.*
Illustrated by F. L. Schmied.
Paris, 1930.
Coll. M. Alain Cical.

919. Mardrus. *Le Paradis Musulman.*
Illustrated by F. L. Schmied.
Lacquer binding by Jean Dunand.
Paris, 1930.
Coll. M. Félix Marcilhac.

920. Mardrus. *Le Paradis Musulman.*
Illustrated by F. L. Schmied.
Binding by F. L. Schmied.
Paris, 1930.
Schmied's own copy. The binding is signed
by him. His designs for the cover are bound
in.
Coll. M. Félix Marcilhac.

921. HERMAN MELVILLE. *Typee.*
Jacket and illustrations by Guido Boer.
Aventine Press, New York, 1931.
Anonymous loan.

922. LEWIS MELVILLE.
The London Scene.
Illustrated by Aubrey Hammond.
Faber and Gwyer, London, 1926.
Coll. Mr Leslie Randle.

923. GWLADYS EVAN MORRIS.
Tales from Bernard Shaw.
Cover design and illustrations by
Phyllis A. Trery.
Harrap, London, 1929.
Anonymous loan.

924. ERIC NEWTON.
The Artist and his Public.
Jacket design by the author.
Allen and Unwin, London, 1935.
Anonymous loan.

925. Newton.
The New York Book of Smart Interiors.
Selected from *Country Life.*
American Home Corporation, New York,
1937.
Coll. Mr Edward Lee Cave.

926. COUNTESS OF NOAILLES.
Les Climats.
Illustrated by F. L. Schmied.
Lacquer binding by Jean Dunand.
Coll. M. Félix Marcilhac.

927. OBERAMMERGAU.
Das Passions-spiel in Oberammergau
(program of the passion-play).
J. C. Hubers, Munich, 1930.
Anonymous loan.

928. PERRAULT. *Contes de Perrault.*
Illustrated by Félix Lorioux.
Hachette, Paris, 1927.
Coll. Mr Adrian Emmerton.

929. POINSOT. *Le Foie des Yeux.*
Binding by André Mare, Paris, 1911.
Lent by Musée des Arts Décoratifs.

930. AINÉ ROSNY. *Tabubu.*
Illustrated by M. Lalau.
Paris.
Coll. M. Alain Cical.

**931. ROYAL INSTITUTE OF BRITISH
ARCHITECTS.**
International Architecture, 1924–1934.
Catalogue of the centenary exhibition of the
Royal Institute of British Architects,
London, 1934.
Anonymous loan.

910

914

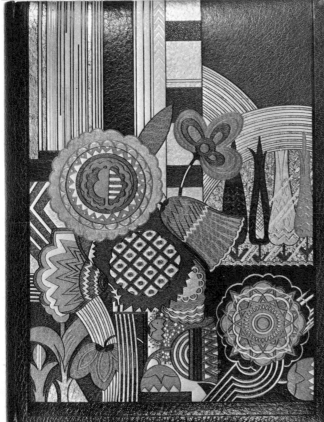

920

929

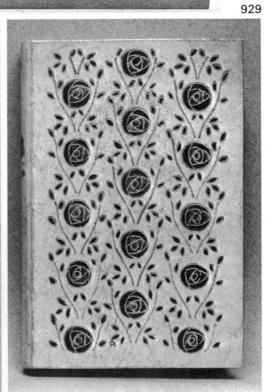

932. ANDRÉ SALMON. *Le Calumet.*
Binding by René Kieffer, after Pierre
Legrain, c.1920.
Paris.
Lent by Musée des Arts Décoratifs.

933. F. L. SCHMIED.
Le Cantique des Cantiques.
Illustrated by F. L. Schmied.
Translated by Ernest Renan.
Lacquer binding by Jean Dunand.
Paris, 1925.
Coll. M. Félix Marcilhac.

934. Schmied.
Le Cantique des Cantiques.
Translated by Ernest Renan.
Illustrated by F. L. Schmied.
Binding executed by Crette.
Lacquer by Jean Dunand, after an original
by F. L. Schmied.
Paris, 1925.
Anonymous loan.

935. SERGE. *Vive la Cirque.*
Marcel Seheur, Paris, 1930.
Anonymous loan.

936. ST JOHN D. SEYMOUR.
Tales of King Solomon.
Oxford, 1924.
Anonymous loan.

937. GENE STRATTON-PORTER.
The Fire Bird.
Illustrated by Gordon Grant and Lee Thayer.
John Murray, London, 1922.
Anonymous loan.

938. KARL TOTH.
Woman and Rococo in France.
Translated by Roger Abingdon.
Harrap, London, 1931.
Anonymous loan.

939. JOHN VASSOS. *Phobia.*
Covici/Friede, New York, 1931.
No.7 of a limited edition of 1,500.
Coll. The artist.

940. RUTH VASSOS.
Contempo, This American Tempo.
Illustrated by John Vassos.
E. P. Dutton and Co., Inc., New York, 1929.
Coll. The artist.

941. Vassos. *Humanities.*
Illustrated by John Vassos.
E. P. Dutton and Co., Inc., New York, 1935.
Coll. The artist.

942. Vassos. *Ultimo.*
Illustrated by John Vassos.
E. P. Dutton and Co., Inc., New York, 1930.
No.1 of a limited edition of 115.
Coll. The artist.

943. VERLAINE. *Chansons pour Elle.*
Binding by Réne Kieffer, after Pierre Legrain.
Paris, 1919.
Lent by Musée des Arts Décoratifs.

944. ALFRED DE VIGNY. *Daphné.*
Illustrated by F. L. Schmied.
Paris, 1924.
Coll. M. Alain Cical.

945. De Vigny. *Daphné.*
Illustrated by F. L. Schmied.
Binding by J. van West.
Paris, 1924.
Coll. M. Félix Marcilhac.

**946. JEAN FRANÇOIS MARIE
AROUET DE VOLTAIRE.** *Candide.*
Illustrated by Rockwell Kent.
The Literary Guild, New York, 1929.
Courtesy of Larcada Gallery.

947. NORMAN WALKER. *The Mill.*
Longmans Green, London, 1930.
Anonymous loan.

948. H. G. WELLS. *The Open Conspiracy.*
Jacket design by E. McKnight Kauffer.
Gollancz, London, 1928.
Anonymous loan.

949. OSCAR WILDE.
The Harlot's House and Other Poems.
Illustrated by John Vassos.
E. P. Dutton and Co., Inc., New York, 1929.
No.3 of limited edition of 200.
Coll. The artist.

949a. *Salomé.*
Illustrated by John Vassos.
Anonymous loan.

950. TONY WONS. *Tony's Scrap Book.*
The Reilly and Lee Co., Chicago, 1937.
Anonymous loan.

951. ARTHUR WRAGG.
The Psalms for Modern Life.
Illustrated by Arthur Wragg.
Selwyn and Blount, London, 1933.
Anonymous loan.

923 and below 934

924 and below 935

931 and below 940

932

947

THE MILL

NORMAN WALKER

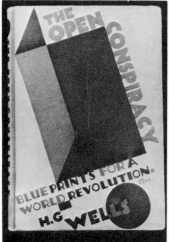

949a 950

948

Portfolios

952. J. J. ADNET. *Sièges Modernes.*
40 plates.
Editions Eugène Moreau, Paris, 1929.
Anonymous loan.

953. LES ARTS DE LA MAISON.
7 vols.
Choix des œuvres les plus expressives de la décoration contemporaine publié sous la direction de Christian Zervos.
Éditions Albert Morance, Paris, 1923–6.
Lent by Minneapolis Public Library.

954. AARON BROUN. *The Poster Stamp.*
1928.
A collection of over 200 specimens of handsome posterettes and labels.
Lent by Minneapolis Public Library.

955. HENRI CLOUZOT. *La Ferronnerie Moderne à l'Exposition des Arts Décoratifs.*
36 plates.
Éditions d'Art Charles Moreau, Paris.
Coll. The Minneapolis Institute of Arts.

956. JEAN FOUQUET.
Bijoux Orfèvrerie.
L'Art International d'Aujourd'Hui, No.16.
50 plates.
Éditions d'Art Charles Moreau, Paris.
Coll. The Minneapolis Institute of Arts.

957. A. GARCELON. *Inspirations.*
80 Motifs en Couleur.
20 plates.
Librairie Génerale de l'Architecture et des Arts Décoratifs, Paris.
Coll. The Minneapolis Institute of Arts.

958. GUILLAUME JANNEAU.
Le Luminaire et Les Moyens d'Éclairages Nouveaux.
Exposition International des Arts Décoratifs Modernes, Paris, 1925.
Premier Série, 48 plates.
Éditions d'Art Charles Moreau, Paris.
Coll. The Minneapolis Institute of Arts.

958a. *Interieurs En Couleurs France.*
Exposition des Arts Décoratifs, Paris 1925.
Éditions Albert Levy, Paris.
Coll. Mr and Mrs Peter M. Brant.

959. PAUL KNOTHE.
Der Mahler als Raumkünstler.
28 plates.
Atelier Stenzel, Dresden.
Coll. The Minneapolis Institute of Arts.

959a. *L'Art Décoratif Français* 1918–25.
Éditions Albert Lévy, Librairie Centrale des Beaux-Art, Paris, 2, Rue de l'Echelle.
Coll. Mr and Mrs Louis V. Winter.

959b. *La Sculpture Décorative à L'Exposition des Arts Décoratifs de 1925.*
Henri Rapin; editeur Charles Moreau, VIII de Prague, Paris.
Coll. Mr and Mrs Barry Friedman.

960. M. M. MATET. *Tapis Modernes.*
Edited by M. H. Ernst.
Exemplaire No.537.
40 plates.
Paris.
Coll. The Minneapolis Institute of Arts.

960a. *Modern French Decorative Art,*
Second Series.
Introduction by Leon Deshairs, London, The Architectural Press, Paris, Éditions Albert Levy.
Coll. Mr and Mrs Lewis V. Winter.

961. RENÉ-HERBST.
Nouvelles Devantures et Agencements de Magasins Parisiens.
Troisième Série.
54 plates.
Éditions d'Art Charles Moreau, Paris.
Coll. The Minneapolis Institute of Arts.

962. René-Herbst.
Nouvelles Devantures et Agencements de Magasins.
Quatrième Séries.
54 plates.
Éditions d'Art Charles Moreau, Paris.
Coll. The Minneapolis Institute of Arts.

963. RÉPERTOIRE DU GOÛT MODERNE.
No.4.
40 plates.
Éditions Albert Lévy, Librairie Centrale des Beaux-Arts, Paris, 1929.
Coll. The Minneapolis Institute of Arts.

964. SIMON FRÈRES.
Fourrures & Pelleteries en Gros.
Paris, London, and Brussels, 1929.
Coll. Mr and Mrs Michael Raeburn.

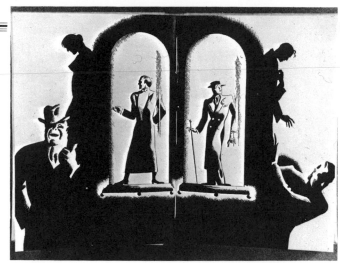

951

966

955

HENRI CLOUZOT

erronnerie moderne

EDITEUR CHARLES MOREAU 8 ET 10 RUE DE PRAGUE PARIS 12e

Periodicals

965. *Gazette du Bon Ton.*
Nos. 1–15, 1913.
Coll. The Minneapolis Institute of Arts.

966. *Pan.*
Odhams, London.
April 17, 1920.
Anonymous loan.

967. *Pan.*
Odhams, London.
March 27, 1920.
Anonymous loan.

968. *The Passing Show.*
Godfrey Phillips, London.
February 27, 1937.
Anonymous loan.

969. *The Passing Show.*
Godfrey Phillips, London.
August 28, 1937.
Anonymous loan.

970. *The Passing Show.*
Godfrey Phillips, London.
August 27, 1938.
Anonymous loan.

971. *The Passing Show.*
Godfrey Phillips, London.
October 1, 1938.
Anonymous loan.

972. *La Vie Parisienne.*
G. de Malherbe, Paris.
May 2, 1925.
The illustration on the back cover is of
special interest as it refers to the Exposition
des Arts Décoratifs of that year: *La Nature,
elle aussi, inaugure son Exposition d'Art
Décoratif.*
Anonymous loan.

973. *La Vie Parisienne.*
G. de Malherbe, Paris.
May 28, 1927.
Anonymous loan.

974. *La Vie Parisienne.*
G. de Malherbe, Paris.
August 20, 1927.
Anonymous loan.

975. *La Vie Parisienne.*
G. de Malherbe, Paris.
October 8, 1927.
Anonymous loan.

970

972

969

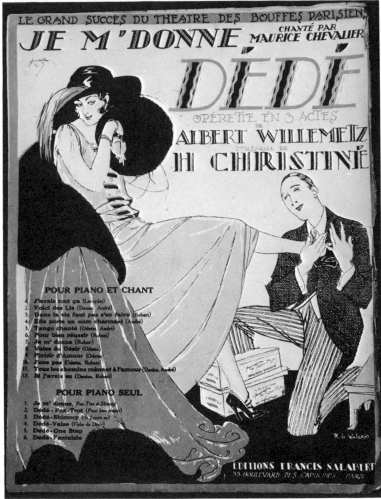

974

977

976

Music Sheets

976. *Je m'donne*.
From the operette *Dédé*.
Words by Albert Willemetz; music by
H. Christine; cover by R. de Valerio.
Francis Salabert, Paris, 1921.
Anonymous loan.

977. *Pas sur la Bouche*.
Operette by André Barde.
Music by Maurice Yvain; cover by
R. de Valerio.
Francis Salabert, Paris, 1925.
Coll. Mr Edward Lee Cave.

978. *In einer kleinen Konditorei*.
Tango by Fred Raymond.
Music sheet by Hans Liska.
Edition Scala, Berlin, Frankfurt and
Vienna, c.1930.
Anonymous loan.

979. *Gather Lip Rouge While You May*.
From the film *My Weakness*.
Lyrics and music by B. G. de Sylva, Leo
Robin and Richard A. Whiting.
Sam Fox Publishing Co., New York, 1933.
Anonymous loan.

980. *Il Fox-Trot delle Gigolettes*.
By Franz Lehár.
Carlo Lombardo, Milan, 1922.
Anonymous loan.

978

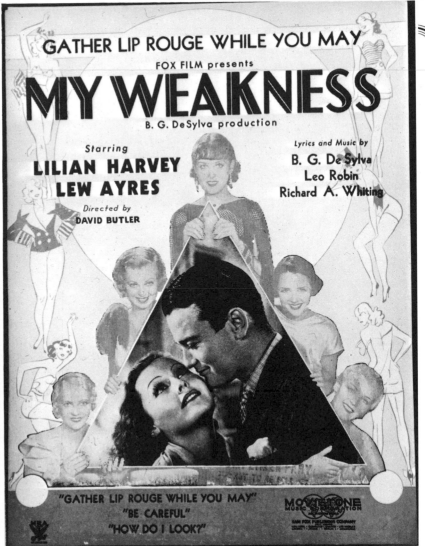

979

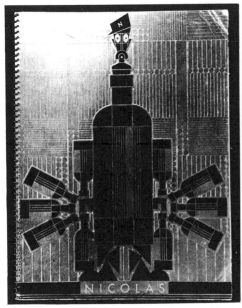

981

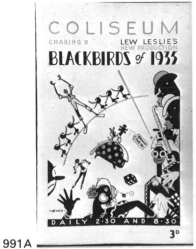

991A

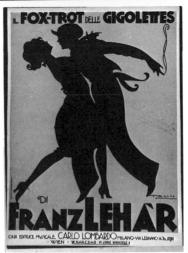

980

992

Printed Ephemera

981. ANONYMOUS. Catalogue for
Nicolas wines, 1930.
Designs and photographic views on
gold paper.
Anonymous loan.

982. ANON. Three fashion advertisement
cards, 1928–9.
Issued by Kosky, London.
Anonymous loan.

983. PAUL DUMAS. *Joueurs de tennis.*
Wallpaper. Designed by Mme de Andrade.
c.1925.
Lent by Bibliothèque Forney.

984. MAISON FOLLOT. *Losanges.*
Wallpaper. Four shades of grey on silver
ground.
Designed by Paul Follot (1877–1941).
c. 1925–9. $39\frac{1}{2} \times 23\frac{1}{2}$.
Lent by Bibliothèque Forney.

985. Maison Follot. *Arlequin Irregulier.*
Wallpaper. Harlequin in black, blue, mauve
and grey on silver ground.
Designed by Edouard Bénédictus.
c. 1925–9. $39\frac{1}{2} \times 23\frac{1}{2}$.
Lent by Bibliothèque Forney.

986. Maison Follot. *Construction arabes.*
Wallpaper. Green, three shades of blue, with
grey-beige.
Designed by Stephany.
c. 1925–9. $39\frac{1}{2} \times 23\frac{1}{2}$.
Lent by Bibliothèque Forney.

987. RENÉ GABRIEL (1890–1950).
Les Sansonnets.
Wallpaper. Orange and iron grey on cream
ground.
Printed by Les Papiers Peints de France,
1921.
$46\frac{1}{2} \times 19\frac{3}{4}$.
Lent by Bibliothèque Forney.

988. Gabriel. *Fructidor.*
Wallpaper. Green and violine on cream
ground.
Printed by Les Papiers Peints de France,
1921.
$46\frac{1}{2} \times 19\frac{3}{4}$.
Lent by Bibliothèque Forney.

989. Gabriel. *La Table est Mise.*
Wallpaper. Orange on cream ground.
Printed by Les Papiers Peints de France,
1923.
$46\frac{1}{2} \times 19\frac{3}{4}$.
Lent by Bibliothèque Forney.

990. Gabriel. *Marrakech.*
Wallpaper. Blue-green on white ground.
Printed by Les Papiers Peints de France,
1925.
$41\frac{1}{4} \times 19\frac{3}{4}$.
Lent by Bibliothèque Forney.

991. Gabriel. *Tombouctou, Camaieu Beige.*
Wallpaper.
Printed by Les Papiers Peints de France,
1926.
$48 \times 19\frac{3}{4}$.
Lent by Bibliothèque Forney.

991a. HICKS. *Blackbirds of 1935.*
Theater program.
Anonymous loan.

992. E. McKNIGHT KAUFFER.
Book-plate for Ifan Kyrle Fletcher, headed,
The Play's The Thing.
Courtesy of Lords Gallery, Ltd.

993. ISIDORE LEROY.
Original design for wallpaper.
Butterfly motif.
c.1925.
Lent by Bibliothèque Forney.

994. ANDRÉ MARE. *Sous-Main.*
Parchment with design of a bouquet of a
stylized roses and marguerites.
c.1925. $12\frac{1}{4} \times 17\frac{1}{4}$.
Exh: *Le Décor de la Vie de 1900 à 1925*,
Paris, 1937, cat.no.1357; *'Les Années '25'*,
Paris, 1966, cat.no.566.
Lent by Musée des Arts Décoratifs.

995. ATELIER MARTINE. *Les Pavots.*
Wallpaper. Yellow, green and blue on
black ground.
No.57497.
c.1912. $36\frac{1}{2} \times 31$.
Lent by Bibliothèque Forney.

996. ATELIER MARTINE. *Les Cactus.*
Wallpaper. Yellow, ochre, orange, beige on
black ground.
c.1912. $36\frac{1}{2} \times 31$.
Lent by Bibliothèque Forney.

997. EMILE-JACQUES RUHLMANN.
(1879–1933). *Fruits de mer.*
Wallpaper. Garnet-red, carmine, dark
green.
No.7522–2. Mark: 'S. F. Fabrication
française'.
c.1923–4. $54\frac{1}{4} \times 29\frac{1}{2}$.
Lent by Bibliothèque Forney.

998. Ruhlmann. *Roses.*
Wallpaper. Black, violet, white on mustard
ground.
No.7521–1. Mark: 'S. F. Fabrication
française'.
c.1923–4. $54\frac{1}{4} \times 29\frac{1}{2}$.
Lent by Bibliothèque Forney.

999. KEM WEBER. Decorative boxes.
Assorted sizes in cardboard.
Designed for Barker Brothers, Los Angeles,
1926.
Coll. Mrs Kem Weber.

993

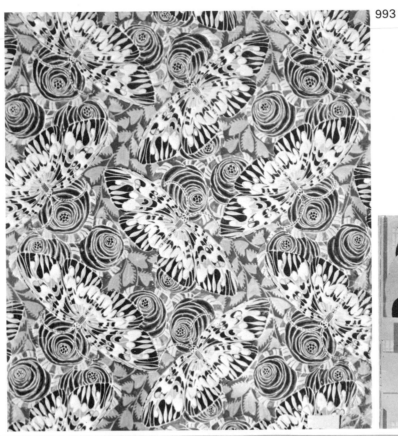

986

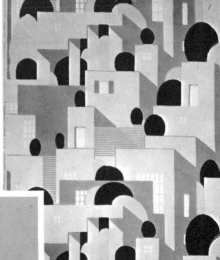

999

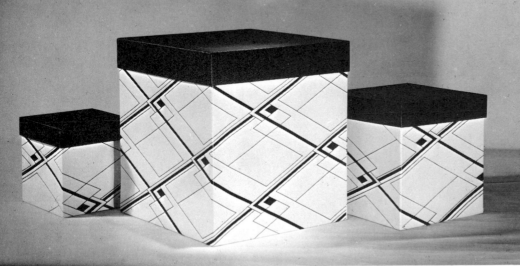

Posters

1000. ANONYMOUS.
Exposition des Arts Décoratifs.
1925. 19¾ × 26½.
Courtesy of Lords Gallery, Ltd.

1001. ANON. *Nouveaux Prix de Baisse.*
13 × 39⅜.
Courtesy of Lords Gallery, Ltd.

1002. BRODOWITCH. *Soldes.*
13½ × 20½.
Illus: Hillier, *Art Deco*, 1968, p.143.
Coll. Mr John Jesse.

1003. CADDY. *Raoul crée et lance la mode.*
29¼ × 21½.
Courtesy of Lords Gallery, Ltd.

1004. Caddy. *Raoul crée la ligne.*
19½ × 25¼.
Courtesy of Lords Gallery, Ltd.

1005. Caddy (att. to). *Chaussures Raoul*
(before the lettering).
23¾ × 39¼.
Courtesy of Lords Gallery, Ltd.

1006. JEAN CARLU.
Exposition Internationale, Paris, 1937.
63¼ × 46¾.
Courtesy of Lords Gallery, Ltd.

1007. CASSANDRE. *Étoile du Nord.*
1927. 41½ × 29⅞.
Coll. Mr and Mrs Jonathon Brown.

1008. Cassandre. *Nord Express.*
1927. 41½ × 29½.
Coll. Mr and Mrs Jonathon Brown.

1009. H. CERUTTI. *Napoléon à Sainte
Hélène d'après le scenario d'Abel Gance.*
c.1925–30. 63¼ × 90¾.
Courtesy of Lords Gallery, Ltd.

1010. PAUL COLIN. *Wiener et Doucet.*
c.1925. 61 × 47.
Courtesy of Lords Gallery, Ltd.

1011. Colin. *Jean-Pierre Aumont.*
Lithograph.
61½ × 44½.
Lent by Museum of Modern Art.

1012. DON. *Bal des Petits Lits Blancs.*
1925. 21½ × 16¾.
Courtesy of Lords Gallery, Ltd.

1013. JEAN DUPAS (1882–).
Green Line.
c.1933. 40 × 25.
Courtesy of Robert K. Brown Art & Books.

1014. Dupas. *Spring Fashions are here.*
54 × 36.
Coll. Mr Fred Hughes.

1015. ALMA FAULKNER.
Go Find the Spring by Underground.
40 × 25.
Courtesy of Lords Gallery, Ltd.

1015a. CHARLES GESMAR (1900–28).
Mistinguett (with rose clenched between
her teeth).
1926. 63¼ × 47½.
Courtesy of Lords Gallery, Ltd.

1016. ASHLEY HAVINDEN ('ASHLEY')
(1903–). *Jam St Martin.*
30½ × 20½.
Courtesy of Lords Gallery, Ltd.

1017. ROLAND HOLST.
Raden van Arbeid.
1920. 43¼ × 31¼.
Courtesy of Lords Gallery, Ltd.

1018. EDWARD McKNIGHT KAUFFER.
Great Western to Devon Moors.
1932. 39½ × 24⅛.
Courtesy of Lords Gallery, Ltd.

1019. Kauffer.
Go Great Western to Devonshire.
39⅝ × 24⅛.
Courtesy of Lords Gallery, Ltd.

1020. Kauffer.
Exhibition of Modern Silverwork.
Goldsmith's Hall, London.
Coll. Mr David Bindman.

1021. Kauffer. *Magicians Prefer Shell.*
Lithograph.
1934. 30 × 45.
Lent by Museum of Modern Art.

1022. Kauffer.
B.P. Ethyl Controls Horse-Power.
Photo-Lithograph.
1933. 30 × 45½.
Lent by Museum of Modern Art.

1023. Kauffer. *Winter Sales.*
Lithograph.
1924. 25 × 40.
Lent by Museum of Modern Art.

1024. Kauffer. *Power, the Nerve Centre of
London Underground.*
Lithograph.
1930. 39½ × 25.
Lent by Museum of Modern Art.

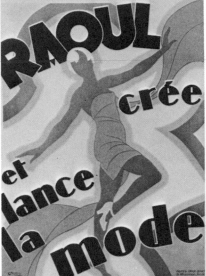

1003

1010

1015a

173

1025. PER KROHG.
Jean Borlin (Ballet Suédois).
1920. $63\frac{1}{4} \times 46\frac{1}{2}$.
Courtesy of Lords Gallery, Ltd.

1026. WALTER JURGONS (att. to).
Koenigsberg Fair (Russian lettering).
1924. $36\frac{1}{2} \times 23\frac{1}{4}$.
Courtesy of Lords Gallery, Ltd.

1027. A. E. MARTY.
'Where runs the river....?'
Poster for London Transport, advertising
tramways.
1931. 40×25.
Illus: In color: Hillier, *Posters,* London, 1969,
p.257.
Anonymous loan.

1028. PIERRE MOURGUE. *Jean Borlin.*
c.1920. $63 \times 46\frac{1}{2}$.
Courtesy of Lords Gallery, Ltd.

1029. WEIMER PURSELL. *Chicago
World's Fair, 1833 A Century of Progress
1933.*
Lithograph.
1933. $41\frac{1}{2} \times 27\frac{1}{2}$.
Courtesy of Robert K. Brown Art & Books.

1030. TOM PURVIS.
East Coast by L.N.E.R.
Lithograph.
c. 1930. $39\frac{1}{3} \times 49\frac{3}{4}$.
Lent by The Museum of Modern Art.

1031. TH. ROJAN-SKYLL. *Jenny Lanvin.*
$33\frac{1}{2} \times 19\frac{1}{8}$.
Courtesy of Lords Gallery, Ltd.

1032. RENÉ VINCENT. *Au Bon Marché.*
c.1925. $37\frac{1}{2} \times 53\frac{3}{4}$.
Courtesy of Lords Gallery, Ltd.

1033. WETTACH.
Spend Summer Days in Vienna.
Lithograph.
c. 1930. $37\frac{1}{2} \times 24\frac{3}{4}$.
Courtesy of Robert K. Brown Art & Books.

1034. ZIG. *Mistinguett.*
1928. $62\frac{3}{4} \times 47\frac{1}{2}$.
Courtesy of Lords Gallery, Ltd.

Opposite: Cat.no.1207.
Overleaf: Cat.nos.1386—97.

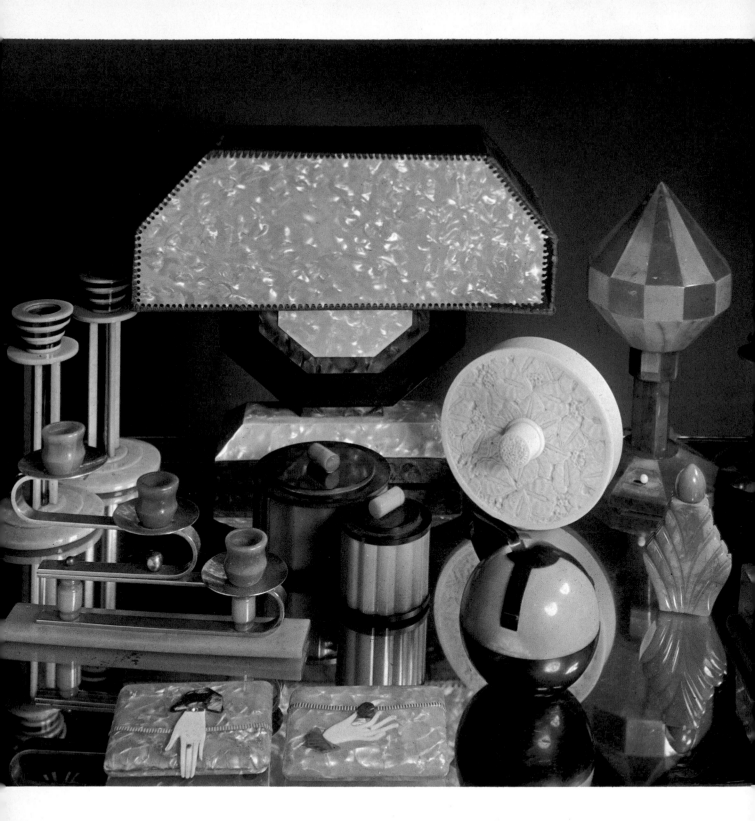

1018

GREAT WESTERN
to DEVON'S MOORS

1031

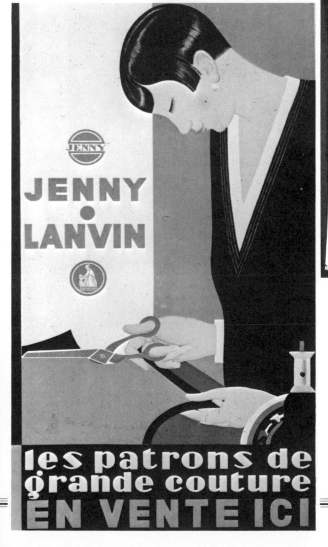

JENNY

JENNY
• LANVIN

les patrons de
grande couture
EN VENTE ICI

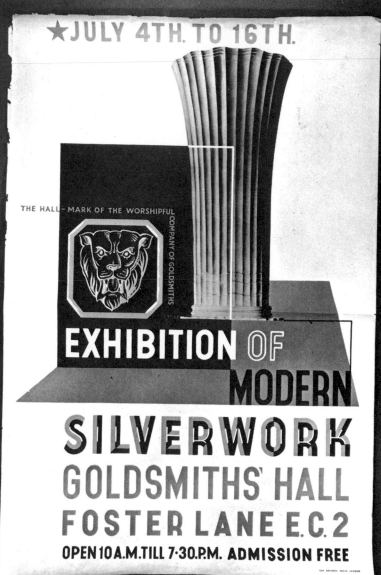

★ JULY 4TH. TO 16TH.

THE HALL-MARK OF THE WORSHIPFUL COMPANY OF GOLDSMITHS

EXHIBITION OF
MODERN
SILVERWORK
GOLDSMITHS' HALL
FOSTER LANE E.C.2
OPEN 10 A.M. TILL 7·30 P.M. ADMISSION FREE

THE BAYNARD PRESS LONDON

1020

Costumes

1035. ANONYMOUS. Evening dress.
Black satin with uneven hemline, shoulder straps and diamanté embroidery.
1919.
Lent by Museum of Costume, Bath.

1036. ANON. Evening dress.
Black georgette brocaded with gold and silver in jazz pattern; flounced border to skirt.
c.1922.
Lent by Museum of Costume, Bath.

1037. ANON. Evening dress.
Silver brocade with jazz pattern in fuchsia and black and a knotted fringe border; fuchsia satin belt for hips.
Early 1920s.
Lent by Museum of Costume, Bath.

1038. ANON. Evening dress.
Mauve satin, sleeveless with boat-shaped neck and yellow satin border; skirt embroidered with flowers, foliage and birds in floss silk, and divided into two large scallops.
Lent by Museum of Costume, Bath.

1039. ANON. Evening dress.
Blue brocade, sleeveless and with V-neck; no waistline but diamanté bow where skirt is slit to reveal a silver lamé petticoat.
From the wardrobe of Mrs Pitt-Rivers (Mary Hinton).
Lent by Museum of Costume, Bath.

1040. ANON. 'Little chemise' dress.
Black georgette tinselled in pink and blue.
c.1927.
Lent by Museum of Costume, Bath.

1041. ANON. Dress.
Black muslin embroidered with blue beads; worn over black slip.
Late 1920s.
Lent by Museum of Costume. Bath.

1042. ANON. Evening dress.
Shaded pink velvet embroidered with beads and pink and gold thread.
1923.
Lent by Museum of Costume, Bath.

1043. ANON. Evening dress.
Cream marocain with printed design of black feathers, each embroidered with diamanté.
Lent by Museum of Costume, Bath.

1044. ANON. Evening coat.
Gold lamé with quadrillé pattern on caramel silk foundation.
c.1925.
Lent by Museum of Costume, Bath.

1045. ANON. Evening coat.
Cut velvet and lamé with large poppy design.
c.1926.
Lent by Museum of Costume, Bath.

1046. ANON. Photograph of Tyrone Power in herringbone tweed coat with wide lapels and strongly patterned tie.
c.1938.

1047. ROSE BERTIN. Jacket in lime green jersey.
c.1930.
From the wardrobe of the late Ranée of Pudukota.
Lent by Museum of Costume, Bath.

1048. CALLOT. Evening dress.
Old gold charmeuse bound with lime green, embroidered by hand with pink and mauve flowers.
1925.
Lent by Museum of Costume, Bath.

1049. Callot. Evening dress.
Pale green bodice and dark green skirt and overskirt, with hand-embroidered flowers.
(The same model as cat.no.1048, in different colours).
1925.
Lent by Museum of Costume, Bath.

1050. SONIA DELAUNAY. A collection of photographs of clothes designed by Mme Sonia Delaunay.
Coll. The artist.

(a) Mme Delaunay in pied costume. 1913.
(b) Cleopatra costume. 1918.
(c) Mme Delaunay in strongly patterned robe. 1923.
(d) Mme Delaunay in zigzag pattern dress. 1923.
(e) Dress designed for a soirée held before General Foch at Claridge's, Paris, 1923.
(f) to (k) Costumes designed for poetry readings at the 1923 soirée at Claridge's.
(l) A page from Mme Delaunay's scrapbook, illustrating two of her inspirations of the 1920s; African textiles and the central nave and choir of the church of Nôtre Dame la Grande, Poitiers.
(m) Jacket. Maroon velvet embroidered with grey, white and black wools. 1925.
(n) Shawl-costume. 1925.
(o) Bathing-costumes. 1928.
(p) Man's dressing-gown. 1928.
(q) A scene from the film *Le petit parigot*. 1928.
(r) Costume with design of woollen curlicues. 1928.
(s) Mme Delaunay and her motor-car. 1923. The checker design on the seats is by Mme Delaunay. Another car was painted with checkers to match one of Mme Delaunay's coats.

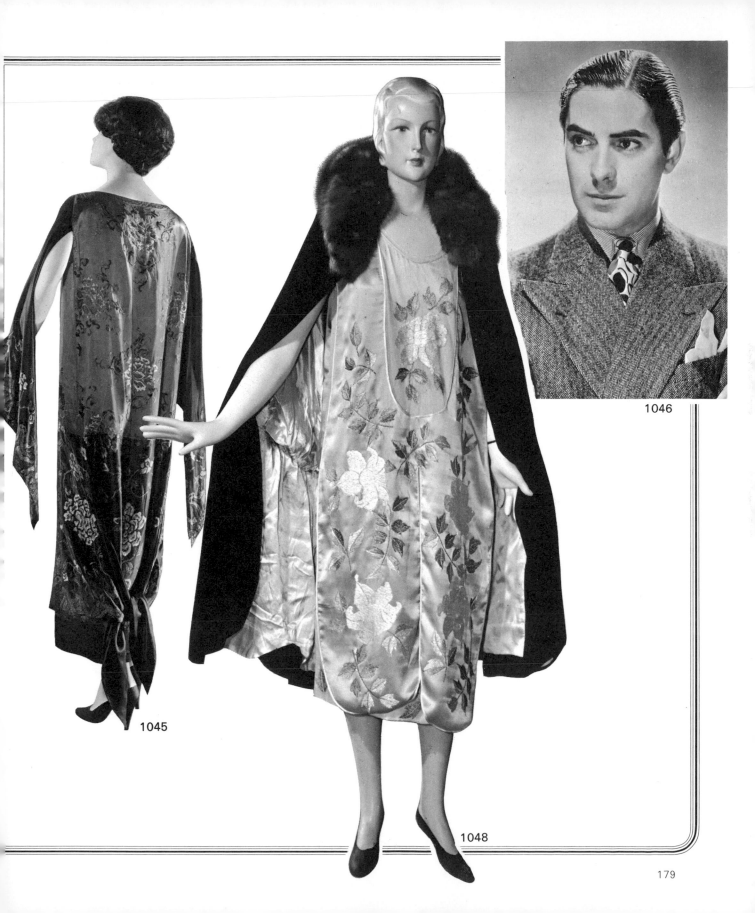

1045

1046

1048

1051. CHARLES KLEIN, PARIS.
Afternoon dress.
Black and royal blue brocaded silk with
pannier sides to skirt.
From the wardrobe of Dame Rebecca West.
Lent by Museum of Costume, Bath.

1052. LIBERTY, LONDON.
Man's dressing-gown.
Polychrome floral and tinsel brocade lined
with black satin; black silk cord girdle.
1927.
Lent by Museum of Costume, Bath.

1053. MARCEL, LONDON.
Evening coat.
Polychrome tinsel brocade with white fur
collar and cuffs.
1926.
Lent by Museum of Costume, Bath.

1054. PAQUIN. Jacket-and-skirt suit.
Pale blue cloth with dark blue silk facings
and sun-ray tucks.
c.1930.
From the wardrobe of the late Ranee of
Pudukota.
Lent by Museum of Costume, Bath.

1055. VIVIAN PORTER. Photograph of
Myra Shepley-Watson (née Mallett)
modelling clothes by Vivian Porter.
1935.
Coll. Mrs M. Shepley-Watson.

1056. WORTH. Afternoon dress.
Light grey satin with zigzag metal
stitching, fur border, and long floating scarf
attached at neck.
c.1920.
Lent by Museum of Costume, Bath.

Costume Accessories

SHOES/SANDALS

1057. ANONYMOUS. Man's shoes.
Leather with sunray motif in tan and dark
brown.
Coll. Mr Anthony d'Offay.

1058. ANON. Shoes.
Black lizard and white suede.
1920s.
From the wardrobe of the late Ranee of
Pudukota.
Lent by Museum of Costume, Bath.

1059. ANON. Sandals.
Royal blue kid.
c.1935.
From the wardrobe of the late Hon. Lady
Ward.
Lent by Museum of Costume, Bath.

1060. ANON. Sandals.
White suede and black patent leather.
From the wardrobe of the late Hon. Lady
Ward.
Lent by Museum of Costume, Bath.

1061. ANON. Sandals.
Pale blue satin with pink strapping.
c.1935.
From the wardrobe of the late Hon. Lady
Ward.
Lent by Museum of Costume, Bath.

1062. ANON. Sandals.
Silver tinsel brocade.
c.1935.
From the wardrobe of the late Hon. Lady
Ward.
Lent by Museum of Costume, Bath.

1063. GRECO, PARIS. Shoes.
Lizard and white kid.
1920s.
From the wardrobe of the late Ranee of
Pudukota.
Lent by Museum of Costume, Bath.

1064. HELLSTERN, PARIS. Sandals.
Natural straw with blue kid decoration.
1920s.
From the wardrobe of the late Ranee of
Pudukota.
Lent by Museum of Costume, Bath.

1065. JOANNY, PARIS. Shoes.
Black and white kid, with vamp of plaited
kid.
1920s.
From the wardrobe of the late Ranee of
Pudukota.
Lent by Museum of Costume, Bath.

1066. JULIENNE, PARIS.
Shoes.
Gold, silver and speckled kid.
c.1929.
From the wardrobe of the late Hon. Lady
Ward.
Lent by Museum of Costume, Bath.

1067. PERUGIA. Shoes.
Black patent leather and snake-skin.
1920s.
From the wardrobe of the late Ranee of
Pudukota.
Lent by Museum of Costume, Bath.

GLOVES

1068. ANONYMOUS. Gauntlets.
Green fabric trimmed with green and white
braid.
c.1930.
Lent by Museum of Costume, Bath.

1069. ANON. Gloves.
White kid with insets of black kid.
Lent by Museum of Costume, Bath.

1070. ANON. Gloves.
White kid with black cuffs.
Lent by Museum of Costume, Bath.

1071. JAY'S, LONDON. Gloves.
Black suede, trimmed with triangular shapes
in white kid. Made in France for Jay's of
London.
1930s.
Lent by Museum of Costume, Bath.

1072. Jay's. Gauntlets.
Black suede and white kid. Made in France
for Jay's of London.
1930s.
Lent by Museum of Costume, Bath.

HATS AND HEAD-DRESSES

1073. ANONYMOUS. Bandeau.
Kingfisher feathers applied on silver mount.
Chinese work.
1912–14.
Lent by Museum of Costume, Bath.

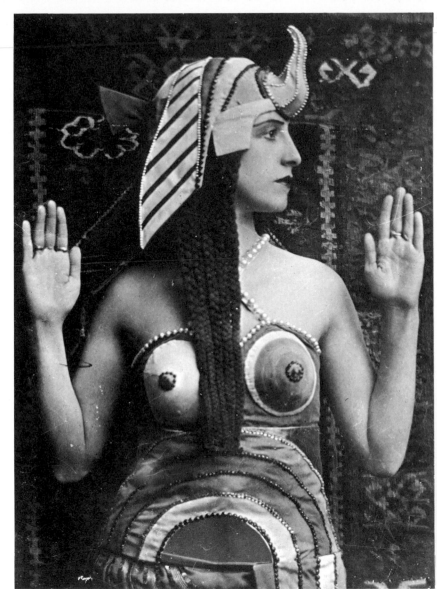

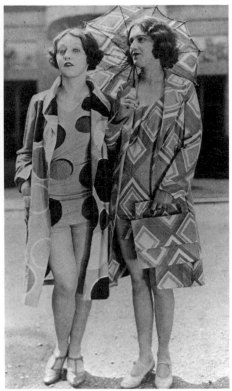

1074. ANON. Bandeau.
Green net embroidered with beads and clusters of French glass fruit.
1912–14.
Lent by Museum of Costume, Bath.

1074a. ANON. Bandeau. Jewelled blue faille with silver lamé center.

1074b. ANON. Bandeau. Pearl and diamanté.
1920s.

1075. ANON. Head-dress à la Russe.
Stiffened gold tissue embroidered with dark blue beads and rococo pearls.
1912–14.
Lent by Museum of Costume, Bath.

1076. ANON. Head-dress.
Black osprey in 'halo' style.
Early 1930s.
Lent by Museum of Costume, Bath.

1077. ANON. Boudoir cap.
Printed silk with pointed lace edging threaded with green ribbon.
1920.
Lent by Museum of Costume, Bath.

BAGS

1078. ANON. Handbag.
Fringed and beaded in blue, orange and pink, with plastic 'tortoiseshell' fittings and blue lining.
c.1925. $6\frac{1}{2} \times 10$.
Anonymous loan.

1079. ANON. Handbag.
Decorated with metallic beads and lined with kid.
c.1925. $5 \times 6\frac{3}{8}$.
Anonymous loan.

1080. ANON. Handbag.
Red with gold lamé and red tassel. French.
c.1930. $4\frac{1}{2} \times 5$.
Courtesy of Sonnabend Gallery.

1081. ANON. Handbag.
Turquoise with gold lamé applied decoration and tassel. French.
c.1930. 4×5.
Courtesy of Sonnabend Gallery.

1082. ANON. Handbag.
Aluminum and black and green *lac de chine*. English.
c.1930. $5\frac{1}{2} \times 9$.
Coll. Miss Marie Middleton.

1083. ANON. Pouch bag.
Silk strongly patterned in white, yellow, mauve and gold. English.
c.1930.
Anonymous loan.

1084. ANON. Handbag.
Black and white grosgrain stripes.
From the wardrobe of the late Ranee of Pudukota.
Lent by Museum of Costume, Bath.

1085. ANON. Pochette.
Natural cream straw edged with black leather.
From the wardrobe of the late Ranee of Pudukota.
Lent by Museum of Costume, Bath.

1086. ANON. Pochette.
Green cross-stitch embroidery.
From the wardrobe of the late Ranee of Pudukota.
Lent by Museum of Costume, Bath.

1087. ANON. Small bag.
Gold brocade, with straps of the same material.
From the wardrobe of the late Ranee of Pudukota.
Lent by Museum of Costume, Bath.

1088. ANON. Pochette.
Natural hessian, drawn thread work, fastened with an amber bead.
From the wardrobe of the late Ranee of Pudukota.
Lent by Museum of Costume, Bath.

1089. ANON. Pochette.
Saffron and deep pink brocade.
From the wardrobe of the late Ranee of Pudukota.
Lent by Museum of Costume, Bath.

1090. ANON. Pochette.
Green and blue brocade, lined with yellow satin, with satin purse attached.
From the wardrobe of the late Ranee of Pudukota.
Lent by Museum of Costume, Bath.

1091. ANON. Pochette.
Polychrome brocade, with inset panel decorated with birds.
From the wardrobe of the late Ranee of Pudukota.
Lent by Museum of Costume, Bath.

1092. ANON. Handbag.
Beige cotton embroidered with flowers.
From the wardrobe of the late Ranee of Pudukota.
Lent by Museum of Costume, Bath.

1093. ANON. Bag.
Gold chain mesh, detachable lining. (The bag had various colored linings to match different ensembles.)
From the wardrobe of the late Ranee of Pudukota.
Lent by Museum of Costume, Bath.

1094. ANON. Evening bag.
Black satin and crêpe de chine; gilt mount, loop fastening; lined with cream satin. A matching purse.
From the wardrobe of the late Ranee of Pudukota.
Lent by Museum of Costume, Bath.

1095. ANON. Evening bag.
Black silk with small diamond-shaped design, silver purse mount. Lined with pale grey card silk, cream satin.
1930s.
From the wardrobe of the late Ranee of Pudukota.
Lent by Museum of Costume, Bath.

1096. ANON. Purse.
Black enamel and glass.
$5\frac{1}{2} \times 4\frac{1}{2}$.
Coll. Mrs Gertrude Bloodhart.

1097. CARTIER, PARIS. Pochette.
Brown suede with tortoiseshell buckle clasp, lined brown kid.
From the wardrobe of the late Ranee of Pudukota.
Lent by Museum of Costume, Bath.

1098. SONIA DELAUNAY (1885–).
Handbag.
Wool with blue, red and black design.
c.1930. $6\frac{3}{4} \times 7\frac{3}{4}$.
Coll. Mr and Mrs Peter M. Brant.

1099. MAGUET, PARIS. Pochette.
Off-white linen.
From the wardrobe of the late Ranee of Pudukota.
Lent by Museum of Costume, Bath.

1100. PAUL POIRET. Handbag.
Black suede, with black mount, decorated in emerald green.
From the wardrobe of the late Ranee of Pudukota.
Lent by Museum of Costume, Bath.

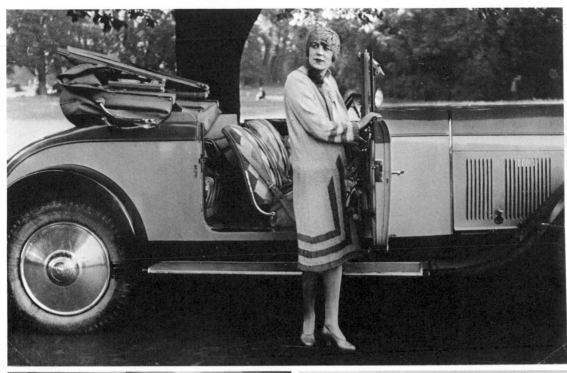

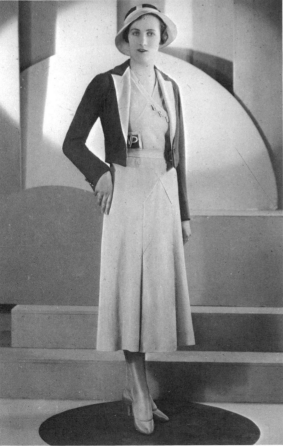

1055

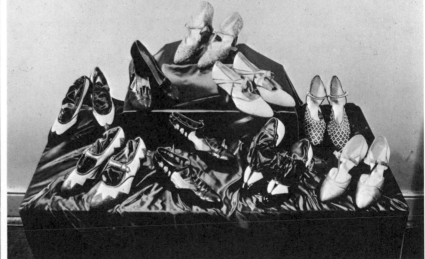

1058–67

FANS

1101. ANONYMOUS. Fan.
Red-dyed frame, gallant and eighteenth-century woman on one side; on the other, the inscription 'The Berkeley' within Art Deco motifs in red.
L: 9¼.
Coll. Mrs Janet Street-Porter.

1102. ANON. Fan.
Plain wood frame, tree motif in silver, on pale blue; on reverse, inscription 'The Berkeley'.
L: 9½.
Coll. Mrs Janet Street-Porter.

1103. ANON. Fan.
Green-dyed frame, 1920s scene on one side, 'La Baule: La plus belle plage d'Europe' inscription in silver on the reverse.
L: 10.
Coll. Mrs Janet Street-Porter.

1104. ANON. Fan.
Figures of the 1920s in color with cubist-inspired motifs.
Coll. Mrs Janet Street-Porter.

1105. DORFI. Fan.
Red-dyed frame, heads of children on one side signed 'Dorfi'; on the other, an advertisement for 'Oxade' with the inscription 'Oh! Boire une Oxade orange ou citron "Produit Liebig"!'
L: 9½.
Coll. Mrs Janet Street-Porter.

1106. MAQUET. Fan.
Red-dyed frame, with fruited boughs on one side, in silver blue and orange-sellers, in Brangwyn style, on the other.
Inscription: 'The Berkeley'.
L: 10½.
Coll. Mrs Janet Street-Porter.

1107. POVO. Fan.
Ogee-shaped, red-dyed frame, plain on one side; on the other, a woman in a swing. Palette of green, blue, orange-yellow and pale mauve.
L: 9¾.
Coll. Mrs Janet Street-Porter.

MISCELLANEOUS

1108. ANONYMOUS. Parasol.
Tinsel canopy mounted on black georgette with fancy spokes and narrow ribbons within.
Lent by Museum of Costume, Bath.

1109. ANON. Belt Buckle.
Two oval clasps with amber foundation and enamelled decoration.
1920s.
Lent by Museum of Costume, Bath.

1110. ANON. Buckle.
Mother of pearl carved with fish-scale design.
From the wardrobe of the late Ranee of Pudukota.
Lent by Museum of Costume, Bath.

1111. ANON. Buckle.
Lalique glass on metal mount.
c.1920.
Lent by Museum of Costume, Bath.

1112. ANON. Two buckles.
White paste.
c.1913.
Lent by Museum of Costume, Bath.

1113. ANON. Girdle.
Green cord knotted at intervals with two large beads.
From the wardrobe of the late Ranée of Pudukota.
Lent by Museum of Costume, Bath.

1114. ANON. Girdle
Cream cord with pale green bead trimming and knotted ends.
From the wardrobe of the late Ranee of Pudukota.
Lent by Museum of Costume, Bath.

1115. ANON. Clasp.
Beaten silver, green-enamelled at each corner.

1116. ANON. Muff.
Fur-lined natural suede with stencilled ocelot edges. From the wardrobe of the late Ranee of Pudukota.
Lent by Museum of Costume, Bath.

1116a. ANON. Belt buckle.
Green in imitation jade with three cylindrical ornaments.
c.1930. 2 × 5½.
Courtesy of Sonnabend Gallery.

1116b. ANON. Belt.
Metallic thread and three pieces in imitation jade.
c.1930. L: 34.
Courtesy of Sonnabend Gallery.

1116c. ANON. Comb.
Ornamented case in black and blue enamel, with tassel.
c.1930. L: 4.
Courtesy of Sonnabend Gallery.

1116d. ANON. Shawl.
Black velvet with floral ornaments in batik.
c.1930. 60 × 60.
Courtesy of Sonnabend Gallery.

1116e. ANON. Shawl.
Brown with geometric pattern in metallic silver.
c.1930. 88 × 41.
Courtesy of Sonnabend Gallery.

1116f. ANON. Scarf.
Black with dots.
c.1930. 48 × 9.
Courtesy of Sonnabend Gallery.

1116g. ANON. Scarf.
Brown with ornaments in three shades of brown.
c.1930. 48 × 9.
Courtesy of Sonnabend Gallery.

1116h. ANON. Scarf.
Triangular in black pailette.
c.1930. 18 × 39½.
Courtesy of Sonnabend Gallery.

1117. PAUL POIRET. Sleeve ends.
Black marocain with stylized flower embroidery in colours.
1919.
From the wardrobe of the late Ranee of Pudukota.
Lent by Museum of Costume, Bath.

1118. CAROLINE REBOUX. Scarf.
Long bias-cut crêpe de chine with coloured spots.
1925.
From the wardrobe of the late Ranee of Pudukota.
Lent by Museum of Costume, Bath.

1119. ANONYMOUS. Scarf.
Cloth of black and grey stripes.
1928–29.
From the wardrobe of the late Ranee of Pudukota.
Lent by Museum of Costume, Bath.

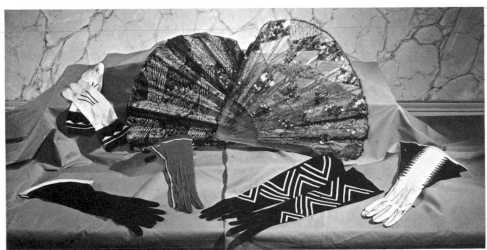

1068—72

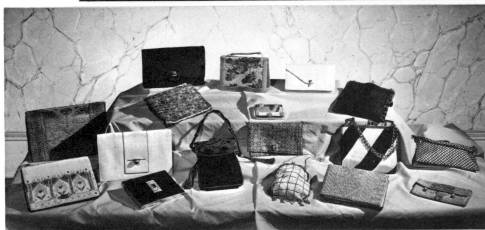

1084—95,
1097
1099—1100

1083

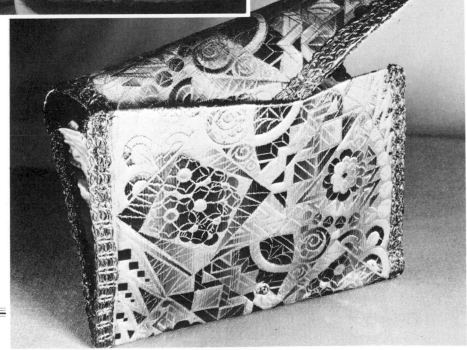

Textiles

1120. ANONYMOUS. Wall hanging.
Austrian.
c.1920.
Coll. Mr Stanley Insler.

1121. ANON. Roller printed cotton.
English.
Egyptian motifs on a blue ground.
c.1924.
Lent by Victoria and Albert Museum.

1122. ANON. Printed silk.
Floral design with silver thread pattern.
c.1930.
Coll. Mr Fred Hughes.

1123. ANON. Draperies (three pair).
Red, green and amber floral design on velvet.
112 × 36.
Coll. Miss Jean Leonard.

1124. ANON. Three valances.
Matching drapery design.
68 × 14.
Coll. Miss Jean Leonard.

1125. ANON. Bedcover.
Matching drapery design.
108 × 96.
Coll. Miss Jean Leonard.

1126. ANON. Draperies (pair).
Blue with silver thread in leaf pattern.
102 × 35.
Coll. Mr Fred Hughes.

1127. ANON. Draperies (pair).
Red with silver thread in leaf pattern.
102 × 35.
Coll. Mr Fred Hughes.

1128. MEA ANGERER. Roller-printed cotton.
Designed for Eton Rural Fabrics, Uxbridge, England, 1928.
Exh: Loan Exhibition of English Chintz Victoria and Albert Museum, 1960 cat.no.473.
Lent by Victoria and Albert Museum.

1129. VANESSA BELL (1879–1961).
Screen-printed satin.
Designed for Allan Walton Textiles.
c.1936.
Illus: H. G. Hayes Marshall, *British Textile Designers Today*, 1939, p.77.
Lent by Victoria and Albert Museum.

1130. EDOUARD BÉNÉDICTUS
(1878–1930). *Les Jets d'Eau*. Brocade.
Gold jets of water against a brick-red background, with cascades of stylized flowers in black, grey-green, yellow, and red, 1927.
Lent by Musée des Arts Décoratifs.

1131. Bénédictus. *Croisillon*.
Brocade. Criss-cross of yellow and green leaves against a blue background.
1927.
Lent by Musée des Arts Décoratifs.

1132. E. BOLCEAU. Gobelins tapestry.
Orange and black border with design of turtles and gazelles.
153 × 162.
Exh: *Paris Exposition, 1925*.
Coll. Mr and Mrs Peter M. Brant.

1133. ROBERT BONFILS. *L'Afrique*.
Silk tissue designed for Bianchini Férier, Paris.
c.1925.
Lent by Victoria and Albert Museum.

1134. T. BRADLEY. Screen-printed satin.
Designed for Allan Walton Textiles.
c.1936.
Lent by Victoria and Albert Museum.

1135. GREGORY BROWN (1887–).
Block-printed linen for W. Foxton Ltd, 1925.
Exh: *Paris Exposition*, 1925.
Illus: M. P. Verneuil, *Etoffes et Tapis Etrangers*, 1929, Pl.12, and in *Furnishing Trades Organiser*, June, 1925 p.308.
Lent by Victoria and Albert Museum.

1136. Brown. Roller-printed linen.
Designed for W. Foxton Ltd, 1932.
Exh: English Chintz: Two Centuries of Changing Taste, Manchester, 1955; cat.no.298.
Lent by Victoria and Albert Museum.

1137. Brown. Roller-printed cretonne.
Designed for W. Foxton Ltd.
1930.
Lent by Victoria and Albert Museum.

1138. Brown. Three roller-printed linens.
Designed for and registered by
W. Foxton Ltd.
July 8, 1931.
Lent by Victoria and Albert Museum.

1138a. Brown. Roller-printed linen.
Designed for and registered by
W. Foxton Ltd.
July 8, 1931.
Lent by Victoria and Albert Museum.

1139. H. J. BULL. Hand-block printed artificial silk and cotton.
Designed for Allan Walton Textiles.
1932.
Lent by Victoria and Albert Museum.

1140. Bull. Screen-printed satin.
Designed for Allan Walton Textiles.
1938.
Lent by Victoria and Albert Museum.

1141. CALICO PRINTERS' ASSOCIATION, MANCHESTER, ENGLAND. Roller-printed cotton.
Registered May 7, 1919.
Lent by Victoria and Albert Museum.

1142. Calico Printers' Association.
Roller-printed cretonne.
Registered, August 20, 1919.
Lent by Victoria and Albert Museum.

1143. Calico Printers' Association.
Roller-printed cotton.
Design of Felix the Cat on a striped ground.
Registered, March 19, 1924.
Lent by Victoria and Albert Museum.

1144. Calico Printers' Association.
Roller-printed cotton.
Registered, October 6, 1924.
Lent by Victoria and Albert Museum.

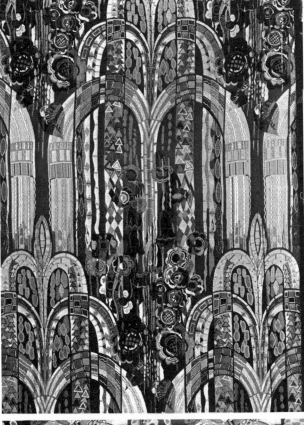

1130

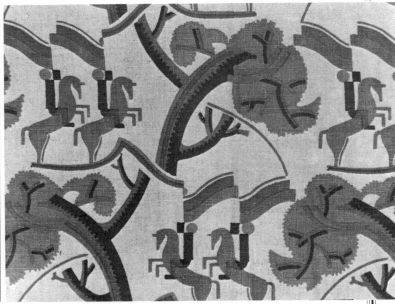

1138

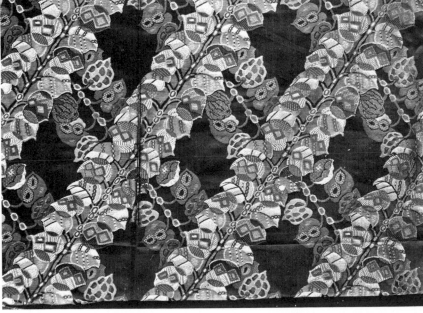

1131

1145. Calico Printers' Association.
Roller-printed cotton.
Registered, June 30, 1928.
Lent by Victoria and Albert Museum.

1146. Calico Printers' Association.
Roller-printed linen.
Registered, August 9, 1934.
Lent by Victoria and Albert Museum.

1147. T. COCKERILL.
Screen-printed pebbled satin.
Designed for Allan Walton Textiles.
1938.
Lent by Victoria and Albert Museum.

1148. SONIA DELAUNAY (1885–).
Textile design.
Watercolor on white paper, black and white checkers.
Entrusted to the printer for execution, August, 1924. Depot number 7806.
Plate engraved by Ferret at Saint-Denis.
Signed on the right in blue ink: *S. Delaunay.*
Lent by Musée des Arts Décoratifs.

1149. Delaunay. Textile design.
Watercolor on white paper, vertical bands of chevrons.
Entrusted to the printer for execution, August, 1924.
Plate engraved by Ferret at Saint-Denis.
Signed at the lower left: *S. Delaunay.*
Lent by Musée des Arts Décoratifs.

1150. Delaunay. Textile design.
Watercolor on white paper, polychrome motif in green, violet, cobalt blue, red and white on black.
Entrusted to the printer, August, 1926.
Plate engraved by Ferret at Saint-Denis.
Unsigned.
Lent by Musée des Arts Décoratifs.

1151. Delaunay. Textile design.
Watercolor on white paper, geometric forms treated in diagonals: black rectangles surrounded by different colors, alternating with squares of different colors, blue, white, red, green.
Entrusted to the printer, November, 1926.
Plate engraved by Ferret at Saint-Denis.
Unsigned.
Lent by Musée des Arts Décoratifs.

1152. FRANK DOBSON, R.A.
(1888–1963). Screen-printed linen.
Designed for Allan Walton Textiles.
1938.
Lent by Victoria and Albert Museum.

1153. DONALD BROTHERS, DUNDEE, SCOTLAND. Screen-printed linen.
Registered, February 22, 1935.
Lent by Victoria and Albert Museum.

1154. MARION DORN. *Langton.*
Screen-printed linen and rayon furnishing fabric.
Designed for Donald Brothers, Dundee.
1938.
Lent by Victoria and Albert Museum.

1155. RAOUL DUFY (1877–1953).
Block-printed linen.
Designed for Bianchini Férier, Paris.
c.1924.
Lent by Victoria and Albert Museum.

1156. Dufy. *Longchamps.* Silk tissue.
Designed for Bianchini Férier, Paris.
1929.
Illus: *Gazette du Bon Ton,* no.8, 1920, Pl.37.
Lent by Victoria and Albert Museum.

1157. ETON RURAL FABRICS, UXBRIDGE, ENGLAND.
Roller-printed cotton.
Registered, September 25, 1929.
Lent by Victoria and Albert Museum.

1158. Eton Rural Fabrics.
Roller-printed cotton.
Registered, September 25, 1929.
Lent by Victoria and Albert Museum.

1159. IRENE FAWKES.
Roller-printed linen.
Designed for W. Foxton Ltd.
1935.
Lent by Victoria and Albert Museum.

1160. T. F. FIRTH, FLUSH MILLS, HECKMONDWIKE, ENGLAND.
Uncut moquette.
Registered, June 28, 1935.
Lent by Victoria and Albert Museum.

1161. WILLIAM FOXTON.
Roller-printed linen.
Registered, April 21, 1928.
Lent by Victoria and Albert Museum.

1162. Foxton. Roller-printed cotton.
Registered April 26, 1930.
Lent by Victoria and Albert Museum.

1163. FRANKLIN AND FRANKLIN.
Warp-printed cretonne.
Registered, February 19, 1934.
Lent by Victoria and Albert Museum.

1164. F. W. GRAFTON AND CO., MANCHESTER, ENGLAND.
Roller-printed cretonne *Grafton's Merriecolour* fabric.
1927.
Lent by Victoria and Albert Museum.

1165. Grafton. Roller-printed cretonne.
c.1923.
Lent by Victoria and Albert Museum.

1166. Grafton. Roller-printed cretonne.
1923.
Lent by Victoria and Albert Museum.

1167. Grafton. Roller-printed cretonne.
1925.
Lent by Victoria and Albert Museum.

1168. DUNCAN GRANT (1885–).
Hand-block printed artificial silk.
Designed for Allan Walton Textiles.
1932.
Lent by Victoria and Albert Museum.

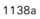

1138a

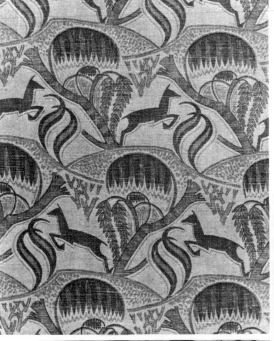

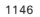

1146

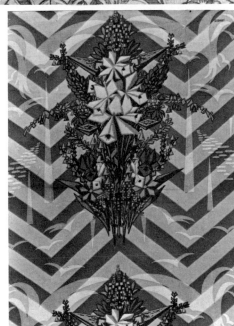

1144

1169. Grant. Screen-printed cotton satin. Designed for Allan Walton Textiles. 1932. Lent by Victoria and Albert Museum.

1170. Grant. Screen-printed cotton satin. Designed for Allan Walton Textiles. Illus: Raymond Mortimer, *Penguin Modern Painters: Duncan Grant*, 1944, Pl.27. Lent by Victoria and Albert Museum.

1171. ALBERT GRIFFITHS. Hand-block printed cretonne. Designed for William Foxton. 1920. Exh: British Institute of Industrial Art, Spring Exhibition, London, 1920; cat.no.2033. Lent by Victoria and Albert Museum.

1172. ASHLEY HAVINDEN (1903–). *Ashley's Abstract.* Screen-printed glazed cotton. Designed for Edinburgh Weavers, Carlisle, England. 1938. Illus: H. G. Hayes Marshall, *British Textile Designers Today*, 1939, p.134. Lent by Victoria and Albert Museum.

1173. G. HAXBY. Artificial silk and cotton uncut moquette. Designed for Courtauld's Ltd. 1937. Exh: *Paris Exposition*, 1937; textile section no.202. Lent by Victoria and Albert Museum.

1174. CONSTANCE IRVING (1880–). Roller-printed cotton. Designed for W. Foxton Ltd. 1929. Exh: Loan Exhibition of English Chintz, Victoria and Albert Museum, 1960, cat.no.474. Lent by Victoria and Albert Museum.

1175. LIBERTY AND CO., LONDON. Roller-printed cotton. Registered, February 11, 1931. Selvedge printed in red *Liberty and Co. Reg. Design.* Lent by Victoria and Albert Museum.

1176. MANSOUROFF. *Symphony.* Screen-printed linen. Designed for Old Bleach Linen Co. 1938. Lent by Victoria and Albert Museum.

1177. MINNIE McLEISH (1876–). Roller-printed cotton. Designed for Foxton Fabrics. c.1927. Lent by Victoria and Albert Museum.

1178. McLeish. Roller-printed cotton. Designed for William Foxton. 1920. Exh: British Institute of Industrial Art, Spring Exhibition, London, 1920; cat.no.2033. Lent by Victoria and Albert Museum.

1179. McLeish. Roller-printed cotton. Designed for Foxton Fabrics. c.1920–5. Lent by Victoria and Albert Museum.

1180. McLeish. Roller-printed cotton. Designed for W. Foxton Ltd. c.1929. Lent by Victoria and Albert Museum.

1181. PAUL NASH (1889–1946). *Fugue.* Screen-printed linen. Designed for Old Bleach Linen Co. 1936. Lent by Victoria and Albert Museum.

1182. OLD BLEACH LINEN COMPANY. *Penguin.* Screen-printed linen. 1936. Lent by Victoria and Albert Museum.

1183. FRANK ORMROD. Roller-printed cotton. Designed for Turnbull and Stockdale, Ltd. 1929. Exh: Loan Exhibition of English Chintz, Victoria and Albert Museum, 1960; cat.no.475. Lent by Victoria and Albert Museum.

1184. Ormrod. Warp-printed textured cotton. Designed for Turnbull and Stockdale Ltd. 1929. Lent by Victoria and Albert Museum.

1185. F. O. R. PLAISTOW. Artificial silk and cotton damask. Designed for Courtauld's Ltd. 1937. Exh: *Paris Exposition*, 1937; textile section no.209. Lent by Victoria and Albert Museum.

1186. RUTH REEVES. *American Scenes.* Printed Cotton 'homespun'. Designed for W. J. Sloane, New York. c.1930. Lent by Victoria and Albert Museum.

1187. Reeves. *Playboy.* Printed cotton towelling. Designed for W. J. Sloane, New York. c.1930. Lent by Victoria and Albert Museum.

1187a. EMILE-JACQUES RUHLMANN (1879–1933). Fabric sample. Crepe georgette with floral pattern in black and white on red background. Courtesy of Sonnabend Gallery.

1187b. Ruhlmann. Fabric sample. Violet with silver and floral pattern. Courtesy of Sonnabend Gallery.

1187c. Ruhlmann. Fabric sample. *Rosefare* with silver lamé floral pattern. Courtesy of Sonnabend Gallery.

1187d. Ruhlmann. Fabric sample. Crepe georgette with floral pattern in blue and black. Courtesy of Sonnabend Gallery.

1188. LOJA SAARINEN (1879–1968). Tapestry. Map of Cranbrook; geometric design in pink, tan and brown. 103 × 122. Lent by Art Galleries, Cranbrook Academy of Art.

1189. Saarinen. Tapestry. Map of Cranbrook: geometric design in coral, green, brown. 53 × 60. Lent by Art Galleries, Cranbrook Academy of Art.

1190. Saarinen. Tapestry. Geometric design with bird motif. 46 × 59. Lent by Art Galleries, Cranbrook Academy of Art.

1191. A. SANDERSON AND SONS, UXBRIDGE, ENGLAND. Roller-printed cotton. Registered, November 18, 1930. . Lent by Victoria and Albert Museum.

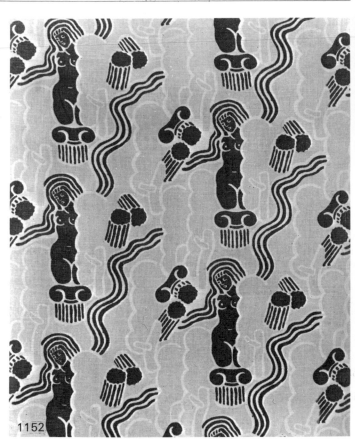

1152

1153

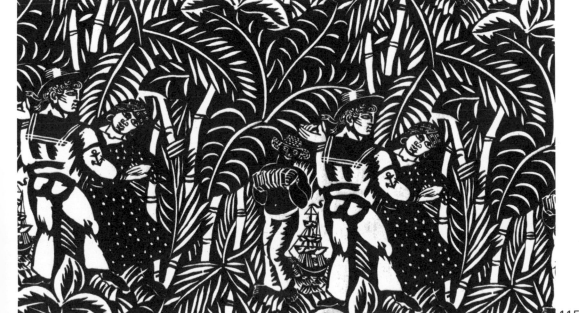

1155

1192. ARTHUR GORDON SMITH.
The History of Radio. Batik mural.
Commissioned by Mrs Nadea Dragonette
Loftus and completed in 1934. 144 × 216.
Coll. Miss Jessica Dragonette.
In the foreground is the Earth, the focus of
the design. Radio antennae atop the
buildings of the New York skyline; the first
zeppelin in the air; the *Berengaria* at sea. At
either side of the batik are column-like
figures of Drama and Music backed by
panels of electrical symbols.
Each corner pictures a news event. *Upper
left*, radio's first broadcasting studio:
Pittsburgh's KDKA and WJZ transmitter.
Lower left, Charles Lindbergh with the
Spirit of St Louis. *Upper right*, Radio City,
studio 8-H, broadcasting the earliest radio
concert programme, Cities Service 40-piece
orchestra with Rosario Bourdon conducting,
Ford Bond announcing, the Revellers
quartette and Jessica Dragonette,
soprano, singing. *Lower right*, Mrs
Franklin D. Roosevelt placing a wreath
on the tomb of the Unknown Soldier at
Arlington on Armistice Day.
Medallions throughout the batik
commemorate famous news broadcasts:
Marconi with his wireless; the first election
returns ever broadcast; the Dempsey-
Tunney prize fight; Graham MacNamee, the
first sports announcer. Symbolic figures
represent Church and State, Industry,
Labour, Agriculture, Arts and Crafts.
Radio itself is personified by a woman
holding a radio speaker at her heart. She
stands in front of the globe; her right arm
extended, holding aloft a long pole topped
with a microphone. Standing on top of the
globe, facing the microphone is Jessica
Dragonette, singing. She is wearing the
hundred-year-old Worth gown which she
wore when she sang at the fiftieth
anniversary celebration of Edison's
invention, the electric-light-bulb.
Bands of music, song and literature of the
world, stream through the microphone in
all directions through space, the theme and
character of the music illustrated by
decorative figures.
Across the top of the batik is a proscenium
arch. Radio proclaims: 'All the world's a
stage! Hear ye—achievements of
philosophy, science, art, lives of great men,
great women, great events.' The design
includes General Sarnoff's 'box to bring
music into every home' (the 'alpha and
omega of radio') and multitudes indicating
the listening world. In the lower left corner of
the batik, the artist, Arthur Gordon Smith,
has portrayed himself.

**1193. F. STEINER AND CO., CHURCH,
LANCASHIRE, ENGLAND.**
Roller-printed cotton with Egyptian motifs.
Registered, July 19, 1923.
Lent by Victoria and Albert Museum.

**1194. TOOTAL, BROADHURST,
LEE AND CO. LTD, MANCHESTER,
ENGLAND.** Roller-printed cotton designed
for the Orient Steam Navigation Company's
vessel *Orion*.
Printed 1935.
Lent by Victoria and Albert Museum.

**1195. WARNER AND SONS,
BRAINTREE, ENGLAND.**
Cotton- and silk-screen printed.
1934.
Lent by Victoria and Albert Museum.

1196. Warner and Sons. *Northiam.*
Jacquard woven cotton furnishing fabric.
1938.
Lent by Victoria and Albert Museum.

1165

1163

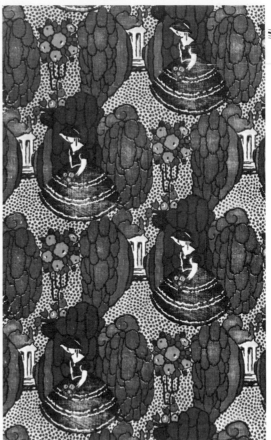

1192

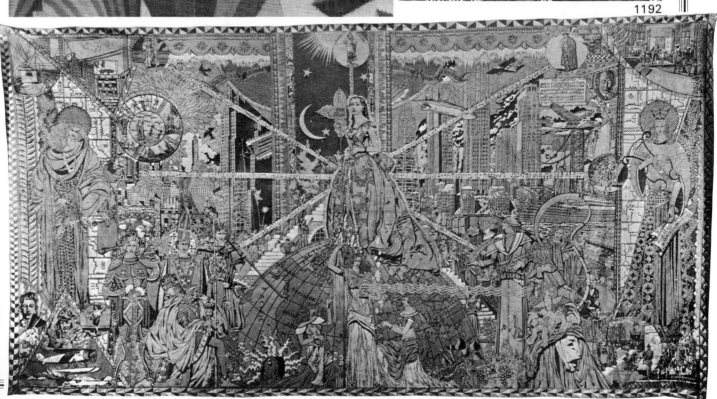

Carpets/Rugs

1197. ANONYMOUS. Small round rug. With fringed edge. Cubist-style design in beige, pink and black.
Dutch.
D: 30.
Coll. Mr and Mrs Michael Pruskin.

1198. ANON. Rectangular rug. With recurring designs.
Dutch.
72 × 60.
Coll. Mr and Mrs Michael Pruskin.

1199. ANON. Rug.
Brown, blue and beige wool.
141 × 196.
Coll. Mr and Mrs Peter M. Brant.

1200. ANON. Rectangular rug. With design of large stylized roses.
77 × 58½.
Courtesy of M. Alain Lesieuture.

1201. ANON. Oval rug. With triple border and design of palm trees. Signed (?) J.P.S.
70 × 48.
Courtesy of M. Alain Lesieutre.

1202. ANON. Round rug. With geometric design.
D: 68.
Courtesy of M. Alain Lesieutre.

1203. ANON. Rectangular rug. With border and abstract floral design.
63½ × 36.
Courtesy of M. Alain Lesieutre.

1204. ANON. Rectangular rug. With border and bold flower and leaf design. After a Sonia Delaunay design.
60 × 36.
Courtesy of M. Alain Lesieutre.

1205. ANON. Thick rug. With pink leaf design on grey.
81 × 44.
Courtesy of M. Alain Lesieutre.

1206. ANON. Rectangular rug. North American Indian style design.
Coll. Miss Mary Hillier.

1207. EDOUARD BÉNÉDICTUS (1878–1930) (att. to). Carpet. Decorated with cascades of small flowers in brilliant colors.
144 × 99.
Courtesy of M. Alain Lesieutre.

1208. JEAN LURÇAT (1892–1966). Rectangular rug. Design of four leaves against an almost plain background, with reticulated border at one end.
72 × 48.
Courtesy of M. Alain Lesieutre.

1209. GUSTAVE MIKŁOS. (1888–). Rug. Wool with metallic threads and woven stepped designs in black, pale green and white on an orange background.
c.1925. 75 × 36.
Exh: *Jacques Doucet — Mobilier 1925*, Paris, 1961; *Les Années '25'*, Paris, 1966; cat.no.690.
Lent by Musée des Arts Décoratifs.

1210. LOJA SAARINEN (1879–1968). Rug. Rose, red, green and tan. Walborg Nordquist, weaver.
1928. 67 × 55.
Lent by the Art Galleries, Cranbrook Academy of Art.

1211. ANON. Rug. Geometric design in green, tan and blue.
38 × 109.
Lent by the Art Galleries, Cranbrook Academy of Art.

1197

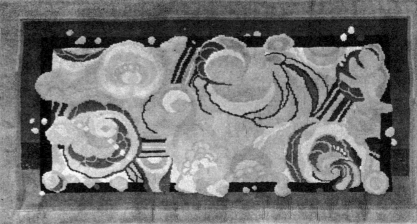

1200

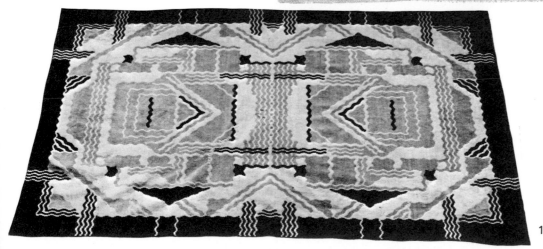

1206

Jewelry

1212. ANONYMOUS. Open necklace.
Five-strand Oriental pearl and emerald bead, with twin tassels composed of 20 strands of Oriental pearls and emerald beads.
c.1925.
L: 50¾.
Anonymous loan.

1213. ANON. Necklace.
Six-strand onyx and coral bead torsade, with sixteen-strand tassel.
c.1923. L. 19¼.
Anonymous loan.

1214. ANON. Pair of ear-rings.
Coral, onyx and diamonds.
c.1925. L: 2.
Anonymous loan.

1215. ANON. Bracelet.
Lapis lazuli, diamond and blue enamel plaque with agate flower motifs.
c.1925. L: 7.
Anonymous loan.

1216. ANON. Bracelet.
Jazz orchestra charms, platinum with diamonds and colored stones.
L: 6¼.
Anonymous loan.

1217. ANON. Brooch.
Carved emerald, diamond, pearl, crystal and platinum with mother of pearl and black enamel.
c.1930. 3½ × 1½.
Anonymous loan.

1218. ANON. Brooch.
Lapis lazuli, diamond, crystal and white gold with green enamel.
c.1928. 2½ × 1½.
Anonymous loan.

1219. ANON. Brooch.
Flower basket motif, platinum with diamonds, carved emeralds, rubies and sapphires.
c.1925. 1⅞ × 1¾.
Anonymous loan.

1220. ANON. Brooch.
Rectangular diamond, platinum, with hanging vine motif of carved emeralds, rubies, sapphires and diamonds.
c.1925. 1¾ × 1¼.
Anonymous loan.

1221. ANON. Pin.
Blue Egyptian faience, smoky topaz scarab, emeralds, diamonds, gold and black enamel.
c.1925. 5½ × 2.
Coll. Mr Jon Nicholas Streep.

1222. ANON. Necklace.
Platinum, aquamarine, rock crystal, onyx, round diamonds and pearls.
c.1925. L: 23½.
Coll. Mr Jon Nicholas Streep.

1223. ANON. Clock.
Lacquered metal, ivory, amber, gold, enamel, rose diamonds.
c.1925. 6 × 4.
Coll: Mr Jon Nicholas Streep.

1224. ANON. Vanity case.
Agate, coral, emerald, rose diamonds, black enamel and gold.
c.1925. 3¾ × 2¾.
Coll. Mr Jon Nicholas Streep.

1225. ANON. Lipstick case.
Gold, onyx, sapphires, enamel.
c.1926. L: 2¾.
Coll. Mr Jon Nicholas Streep.

1226. ANON. Vanity case and lipstick case.
Rose diamonds, platinum, enamel.
c.1927. Vanity case: 2 × 2. Lipstick: 2.
Mr Jon Nicholas Streep.

1227. ANON. Vanity case.
Gold and black enamel.
c.1928. 3 × 2.
Coll. Mr Jon Nicholas Streep.

1228. ANON. Lipstick case.
Gold and enamel.
c.1930. L: 3.
Anonymous loan.

1229. ANON. Cigarette-box.
Silver with Burgau mother of pearl and gold inlay plaque of lady in horsedrawn carriage.
c.1925. 6 × 4½.
Anonymous loan.

1230. ANON. Ring.
White gold, diamonds, carved sapphire in shape of a bird; enamelled leaves.
D: ½.
Courtesy of Lillian Nassau, Ltd.

1231. ANON. Necklace.
Opaque green glass and white frosted glass with white paste beads, brass-mounted.
Coll. Miss Marie Middleton.

1232. ANON. Necklace.
Pendant of green plastic and chrome on chrome chain.
Coll. Miss Marie Middleton.

1233. ANON. Necklace.
Blue and red plastic pendants set in chrome, on chrome chain.
Coll. Miss Marie Middleton.

1234. ANON. Pendant.
Metal and enamel set with green scarab within Egyptian-style design, and hung on chain with miniature mummy as clasp.
c.1925. D: 1¼.
Coll. The Minneapolis Institute of Arts.

1235. ANON. Pair of ear-rings.
Metal decorated with green, black and white enamel and set with glass stones. Screw fasteners for unpierced ears.
¾ × ½.
Anonymous loan.

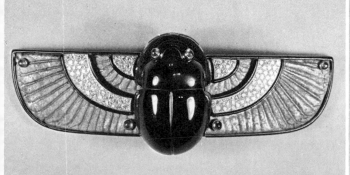

1221 and below 1234

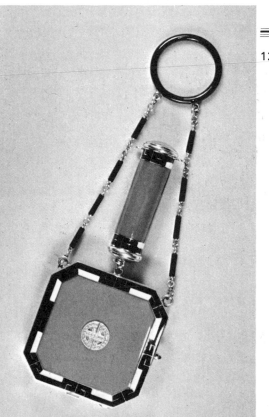

1226

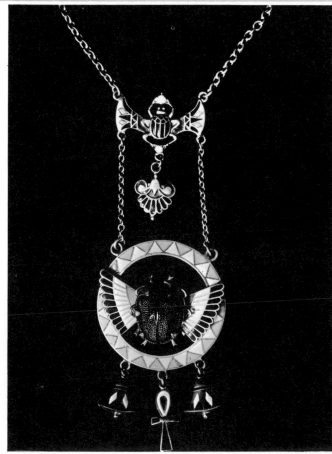

1235

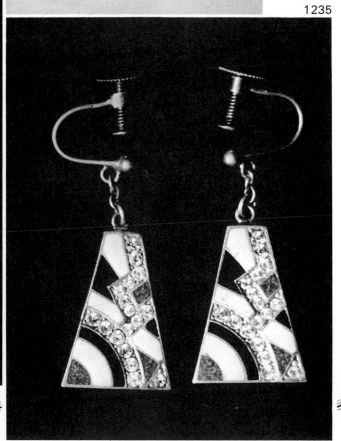

1236. ANON. Brooch. French.
Jade, cornelian, lapis lazuli, diamond, onyx
and platinum.
L: $1\frac{1}{4}$.
Anonymous loan.

1237. ANON. Clasp brooch.
Jade, coral, enamel, diamond, onyx and
platinum.
L: $3\frac{1}{2}$.
Anonymous loan.

1238. ANON. Brooch.
Lapis lazuli, gold, and dyed ivory. Bears
monogram 'J.R.'
$2\frac{1}{2} \times 2$.
Illus: Hillier, *Art Deco*, 1968, p.43.
Anonymous loan.

1239. ANON. Pendant.
Plastic, with coral beads.
Triangular sides of pendant: $1\frac{5}{8}$.
Illus: Hillier, *Art Deco*, 1968, p.43.
Anonymous loan.

1240. ANON. Brooch.
Set with marcasite and precious stones.
$2\frac{1}{2} \times 1\frac{3}{4}$.
Illus: Hillier, *Art Deco*, 1968, p.125.
Anonymous loan.

1241. ANON. Bracelet.
Three enamelled lozenges on metallic
thread band. Marked 'Paris'.
Each lozenge L: 1.
Anonymous loan.

1242. ANON. Brooch.
In the form of a white paste bow.
c.1935.
Lent by Museum of Costume, Bath.

1243. ANON. Wooden boss brooch.
Painted with polychrome stylized flowers.
Lent by Museum of Costume, Bath.

1244. ANON. Necklace.
Amber-coloured rococo beads alternating
with flattened pearl beads.
Lent by Museum of Costume, Bath.

1245. ANON. Necklace.
Six chrome cones and two blue beads.
c.1930. L: 17.
Courtesy of Barry and Audrey Friedman,
Antiques.

1246. ANON. Necklace.
Green and blue bakelite.
c.1930. L: 20.
Courtesy of Barry and Audrey Friedman,
Antiques.

1246a. ANON. Necklace.
Ziggurat pendant in wood and imitation
jade.
c.1930. $2\frac{1}{2} \times 1\frac{1}{2}$.
Courtesy of Sonnabend Gallery.

1246b. ANON. Necklace.
Articulated chrome links and a round
chrome central piece joined by two red
plastic ornaments.
c.1930. L: 18.
Courtesy of Sonnabend Gallery.

1246c. ANON. Necklace.
Two black pyramids and two spheres in
chrome and imitation jade.
c.1930. L: 17.
Courtesy of Sonnabend Gallery.

1246d. ANON. Necklace.
Two chrome cones and two imitation ivory
spheres and black enamel with chrome
cylindrical ornaments.
c.1930. L: 17.
Courtesy of Sonnabend Gallery.

1246e. ANON. Necklace.
Articulated chrome links, black cubes and
green discs, chrome sphere.
L: 17.
Courtesy of Sonnabend Gallery.

1246f. ANON. Pendant.
Round, red and white enamel, representing
an antelope and foliage, with chain.
c.1930. D: $1\frac{1}{2}$.
Courtesy of Sonnabend Gallery.

1246g. ANON. Pendant.
Rhinestones, green hardstones, and tassel
of small pearls with chain.
c.1930. D: $2\frac{1}{3}$.
Courtesy of Sonnabend Gallery.

1246h. ANON. Two necklaces.
Red and blue, yellow and blue plastic
elements joined by chrome.
c.1930. L: 18.
Courtesy of Sonnabend Gallery.

1246i. ANON. Necklace.
Black, brown and green beads.
c.1930. L: 23.
Courtesy of Sonnabend Gallery.

1246j. ANON. Necklace.
Black and translucent yellow beads with
foliage design.
c.1930. L: 17.
Courtesy of Sonnabend Gallery.

1246k. ANON. Necklace.
Alternating groups of chrome, blue and
cream-colored beads.
c.1930. L: $16\frac{1}{2}$.
Courtesy of Sonnabend Gallery.

1246l. ANON. Necklace.
Chrome central piece, one imitation jade
half-sphere, and one imitation onyx disc.
c.1930. L: 16.
Courtesy of Sonnabend Gallery.

1246m. ANON. Necklace.
Voluted central piece in chrome and
imitation onyx.
c.1930. L: 16.
Courtesy of Sonnabend Gallery.

1246n. ANON. Brooch.
Aluminum, gold metal and imitation jade.
c.1930. $\frac{3}{4} \times 3\frac{3}{8}$.
Courtesy of Sonnabend Gallery.

1246o. ANON. Brooch.
Ornaments in gold metal, black and red
enamel.
c.1930. $\frac{5}{8} \times 1\frac{7}{8}$.
Courtesy of Sonnabend Gallery.

1246p. ANON. Pin watch.
Ornaments in two shades of blue enamel.
c.1930. $3\frac{1}{2} \times \frac{3}{4}$.
Courtesy of Sonnabend Gallery.

1246q. ANON. Bracelet.
Circular, three aluminum discs and a black
sphere.
c.1930. D: $2\frac{3}{4}$.
Courtesy of Sonnabend Gallery.

1246r. ANON. Bracelet.
Circular, two elements, one black and the
other transparent yellow plastic.
c.1930. D: $2\frac{1}{2}$.
Courtesy of Sonnabend Gallery.

1246s. ANON. Bracelet.
Chrome, imitation jade and onyx elements.
c.1930. L: $7\frac{1}{2}$.
Courtesy of Sonnabend Gallery.

1246t. ANON. Pair of ear-rings.
Chrome and blue plastic spheres.
c.1930. L: $2\frac{1}{2}$.
Courtesy of Sonnabend Gallery.

1246u. ANON. Pair of ear-rings.
Round, in chrome and imitation jade.
c.1930. D: $\frac{3}{4}$.
Courtesy of Sonnabend Gallery.

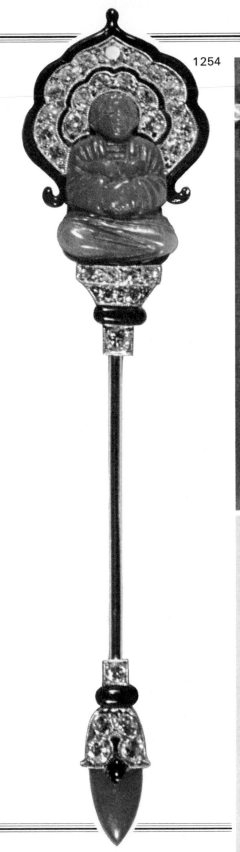

1254

1278

1271

1251

1247. ANON. Necklace.
Chromed metal, six balls.
c.1930. L: 18.
Coll: Kiki Kogelnik.

1248. ANON. Necklace.
Metal with black wooden ball.
c.1930. L: 17.
Coll. Kiki Kogelnik.

1248a. ANON. Pair of cuff links.
Chrome, red and black enamel.
c.1930. $\frac{5}{8} \times \frac{1}{4}$.
Courtesy of Sonnabend Gallery.

1248b. ANON. Pair of cuff links.
Silver, decorated with red and blue enamel.
c.1930. $\frac{5}{8} \times \frac{1}{4}$.
Courtesy of Sonnabend Gallery.

1249. ANON. Teething-ring.
Silver and ivory.
c.1930. 3 × 2.
Coll. Mr and Mrs Lewis V. Winter.

1250. BOIVIN, PARIS. Lipstick case.
Gold and black enamel cabochon ruby
studded.
L: $1\frac{7}{8}$.
Anonymous loan.

1251. BOUCHERON, PARIS.
Oval brooch.
Platinum, onyx and coral.
1925. $2 \times 4\frac{1}{4}$.
Exh: *Paris Exposition*, 1925; *Paris
Exposition*, 1937, cat.no.1293; *Les Années
'25'*, Paris, 1966, cat.no.814.
Illus: Léon Deshairs, 'L'Exposition des Arts
Décoratifs, la section Français,' *Art et
Décoration*, vol.xlviii, July–December 1925,
p. 209.
Lent by Musée des Arts Décoratifs, Paris.

1252. BOURDIER, PARIS. Vanity-case.
Gold and platinum, red and black enamel
with malachite centre and ends, diamonds
and onyx decoration.
c.1924. $3\frac{3}{4} \times 1\frac{5}{8}$.
Anonymous loan.

1253. CARTIER. *Nenette, Rintintin et
Tintinet:* Pendant.
Diamonds and rubies on platinum chain.
c.1918. L: 12.
Anonymous loan.

1254. Cartier. Jabot pin.
Diamonds, platinum, enamel with coral
Buddha.
c.1925. L: 3.
Coll. Mr Jon Nicholas Streep.

1255. Cartier. Pair of ear-rings.
Pear-shaped in yellow sapphire, onyx, pearl,
diamond, black enamel and platinum.
c.1930. L: 3.
Anonymous loan.

1256. Cartier. Brooch.
Green tourmaline and diamond, coral and
white enamel, in gold and platinum mount.
c.1925. $1\frac{3}{4} \times 1$.
Anonymous loan.

1257. Cartier. Jabot pin.
Coral, emerald, gold and platinum with
pearl, onyx, diamonds and black enamel.
c.1930. L: $4\frac{1}{8}$.
Anonymous loan.

1258. Cartier. Watch.
Jade chimera, gold and platinum pendant,
lapel brooch watch with rubies, diamonds,
onyx and black enamel.
c.1923. L: $4\frac{3}{8}$.
Anonymous loan.

1259. Cartier. Watch.
Carved emerald, ruby, diamond, onyx,
black enamel, platinum and gold pendant,
lapel brooch watch.
c.1925. L: $3\frac{1}{2}$.
Anonymous loan.

1260. Cartier. Clock.
Transparent quartz topaz and gold boudoir
clock with diamonds, coral, jade, black
enamel and mother of peal numerals.
c.1926. H: $5\frac{3}{4}$. Anonymous loan.

1261. Cartier. Clock.
Small jade and gold boudoir clock
decorated with black niello arabesques and
standing on two carved coral and onyx
supports.
c.1925. H: 2.
Anonymous loan.

1262. Cartier. Clock.
Rose diamonds, cabochon rubies,
platinum, red and black enamel on onyx
base.
c.1925. $3 \times 2\frac{1}{4} \times 1\frac{3}{4}$.
Coll. Mr Jon Nicholas Streep.

1263. Cartier. Clock.
Black lacquer, bronze, coral and chalcedony.
c.1925. 4 × 2.
Coll. Mr Jon Nicholas Streep.

1264. Cartier. Vanity-case.
Gold and platinum, red enamel, with carved
jade center; coral, diamonds, niello
arabesque design and onyx ring at top.
c.1930. $5 \times 1\frac{3}{4}$.
Anonymous loan.

1265. Cartier. Vanity-case.
Rose diamonds, emeralds, rubies, sapphires,
gold, tortoiseshell and jade.
c.1925. $3\frac{3}{4} \times 2\frac{1}{2}$.
Coll. Mr Jon Nicholas Streep.

1266. Cartier. Vanity-case.
Tortoiseshell, rose diamonds, platinum.
c.1925. $3\frac{3}{4} \times 2\frac{3}{4}$.
Coll. Mr Jon Nicholas Streep.

1267. Cartier. Scent-bottle.
Carved topaz, quartz, jewelled mounting.
c.1928.
Courtesy of Lillian Nassau, Ltd.

1268. Cartier. Clock.
Crystal, mounted with enamelled gold and
rose diamonds.
c.1930. $6 \times 4\frac{1}{2}$.
Coll. Miss Barbra Streisand.

1269. Cartier. Clock.
Ornamented with jade lions, diamonds and
mother of pearl.
c.1925. $3 \times 2\frac{1}{5}$.
Anonymous loan.

**1270. CHARLTON AND CO.,
NEW YORK.** Watch.
Red and black enamel, diamond, platinum
pendant, lapel brooch watch.
c.1930. L: $4\frac{1}{4}$.
Anonymous loan.

1271. JEAN DESPRÈS. Ring.
In silver, gold and black enamel.
c.1930.
Courtesy of Mr John Jesse.

1271a. Desprès. Brooch.
Semicircular in gold, white gold, black
enamel and turquoise.
1925. $1\frac{3}{8} \times 2\frac{1}{2}$.
Courtesy of Sonnabend Gallery.

1271b. Desprès. Pair of clips.
Gold, white gold, turquoise and blue
enamel.
$1\frac{1}{8} \times 3\frac{3}{4}$.
Courtesy of Sonnabend Gallery.

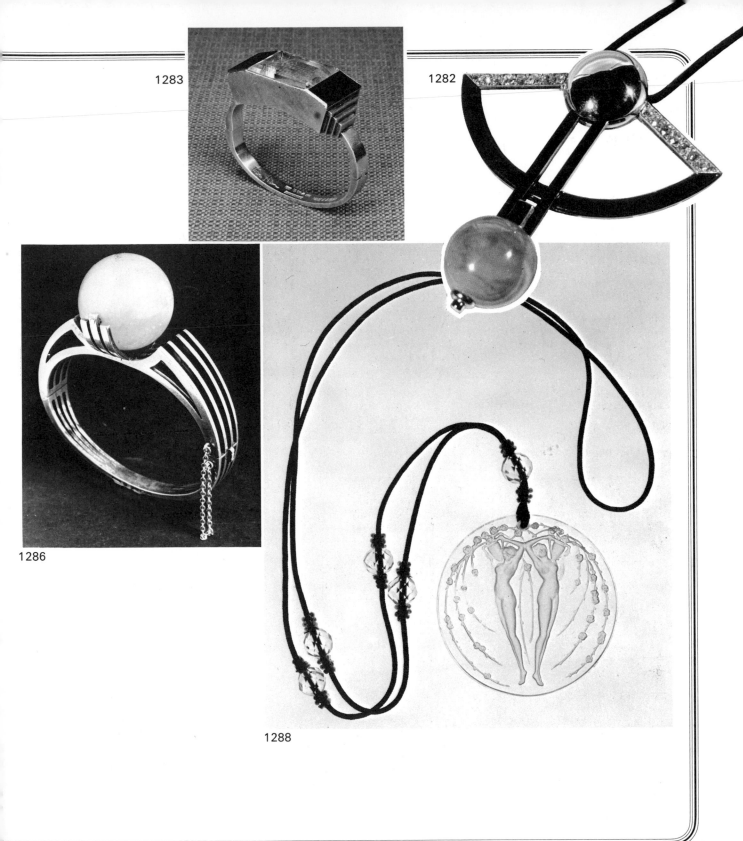

1283

1282

1286

1288

1271c. Després. Necklace and pendant.
Silver and ivory.
Exh: *Paris Exposition*, 1937.
Pendant: $2\frac{3}{4}$.
Courtesy of Sonnabend Gallery.

1271d. FAURÉ. Brooch.
Circular in Limoges enamel of different lines
of orange, mauve and yellow.
c.1930. D: 2.
Courtesy of Sonnabend Gallery.

1272. GEORGES FOUQUET (1862–
1957). Necklace.
Large coral bead, black enamel and
diamond pendant on pearl and platinum
chain.
c.1920. Pendant: $3\frac{1}{2}$. Chain: $15\frac{7}{8}$.
Anonymous loan.

1273. G. Fouquet. Necklace.
Frosted glass bead with pearl tassel, and
circular pendant.
c.1925. L: 22.
Coll. Mr Jon Nicholas Streep.

1274. G. Fouquet. Pair of ear-rings.
Black onyx and diamond urn shape.
c.1925. L: $3\frac{7}{8}$.
Anonymous loan.

1275. G. Fouquet. Pair of ear-rings.
Moonstone and sapphire hoop and ball
ear-clips with blue enamel and diamond
pendant, globe motif.
c.1930. L: $2\frac{1}{4}$.
Anonymous loan.

1276. G. Fouquet. Brooch.
White agate, diamond, onyx, platinum and
white gold.
c.1930. $2\frac{3}{8} \times 1\frac{3}{8}$.
Anonymous loan.

1277. G. Fouquet. Brooch.
Triangular, ivory, turquoise, diamond, onyx
and gold.
c.1924. $3\frac{3}{8} \times 3\frac{3}{8}$.
Anonymous loan.

1278. G. Fouquet. Necklace.
Frosted-glass beads with onyx and red
enamel ornaments and conical-shaped
frosted-glass pendant with glass and onyx
bead tassel.
L: 24.
Exh: *Paris Exposition*, 1925.
Anonymous loan.

1279. JEAN FOUQUET (1899–).
Necklace.
Art Nègre ebony hoop with four white
metal and gold discs.
c.1929. D: $18\frac{1}{2}$.
Anonymous loan.

1280. J. FOUQUET. Bracelet.
Art Nègre ebony and white arm hoop
c.1928. D: 7.
Anonymous loan.

1281. J. Fouquet. Necklace.
Oval frosted-glass medallion and white gold
pendant with coral, agate, moonstone and
onyx set in Cubist style design on silver
snake chain.
Pendant: $4 \times 2\frac{3}{4}$. Chain: 16.
Exh: *Paris Exposition*, 1925.
Anonymous loan.

1282. J. Fouquet. Pendant.
Platinum, white gold, diamonds, coral and
onyx, in the form of a pendulum. Similar
brooch is illustrated in *L 'Oeil*, October,
1969, p.43.
Coll. Mme Francine Legrand-Kapferer.

1283. W. HILMAN. Bracelet. Swedish.
Silver, jet and crystal.
$2\frac{1}{2} \times 2\frac{1}{2}$.
Illus: Hillier, *Art Deco*, 1968, p.122.
Coll. Mr John Jesse.

1284. JANESICH, PARIS. Circular brooch.
Coral and jadeite, onyx and diamond set in
white gold.
c.1925. L: $2\frac{1}{2}$.
Anonymous loan.

1285. Janesich. Bracelet.
Recurring sun motifs in jade, different
colored golds, cornelian and enamel.
Mark: 3914 ECE.
$7\frac{1}{8} \times \frac{7}{8}$.
Anonymous loan.

1286. A. JILLANDER. Bracelet.
Silver with revolving jade ball.
$2\frac{1}{2} \times 3$.
Illus: Hillier, *Art Deco*, 1968, p.123.
Coll. Mr John Jesse.

1287. RENÉ LALIQUE (1860–1945).
Brooch.
Square crystal frame with four faceted glass
stones and scenes of Spring Maidens etched
in crystal.
c.1920. $1\frac{11}{16} \times 1\frac{11}{16}$.
Anonymous loan.

1288. Lalique. Pendant medallion.
Glass, on black silk cord with seed pearls.
Pendant: $2\frac{1}{8}$. Cord: $11\frac{1}{2}$.
Coll. The Minneapolis Institute of Arts,
gift of Mrs Carl W. Jones.

1289. Lalique. Pendant.
Oval with carved wasp motif and tassel on
cord.
L: 40.
Coll. Miss Jean Leonard.

1290. MARCHAK, PARIS. Framed
octagonal Burgau mother-of-pearl plaque
showing young girl and a man smoking,
with dog seated beneath a tree of inlaid gold,
with gilded foreground.
c.1925. D: 3.
Anonymous loan.

Far right: Madame Templier wearing
bracelet: Cat.no.1298.

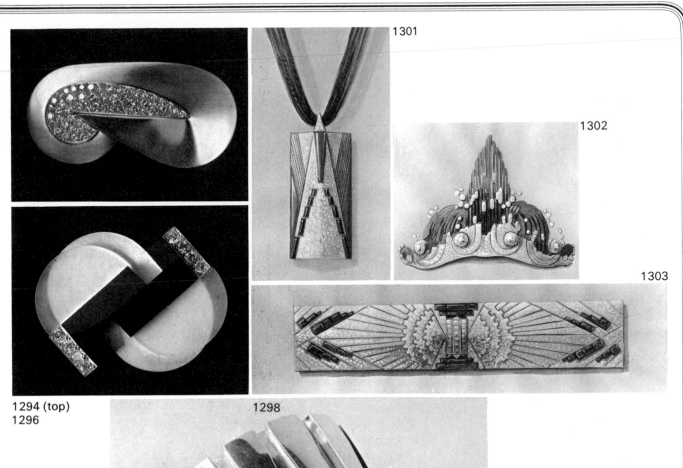

1301

1302

1303

1294 (top)
1296

1298

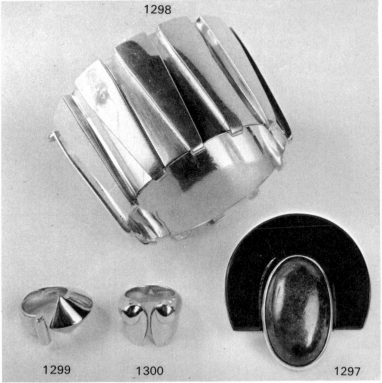

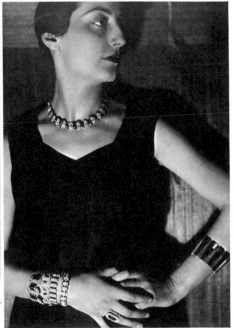

1299 1300 1297

1291. MAUBOUSSIN. Jabot pin.
Carved jade wreath with rubies, diamonds,
sapphires and white gold.
L: 4.
Anonymous loan.

1292. Mauboussin. Lorgnette.
Black enamel with rose diamonds, white
gold and intaglio center with figures of
Diana and Cupid. Attached to a pearl and
white gold chain.
L: 29.
Anonymous loan.

1293. Mauboussin. Parrot pin.
Amethysts, topaz and diamonds.
L: 1¼.
Anonymous loan.

1294. RAYMOND TEMPLIER. Brooch.
Lent by Musée des Arts Décoratifs.

1295. Templier. Ring.
Lent by Musée des Arts Décoratifs.

1296. Templier. Brooch.
Lent by Musée des Arts Décoratifs.

1297. Templier. Brooch.
Silver and lapis lazuli.
2¼ × 2.
Courtesy of M. Alain Lesieutre.

1298. Templier. Bracelet.
Silver, made for Madame Templier.
2 × 2¼ × 3.
Courtesy of M. Alain Lesieutre.

1299. Templier. Gold ring.
Courtesy of M. Alain Lesieutre.

1300. Templier. Gold ring.
Courtesy of M. Alain Lesieutre.

1301. Templier. Drawing of pendant.
China ink and gouache on tracing paper. The
drawing was executed after a photograph of
a jewel made about 1925 by the Maison
Templier, in gold, silver and emeralds.
1925. Paper: 9½ × 6½. Frame: 11¾ × 8¾.
Exh: *Les Années '25'*, Paris, 1966.
Lent by Musée des Arts Décoratifs.

1302. Templier. Drawing of diadem.
China ink and gouache on tracing paper.
Signed and dated 1925. The gem is of
amber, platinum and diamonds.
Paper: 6½ × 9¾. Frame: 11¾ × 8¾.
Exh: *Les Années '25'*, Paris, 1966.
Lent by Musée des Arts Décoratifs.

1303. Templier. Drawing of brooch.
China ink and gouache on tracing paper.
Signed and dated 1925. The brooch is of
platinum, emeralds and diamonds, in
rectangular form.
Paper: 6¼ × 9¾. Frame: 8¾ × 11¾.
Exh: *Les Années '25'*, Paris, 1966.
Lent by Musée des Arts Décoratifs.

1304. TIFFANY AND COMPANY.
Jewel-case.
Beige shagreen.
c.1920. 6½ × 3.
Coll. Mr Edward Lee Cave.

**1305. VAN CLEEF AND ARPELS,
'PARIS.** Vanity-case.
Gold and platinum, black enamel with
carved lapis lazuli plaque, moonstones,
sapphires, diamonds and mother-of-pearl.
3¼ × 1⅔.
Anonymous loan.

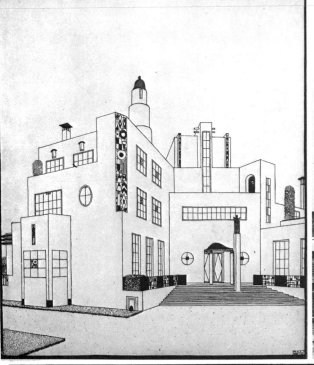

1336

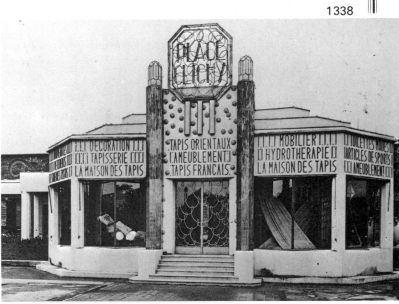

1338

1350

Architecture Interior Design

FRANCE
1334. ROBERT MALLET-STEVENS
(1886–1945). Design for pavilion.
Ink and lavis.
c.1923.
Exh: *Les Années '25'*, Paris, 1966,
cat.no.561.
Lent by Musée des Arts Décoratifs.

1335. Mallet-Stevens.
Two designs for villas.
Black and green ink.
Both signed and dated 1923.
Exh: *Les Années '25'*, Paris, 1966,
cat.no.562.
Lent by Musée des Arts Décoratifs.

1336. Mallet-Stevens.
Design for a country house.
Black and green ink.
c.1923.
Exh: *Les Années '25'*, Paris, 1966,
cat.no.563.
Lent by Musée des Arts Décoratifs.

1337. PARIS EXPOSITION.
1925.
Fontaine René Lalique.
Architect Marc Ducluzéaud,
with *Cœur des Métiers.*
Architect Charles Plumet.
Pl.40 from the portfolio *L'Architecture
Officielle.* Charles Moreau, Paris, 1925.
Coll. The Minneapolis Institute of Arts.

1338–8a. SHOP FRONTAGES.
Plates from the portfolio *Devantures et
Installations de Magasins*, 2nd Series,
Charles Moreau, Paris.
1925.
Coll. The Minneapolis Institute of Arts.

1338 *Place Clichy.*
Architect Charles Siclis. Pl.45.

1338a. *Parfumerie d'Orsay.*
Architects Sue et Mare. Pl.42.

1339–46. Shop frontages.
Plates from the portfolio *Façades et
Agencements de Magasins*, 4th series.
Charles Moreau, Paris.
Coll. The Minneapolis Institute of Arts.

1339. *Joaillerie, boulevard Haussmann.*
Decorator Poitevin. Pl.24.

1340. *Bar, avenue Portalis.*
Architect Colombier. Pl.96.

1341. *Au Siamois, Place de la Madeleine.*
Contractor Bouche.
Façade in stucco and wrought iron. Pl.20.

1342. *Alfa-Romeo* showrooms.

1343. *Galeries Lafayette.*
Architect Chanut.
Granite façade. Pl.11.

1344. *Pinoco, arcades des Champs-Elysées.*
Decorator Deschanel.
Interior. Pl.46.

1345. *Bijouterie, rue Royale.*
Architect René Crevel. Pl.21.

1346. *Le Bazar.*
Architect Marcel Oudin. Pl.18.

1347. *Boutique,* Paris.
Architect Georges Gumpel.
From the *Encyclopédie de l'Architecture,*
ii, Pl.90.
Coll. The Minneapolis Institute of Arts.

1348. *Boutique, Paris.*
Architects Raguenet and Maillard.
1925.
From the *Encyclopédie de l'Architecture,*
i, 43.
Coll. The Minneapolis Institute of Arts.

1349. *Travel Agency,* rue Danou, Paris.
Architect Pierre Petit.
From the portfolio *Hôtels de Voyageurs,*
Pl.28.
Coll. The Minneapolis Institute of Arts.

1350. *Maison de Verre.*
Architect Pierre Chareau.
1929.
Built for Dr Dalsace, rue Saint-Guillaume,
Paris.
Completed in 1931.

1351. Interior.
With Art Deco stained-glass window, from
the film *L'Epingle Rouge,* presented by
L. Aubert and Films Lucifer from a
dramatic novel by M. P. Bienaimé, mise en
scène by M. E. E. Violet.
c.1920–5.

1352. Two interiors.
With Art Deco wallpapers, from the film
Li-Hang le Cruel, presented by L. Aubert and
Films Lucifer from a script by André de
Lorde and Henri Bauche, mise en scène by
M. E. E. Violet, interiors and decoration by
Donatien.
c.1920–5.

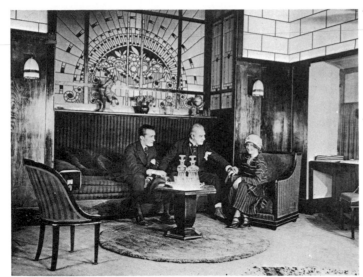

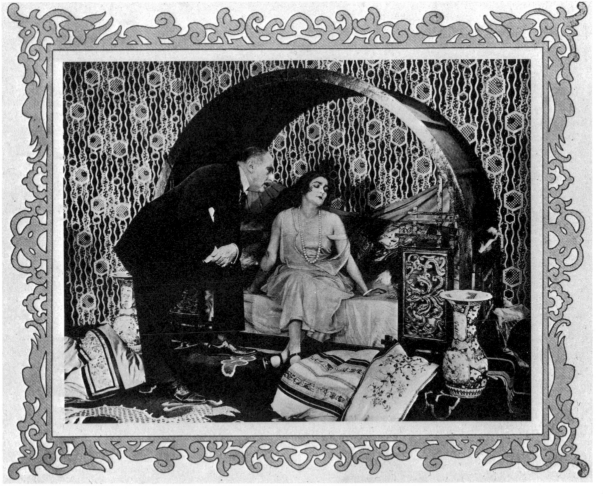

HOLLAND

1353. The American Hotel, Amsterdam.

1354. The Tuschinski Cinema, Amsterdam.

GREAT BRITAIN

1355. Strand Palace Hotel, London.
Architect Bernard.
1929.
(Photographs before alteration in 1968.)
The original glass entrance is now in
storage at the Victoria and Albert Museum.

1356. Derry and Toms store, High Street,
Kensington, London.

1357. Odeon Cinema, Camberwell,
London.
Interior decoration by Condecor, Ltd.

1358. Odeon Cinema, Balham, London.
Interior decoration by Condecor, Ltd.

1358a. Savoy Cinema, Hayes, Middlesex.
Interior decoration by Condecor, Ltd.

1359. Bar with design of cocktail glasses on
floor by Condecor, Ltd.

1360. Kipling House, Villiers Street,
London.
Art Deco linoleum design.

1361. Daily Express Building, Fleet Street,
London.
Architects Sir Owen Williams, Herbert O.
Ellis and Clarke; interiors by Robert
Atkinson.
1931.
Literature: 'Daily Express Building, Fleet
Street, London,' *Architecture Illustrated*,
June, 1932.

1362. The 'Wharrie Shelter', taximen's tea
kiosk, Haverstock Hill, Hampstead,
London.
Mosaic floor with industrial imagery,
dated April, 1935.

1363. Ritz Cinema, Bradford, Yorkshire.
Interior decoration by Condecor, Ltd.

1363a. Cavendish Cinema, Nottingham.
Interior decoration by Condecor, Ltd.

1364. Royd House, Manchester.
224 Hale Road.
Architect Edgar Wood 1914–16.

1353

1354

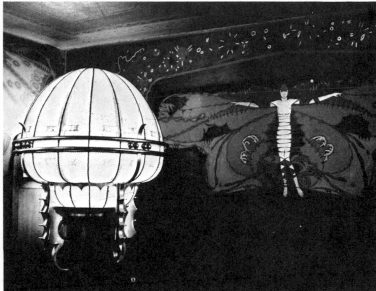

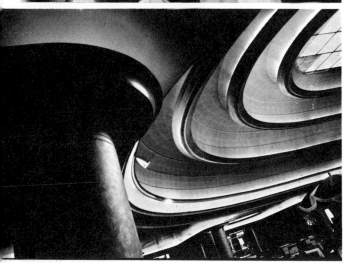

1356

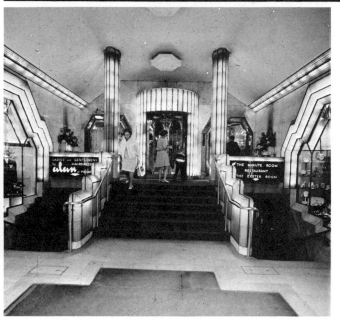

1355

UNITED STATES OF AMERICA

1365. Theoretical drawing for house, by Kem Weber.
c.1918–21.
Lent by Art Galleries, University of California, Santa Barbara.

1366. Project for outdoor light standards by Kem Weber.
1939.
Lent by Art Galleries, University of California, Santa Barbara.

1367. Berkeley High School, Berkeley, Calif.
Sculptor Jacques Sohnien.
1940.

1367a. House, corner of Ellis and Powell. Emeryville, Calif.
Architects Balaam Brothers.
1940.

1368. Wilshire Tower, 5514 Wilshire Boulevard, Los Angeles.
Architect Gilbert Stanley Underwood.
1928–9.

1369. Fox-Wilshire Theater, 8444 Wilshire Boulevard, Los Angeles.
Architect Gilbert Stanley Underwood.

1370. Bullocks-Wilshire Store, Los Angeles.
Architects John and Donald Parkinson.
1928.

1371. Richfield Building, Los Angeles.
Architects Morgan, Walls and Clements; sculptor Haig Patigian.
1928–9.
Lit: David Gebhard, *The Richfield Building, 1928–68.*
Atlantic Richfield Co., U.S.A., 1969.

1371a. Coca Cola Bottle Works, Los Angeles.
Architect Robert W. Derran.
1937.

1372. Sunset Towers, Hollywood.
Architect Leland A. Bryant.
1929.

1373. Maritime Museum, San Francisco.
Architects William Mooser and Co.
1939.

1373a. Sommer & Kaufmann Shoe Store, San Francisco.
Architect Kem Weber.
1936.

1374. Cranbrook Academy, Bloomfield Hills, Michigan.

1375. Eye Clinic, 3939 West 50th St, Edina, Minns.

1376. Dain Tower, 6th and Marquette, Minneapolis.

1377. Forum Cafeteria, 36th South 7th St, Minneapolis.

1378. Grandview Theater, 1830 Grand Ave., St Paul.

1379. State Capitol Building, Lincoln, Neb.
1927. Blueprint.
Architects Bertram Grosvenor Goodhue Associates.
Lent by Nebraska State Historical Society.

1380. State Capitol Building, Lincoln, Neb.
Design for East Senate Chamber doors by Lee Lawrie; executed by Harry F. Cunningham.
Lent by Nebraska State Historical Society.

1381. Chrysler Building, New York.

1382. Chanin Building, New York.

1383. Radio City Music Hall, Rockafeller Center, New York.
Architects Reinhard and Hofmeister; Corbett, Harrison & MacMurray; Hood and Fouilhoux.
Interior decoration by Donald Deskey.

1384. Swing's Store, Bartlesville, Okla.

1385. *Laramie Daily Boomerang* Building, Laramie, Wyo.

1381

1357

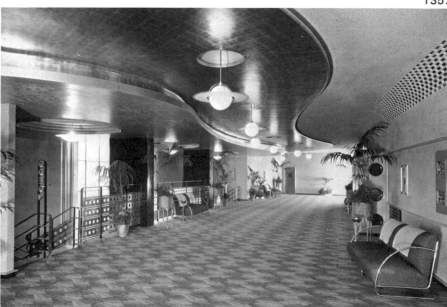

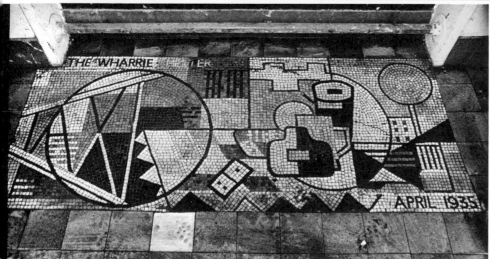

1362

Plastics

1386. Pair of candlesticks.
Imitation onyx.
$6\frac{1}{2} \times 3\frac{1}{2}$.
Coll. Mr John Jesse.

1387. Ash-tray.
Spherical shape, black and green
imitation onyx.
3×3.
Coll. Mr John Jesse.

1388. Box.
Orange and black with fluted sides.
$2\frac{1}{4} \times 4$.
Coll. Mr John Jesse.

1389. Box.
Orange and black with fluted sides.
$2\frac{1}{4} \times 2\frac{1}{2}$.
Coll. Mr John Jesse.

1390. Box.
White with leaf design and thimble knop.
$1\frac{1}{2} \times 5\frac{1}{2}$.
Coll. Mr John Jesse.

1391. Scent-bottle.
Imitation amber.
$4 \times 2\frac{1}{4}$.
Coll. Mr John Jesse.

1392. Cigarette-case.
Clasp in form of small hand.
$4 \times 3\frac{1}{4}$.
Coll. Mr John Jesse.

1393. Cigarette case.
Clasp in form of small hand.
$4 \times 3\frac{1}{4}$.
Coll. Mr John Jesse.

1394. Lamp.
Blue and beige design with conical shade.
10×5.
Coll. Mr John Jesse.

1395. Lamp.
Mock mother-of-pearl, stitched with
leather.
$11 \times 13 \times 4\frac{1}{2}$.
Illus: Hillier, *Art Deco*, 1968, p.155.
Coll. Mr John Jesse.

1396. Battery-operated lamp.
Sang de bœuf and white.
$7\frac{1}{2} \times 8 \times 1\frac{1}{2}$.
Coll. Mr John Jesse.

1397. Pair of candlesticks.
Plastic and chrome.
$4\frac{3}{4} \times 3\frac{3}{4}$.
Illus: Hillier, *Art Deco*, 1968, p.155.
Coll. Mr John Jesse.

1398. Biscuit-barrel.
Dark and light green with stepped handles.
Anonymous loan.

1399. Skittles trophy.
Orange and black, surmounted by
chrome-plated figure of a man bowling.
Decorated with plastic skittles.
Anonymous loan.

1400. Cigarette-holder.
L: 36 extended.
Coll. Dr K. C. P. Smith and Mr Paul Smith.

1401. Shoe-trees.
White, with painted black and gold designs.
Probably Japanese.
$11 \times 5\frac{1}{2}$.
Coll. Miss Marie Middleton.

1402. Stylized scene of Chicago's World
Fair.
1933.
Iridescent plastics.
Coll. Mr and Mrs Lewis V. Winter.

1403. Twenty-four boxes.
Ivory, plastic with screw-tops. For solid
perfume, each painted with characteristic
Art Deco motif. In original leather/paper
case.
French, c.1928.
Coll. Miss Marie Middleton.

1367a

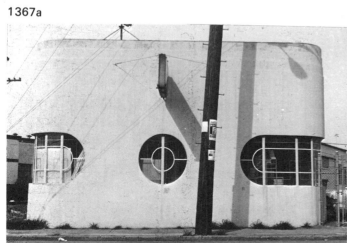

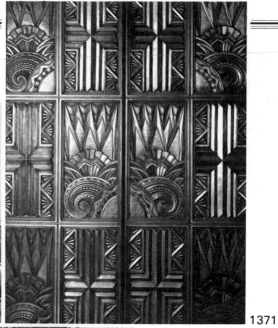

1371

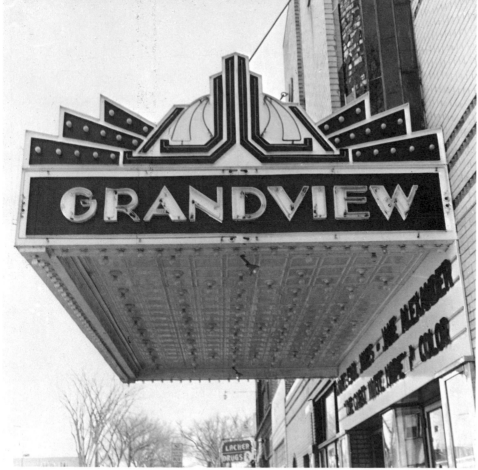

GRANDVIEW

1378

Art Deco Revival

ART DECO REVIVAL: This section of the exhibition attempts to illustrate some of the ways in which interest in ART DECO has affected contemporary art and fashions.

1404. ANONYMOUS. Menu card for 'A Taste of the Twenties' (restaurant), London.
1970. 14 × 11.
Anonymous loan.

1405. ANON. Bow tie with Art Deco design in red and black.
From Arnold Bennett (Men's Store), New York.
1969.
Anonymous loan.

1406. ANON.
This is the Look Autumn, 1970.
Harrod's, London, autumn catalogue of women's dresses.
$11\frac{1}{2} \times 5\frac{3}{4}$.
Anonymous loan.

1407. BENTLEY/FARRELL/BURNETT, LONDON. Three window cards for Achille Serre Dry Cleaners, London.
1969. 30 × 20.
Anonymous loan.

1408. MICHAEL ENGLISH.
Come to the Edge.
Poster. Designed from a poem entitled *New Numbers* by Christopher Logue, Institute of Contemporary Arts, London.
30 × 22.
Anonymous loan.

1409. English. *Message 2.*
Poster. Poem by Allen Ginsberg. Design for Ad Infinitum, Ltd, London.
1968. 38 × 22.
Anonymous loan.

1410. English. *Sun Dae,* 1969.
Tinprint.
22 × 16.
Anonymous loan.

1411. ERTÉ (ROMAIN DE TIRTOFF, 1893–). Book illustrations from Lytton Strachey's *Ermyntrude and Esmeralda.*
Anthony Blond, London, 1969.
Signed by the artist.
Anonymous loan.

1412. MICHAEL FARRELL. Jacket for Anthony Gibbs, *In My Time: An Autobiography.*
Peter Davies, London, 1969.
Literature: Hillier, *A Case for Book Jackets, The Guardian*, London, January 21, 1970.
Anonymous loan.

1413. GALLERY FIVE, LONDON. *Tango.*
Poster.
1968. 19 × $17\frac{1}{2}$.
Anonymous loan.

1414. Gallery Five. *Bedside Manner.*
Poster.
1968. 19 × $17\frac{1}{2}$.
Anonymous loan.

1415. Gallery Five. Fourteen Art Deco style greeting cards.
Designers: Graham Houghton and Michael Roberts.
1969.
Anonymous loan.

1416. Gallery Five. Card of five detachable gift tags.
1969.
Anonymous loan.

1417. HALLMARK CONTEMPORARY CARDS, NEW YORK. Six Art Deco style cards.
1970.
Anonymous loan.

1418. MILTON GLASER. *Art Deco.*
Poster.
1970. 36 × 24.
Anonymous loan.

1419. INTRO MAGAZINE, No. 2.
September 30, 1967.
Contains cut-out 1930s style girl.
$17\frac{1}{2} × 11$.
Anonymous loan.

1420. JUST MEN, LONDON.
Art Deco revival shirt.
Anonymous loan.

1421. ROY LICHTENSTEIN.
Modern table.
Edition 2/3. Brass and dark glass.
1970. $17\frac{3}{4} × 58 × 58$.
Lent by the artist.

1422. Lichtenstein.
Modern Sculpture with Horse Motif.
Edition 3/6. Aluminum and marble.
1967. H: $28\frac{3}{4}$.
Courtesy of Locksley/Shea Gallery.

1423. Lichtenstein.
Modern Sculpture with Three Voids.
Edition 4/6. Wood and mirror.
1968. $10\frac{1}{2} × 25 × 9$.
Courtesy of Locksley/Shea Gallery.

1420

1425
and below 1435

1424. Lichtenstein.
Modern Sculpture with Intersecting Arcs.
Edition 3/6. Aluminum and plexiglas.
1968. H: 31½.
Courtesy of Locksley/Shea Gallery.

1425. Lichtenstein. *The Modular.*
Vinyl and felt banner.
96 × 96.
Coll. Mr and Mrs Miles Fiterman.

1426. MACMILLAN AND CO.,
LONDON. Brochure advertising
C. P. Snow's novel, *Last Things,* 1970, in
Art Deco style lettering.
13 × 10.
Anonymous loan.

1427. A. MOITNIEZ.
Cover of *l'Automobiliste.*
Adrien Maeght, Paris, 1970.
Design of veteran car.
8¼ × 11.
Anonymous loan.

1428. PERSONALITY POSTERS, INC.,
NEW YORK. Poster of Fred Astaire and
Ginger Rogers. Photographic still.
1970. 43 × 29½.
Anonymous loan.

1429. Personality Posters.
*Who is That? The Late Late Viewer's Guide
to the Old Movie Players, 1967.*
Text by Warren B. Meyers. Illustrated by
Jerry Lang and Gosta Viertel.
7¾ × 10.
Anonymous loan.

1430. Personality Posters.
The Bonnie and Clyde Scrapbook.
Text by G. Gelman and R. Lackmann.
1967. 8 × 11.
Anonymous loan.

1431. DAVE ROE.
Isle of Wight Pop Festival.
Poster. Designed for Fiery Creations Ltd.
1969. 31 × 20½.
Anonymous loan.

1432. Roe. *Jackpot.*
A Polypops Paper Design.
1970. 28½ × 19½.
Anonymous loan.

1433. Roe. *Jukebox.*
A Polypops Paper Design.
1970. 28½ × 19½.
Anonymous loan.

1434. Roe. *Polyscope.*
A Polypops Paper Design.
1970. 28½ × 19½.
Anonymous loan.

1435. FRANK STELLA.
Tahkt-I-Sulayman Variation II.
Acrylic on canvas.
1969. 120 × 240.
Coll. The Minneapolis Institute of Arts.
Gift of Mr and Mrs Bruce B. Dayton.

1436. JOE TILSON. *Ziggurat 5.*
Screenprint.
1966. 27¼ × 40.
Anonymous loan.

1437. MARC TREIB.
David Gebhard: Moderne.
Poster. Brown ozalid.
1970.
Coll. The Minneapolis Institute of Arts.

1438. TRITON GALLERY, NEW YORK.
Poster for 'The Who' in the rock opera,
Tommy.
1969. 26 × 18.
Anonymous loan.

1439. PETER LE VASSEUR.
Gangsters from Movies.
1970.
Courtesy of Mr John Astrop.

1440. THE VILLAGE GATE, LONDON.
Shirt in Art Deco style.
From The Village Gate, London.
1970.
Anonymous loan.

1441. BARRY ZAID. Tea-towel.
Printed by Dodo Designs, London.
1970.
Anonymous loan.

1438

1404

1441

Bibliography

1. PERIODICALS

American Architect. International Publications, New York, 1876–1938.

L'Architecte. Éditions Albert Lévy, Paris, 1924–36.

The Architect's Journal. Architectural Press, London, 1895 to date.

Architectural Record. F. W. Dodge, New York, 1891 to date.

L'Architecture Vivante. Albert Morance, Paris, 1923–33.

Der Architekt. Kunstverlag Anton Schroll, Vienna, 1898–1922.

Architettura & Arti Decorative. Restetti & Tumminelli, Milan, 1921–41.

Art & Industry. The Studio Ltd, London, 1922–33. Previous titles: **Commercial Art,** Nov. 1922–Dec. 1931; **Commercial Art and Industry,** Jan. 1932–Dec. 1935.

Art & Décoration. Éditions Albert Lévy, Paris, 1897–1938.

Les Arts Français. Librairie Larousse, Paris, 1917–19.

Bâtir. Société des Métiers d'Art, Brussels, 1932 to date.

Der Baumeister. B. Hessling, Berlin, 1902.

Der Bau- und Werkkunst. A. Weiser, Vienna, 1924–32.

California Arts and Architecture. Western States Pub. Co., Los Angeles, 1929–44.

Casabelia. Milan, 1928–43.

La Cité. R. Verwilghen, Brussels, 1919–35.

Clarté. M. H. Dons, Directeur, Brussels, 1928–39.

Le Décor d'Aujourd'hui. Paris, 1935–50; 1952–7.

Deutsche Kunst und Dekoration. Alexandre Koch, Darmstadt, 1897–1934.

Lê Document. Organe de l'Association Professionnelle des Architectes Belges, Brussels, 1925–39.

Die Form – Monatsschrift für Gestaltende Arbeit. Verlag Hermann Rackendorf, Berlin, 1925–35.

Forum: Zeitschrift für Kunst, Bau und Einrichtung. Herausgeber und Verantwortlicher, Bratislava, 1931–8.

Gazette du Bon Ton. Lucien Vogel, Paris, 1913–14; 1920–5.

Gebrauchsgraphik. Phönix Illustrationsstück, Berlin, 1924–44; 1949 to date.

Haus und Raum. Ratgeber für Bauen und Wohnen, Haus und Raum, Stuttgart, 1929–37.

Interior Architecture & Decoration. Combined with **Good Furniture and Decoration,** October, 1931. Interior Architecture and Decoration Pub. Co., New York, 1921–32.

Journal des Dames et des Modes. Bureaux du Journal des Dames, Paris, 1912–14.

Mobilier et Décoration. Revue Mensuelle des Arts Décoratifs Appliqués et de l'Architecture Moderne. Éditions Mobilier et Décoration, Sèvres, 1920 to date.

Moderne Bauforman. J. Hoffman, Stuttgart, 1902–44.

Monatshefte für Baukunst. Wasmuth, Berlin, 1914–42.

Pencil Points. Architectural Review, Inc., New York, 1920 to date.

Das Plakat. Max Schildberger, Berlin, 1910–21.

The Poster. Poster Advertising Assoc., Inc., Chicago, 1915–38.

Profil-Mensch und Landschaft. H. A. Vettern, Vienna, 1933–6. Supersedes **Bau- und Werkkunst.**

Revista de Arquitectura. Órgano Oficial de las Asociaciones de la Sociedad Central de Arquitectos, Centro de Estudiantes de Arquitectura de la República Argentina, 1924–51.

Das Schöne Heim. F. Bruckmann, Munich, 1929–42.

Styl: Mesicinik pro Architekturu, Stavbu Mest a Umelecky Prumysl. Prague, 1908–38.

Union de l'Affiche Française. n.d.

Wendingen. H. Th. Wijdeveld, Amsterdam, 1918–31.

2. EXHIBITION CATALOGS

American Federation of the Arts. **Decorative Metalwork and Cotton Textiles.** New York, 1931.

American Federation of the Arts. **International Exhibition of Ceramic Art.** New York, 1928.

American Federation of the Arts. **International Exhibition of Contemporary Glass and Rugs.** New York, 1929.

Finch College Museum of Art. **Art Deco.** New York, 1970.

Guide-Album de l'Exposition Internationale des Arts Décoratifs et Industriels Modernes. L'Édition Moderne, Paris, 1925.

Internationale Buchdruckkunst Ausstellung. Leipzig, 1927.

L'Italia alla Esposizione Internazionale dei Arti Decorative ed Industriale Moderne. Paris, 1925.

Musée des Arts Décoratifs. **Les Années 25. Art Deco/Bauhaus/Stijl/Esprit Nouveau.** Paris, 1966.

Musée des Arts Décoratifs. **Le Décor de la Vie de 1900–1925.** Paris, 1937.

Museum für Angewandte Kunst. **Um 1930.** Munich, 1969.

Paris Arts Décoratifs – 1925; Guide Pratique du Visiteur de Paris et de l'Exposition. Librairie Hachette, Paris, 1925.

United States Department of Commerce. **Report on the International Exposition of Modern Decorative and Industrial Art in Paris, 1925.** Report of Commission appointed by the Secretary of Commerce to visit and report on the above Exposition. Washington, D.C., 1925.

Salon International du Livre d'Art. Petit Palais des Beaux-Arts de la Ville de Paris. Paris, 1931.

3. GENERAL SURVEYS

Album de l'Exposition Internationale des Arts Décoratifs. Édité par l'Art Vivant. Librairie Larousse, Paris, 1925.

Annual of American Design – 1931. I. Washburn, New York, 1930.

L'Art Décoratif Français : 1918–25. Editions Albert Lévy, Paris, 1926. Vol. 2, 1930. A selection of photographs from the periodical, **Art et Decoration.**

Art Décoratif à Paris. A. Calvas, Paris, 1928.

L'Art Français depuis Vingt Ans. Librairie Ridier, Paris, n.d.
Vol. 1: E. Sedeyn, **Le Mobilier ;**
Vol. 2: H. Clouzot, **Le Travail du Métal ;**
Vol. 3: T. L. Klingsor, **La Peinture ;**
Vol. 4: H. M. Magne, **L'Architecture ;**
Vol. 5: L. Moussinac, **La Décoration Théatrale ;**
Vol. 6: Ch. Saunier, **Les Décorateurs du Livre ;**
Vol. 7: René Bizet, **La Mode ;**
Vol. 8: A. H. Martinie, **La Sculpture ;**
Vol. 9: R. Chorance.
La Céramique et la Verrerie ;
Vol. 10: Luc-Benoist, **La Tapisserie, Les tapis.**

Les Arts Décoratifs en 1925. Numéro Spécial de Vient de Paraître. Éditions Cries et Cie, Paris, 1925.

Les Arts de la Maison. Albert Morance, Paris, 1923–9.

Banham, Reyner. **Theory and Design in the First Machine Age.** Architectural Press, London, 1960.

Battersby, Martin. **The Decorative Twenties.** Studio Vista, London; Walker & Co., New York, 1969. (To be followed by **The Decorative Thirties.**)

Bayard, Émile. **L'Art Appliqué d'Aujourd'hui.** Ernst Grund, Paris, n.d.

Bayard, Émile. **Le Style Moderne.** Librairie Garnier Frères, Paris, 1919.

Bitterman, Eleanor. **Art in Modern Architecture.** Reinhold, New York, 1952.

Brunhammer, Yvonne. **The Nineteen-Twenties Style.** Paul Hamlyn, London, 1969. Translated by Raymond Rudorff from the Italian original entitled, **Lo Stile 1925,** Fratelli Fabbri Editori, Milan, 1966.

Chavance, René.
Une Ambassade Française.
Charles Moreau, Paris, 1925.

Cheney, Sheldon & Martha.
Art and the Machine.
Whittlesey House, New York, 1936.

Le Corbusier (Pierre Jeanneret-Gris).
L'Art Décoratif d'Aujourd'hui.
Collection de l'Esprit Nouveau.
Éditions G. Cries et Cie, Paris, n.d.

La Décoration Française Contemporaine à l'Exposition Internationale de Paris, 1937.
Décoration Intérieure du Pavillon du Comité Français des Expositions.

Defries, Amelia. **Purpose in Design.**
Methuen and Co., London, 1938.

Drexier, Arthur and Greta Daniel.
Introduction to Twentieth-Century Design from the Collection of the Museum of Modern Art.
The Museum of Modern Art, New York, 1959.

D'Uckerman, P. **L'Art dans la Vie Moderne.**
Flammarion, Paris, 1927. A good survey of the 1937 Paris Exposition of the same name.

Encyclopédie des Métiers d'Art: Décoration Moderne.
4 vols. Charles Moreau, Paris, n.d.

Exposition Internationale des Arts Décoratifs et Industriels Modernes.
Rapport Général.
Librairie Larousse, Paris, 1929.
Vol. 1: **Préface: Origines de l'Exposition & Évolution de l'Art Moderne;**
Vol. 2: **Architecture;**
Vol. 3: **Décoration Fixe de l'Architecture;**
Vol. 4: **Mobilier;**
Vol. 5: **Accessoires du Mobilier;**
Vol. 6: **Tissus et Papier;**
Vol. 7: **Livre;**
Vol. 8: **Jouets, Appareils Scientifiques, Instruments de Musique et Moyens de Transport;**
Vol. 9: **Parure;**
Vol. 10: **Théâtre, Photographie et Cinématographie;**
Vol. 11: **Rue et Jardin;**
Vol. 12: **Enseignement.**
Perhaps the most useful and illustrative documents in the field. Each volume is profusely illustrated and includes a substantial text and relevant bibliography.

Felice, Carlo A. **Arti Industriale d'Oggi.**
Quadernidella Triennale, Milan, 1937.

Frankl, Paul T. **Form and Re-Form.**
Harper Bros., New York, 1930.

Frankl, Paul T. **New Dimensions.**
Payson Clarke, New York, 1928.

Gluck, Franz. **Adolf Loos.**
Collection Les Artistes Nouveaux.
Éditions G. Cries et Cie, Paris, 1931.

Guevrekian, Gabriel. **Objets de Série**, Vol. 19 —
L'Art International d'Aujourd'hui.
Ch. Moreau, Paris, 1930.

Hillier, Bevis.
Art Deco of the Twenties and Thirties.
Studio Vista, London, 1968.
Dutton Studio Vista, New York, 1969.

Kahle, Katherine Morrison.
Modern French Decoration
G. P. Putnam's Sons, New York; London, 1930.

Koch, Alexander. **Das Neue Kunsthandwerk in Deutschland und Österreich.**
Alexander Koch, Darmstadt, 1922.

Legrain, Pierre.
Objets d'Art Présentés par Pierre Legrain.
Vol. 2 of the Series:
L'Art International d'Aujourd'hui.
Charles Moreau, Paris, n.d.

Modern American Design.
I. Washburn, New York, 1930.

Modern French Decorative Art. 2 vols.
The Architectural Press, London, 1926–39.

Mourey, Gabriel.
Essai sur l'Art Décoratif Français Moderne.
Librairie Ollendorff, Paris, 1921.

Olmer, Pierre.
L'Art Décoratif Français en 1928.
Société Artistique de Publications Techniques, Paris, 1928.

Olmer, Pierre & Bouche Le Clerq, Henri.
L'Art Décoratif Français en 1929.
Société Artistique de Publications Techniques, Paris, 1929.

La Participation de la Ville de Paris à l'Exposition Internationale des Arts Décoratifs et Industriels Modernes.
Imprimerie Nationale, Paris, 1925.

Pevsner, Nikolaus.
An Enquiry into Industrial Art in England.
Cambridge University Press, Cambridge, England, 1937.

Quenioux, Gaston.
Les Arts Décoratifs Modernes.
Librairie Larousse, Paris, 1925.

Roche, Antoine. **Paris, 1928.**
Librairie des Arts Décoratifs, Paris, 1928.

Sandoz, Gérard.
Objets Usuels Présentés par Gérard Sandoz.
Vol. 14 of the series:
L'Art International d'Aujourd'hui.
Charles Moreau, Paris, 1931.

The Studio Yearbook of Decorative Art.
The Studio, Ltd, London, 1906 to date.

Teague, Walter Dorwin. **Design This Day.**
Harcourt, Brace, New York, 1940.

Templier, Raymond.
La Forme sans Ornement.
Vol. 18 of the series:
L'Art International d'Aujourd'hui.
Charles Moreau, Paris, 1930.

Veronesi, Giulia. **Style and Design: 1909–29.**
George Braziller, New York, 1968.

4. ARCHITECTURE, ARCHITECTS AND INTERIOR DESIGNERS

Barr, Alfred H., Henry Russell Hitchcock, Philip Johnson and Lewis Mumford.
Modern Architects.
The Museum of Modern Art, New York, 1932.

Barrez, Alphonse. **Maisons d'Habitation.**
Vol. 3 of the series:
L'Art International d'Aujourd'hui.
Charles Moreau, Paris, n.d.

Choay, Françoise. **Le Corbusier.**
George Braziller, New York, 1960.
Includes selective bibliography.

Christ-Janer, Albert. **Eliel Saarinen.**
Univ. of Chicago Press, Chicago, 1948.

Cizaletti, Maxime.
L'Art dans la Façade Moderne.
Éditions Alexis Sinjohn, Paris, 1931.

Cizaletti, Maxime.
Halls et Bureaux Modernes.
Alexis Sinjohn, Paris, n.d.

Le Corbusier.
Ihr Gesamtes Werk von 1910–1929;
Ihr Gesamtes Werk von 1929–1934.
Verlag H. Girsborger, Zurich, 1930, 1935.

Le Corbusier, **Oeuvre Complète, 1934–8.**
Les Éditions d'Architecture, Erlenbach, Zurich, 1939.

Le Corbusier.
Pierre Jeanneret et Le Corbusier.
Series 1–6.
Albert Morance, Paris, 1929–34.

Le Corbusier. **Urbanisme Moderne.**
Vol. 20 of the series:
L'Art International d'Aujourd'hui.
Charles Moreau, Paris, n.d.

De Fries, H.
Moderne Villen und Landhäuser.
Verlag Ernst Wasmuth, Berlin, 1925.

Dervaux, Adolphe.
L'Architecture Étrangère à l'Exposition Internationale des Arts Décoratifs.
Charles Moreau, Paris, 1925.

Dervaux, A.
Les Pavillons Étrangers à l'Exposition.
Charles Moreau, Paris, 1925.

William M. Dudok.
Published with the aid of the Prince Bernhard Fund by G. Van Saans **'Lectura architectura'**
Amsterdam and F. G. Kroonder, Bussum, 1954.

Ferriss, Hugh.
The Metropolis of Tomorrow.
I. Washburn & Co., New York. 1929.

Gebhard, David.
The Richfield Building: 1928–68.
Atlantic Richfield Company, Los Angeles, 1970.

Gebhard, David and H. von Breton.
Kem Weber - The Modern in Southern California, 1920 through 1941.
University of California, Santa Barbara, 1969.

Jamot, Paul. **A. & G. Perret & l'Architecture du Beton Armé.** Éditions Van Oest, Paris, 1927.

Loos, Adolf.
Adolf Loos: Das Werk des Architekten.
Anton Schroll, Vienna, 1931.

Lurçat, André. **Projets et Réalisations.**
Vincent Fréal, Paris, 1929.

Mallet-Stevens, R. **Dix Années de Réalisations en Architecture et Décoration.**
Charles Massin, Paris, 1930.

Mallet-Stevens, Robert
Grandes Constructions.
Vols. 1 and 2 of the series:
L'Art International d'Aujourd'hui.
Charles Moreau, Paris, n.d.

Mayor, J.
Les Kiosques et Pavillons Urbains.
Charles Moreau, Paris, n.d.

McGrath, Raymond and A. C. Frost.
Glass in Architecture and Decoration.
Architectural Press, London, 1937.

McGrath, Raymond.
Twentieth-Century Houses.
Faber & Faber, London, 1934.

Mendelsohn, Erich.
Das Gesamtschaffen des Architekten.
Rudolf Mosse Buchverlag, Berlin, 1930.

Mendelsohn, Erich.
Neue Haus - Neue Welt.
Rudolf Mosse, Berlin, 1932.

Modernage Furniture Co.
House of the Modern Age.
New York, 1936.

Moderne Cafés, Restaurants und Vergnügungsstätten.
Ernst Pollak Verlag,
Berlin-Charlottenburg, 1928.

Mouray, Gabriel.
La Vérité sur la Cour des Métiers.
Librairie de France, Paris, 1925.

Moussinac, Léon.
Robert Mallet-Stevens.
Collection Les Artistes Nouveaux.
Éditions G. Cries et Cie, Paris, 1931.

Munz, Ludwig and Gustav Kunstler.
Adolf Loos: Pioneer of Modern Architecture.
Thames and Hudson, London, 1966.

Novi, A. **Détails d'Architecture Intérieure Présentés par A. Novi.**
Vol. 5 of the series:
L'Art International d'Aujourd'hui.
Charles Moreau, Paris, 1929.

Patout, P. **L'Architecture Officielle et Les Pavillons à l'Exposition des Arts Décoratifs Modernes.**
Charles Moreau, Paris, 1926.

Porcher, Jean
Michel Roux-Spitz: Réalisations.
Vol. 1, 1924–32.
Éditions Vincent Fréal, Paris, n.d.

Robertson, Howard and F. R. Verbury.
Examples of Modern French Architecture.
Charles Scribner's Sons, New York, 1928.

Roux-Spitz, Michel. **Bâtiments et Jardins.**
Albert Lévy, Paris, 1925.

Selmersheim, Pierre.
Le Village Moderne, Les Constructions Régionales et Quelques Autres Pavillons.
Charles Moreau, Paris, 1926.

Shand, Morton P.
Modern Theatres and Cinemas.
B. T. Batsford, London, 1930.

Sharp, Dennis. **The Picture Palace.**
Hugh Evelyn, London, 1969.

Sharp, Dennis.
Sources of Modern Architecture.
Wittenborn, New York, 1967.

Svřček, Jaroslav. **Jiři Kroha.**
Verlag Meister der Baukunst, Geneva, 1930.

36 Progetti di Ville di Architetti Italiani a Cura dell'Esposizione Triennale (Monza). Editore d'Arte Restetti e Tumminelli, Milan, 1931.

Von Eckhardt, Wolf. **Erich Mendelsohn.**
George Braziller, New York, 1960.

Wattjes, J. G. **Modern Dutch Architecture.**
2 vols, John Tiranti & Co., London, 1928.

Wattjes, J. G. **Moderne Architectuur.**
Uitgevers-Maatschappij Kosmos,
Amsterdam, n.d.

Wattjes, J. G.
Moderne Villas en Landhuizen in Europa en Amerika. Kosmos, Amsterdam, 1930.
Introduction in Dutch, French, English, and German.

Wirth, Zdanek. **Jusef Gocor,**
Verlag Meister der Baukunst Geneva, 1930.

Yerbury, F. R. **Modern European Buildings.**
Payson & Clarke, Ltd, New York, n.d.

5. STOREFRONTS AND STORE DESIGN

Chavance, René. **Nouvelles Boutiques.**
Charles Moreau, Paris, n.d.

Delacroix, Henri and A. Lezine.
Boutiques Présentées par Henri Delacroix. S. de Bonadona, Paris, 1936.

Herbst, René.
Boutiques et Magasins Présentés par René Herbst. Vol. 8 of the series **L'Art International D'Aujourd'hui.**
Charles Moreau, Paris, 1929.

Herbst, René.
Les Devantures, Vitrines, Installations de Magasins. Charles Moreau, Paris, n.d.

Herbst, René.
Modern French Shop Fronts and Their Interiors. John Tiranti & Co., London, 1927.

Herbst, René.
Nouvelles Devantures et Agencements de Magasins, 1–5. Charles Moreau, Paris, 1925–30.

Kiosler, Frederick.
Contemporary Art Applied to the Store and its Display. Brentano's, New York, 1930.

Lacroix, Boris. **Magasins et Boutiques.**
Charles Massin, Paris, n.d.

Trethowen, Harry.
Selling through the Window.
The Studio, Ltd, London, 1935.

6. INTERIOR DESIGN, DECORATION AND FURNITURE

Adnet, J. J. **Sièges Modernes.**
Éditions Eugène Moreau, Paris, 1929.

Badovici, Jean.
Harmonies – Intérieurs de Ruhlmann.
Albert Morance, Paris, 1924.

Badovici, Jean.
Intérieurs Français Présentés par Jean Badovici. Albert Morance, Paris, 1925.

Chareau, Pierre.
Intérieurs Présentés par Pierre Chareau.
Vol. 6 of the series: **L'Art International d'Aujourd'hui.** Charles Moreau, Paris, n.d.

Cherronet, Louis. **Jacques Adnet.**
Art et Industrie, Paris, 1948.

Clouzot, Henri.
Style Moderne dans la Décoration Intérieure. Charles Massin, Paris, 1926.

Delacroix, Henri.
Décoration Moderne dans l'Intérieur.
Éditions S. de Bonadona, Paris, n.d.

Delacroix, Henri. **Intérieurs Modernes.**
Éditions S. de Bonadona, Paris, 1930.

Deshairs, Léon. **L'Hôtel du Collectionneur.**
Albert Lévy, Paris, 1926.

Dufrène, Maurice, ed.
Ensembles Mobiliers à l'Exposition Internationale de 1925. Charles Moreau, Paris, 1925.

Dufrène, Maurice, ed.
Les Intérieurs Français au Salon des Artistes Décorateurs en 1926.
Charles Moreau, Paris, 1928.

Dufrène, Maurice, ed.
Meubles du Temps Présent. Eugène Moreau, Paris, 1930.

Ensembles Mobiliers. Vols. 1 & 2, 1937;
vol. 3, 1938; vol. 4, 1939. Charles Moreau, Paris.

Ensembles Nouveaux. Charles Moreau, Paris, n.d.

Exton, E. and Littman, Frederic.
Modern Furniture. Boriswood, London, 1936.
A look at British modern furniture.

Fleury, Gaston.
Décors et Ameublements au Goût du Jour.
Charles Massin, Paris, 1926.

Frechet, André. **Intérieurs Modernes.**
Charles Moreau, Paris, n.d.

George, Waldemar.
Intérieurs et Ameublements Modernes.
Eugène Moreau, Paris, n.d.

Goumain, A. **Les Meubles.** Charles Moreau, Paris, n.d.

Henriot, Gabriel, **Luminaire Moderne.**
Charles Moreau, 1937.

Hoffmann, Herbert.
Intérieurs Modernes de Tous les Pays.
Librairie Grund, Paris, 1930.

Janneau, Guillaume.
Le Luminaire et les Moyens d'Éclairage Nouveaux. 2 vols. Charles Moreau, Paris, 1925, 1930.

Janneau, Guillaume. **Meubles Nouveaux**
(Exposition Internationale de 1937).
Charles Moreau, Paris, n.d.

Janneau, Guillaume. **Meubles Nouveaux.**
Charles Moreau, Paris, 1937.

Janneau, G. **Technique du Décor Intérieur Moderne.** Éditions Albert Morance, Paris, 1928.

Jourdan, Francis.
Interieurs Présentés par Francis Jourdan.
Vol. 6 of the series **L'Art International d'Aujourd'hui.** Charles Moreau, Paris, n.d.

Keim, Albert. **Le Beau Meuble de France.**
2 vols. Éditions Nillson, Paris, 1928.

Kohlmann, E. **Petits Meubles Modernes.**
E. Moreau, Paris, 1929.

Lefol, Gaston.
Intérieurs d'Hôtels Particuliers.
Charles Massin et Cie, Paris, 1926.

Lumet, Louis. **Francis Jourdain.**
Éditions d'Art E. Mary, Paris, n.d.

Moussinac, Léon. **Intérieurs.** Vols. 1–4.
Albert Lévy, Paris, 1924.

Moussinac, Léon.
Le Meuble Français Moderne.
Librairie Hachette, Paris, 1925.
Good essay on the origins of Art Deco.

Nouveaux Intérieurs Français (Salon des Artistes Décorateurs). Charles Moreau, Paris, 1933–6.

Olmer, Pierre. **Le Mobilier Français: 1910-25.**
Van Oest, Brussels, n.d.

Petits Meubles du Jour. Charles Moreau, Paris, 1931.

Rambosson, Yvanhoé, **Maurice Dufrène.** Éditions d'Art E. Mary, Paris, n.d.

Répertoire du Goût Moderne. 5 vols. Éditions Albert Lévy, Paris, 1928–29.

Rieter, Léon. **P. Follot.** Édition d'Art E. Mary, Paris, n.d.

Saint-Sauveur (Charles Massin). **Intérieurs Modernes.** Charles Massin et Cie, Paris, 1926.

Salon des Artistes Décorateurs: Intérieurs au Salon. Vol. 1, 1926; vol. 2, 1927; vol. 3, 1928; vol. 4, 1929; vol, 5, 1930; vol. 6, 1931; vol. 7, 1932. Charles Moreau, Paris.

Sedeyn, Émile. **Le Mobilier.** F. Reder & Co., Paris, 1921.

Smithells, Roger and S. John Woods. **The Modern Home.** F. Lewis Ltd, Essex, 1936.

Société des Artistes Décorateurs. **Le Salon des Artistes Décorateurs, 1930.** Vincent Fréal & Co., Paris, 1930.

Tabarant, Adolphe. **Huillard, Louis Suë et André Mare.** Éditions d'Art E. Mary, Paris, n.d.

Warchalowski, Jerzy. **Polska Sztuka Dekoracyjna.** Wydawnictwo J. Mortkowicza, Warsaw, 1928.

Wettergren, Erik. **Les Arts Décoratifs Modernes de la Suède,** Musée de Malmo, n.d.

7. GLASS, CERAMICS, JEWELRY AND SILVER

Barillet, Louis. **Le Verre Présenté par Louis Barillet.** Vol. 10 of the series **L'Art International d'Aujourd'hui.** Charles Moreau, Paris, 1929.

Chavance, René. **La Céramique et la Verrerie.** Éditions Rieder, Paris, 1928.

Clouzot, Henri. **André Mettey - Décorateur et Céramiste.** Librairie des Arts Décoratifs, Paris, 1922.

Fouquet, Jean. **Bijoux et Orfèvrerie Présentés par Jean Fouquet.** Vol. 16 of the series **L'Art International d'Aujourd'hui.** Charles Moreau, Paris, 1929.

Geffroy, Gustave. **René Lalique.** Éditions d'Art E. Mary, Paris, n.d.

Gruber, J. **Les Vitraux à l'Exposition Internationale.** Charles Moreau, Paris, n.d.

Janneau, Guillaume. **Modern Glass.** The Studio Ltd, London, 1931.

Janneau, Guillaume. **La Vie et l'Oeuvre de Maurice Marinot.** H. Floury, Paris, n.d.

Kahn, Gustave. **L'École de Nancy: E. Gallé, Majorelle, Daum, V. Prouvé, Gruber.** Éditions d'Art E. Mary, Paris, n.d.

Prouvé, Jean. **Le Métal Présenté par Jean Prouvé.** Vol. 9 of the series **L'Art International d'Aujourd'hui.** Charles Moreau, Paris, n.d.

Puiforcat, Jean. **Orfèvrerie, Sculpture.** Flammarion, Paris, 1951.

Valotaire, M. **La Céramique Française Moderne.** G. Van Oest. Brussels, Paris, 1930.

8. TEXTILES, WALL PAPER AND RUGS

Clouzot, Henri. **Le Décor Moderne dans la Teinture et le tissu.** Charles Massin, Paris, 1929.

Clouzot, Henri. **Papiers Peints et Teintures Modernes.** Charles Massin, Paris, 1928.

Delaunay, Sonia. **Composition, Couleurs, Idées.** Éditions d'Art Charles Moreau, Paris, 1929.

Delaunay, Sonia. **Ses Peintures, ses Objets, ses Tissus Simultanés, ses Modes.** Librairie des Arts Décoratifs, Paris, 1924.

Delaunay, Sonia. **Tapis et Tissus Presentés par Sonia Delaunay.** Vol. 15 of the series **L'Art International d'Aujourd'hui.** Charles Moreau, Paris, 1929.

Matet, M. M. **Tapis Modernes.** M. H. Ernst, Paris, n.d.

Verneuil, M. P. **Étoffes et Tapis Étrangers.** Albert Lévy, Paris, 1926.

9. IRONWORK

Clouzot, Henri. **La Ferronnerie Moderne.** Series 1–5. Charles Moreau, Paris. n.d.

Clouzot, Henri. **La Ferronnerie Moderne à l'Exposition des Arts Décoratifs.** Charles Moreau, Paris, 1925.

Gauthier, Maximilien. **Raymond Subes.** Collection Les Gémeaux, Paris, 1950.

Janneau, Guillaume. **Le Fer à l'Exposition Internationale des Arts Décoratifs Modernes.** F. Contet, Paris, 1925.

Lacour, Léopold. **Robert et Brandt.** Éditions d'Art E. Mary, Paris, n.d.

Martinie, Henri. **La Ferronnerie – Exposition des Arts Décoratifs.** Albert Lévy, Paris, 1926.

Subes, Raymond. **Raymond Subes - Maître Ferronnier.** Charles Massin et Cie, Paris, 1931.

Virette, Jean. **La Ferronnerie.** S. de Bonadona, Paris, 1930.

10. SCULPTURE

Derny, L. **Sculptures Modernes d'Ameublement.** Emile Thézard et Fils, Dourdan (Seine et Oise), n.d.

Hauteur, Louis. **Sculpture Décorative: Exposition Internationale de 1937.** Charles Moreau, Paris, 1937.

Jean, René. **Sculptures Décoratives de Céline Lepage.** Librairie des Arts Décoratifs, Paris, n.d.

Malcles, Laurent. **Le Décor Sculpté Moderne.** Eugène Moreau, Paris, 1933.

Martel, Joël and Jan. **Sculpture Présentée par Joël et Jan Martel.** Vol. 13 of the series **L'Art International d'Aujourd'hui.** Charles Moreau, Paris, 1931.

Rapin, H. **La Sculpture Decorative.** 3 Vols. Charles Moreau, Paris, 1929.

11. POSTERS AND ADVERTISING ART

Advertising the Motion Picture. A Specimen Survey of Intra-Industry Production Presentations of 1936–7. Quigley Publications, New York, 1937.

Annual of Advertising Art in the United States. Art Director's Club, New York, 1921 to date.

Annuario della Publicità Italiana 1929-30, 1931. Casa Editrice Reclame, Bolzano.

Art for All. London Transport Posters: 1908–49. Art & Technics, Ltd, London, 1949.

Biegeleisen, J. I. **Poster Design.** Greenberg, New York, 1945.

Binder, Joseph. **Colour in Advertising.** The Studio Ltd, London, 1934.

Bradshaw, Percy V. **Art in Advertising.** The Press Art School, London, 1925.

Les Cahiers Jaunes 3. Maîtres Français de L'Affiche. Librairie José Corti, Paris, n.d. Consists of works by Carlu, Cassandre, Colin, Loupot and Germaine Marx.

The Museum of Modern Art. **Posters by A. M. Cassandre.** The Museum of Modern Art, New York, 1936.

Cassandre, A. M. **Posters.** Zollikofer & Co., St Gall, 1948.

Cassandre, A. M. **Publicité Présentée par A. M. Cassandre.** Vol. 12 of the series **L'Art International d'Aujourd'hui.** Charles Moreau, Paris, 1929.

Cassandre, A. M. **Le Spectacle est dans la Rue.** Draeger Frères, Paris, 1936.

Conway, Sir Martin. **Posters by Royal Academicians: The Elevation of Poster Art.** Eyre & Spottiswoode, London, 1925.

Gossop, R. P. **Advertisement Design.** Chapman & Hall, London, 1927.

Hillier, Bevis. **Posters.** Weidenfeld and Nicolson, London; Stein & Day, New York, 1969.

Ludwig Holwein and His Work. H. C. Perlberg, New York, 1925.

Holwein, Ludwig. **Ludwig Holwein, München.** Phönix Illustrationsstück, Berlin, 1926.

Kauffer, E. McKnight. **Art of the Poster.** Albert & Charles Boni, New York, 1925.

The Museum of Modern Art. **Posters by E. McKnight Kauffer.** The Museum of Modern Art, New York, 1937.

Laville, C. **L'Imprimé de Publicité.** Vols. 1–3. Aux Éditions Topo, Paris, 1923.

Mercer, Frank. **Poster Progress.** The Studio Ltd, London, 1939.

Metzl, Ervine. **The Poster –
Its History and Its Art.**
Watson-Guptill Publications, New York, 1963.
**Modern Publicity:
The Annual of Art and Industry.**
The Studio Ltd, London, 1924 to date.
Previous titles: **Art & Publicity:
Fine Printing and Design, 1925;
Posters and Publicity:
Fine Printing and Design, 1926-9;
Modern Publicity:
Commercial Art Annual, 1930-2;
Modern Publicity, 1933, 1934-6, 1936-7;
Modern Publicity –
Annual of Art and Industry, 1937-8.**
Oesterreichische Plakate 1890-1957.
Anton Schroll, Vienna, 1957.
The Poster: The Essentials of Poster Design.
Poster Advertising Inc., 1925.
Price, Charles Matlock. **Poster Design.**
George W. Bricka, New York, 1913, 1922.
Procédés. Braun et Cie, Paris, n.d.
Publicité 1939.
Éditions Arts et Métiers Graphiques, Paris, 1940.
Purvis, Tom. **Poster Progress.**
The Studio Ltd, London, 1939.
Raffe, Walter G. **Poster Design.**
Chapman & Hall, London, 1929.
Richmond, Leonard.
The Technique of the Poster.
Sir Isaac Pitman & Sons Ltd, London, 1933.
Rickards, Maurice.
Posters of the 1920s.
Walker & Co., New York, 1968.
Schubert, Walter F.
Die Deutsche Werbegraphik.
Verlag Francken & Lang, Berlin, 1927.
Sheldon, Cyril.
A History of Poster Advertising.
Chapman & Hall, London, 1937.
Sheldon, Cyril. **Poster Advertising.**
Sheldons Ltd, London, 1927.
Sparrow, Walter Shaw.
Advertising and British Art.
The Bodley Head, London, 1924.
Twining, E. W. and D. Holdich.
Art in Advertising.
Sir Isaac Pitman, London, 1931.
Young, Frank H.
Modern Advertising Art.
Covici, Friede, New York, 1930.

12. BOOK BINDINGS, FASHION
ILLUSTRATIONS AND TYPOGRAPHY
Adler, Rose.
Reliures Présentées par Rose Adler.
Vol. 17 of the series
L'Art International d'Aujourd'hui.
Charles Moreau, Paris, 1930.
Les Artistes du Livre.
Henri Babou, Paris, n.d.
Godfroy, Louis. **L'Oeuvre Gravée de
Jean-Émile Laboureur.**
Chez L'Auteur, Paris, 1929.
Hoffman, Herbert. **Modern Lettering:
Design and Application.**
William Helburn, New York, n.d.
Kahn, Gustave. **Paul Iribe.**
Éditions d'Art E. Mary, Paris, n.d.

Leighton, Clare.
Wood Engraving of the 1930s.
Special Winter issue of The Studio,
London, 1936.
Loyer, Jacqueline. **Laboureur:
Oeuvre Gravée et Lithographie.**
Paris, 1962.
Catalog raisonné and bibliography.
Lumet, Louis. **Robert Bonfils.**
Éditions d'Art E. Mary, Paris, n.d.
Moreau, George.
Le Livre et l'Illustration.
Éditions d'Art E. Mary, Paris, n.d.
Mornand, Pierre. **Huit Artistes du Livre.**
Le Courrier Graphique, Paris, 1939.
Mornand, Pierre. **Trente Artistes du Livre.**
Editions Morval, Paris, 1945.
Mornand, Pierre.
Vingt-Deux Artistes du Livre.
Le Courrier Graphique, Paris, 1943.
Neumann, Eckhard.
Functional Graphic Design in the 20s.
Reinhold Publishing Co., New York, 1967.
Pichon, Léon.
The New Book Illustration in France.
The Studio Ltd, London, 1924.
Poiret, Paul. **Art et Phynance.**
Editions Lutétia, Paris, 1935.
Poiret, Paul. **En Habitant l'Époque.**
Bernard Grasset, Paris, n.d.
English version: **My First 50 Years,**
Victor Gollancz, London, 1931.
Poiret, Paul. **The King of Fashion.**
J. B. Lippincott, Philadelphia, 1933.
Rambosson, Yvanhoë.
Paul Poiret et ses Collaborateurs.
Éditions d'Art E. Mary, Paris, n.d.
Spencer, Charles N. **Erté.**
Studio Vista, London;
Clarkson N. Potter, New York, 1970.

13. PERIODIC LITERATURE ARRANGED BY
DESIGNER
J. J. Adnet
Champigneulle, Bernard.
Une Installation de Jacques Adnet.
Mobilier et Décoration, Paris, 1938. Year 18,
no.1, pp.1–12.
Chavance, René.
**Jacques Adnet dans le Mouvement
Contemporain.** Mobilier et Décoration, Paris,
1936. Year 16, pp.329–47.
Clouzot, Henri. **Jacques Adnet, Décorateur.**
Mobilier et Décoration, Paris, 1932. Year 12,
pp.349–63.
Derys, Gaston.
Ensembles Récents de Jacques Adnet.
Mobilier et Décoration, Paris, October, 1935.
Pp. 276–86.
Deshairs, Léon.
Les Céramiques de Jean et Jacques Adnet.
Art et Décoration, Paris, 1928. Vol. 54, pp.126–8.

Georges Barbier
Flament, Albert.
**Un Créateur d'Élégances: George Barbier
de Nantes.** Renaissance de l'Art Français et des
Industries de Luxe, Paris, 1918. Pp.157–62.

Flament, Albert.
George Barbier: Dessinateur de Théâtre.
Renaissance de l'Art et des Industries de Luxe,
Paris, 1919. Year 2, pp. 17–21.
Jaleux, Edmond.
**A Propos du 'Casanova' de Maurice
Rostand.** Renaissance de l'Art et des
Industries de Luxe, Paris, 1919. Year 2, pp.17–21.
Miomandre, Francis de. **George Barbier.**
L'Art et les Artistes, Paris, 1914. Vol. 19.
pp.177–83.
Valotaire, M. **George Barbier.**
The Studio, London, 1927. Vol. 93, pp.404–10.

Paul Bonet
Moutard-Uldry, Renée. **Paul Bonet.**
Mobilier et Décoration, Paris, February, 1940.
Pp.35–41.

Edgar Brandt
Chavance, René. **Edgar Brandt et l'Art du Fer.**
L'Art et les Artistes, Paris, 1922. Nouvelle Série.
Vol. 5, pp.276–80.
Derys, Gaston. **Edgar Brandt.**
Mobilier et Décoration, Paris, January, 1934.
pp.1–15.
Dormoy, Marie. **Edgar Brandt.**
L'Amour de l'Art, Paris, 1925. Year 6, pp.342–3.
Esembrey, Paul.
Edgar Brandt, Master Ironworker.
International Studio, New York, 1924. Vol. 80,
pp.253–8.
Martinie, A.-H.
Nouvelles Ferronneries du Brandt.
Art et Décoration, Paris, 1928. Vol. 54, pp.149–53.
Mourey, Gabriel.
Edgar Brandt, the French Ironworker.
The Studio, London, 1926. Vol. 91, pp.330–5.
Paris, W. Francklyn.
The Rejuvenescence of Wrought Iron.
Architectural Forum, New York, 1929. Vol. 50,
pp.89–96.
Regamey, Raymond.
Le Ferronnier d'Art, Edgar Brandt.
Archives Alsaciennes de l'Histoire de l'Art,
Strasbourg, 1924. Year 3, pp.147–66.

Umberto Brunelleschi
Zam, Carlo.
**Nello Studio del Pittorio Umberto
Brunelleschi a Parigi.** Rivista d'Arte,
Torino, November, 1937. Pp.12–13.

Cassandre, A. M.
Allner, W. H. **A. M. Cassandre.** Graphis,
Zurich, 1945. Year 1, nos.9–10, pp.270–3.
Dupuy, R. L.
**Contemporary Poster Artists:
A. M. Cassandre.** Gebrauchsgraphik, Berlin,
1927. Year 4, Vol. 6, pp.56–7.
Une Exposition: Loupet, Cassandre.
Arts et Métiers Graphiques. Paris, July, 1931.
Pp.309–15.
Saurel, Marc. **Une Création de Cassandre.**
ABC Magazine, Paris, 1936. Year 12, pp.130–1.
Valotaire, Marcel. **Posters of Cassandre.**
Commercial Art, London, January, 1928. Vol. 4,
pp.20–4.

Zahar, Marcel.
**L'Affiche de 1900 à 1939: Paul Colin,
A. M. Cassandre.** Arts de France, Paris, 1947.
Nos.17–18, pp.31–45.

Paul Colin

Champigneulle, Bernard.
Un Appartement Décoré par Paul Colin.
Mobilier et Décoration, Paris, February, 1935.
Pp.41–8.

Dupuy, R. L.
Paul Colin: Ein Theaterplakatmaler.
Gebrauchsgraphik, Berlin, 1928. Year 5, Vol. 1,
pp.31–7.

L' École Paul Colin.
**Les Expositions de 'Beaux Arts' et de
'La Gazette des Beaux Arts'.** Catalogue.
Paris, 1933. No.4, pp.1–8.

Thérive, André.
Paul Colin: Peintre de Décors et d'Affiches.
Arts et Métiers Graphiques, Paris, 1929.
Pp.615–20.

Valotaire, Marcel.
Continental Publicity Posters by Paul Colin.
Commercial Art, London, 1929. Vol. 6,
pp.108–11.

Zahar, Marcel (see above under **Cassandre**).

Sonia Delaunay

Benoist, Luc. **Les Tissus de Sonia Delaunay.**
Art et Décoration, Paris, 1926. Vol. 50, pp.142–4.

Dormoy, Marie. **Les Tissus de Sonia Delaunay.**
Amour de l'Art, Paris, 1927. Year 8, pp.97–8.

Maurice Dufrène

The Art Ideals of Maurice Dufrène.
The Upholsterer, New York, 1922. Vol. 68,
pp. 77–8.

Chavance, René.
**Maurice Dufrène et la Renaissance des
Arts Appliqués.** Mobilier et Décoration, Paris,
1936. Year 16, pp.121–38.

Guenne, Jacques.
Un Grand Décorateur: Maurice Dufrène.
Art Vivant. Paris, October, 1935. Pp.226–7.

Valotaire, Marcel.
**La Maîtrise: A Creative Force in
Decorative Art.** Creative Art, New York, 1928.
Vol. 3, pp.324–30.

Jean Dunand

Jean Dunand (Autobiographical Sketch).
Art d'Aujourd'hui. Paris, Spring, 1927. P.10.

Gauthier, Maximilien. **Jean Dunand.**
Art Vivant, Paris, November 15, 1925. Vol. 1,
pp.28–9.

Guiffrey, Jean.
**Jean Dunand: Le Studio de
Madame Agnès.** Renaissance de l'Art
Français et des Industries de Luxe, Paris, 1927.
Year 10, pp.175–8.

Rambosson, Yvanhoë.
**Le Décor Géométrique et les Laques dans
l'Oeuvre de Dunand.** L'Amour de l'Art, Paris,
1923. Year 4, pp.613–16.

Sedeyn, Émile. **Jean Dunand.**
Art et Décoration, Paris, 1919. Vol. 36,
pp.118–26.

Thubert, Emmanuel de. **Jean Dunand.**
L'Art et les Artistes, Paris, 1920.
Nouvelle Série. Vol. 7, pp.381–6.

Jean Dupas

Jean Dupas. His Work and Ideas.
Creative Art, New York, 1928. Vol. 2, pp.383–9.

Erté (Roman de Tirtoff)

Barbier, George. Catalogs of Erté's exhibitions
at the Charpentier Gallery, Paris, and the
William E. Cox Gallery, New York, 1929.

Catalogs of Erté exhibitions: Galleria Milano,
Milan, Italy, 1966; Grosvenor Gallery,
London, 1967; Sears-Vincent Price Gallery,
Chicago, 1967–8; Follies and Fashions,
Metropolitan Museum of Art, New York, 1968;
Sonnabend Gallery, New York, 1970–1.

Feuillet, Maurice. **Le Peintre-Poète Erté.**
Le Gaulois Artistique, Paris, 1929. Nos.33–4.

Paul T. Frankl

Migennes, Pierre.
**Un Artiste Décorateur Americain:
Paul Th. Frankl.** Art et Décoration, Paris, 1928.
Vol. 53, pp.49–56.

René Herbst

Clouzot, Henri. **René Herbst, Décorateur.**
Mobilier et Décoration, Paris, 1933. Year 13,
pp.81–94.

E. McKnight Kauffer

E. McKnight Kauffer. The Studio, London,
July 15, 1925. Vol. 90, pp.42–3.

**E. McKnight Kauffer, English Commercial
Artist.** Gebrauchsgraphik, Berlin, May, 1929.
Vol. 6, pp.35–45.

**E. McKnight Kauffer Has Come Back to
His Native Land.** American Artist, New York,
April, 1941. Pp.12–13.

**New Rug Designs by E. McKnight Kauffer
and Marion V. Dorn.** Creative Art,
New York, January, 1929. Pp.37–8.

René Lalique

Clouzot, Henri. **René Lalique.**
Mobilier et Décoration, Paris, 1932. Year 12,
pp.213–9.

Derys, Gaston.
**L'Exposition de l'Oeuvre de René Lalique au
Pavillon de Marsan.**
Mobilier et Décoration, Paris, 1933. Year 13,
pp.95–102.

Glass and China: René Lalique. Hobbies,
Chicago, May, 1940. Pp.49–50.

Marx, Roger. **René Lalique.** L'Art Social, Paris,
1913. Pp.169–87.

Tisserand, Ernest.
**Le Poème en Verre d'Émile Gallé à
René Lalique.** L'Art Vivant, Paris, 1929.
Year 5, pp.722–1.

Georges Le pape

Vaudoyer, Jean-Louis. **George Le pape.**
Art et Décoration, Paris, 1913. Year 17, pp.65–76.

Pierre Legrain

Rosenthal, Léon. **Pierre Legrain: Relieur.**
Art et Décoration, Paris, 1923. Vol. 43, pp.65–70.

Varenne, Gaston.
Quelques Ensembles de Pierre Legrain.
Amour de l'Art, Paris, 1929. Year 5, pp.401–8.

Robert Mallet-Stevens

Born, Wolfgang.
Der Pariser Architekt Rob. Mallet-Stevens.
Deutsche Kunst & Dekoration, Darmstadt, 1928.
Vol. 62, pp.391–2.

Mourey, Gabriel.
Opening of the Rue Mallet-Stevens.
The Studio, London, 1927. Vol. 94, pp.437–41.

Robertson, Howard & F. R. Yerbury.
**Parisian Publicity: a Façade by
Mallet-Stevens.** Architect and Building News,
London, 1931. Vol. 127, pp.351–3.

**Villa à Sceaux: Architecte
Robert Mallet-Stevens.** L'Architecte, Paris,
June, 1932. P.54.

Werth, Léon.
**L'Architecture Intérieure et
Mallet-Stevens.** Art et Décoration, Paris, 1929.
Vol. 55, pp.177–88.

André Mare

Chantre, Ami. **Les Reliures d'André Mare.**
Art Décoratif, Paris, 1913. Vol. 30, pp.251–8.

Deshairs, Léon. **André Mare, Peintre.**
Art et Décoration, Paris, 1928. Vol. 55, pp.17–22.

Kunstler, Charles. **André Mare.** Amour de l'Art,
Paris, 1928. Year 9, pp.286–92.

Pradel, Marie-Noëlle.
La Maison Cubiste en 1912. Art de France,
Paris, 1961. No. 1, pp.177–86.

Sauvage, Marcel.
Artistes d'Aujourd'hui: André Mare.
Art Vivant, Paris, 1928. Year 4, pp.526–7.

Maurice Marinot

Chantre, Ami.
Les Verreries de Maurice Marinot.
Art et Décoration, Paris, 1920. Vol. 37,
pp.139–46.

Chavance, René.
Maurice Marinot: Peintre et Verrier.
L'Art et les Artistes, Paris, 1923.
Nouvelle Série, Vol. 6, pp.151–7.

Maurice Marinot. Art d'Aujourd'hui, Paris,
1928. Year 5, No.17, pp.10–11.

Mourey, Gabriel.
A French Glassmaker: Maurice Marinot.
The Studio, London, 1927. Vol. 93, pp.247–50.

Mourey, Gabriel. **Maurice Marinot, Verrier.**
Amour de l'Art, Paris, 1923. Year 4, pp.701–6.

Vaillat, Léandre.
**Marinot, Peintre Verrier; à Propos de
l'Exposition de la Galerie Hébrard.**
L'Art et les Artistes, Paris, 1914. Vol. 19,
pp.138–43.

André-E. Marty

Derys, Gaston. **André-E. Marty.**
Mobilier et Décoration. Year 16, pp.185–9.

Jean Puiforcat

La Richesse Inventive de Jean Puiforcat.
Mobilier et Décoration, Paris, March, 1938.
Pp.97–103.

Clouzot, Henri.
Jean Puiforcat, Rénovateur de l'Art Religieux. Mobilier et Décoration, Paris, 1938. Year 18, No.1, pp.21–8.

Jean Puiforcat. Art d'Aujourd'hui, Paris, Spring, 1927. P.11.

Jean Puiforcat, Sculpteur. Art Vivant, Paris, October, 1933. P.433.

Martinie, A.-H. **Jean Puiforcat.** Art Vivant, Paris, April, 1932. Pp.106–8.

Varenne, Gaston. **Jean Puiforcat, Orfèvre.** Art et Décoration, Paris, 1925. Vol. 47, pp.1–11.

Weinold Reiss

Bei den Schwarzfussindianern, mit acht Bildern nach Oelgemälden des Verfassers. Velhagen & Klasings Monatshefte, Berlin, October, 1937. Pp. 121–8.

The Modern Style Reflected in the Design of the Offices of Rudolph Mosse, Inc., New York: Weinold Reiss, Interior Architect. American Architecture, New York, 1929. Vol. 135, pp.461–3.

Smith, Beverly.
An Artist who Captures Indians: Weinold Reiss. American Magazine, Springfield, January, 1932. Vol. 113, pp.26–7, 84.

Émile-Jacques Ruhlmann

Besnard, Charles-Henri.
Quelques Nouveaux Meubles de Ruhlmann. Art et Décoration, Paris, 1924. Vol. 45, pp.65–72.

Mourey, Gabriel.
A Great French Furnisher: Émile-Jacques Ruhlmann. The Studio, London, 1926. Vol. 92, pp.244–50.

Varenne, Gaston.
Un Ensemble de Ruhlman à la Chambre de Commerce de Paris. Art et Décoration, Paris, 1928. Vol. 53, pp.109–12.

Vauxcelles, L. **Jacques-Émile Ruhlmann.** Carnet des Artistes, Paris, 1917. No.14, pp.8–14.

Raymond Subes

Champigneulle, Bernard. **Raymond Subes.** Mobilier et Décoration, Paris, 1937. Year 17, pp.113–19.

Chavance, René.
Raymond Subes et la Technique de la Ferronnerie. Mobilier et Décoration, Paris, 1938. Year 18, pp.429–37.

Clouzot, Henri. **Raymond Subes, Ferronier.** Mobilier et Décoration, Paris, 1933. Year 13, pp.430–42.

Dervaux, Adolphe.
Raymond Subes, Ferronnier. Art et Décoration, Paris, 1924. Year 28, pp.149–56.

Farnoux-Reynaud, Lucien. **Raymond Subes.** Mobilier et Décoration, Paris, 1935. Year 15, pp.166–77.

Goissat, Antony.
Les Oeuvres du Ferronnier Raymond Subes à l'Exposition. Mobilier et Décoration, Paris, 1937. Year 17, pp.393–405.

Leroy, Marcel.
La Ferronnerie Moderne: Raymond Subes. Clarté, Brussels, April, 1932. Pp.1–5.

Martinie, A.-H.
Ferronneries Récentes de Raymond Subes. Art Vivant, Paris, March, 1933. Pp.124–6.

Martinie, A.-H. **Raymond Subes.** Art Vivant, Paris, June, 1931. P.285.

Rambosson, Yvanhoë.
Les Ferronneries de Subes. Mobilier et Décoration, Paris, 1932. Year 12, pp.173–84.

Louis Sue

Vaillat, Léandre. **Louis Sue, Architecte.** Amour de l'Art, Paris, 1923. Year 4, pp.477–82.

Raymond Templier

Varenne, Gaston.
Raymond Templier et le Bijou Moderne. Art et Décoration, Paris, 1930. Vol. 57, pp.49–58.